Bournemouth

The Biography

1810-1910

CHARLES H. MATE

AMBERLEY

Discalimer: This book is an adaptation of Charles H. Mate's 1910 *Bournemouth: The History of a Modern Health and Pleasure Resort.* This text was completed with the use of OCR scanning technology and therefore, while all efforts have been made to appropriately copy-edit the resulting text, there may be several small errors.

Originally published in 1910
This edition first published 2014

Amberley Publishing
The Hill, Stroud
Gloucestershire, GL5 4EP

www.amberley-books.com

Copyright © Amberley Publishing, 2014

The right of Amberley Publishing to be identified as the Author of this work has been asserted in accordance with the Copyrights, Designs and Patents Act 1988.

British Library Cataloguing in Publication Data.
A catalogue record for this book is available from the British Library.

ISBN 978 1 4456 4224 6 (paperback)
ISBN 978 1 4456 4246 8 (ebook)

Typesetting and Origination by Amberley Publishing.
Printed in the UK.

Contents

Introduction by the Editor

Founded in 1810 by Lewis Tregonwell, Bournemouth was originally a deserted heathland, home to fishermen and smugglers. Initially marketed as a health resort, the town began to grow after appearing in Dr Granville's book, *The Spas of England*. Bournemouth's growth really accelerated with the arrival of the railway and it became a town in 1870. The arrival of the railways precipitated a massive growth in seaside and summer visitors to the town, especially from the Midlands and London. In 1880, the town had a population of 17,000, but by 1900, when railway connections to Bournemouth were at their most developed, the town's population had risen to 60,000 and it had become a favourite location for visiting artists and writers. The town was improved greatly during this period through the efforts of Sir Merton Russell-Cotes, the town's mayor and a local philanthropist, who helped to establish the town's first library and museum. Bournemouth became a municipal borough in 1890 and a county borough in 1900. The town's growth only increased in the early twentieth century, the town centre spawned theatres, cafés, two art deco cinemas and more hotels.

Today, Bournemouth has a population of almost 190,000 people, and is a tourist centre of leisure, entertainment, culture and recreation. It has come a long way from its roots in the nineteenth century. Those roots, the formative years of the town, are the focus of *Bournemouth: The Biography 1810–1910,* which charts the evolution of Bournemouth from a smuggler's haven to the coastal resort we know today. The period 1910 to the present day will be covered in a seperate volume.

Preface

Bournemouth! Your Guide Book will tell you all about its History and Climate, but you should hear also from one of the ladies who have stayed there, both during winter and summer, the experience of each season.

A friend of mine used to say that a Man's account of an Event or of a Place was History, and that a Woman's description was merely Her Story. But Her story often brings more home to you that which you desire to know in regard to climate and local interest than does the Man's History! And Women will speak gratefully to you of the shelter given by the Pinewoods in Winter, and of their pleasant resinous smell in summer. For anyone not in the strongest health a Lady's impressions of a place are more to be trusted than those of a healthy Man, if we wish to know how enjoyment, peace of mind and ease of body, may be sought and found.

Let me then briefly repeat what I have heard from them.

We must leave the summer yachting and the winter sports, the fishing and the riding, to those who can well shift for themselves and obtain as much as they can care to have or afford to have – to those who can find out for themselves what, every corner in England may afford. We must become mentally shortsighted and for the moment think only of what can be seen by the easy means of the motor car, or by the aid of the humbler carriage and pair.

Limited to this, how full may life still be of interest, if the lessons of pleasant country houses, of historic churches, of antiquarian researches, of excursions by steamer to other parts of the mainland coast and to the Isle of Wight, be happily inquired after and learnt. And then, the interest of all animal life to be watched each in due season: the departing crowds of migratory birds in the autumn, the farewell notes of many of our singing birds, of swallows and waterfowl, and the arrival from the yet colder north of the little migrants who think our Bournemouth climate all that bird comfort ought to ask to have, and to hear this said pleasantly in the language of Crossbills, who are not cross in disposition, except in the disposition of their beaks; and to have it repeated by other visitors who

deem Norway and the rest of Scandinavia too cold, and find nearly as many Pines in the South of England as at home, and a more friendly temperature. There are Brambling Finches for the Pine Woods and Woodcocks for the marshy low-ground.

Mr Gould, the great bird lover, always declared he could distinguish a Norwegian Woodcock from those who live with us all the year round, and these again from those who prefer Albania and other Mediterranean shores in winter.

And in summer, when the birds are nesting or looking after their young, you may change your studies of Natural History, and your diet, by trying to perfect yourself in a difficult art, namely, that of catching the nutritious Razor Shell-fish yourself for your own dinner. This requires a lot of practice and a local professor who will show you how to put a long barbed wire down into the spot in the sand where, by signs not easily read, he knows a Razor Shell has made preparations either to rise or to sink in the sand, and down goes his barbed wire, running through the 'fish' and bringing it up, a wholesome dish, in many people's opinion much better than an oyster!

It was at Highcliff that the late beautiful Lady Waterford was inspired to paint many of her striking water-colour sketches. Her sense of colour was always true, however vivid her tints, and her pictures were always the outcome of charming sentiment and love of all that is graceful in woman or child.

Queen Victoria's able Physician, Sir James Clark, was one of Bournemonth's greatest benefactors, for he lived there and praised the influence of its Pine Woods, and was keen that these Woods should be preserved, and that wherever land were taken for building, a certain number of the trees should be preserved, as they were among Bournemouth's best Doctors.

From Lord Malmesbury's house near the clear little river which gives Bournemouth its name, much of the history of England during the time of Lord Derby's Administration, was guided, for Lord Malmesbury was then Foreign Minister of this country during trying times. But such family reminiscence can go much further back, and can unite with us the age of the Norman Conquest, when the forefathers of our English Statesmen had to consolidate our own country, still seething with the enmities of Celt, Saxon, Dane, and Norman. One of the finest of the Norman Abbey Churches is within a short motor drive, namely Romsey, where the painting of wall and column has disappeared, and the white stoned round arches and columns stand as they stood when Norman hands first finished the structure. But temptation to tell what is better told within the Book must be resisted, and all I have to say further is –

Open and Read, and may you become wiser as well as healthier through Bournemouth air and learning.

I

Introductory

On one of the terraces in the picturesque churchyard of St Peter's, embowered amid a wealth of foliage, stands a low flat tomb, erected as a memorial of Mr Lewis Dymoke Grosvenor Tregonwell, a Dorset Squire, celebrated in local history as the 'Founder of Bournemouth'. His claim to that distinctive title rests on the fact that in 1810–11 he here erected 'a mansion for his own occupation' and 'was the first to bring Bournemouth into notice as a watering place.' From that modest beginning – the erection of a seaside villa residence – has been evolved the Bournemouth of today: the second largest health and pleasure resort in the United Kingdom – of world-wide renown, of unique charm, and growing attraction: 'A Garden City,' 'A Paradise of Pines,' 'A Stately Pleasure Dome,' 'A Temple of Hygiea' – a town which has beauty and salubrity as its chief characteristics and health and pleasure as its staple manufactures.

Huge development and many changes have taken place since 1810. The Bournemouth which Mr Tregonwell brought into notice was a district of very restricted area. From that centre boundaries have been extended in all directions, and in this Centenary Year of 1910 the County Borough of Bournemouth includes an area of nearly six thousand acres, with six miles of sea frontage, and upwards of six hundred acres of Parks, Pleasure Grounds, and open spaces secured for all time against the attacks of the speculative builder or any others who would destroy the special characteristics of the 'Town in a Pine Forest' – the 'Forest City by the Southern Sea.' It has a population of from 75,000 to 80,000, and a rateable value of over £650,000. Its boundaries extend from the Branksome Pine Woods, in 'the county of the town of Poole,' on the west, to the River Stour and the bold promontory of Christchurch (Hengistbury) Head on the east, and inland from the sea to the broad moorlands behind Talbot Woods and Winton. With the causes and the circumstances attending these remarkable developments we shall have to deal later on. All that is necessary at this stage is to put into brief contrast the seaside village of 1810, when Mr Tregonwell first brought Bournemouth 'into notice as a watering place,' and the 'Great Town' of 1910.

Mr Tregonwell's title to be called the 'Founder of Bournemouth' rests, as we have said, on his having been the first to bring it into notice 'as a watering place.' Bournemouth did not originate in 1810; it simply entered upon a new phase of history. The making of Bournemouth began far back in the remote ages of which geologists discourse learnedly and glibly, but which the man of average education only feebly appreciates. In one of the cases at the Public Library there is a stone kelt with a label attached stating that it was 'found at Boscombe, some eight feet below the surface' of the soil, that it is 'supposed by Sir Archibald Geikie to be at least 500,000 years old,' and that it was 'presented by John Sleigh, Esq., March, 1896.'

Other relics of prehistoric eras have been dug up from time to time: memorials of a period wrhen there was no trickling Bourne, but a great tropical river as broad as the Amazon disembogued its vast waters into the sea. It is a far cry from that time to the present; but then it was that the foundations of Bournemouth were first laid, and it is to the great natural forces which operated then, and subsequently, that Bournemouth is indebted for its climatic advantages, the composition of its soil, the formation of its cliffs and chines, the configuration of the land, and its proximity to the sea. In Bournemouth, as Thomas Hardy has said, with a narrower application, we have 'a new world in an old one.' It is equally true as he has applied it: this 'glittering novelty' which we now call Bournemouth has grown up 'on the very verge of a tawny piece of antiquity.' 'Within the space of a mile from its outskirts every irregularity of the soil was prehistoric, every channel an undisturbed British trackway; not a sod having been turned there since the days of the Caesars.' Within the past year the fact has been emphasised by the discovery, close to the railway line at Pokesdown, of prehistoric remains which have led to the suggestion that Bournemouth may claim a higher antiquity as a human settlement than even London itself. In the course of excavations for the making of a road and the development of a small building estate at what is known as Hillbrow – a jutting piece of land with an oak grove sloping away towards the valley of the Stour – upwards of thirty urns were exhumed – of various sizes. The larger urns were almost certainly used for funeral purposes; the smaller, it is suggested, may have been for domestic use or for religious ritual. The theory put forward by Mr D. Chambers, of Southbourne, an antiquary who personally superintended the work, is that the hill ridges from Hengistbury to Pokesdown, and from thence to Moordown, Redhill, and Parkstone were the homes of a prehistoric people, who selected the hilltops for their residences and their cattle stockades, whilst the valleys below formed their pasturage or grazing lands. The site at Hillbrow would appear to have consisted of ramparts and a fosse enclosing two tumuli, and what seemed to be a general cemetery for the settlement, with a roadway leading into the valley. From time to time there have been

other discoveries in the neighbourhood of very similar character. More than thirty years ago the late Mr T. Cox unearthed no less than 96 'black pots' at Redbreast Hill, a couple of miles further up the Stour Valley, and in the possession of the Corporation – and housed at the Central Library – is an ancient British urn which was dug up near the Stour some years ago when excavations were being made in connection with the construction of Tuckton Bridge. Barrows in Talbot Woods – and some still existing in the very heart of the town – fortified camps and entrenchments extending up the Stour Valley from Ilengistbury to Dudsbury, from Dudsbury on past Wimborne Minster (the ancient Vindogladia) to Badbury Rings – occupied but not constructed by the Romans, and identified by Professor Freeman with the Mons Badonicus held by Arthur and his 'Knights of the Round Table' – all testify to the same effect: that Bournemouth has been built up in the very midst and upon the foundations of an earlier civilisation: that the place was the home and habitation of peoples of whom we have now but very imperfect record.

The 'new world within an old world' characteristic of Bournemouth is shown also by its position between the ancient towns of Poole and Christchurch. The eastward boundary of the borough is at Double Dykes, the prehistoric earthworks traditionally associated with the landing – at Hengistbury Head – of Hengist and Horsa, on their second invasion of England. Historians now discredit the whole story; but the entrenchments are there – memorials of a period of which all authentic record has been lost. The town of Christchurch dates back at least to Saxon times; for Bournemouth's western neighbour, Poole, it is claimed that there is 'ample evidence' that 'the smooth waters of its harbour have, assuredly, been ploughed by the more aspiring beaks of the Roman galleys, if, indeed, they have not also shadowed the frail coracle of the early Britons.' That Poole was visited by the Danes there is conclusive evidence. It is recorded that a Danish Army under Ilalfden in 877 were summoned from Wareham to the relief of Exeter. Sailing down the Harbour and out into the Channel within sight of Bournemouth Cliffs they encountered a fleet manned by King Alfred – the founder of the British Navy. A storm arose, the Danes became hemmed in between their enemy and the rocky Purbeck coast, and eventually no less than 120 of their boats were driven ashore and wrecked 'where Purbeck's ancient promontory bares her stony teeth,' and

Alfred won –
There in the lee and shelter of those hills –
The first sea battle of our glorious roll;
Flinging the Norseman, full of panic fear,
To meet on Peveril's grim ledges, death.

Off the mouth of the Bourne the remains have been traced of a submerged pine forest (of which an account was first given by Sir C. Lyell, in his 'Principles of Geology') and further up the valley have been found the trunks of oak, alder, birch, and other trees, bearing traces both of fire and axe. 'The peasantry,' says the writer of an early guide book, 'have a tradition that the forest was burned down during the reign of Stephen,' though the Rev. W. B. Clark, F.G.S., in a paper read before the Geological Society, 'conceives that its destruction was effected during the occupation of England by the Romans.'

In the making of excavations for the West Undercliff Promenade in the Spring of the present year, the contractor had to cut through a complete section of the forest bed. It was eight feet in thickness, with trees in situ, imposed upon a strata of gravel and sand, this new evidence suggesting the theory that the whole land must have fallen (by subterranean agency) since they grew.

The Rev. Mackenzie Walcott in his 'Guide to Hants and Dorset' suggests that it was to the spot where Bournemouth now stands that the Duke of Monmouth was hastening when seized under a tree near Cranborne, some twenty miles distant across country, in 1685; and there is a tradition that, after the death of King Rufus, when hunting in the New Forest, Sir Walter Tyrrell fled to the sea-coast, crossing the Avon at a point still known as Tyrrell's Ford and the Stour at a spot close to where is now Heron Court – the country seat of the Earl and Countess of Malmesbury. If this be correct Tyrrell's flight must have brought him to Bournemouth.

It has been frequently assumed that the name 'Bournemouth,' like the Great Town which it now designates, is of quite modern origin: that it was adopted some time during the last century when the inhabitants took it in preference to the more homely 'Bourne,' which was at that period the common appellation of 'the village.' But the name is, in fact, one of considerable antiquity. Going back to the time of Queen Elizabeth – and we are told, but have not had opportunity to establish, that there are still earlier records – we find in the Calendar of Domestic State Papers, under date July 8th, 1574, a return from Lord Thomas Poulet, the Earl of Southampton, and others, to the Council, of the 'musters and surveys' of the County of Southampton, inclosing a 'certificate of the dangerous places for the landing of an enemy on the coasts of Hampshire, from Bournemouth, in Westover Hundred, to the East Haven of Hayling Island,' and examining the return itself we get the following:

A viewe taken the 23, 24, 25 of June anno dni. 1574, and in the xvith yere of the Reigne of or Sovereigne Ladye Elisabeth bye the grace of God Quene of Ingland, Fraunce and Ireland, defendor of the Fayth, etc., bye the Right Honorable the

Erie of Southampton Edward Horseye, James Pagett, Thomas Carewe, Willm Bowyer, and Thomas Uvedale, esquires, of the daungerous landing places uppon the sea coste from Bornemouthe, within the hundred of Westover, adioyning to Dorsetshire unto the Est haven of the Isle of Hayling leading to the Dell nere Chichester in Sussex.

First, we finde at Bournemouth within the west baye at Christchurche a place very easy For the ennemye to lande there conteyning by estimacion oon quarter of a myle in length, being voyde of all inhabiting:

Wee Finde more a place called Bastowe within the said Baye wch is also an easy place for the ennemye to lande conteining in length a Flight shott:

Wee Finde more oon other like place within the same baye betwixt Redd Cliff, and Hensbury ende, called lowe lands, conteining in length by estimacion half a myle, and the See ever aginst the same place ys of Depthe viii or ix Fathem, having verye good ancorhold within the same.

Wee Finde more within the Est Baye of Christchurch a place called Longeboroughe where Beacons are nigh Christchurch haven, being an easy place for the ennemye to land conteyning in lengthe half a myle, and is of depthe iiii Fethem, and hath a good ancor holde.

Wee Finde more a place called the Black Bulworke at the Chessell ende, leading to Hurste Castell, an easye place for the ennemye to lande, conteyning in length iii quarters of a myle.

The document is of historic importance and special local interest, remembering that fourteen years later the 'Invincible Armada' appeared in the Channel, and that the Bournemouth Beach was not only a 'very easy' place 'for the ennemye to lande,' but adjoined the scene of a former raid – made upon Poole by a combined French and Spanish force in revenge for ravages by the celebrated Harry Page, described in the 'Cronica del Conde D. Pero Nino' as 'a Knight who scours the seas as a corsair, with many ships, plundering all the Spanish and French vessels that he can meet with.'

Reference to Bournemouth is also to be found in a MS. map of Dorset ('Dorcestriae Comitatus Vicinarumque Regionum nona verage Descriptio, A.D. 1575') in the Harleian collection at the British Museum. There we find mention of 'Burnemouthe" – shown as in the county of Dorset – of Sturfeld heathe, of Holenest, and of Iverbridge, as well as of Poole, Longflete, Hickford, and Parkstone, with 'The Myncs,' and 'Canford Lawndes': those 'launds' referred to by Drayton in his 'Poly Olbion':

Canford's goodlie launds (That leene upon the Poole), enrich with coppras vaines.

In Camden's 'History and Description of Britain' (1567), the writer states: 'Having passed Christchurch Hed we come to the fall of the Burn, which is a little brooke runnying from Stourfield Heath, without braunches, and not touched in my former voyage, for want of knowledge and information thereof in tyine.' The Rev. Mackenzie Walcott, in his 'Guide to Hants and Dorset,' says the place was known in 1586 as the 'Fall of the Bourne.' His authority probably was the map of Ralph Tresswell, which shows the Bourne as west of the Hampshire boundary, and within the County of Dorset. In the map of Dorset, included in Camden's 'Britannia' (1610), the stream is similarly placed; so it is in Morden's map (1690), and in a map of Dorset 'drawn from the best authorities' published in 1749. In Overton's map (1600), which corresponds very closely with that of Ralph Tresswell, the stream is shown, without a name being given, but to the west we find mention of 'Allom Chine Copperas House,' and to the east 'Bascomb Copperas House.'

Bournemouth has undergone many metamorphoses. Before Mr Tregonwell brought it 'into notice' as a watering place it was a smugglers' resort, and in the sixteenth century, as already indicated, there were 'copperas works' at Alum Chine and Boscombe, where presumably trade of a more reputable character was conducted.

The story of the 'Mynes' reads like a romance. James Blount, sixth Lord Mountjoy, is said to have been 'a curious searcher into Nature,' and whilst possessor of the Manor of Canford – stretching from the village of that name down to the seashore – he 'discovered that there was, near Parkstone, earth yielding alum, on which, in 1564, he began to make calcanthum, or copperas, and boil alum.' The credit of being the first to introduce the manufacture of alum into this country has been erroneously attributed to Sir Thomas Chaloner, who in 1595 erected alum works near Gainsborough. But there is conclusive proof that Lord Mountjoy commenced operations on Poole Heath some thirty years earlier – importing his knowledge of the process of manufacture from the south of Europe. 'He is stated,' says Mr Philip Brannon, 'to have been guided to the discovery of the rich alum shale of the Poole trough, by observing the holly growing spontaneously and with luxuriance (as at these chines) near the outcrop of the alum shales; and as he had observed the same circumstances in his continental travels so frequently that he found it was there considered an almost certain indication of the existence of such beds, he was encouraged to carry out the manufacture near Poole, and but for litigious opposition would doubtless have attained eminent success.' From the maps it would appear that the Parkstone 'Mynes' were somewhere near Lilliput; there is no doubt, however, work was also carried on at Alum Chine – which probably derived its name from this fact – and early seventeenth century

maps show 'Allom House' – well within the Dorset boundary! Lord Mountjoy's experiments seem not to have been a commercial success; but for a time they no doubt attracted attention, and they were extended, not merely from Parkstone to Boscombe, but also to Brownsea Island. The late Mr Charles van Raalte, in his delightful monograph on that Island, refers to certain proceedings in the Court of Chancery, during the reign of Queen Elizabeth, respecting the partnership accounts of a joint concern, wherein the parties were engaged in 'certain mines of alum and copperas called Baskaw, in the county of Southampton, Allom Chine and Brounsey, alias Brownsea, in the county of Dorset.' 'Baskaw' no doubt refers to Boscombe.

As these 'mynes' – at Parkstone, Branksea, Alum Chine, and Boscombe – were doubtless all of similar character it may be interesting to quote the description of the industry as given by Mistress Celia Fiennes, in a journal entitled 'Through England on a Side Saddle,' published in the time of William and Mary:

'We went by boate to a little Isle called Brounsea, where there is much Copperace made, the stones being found about ye Isle in ye shore in great quantetyes. There is only one house there which is the Governour's, besides little fishermen's houses; they all being taken up about ye Copperace Works. They gather ye stones and place them on ground raised like ye beds in gardens, rows one above the other, and all are shelving, so that ye raine disolves ye stones, and it draines down into trenches and pipes made to receive and convey it to ye house, ych is fitted with iron panns four square, and of a pretty depth, at least twelve yards over. They place iron spikes in ye panns full of branches, and so aye Liquar boyles to a candy it hangs on those branches. I saw some taken up, it look'd like a vast bunch of grapes. Ye colour of ye Copperace not being much differing, it looks clear like sugar candy; so when ye water is boyled to a candy they take it out and replenish the panns with more liquar. I do not remember they added anything to it, only ye Stones of Copperace, dissolved by ye raine into liquor, as mentioned at first. There are great furnaces under to keep the panns boy ling; it was a large room or building, with several of these panns. They do add old Iron and nails to ye Coperice stone.'

Copperas, which seems to have been a very important product in those days, is a salt of iron, ferrous sulphate. It has a bluish-green colour, and an astringent, inky, sweetish taste, and is used for tanning and in the manufacture of ink, Prussian blue, oil of vitriol, plate powder, etc.

We have no description of the methods of the Bournemouth 'myners' with regard to alum. It would appear, however, that the alum works were carried on in conjunction with the manufacture of the copperas.

This was Bournemouth's first local industry. It was not very long lived. Why it came to grief is not quite clear, but a story told in the Chancery records of Queen Elizabeth is very suggestive. Sir Thomas Smith, one of the Queen's Secretaries of State, like the Lord Mountjoy already referred to, was 'a curious searcher into Nature' – and apparently somewhat credulous. A man named Medley persuaded him into the belief that he (Medley) had discovered a secret process of converting iron into copper, and, associating some others with themselves, a company was formed to work the new discovery 'in the Isle of Wight, or at Poole or elsewhere.' Medley said he had discovered the process at Winchelsea, but that spot was not so convenient for the larger undertaking. The Isle of Wight also was abandoned for the neighbourhood of Poole, where land was leased from the Dowager Lady Mountjoy, at a rental of £300 a year. Medley undertook to 'make of raw iron good copper,' and that the liquor in which the iron was boiled would ultimately make copperas and alum ready for the merchant. Immense profits were foreshadowed, and even the great Lord Burleigh was drawn into the scheme. But this transmutation of metals never took place; the whole thing proved to be a gross deception, and the investors lost their money. The 'curious' Lord Mountjoy, son of the lady above mentioned, perhaps because he was too much of a scientist, does not appear to have been one of the victims. But possibly this strange swindle discredited the Parkstone and Boscombe 'Mynes.' Or their failure and discontinuance may have been due to other and quite different causes.

2

Smuggling

Bournemouth has passed through various metamorphoses. It is sometimes spoken of as having had its origin in a fishing village. It was never, however, a fishing village in the sense, say, that Hastings was. The Poole and Christchurch fishermen climbed the cliffs to watch for the coming of the mackerel – just as they do now – and frequently, no doubt, they drew their nets to shore on Bournemouth Beach; but they had neither home nor market in Bournemouth itself. The 'staple industry' of the eighteenth and the early part of the nineteenth century was of a far less reputable character: it was concerned with the smuggling of contraband goods. There are many records of Bourn Mouth during this period – and all that are not concerned with national defence relate to smuggling. In the Diaries of the first Earl of Malmesbury it is put upon record that at the early part of the last century 'a considerable contraband trade' was carried on along this part of the coast. 'All classes contributed to its support. The farmers lent their teams and labourers, and the gentry openly connived at the practise and dealt with the smugglers. The cargoes, chiefly of brandy, were usually concealed in the furze bushes that extended from Ringwood to Poole, and in the New Forest for thirty miles.'

In the 'Memoirs of an ex-Minister,' the third Earl of Malmesbury, the friend and colleague of Lord Beaconsfield, states that: 'During the long war with France, this wild country, which extended in an uncultivated state from Christchurch to Poole, was the resort of smugglers upon a large scale,' and he tells the following anecdotes as illustrative of the times: 'About 1780 Lord Shaftesbury was sitting at dinner in the low hall at Heron Court with his relation (Mr Hooper), the latter having his back to the window. The road, which has since been turned, passed by the front door of the house. Suddenly an immense clatter of waggons and horses disturbed their meal, and six or seven of these, heavily loaded with kegs, rushed past at full gallop. Lord Shaftesbury jumped up to look at the sight, but the old squire sat still, refusing to turn round, and eating his dinner complacently. Soon after a detachment of cavalry arrived with their horses blown, and asking which way the smugglers had gone. Nobody would tell

them, and no doubt they got safely through the New Forest. The smugglers had dashed through two deep fords in the Stour close by, which the soldiers had refused, and so lost their prey. These fords are the same through which Sir Walter Tyrrell rode red-handed for his life on his way to Poole after he had crossed the Avon at a place which bears his name, Tyrrell's Ford... At the beginning of the present century [the nineteenth], and during the war, a great contraband trade was carried on. And I myself, when a small boy, had an adventure with these heroes. I was bird-nesting in one of the copses in the park by myself when a rough fellow seized me, and seeing I was frightened was very civil, promising to let me go in an hour if I did not resist. He kept his word, and made me swear I would not tell of the incident. Although rated when I got home for my long absence, I did not betray the man or his companions, whom I saw in the wood hiding kegs of brandy, of which they insisted on giving me a specimen. The principal stronghold round which the smugglers operated was the seashore and its hollow cliffs that run from Christchurch Head to Poole, then a district of gorse and heath for ten miles, with fir-woods above them.'

The Rev. Richard Warner in his 'Literary Recollections' has also some personal reminiscences relating to the early part of the last century. He mentions having more than once seen 'a procession of twenty or thirty waggons, loaded with kegs of spirits; an armed man sitting at the front tail of each, and surrounded by a troop of two or three hundred horsemen, every one carrying on his enormous saddle from two to four tubs of spirits; winding deliberately, and with the most picturesque and imposing effect, along the skirts of Hengistbury Head, on their way towards the wild country to the north-west of Christchurch, the point of their separation.' Between these armed bands and the Revenue Officers there not infrequently was conflict, sometimes of a serious and fatal character.

In the little churchyard at Kinson, away behind the Bournemouth heathlands, there is a headstone inscribed as follows: 'To the memory of Robert Trotman, late of Rowd, in the county of Wilts, who was barbarously murdered on the shore near Poole, the 24th March, 1765:

'A little tea, one leaf I did not steal,
'For guiltless blood shed I to God appeal;
'Put tea in one scale, human blood in t'other,
'And think what'tis to slay a harmless brother.'

No doubt, as already shown, there was much sympathy with the smuggler: smuggling was not regarded as a crime demanding severe censure. But the men engaged in the trade were not 'harmless brothers'; upon occasion they displayed great daring and wreaked most terrible vengeance upon

any who stood in the way of their illicit trade. One such instance was the historic case of the attack on the Poole Custom House in 1747, described as 'the most unheard of act of villainy and impudence ever known.' A cargo of tea had been captured and stored in the Custom House. Some sixty armed men assembled in the neighbourhood of Charlton Forest, marched to Poole, broke into the Custom House, took the tea, and then rode off with their booty up through the country, hundreds of people turning out to view the cavalcade. Not till eighteen months later, when murder had been added to their other crimes, were the ringleaders brought to justice. It was given in evidence at the time of the trial that there was a large sloop laid up against the Quay, and some of the men were afraid she would plant her guns to the Custom House door and tear them to pieces; but others pointed out that the tide was low, and she could not possibly bring her guns to bear. The accused maintained to the last they were guilty of no crime in rescuing the goods from the Custom House, as these were the property of no one but those who sent their money to Guernsey for them. Like Robert Trotman, 'for guiltless blood shed they to God appealed.'

'A celebrated adventurer in contraband articles, nicknamed Slippery Rogers, from his eel-like faculty of escaping the grasp of his maritime pursuers,' operated along the coast with a 'remarkable vessel,' rowed by forty daring mariners, with 'a cuddy, fore and aft, for sleeping berths, and a large open space, in midship, for the stowage of two or three thousand ankers of spirits.' Mr Warner tells of some of his exploits; and Mr Grantley Berkeley, writing of a later period, when 'the contraband trade from the sea on the coast of Hampshire was still rife,' tells of other smuggling operations at or near Christchurch Head. And famed in romance (see Colonel H. M. Walmesley's story entitled 'Branksome Dene'), there was 'Old Gulliver,' the greatest of all smugglers who harassed the preventive officers along the south coast. This Gulliver lived during the latter part of the eighteenth and the beginning of the nineteenth century. It is said that his smuggling operations were most extensive, his servants numerous, and his fleet of vessels and team of pack horses admirably suited for the purpose for which they were employed. A favourite landing place for his cargoes was at Branksome Chine, from whence his waggons and horses journeyed, either across the New Forest to the large towns in the Midlands or to London, westward across Crichel Down to Bath, Bristol, and the cities of the West. Gulliver was a landowner, and is said to have planted part of Eggardun Hill in Dorset to serve as a landmark to his vessels when homeward bound across the Channel. Mr Roberts says he 'kept forty or fifty men constantly employed'; they 'wore a kind of livery, powdered hair and smock frocks, from which they obtained the name of 'white wigs.' Gulliver amassed a large fortune, and lived to a good old age... Till of late

years a chamber, open towards the sea at the mouth of the river Lyme, was in existence, where the 'white wigs' took refreshments, and remained in waiting till their services were required.' The incident narrated in Colonel Walmesley's 'Branksome Dene,' where Gulliver, pursued by the revenue officers, hides in the cottage chimney, is said to have been founded on fact, and a house at Wimborne Minster is still pointed out as a place where Gulliver died. In Dorset and South-West Hants 'Old Gulliver' was not regarded as a mere hero of romance, but a champion of local industry.

We have no wish to dwell too long on a subject so unpleasant as a catalogue of crime, and we shall not attempt to reproduce all the record which has come to hand. But as these stories constitute almost all that is known of Bournemouth during a considerable period preceding the coming of Mr Tregonwell, and for some years later, some few extracts from newspaper reports of the period will not be inappropriate. Our first selection is from the 'Salisbury and Winchester Journal,' of the 20th December, 1762, wherein we find a reference to Bourn Mouth and to the Decoy Pond which formerly existed here. The story is to the effect that one night in September, 'a gang of supposed smugglers, consisting of eight persons,' representing themselves as a Press Gang, broke into the house of one William Manuel at Iford, violently seized his son Joseph, 'dragged him by force out of the house, carried him across the heath to the seashore towards Poole, and forced him down to Bourn Mouth to a lone house there called the Decoy Pond House, notoriously frequented by smugglers.' Manuel was afterwards put into a boat, forcibly carried on board a smuggling cutter, and conveyed to Alderney, where he managed to effect his escape, but not without severe injury. 'This audacious outrage' was believed to be prompted by the supposition that Manuel had given information to the Revenue Officers, and the men who committed the crime were, it was said, 'hired or instigated to do it by some of the principal smugglers on that part of the coasts of Dorsetshire and Hampshire.' The Commissioners of Customs, 'in order to bring the offenders to justice and to suppress the enormous smuggling now most audaciously carried on upon that part of these coasts,' offered a reward of £50 for evidence leading to conviction. Whether the criminals were brought to justice we cannot say, but the practise of smuggling was not stopped, and, indeed, not seriously checked, for many long years. This story of a sham 'Press Gang' may be appropriately, perhaps, supplemented with one of a real 'Press Gang' which raided Bournemouth early in the last century. One summer's evening, in the height of the mackerel season, the fishermen were busy with their nets, and many of the farm labourers from the country had come in to assist them. Suddenly an armed party of sailors appeared, made many of the men prisoners, and marched them off to Poole. No man, it

should be remembered, was liable to impressment for the Navy unless he had previously been to sea. The morning following the raid the captives were taken before the magistrates; most of the men and boys were able to justify their claim to exemption; but in one case the Lieutenant swore that he had seen the man at sea, and though there was non-official testimony to the effect that he was an 'inland man,' the magistrates gave credence to the word of his Majesty's officer. Very much against his will the man was drafted into the Navy, from which service he was only released (without a pension) after an interval of thirteen years, in 1816.

In 1791, there is record of a smuggling lugger attempting to land a cargo at Beacon Bunny, to the east of Christchurch; on being discovered the crew set sail. A Revenue cutter, however, fell in with the lugger off Christchurch, gave chase, and came up with her, 'when the crew of the lugger ordered the officer and his men on board, whom they forced below, and kept a guard over them, whilst the lugger proceeded to the westward, and at two o'clock next morning landed her goods at Bourne Bottom, consisting of about one thousand casks of foreign spirituous liquors, some tea and tobacco; they then ordered the officer and his men into their boat, and dismissed them after having plundered the boat of firearms and some of her materials.'

Among other miscellaneous reports of similar character we get the following under date Poole, October 23rd, 1821: 'In the night of Friday, the 12th inst., the officers stationed at Bourne Mouth seized near that place 42 tubs of brandy, gin and other foreign spirits, and lodged them the next day in his Majesty's Excise Warehouse, at this port.' Another report, dated March of the same year, states that 'About 130 tubs of foreign spirits have lately been picked up on the beach at Bourne Mouth and deposited in the Excise Warehouse at Poole.'

It was not till the nineteenth century was well advanced that smuggling was effectually put down – not, in fact, till long after the period when Bournemouth came into note as a rising watering place and health resort.

3

Coast Defence

'The great cause of excitement within many miles of Bournemouth in 1804 was the generally understood intention of Napoleon Buonaparte to invade England with a large army – for which object he was preparing a fleet of very numerous gunboats, to be used for transporting the French soldiers to some convenient landing place across the English Channel. And as Bournemouth had a fine shelving beach and sufficient depth of water for gunboats to approach within a short distance of the shore, was easy of access by its opening in the cliff to the neighbouring country, in which were but few impediments for an army to encounter, and having but small population, many official and non-official authorities supposed that the landing of the French Army might be attempted at that place.'

Our extract is taken from a communication addressed many years ago, to the 'Bournemouth Visitors' Directory,' by one who shared the exciting experience of the time, and was able to remember and describe the preparations made to meet the expected emergency. There was alertness all along the coast – nowhere, certainly, with greater reason than along our Southern shores, situate as they are within some sixty miles of the coast of France, and besides accessibility having other important advantages for such a flotilla as that which Napoleon collected. The danger was averted, the threatened invasion was never even attempted – but our retrospect of Bournemouth's history would be incomplete were we to omit mention of the peril which seemed peculiarly to threaten this district in the early years of the nineteenth century, and to make some brief extract from contemporary records showing how the people realised the danger and prepared to meet it.

This was not the first occasion upon which a hostile French fleet had menaced the Hants and Dorset coast. In the chronicles of the town of Poole there is reference to a hurriedly summoned meeting of the inhabitants of that town on the 21st June, 1690, to consider measures for the better securing of the place against the dangers threatened by the French, described as 'the common enemy of the Kingdom, now having a

very great fleet of ships in sight of this place.' The 'very great fleet' referred to consisted of 78 ships of war and 22 fireships, and the description of it as being 'in sight' of Poole shows that it must have been in what we now know as Bournemouth Bay. But the danger passed; the following day the fleet sailed up the Channel and 'fought and defeated the English Admiral, Lord Torrington, in an engagement off Beachy Head.'

Two centuries earlier – in 1483 – Henry, Earl of Richmond, in prosecution of his claim to the Crown of England, had sailed from St Malo with forty ships and a force of five thousand men, 'designing to make a descent on the western coast of England, where his partisans were then in arms, arrangement having been made for a general insurrection on their arrival. In the attempt to cross the Channel, however, his fleet was dispersed by a violent storm that arose, and most of his vessels were compelled to put back; but the Earl's ship, weathering the tempest, arrived off Poole Harbour. He found the coast lined with men, but whether friends or foes he could not satisfactorily determine. The intended revolt had been discovered by Richard, who, previously to the arrival of the Earl, had succeeded in crushing the rising in embryo, had taken and beheaded the Duke of Buckingham, and dispersed the rest of the confederates. The forces of Richard appointed to guard the coasts had, therefore, instructions not to oppose the landing of Richmond, but to make signals to encourage him to leave his vessel, and if he sent for intelligence, to pretend that they were posted there by the Duke of Buckingham to receive him.' Sydenham – the Poole historian – from whom we have quoted, goes on to show that Henry was 'too cautious to be entrapped by an artifice, which, if successful, would have thrown him entirely into the power of his relentless enemy,' and a messenger sent to the shore returning with an answer which he mistrusted he weighed anchor and sailed off to Normandy. 'The tempest, which dispersed his fleet, had been his preservation, for if he had effected a landing after the failure of Buckingham, the fortunes of the Tudors would in all human likelihood never have obtained that ascendant which brought with it to the nation so much evil and so much greater good.'

The incident is referred to in Shakespeare's 'Richard III.' (Act iv., Scene iv.).

Richmond, in Dorsetshire, sent out a boat Unto the shore, to ask those on the banks,
If they were his assistants, yea or no;
Who answer'd him, they came from Buckingham
Upon his party; He, mistrusting them,
Hois'd sail, and made his course again for Bretagne.

Reverting, after this digression, to the 'cause of excitement' in 1804, we find interesting corroboration of the testimony already quoted. The defence of the coast had been a subject of serious concern and of much attention for many years. In 1792 Artillery Barracks were built at Christchurch. Supplementing the protection afforded to the neighbourhood by the soldiers quartered there, the inhabitants formed a Volunteer Force of their own, which continued up till the Short Peace of 1802. That these gallant patriots did a very useful work may be gathered from the following extract which we take from 'The Salisbury and Winchester Journal' of May 3rd, 1802. It relates to the time of their disbandment – when it was erroneously thought that all danger has passed away – but it is nevertheless interesting: 'On Sunday last the Christchurch Fensible Volunteers were disbanded by Captain Lyons, in the absence of Colonel Walcott, confined by severe illness. This Corps has long been distinguished for its military appearance and professional excellence; under the eye and close attention of their Colonel, and the general zeal of all the other officers, they have been rendered perfect soldiers; the steadiness of their discipline and the precision of their manoeuvres procuring them the highest approbation from General Stevens when he inspected them, who reported them so truly meritorious to the Commander-in-Chief that his Royal Highness expressed his wish and intention of seeing them himself; this flattering compliment they expected this summer, and they were deprived of the honour only by their being no longer a Corps. Captain Lyons, in his address to the men, was impressively interesting, bestowing on them a choice tribute of praise for their loyalty as subjects, steadiness as soldiers, and good conduct as men, during the late severe trials of difficulty and danger – declaring at the same time, however joyful the occasion of their being now disbanded, he, in common with his brother officers, could not help feeling sensations of regret at parting with men with whom they had been so long attached, assuring them it would ever be to him a pleasing reflection that he had been an officer in so respectable a corps; and it must be an equal source of happiness for each man to recollect that he had been a Christchurch Volunteer.'

The 'joy' of disbandment soon passed away; the necessity for re-arming came very quickly, and in the journal already quoted, under date October 31st, 1803, we get the following:

'Our Western bay being supposed a probable part of the coast for the enemy to attempt a landing, the Windsor Castle guardship, of 98 guns, and two frigates, have received orders to cruise off this place and the Needles. A troop of the 20th Light Dragoons have reinforced the military already in this quarter; piquets are established along the coast; beacons and night signals to prevent the possibility

of surprise; and the utmost vigilance in every department. Our Volunteers, forming a body of over 400 men, well disciplined, have received orders to hold themselves in readiness to march at an hour's notice; this intimation has been received with alacrity both by men and officers. The different corps of Yeomanry in this neighbourhood, with a spirit truly becoming, have volunteered going into quarters for ten days to perfect themselves in military tactics and inure themselves to a soldier's life. At the suggestion of the Lord Lieutenant of the County several gentlemen have been appointed superintendents of districts and directed to enrol those men as pioneers and cattle drivers, guides, overseers of removals, etc., as are not engaged in any Volunteer Corps; by this judicious proceeding every individual (except the infirm) will be able to render some service to the country. From the goodwill and activity of most of the above gentlemen (a good example to others in this capacity) such regulations have been adopted whereby every man previously knows his situation and department should the enemy invade this country. Thus the removal of property and persons (in case of necessity) can be effected, at a very short notice, without confusion and misunderstanding.'

A month later we find these gallant defenders of the coast assuring their worthy Colonel that they would follow wherever he would lead them to serve their King and country, and the Colonel (Walcott) replying in 'a neat and proper speech' promising to 'attend to their every comfort in quarters.' Two new companies are reported to have been lately added to the regiment and to be 'by emulous exertions rapidly advancing to equal those on the old establishment.' Then comes the following interesting paragraph: 'A report having prevailed that the above corps would be called on to watch the coast nightly during the winter, Sir George Tapps, with the liberality characteristic of his known generosity, presented the men with fifty great-coats, a most essential bounty for protecting them against the inclemency of the weather should this duty be required of them. The very handsome donation was accepted by Colonel Walcott, who expressed his warmest thanks to the worthy baronet for his benevolent regard and provident attention to the comfort of the men under his command.' Later there was an announcement that 'Thomas Wilson, Esq., of Stourfield, has presented the Christchurch Volunteers with twenty great-coats.'

The great-coats were very badly needed, and one would infer from the following, appearing under date December 31st, 1803, that they were not supplied quite as quickly as might be desired, notwithstanding the liberality of the gentlemen named above: 'The conduct of the Christchurch Volunteers has been so exemplary in every respect since they went on permanent duty, both in Dorsetshire and at home, that his Royal Highness the Duke of Cumberland took the trouble, most condescendingly and kindly, to go to Christchurch on Tuesday last for the express purpose of

returning his thanks to them in the most public manner on their parade; but a heavy and incessant rain prevented their being assembled there on that day: it was then agreed that the corps should be assembled for the purpose the following morning at Mr Rose's cottage, where his Royal Highness dined and slept; but the weather continued so extremely bad as again to defeat the object he so considerately took the journey for. His Royal Highness then, disappointed of affording the officers and men the highest gratification they could have received, was reduced to the necessity of returning his thanks to the whole Corps in writing, which he put into the hands of Lieutenant-Colonel Walcott, their Commandant, on whom too much praise cannot be bestowed, nor can it be repeated too often. The time of service originally proposed being expired, the Corps was to have been disbanded; but his Royal Highness having, for reasons he stated, left an earnest request that it would continue for some time longer on permanent duty, from the zeal and alacrity invariably shown both by the officers and men, the same met with a cheerful compliance.'

One can hardly refrain from a smile at this picture of soldiers, called upon for nightly patrol duty along the coast, yet unable to appear for review by the Duke of Cumberland, because it rained! But we must be thankful to them and to their comrades of the South Hants Cavalry (commanded by Lieut.-Colonel G. H. Rose), detailed 'to act as patrols along the coast between Christchurch and Poole.' It was the patriotism of the people – their readiness to defend our shores at every point – that prevented the actual attempt at invasion, and the faded colours of the old regiment deserve the honoured place still allotted to them in the Priory Church at Christchurch.

Another relic of that interesting period is in the possession of Alderman Tucker, of Christchurch. It is a receipt given to his grandfather, Sergt.-Major Tucker, by one Thomas Hughes, a London tailor, for the sum of £4 14s. 6d. There is one entry only on the bill, and this, under date September 13th, 1803, reads as follows: 'To a superfine dark extra blue cloth Regementall coat, scarlet cloth lapels, cuffs and cape, lined with fine white pratenet, with gold skirt, ornaments com- pleat.' The Sergt.-Major, no doubt, presented a very smart appearance – as befitted his rank.

Napoleon's threatened invasion never came off: the only ship of the French flotilla that ever reached here came as a wreck – if we may accept the following, which appears in the Reminiscences of the late Marchioness of Waterford: 'On the Beach at the Christchurch side of Haven House were the backbone and ribs of a large boat, and I was told one of Napoleon's flotilla wrecked on the shore.'

Half a century later, when the modern Volunteer force was formed, the possibility of French invasion was again considered, and in the 'Poole

Herald' of April 1st, 1858, we find the following: 'The present Emperor of the French, in his much discussed pamphlet on the invasion of England, himself condescended to notice the peculiar adaptation of Bournemouth and its neighbouring shores for effecting a landing.' We have been unable to trace the 'much-discussed pamphlet' referred to, but we quote the extract as evidence, if not of actual fact, at least of current opinion at a period when Ventente cordiale had not been established.

4

The Evolution of Health Resorts

Mr George Roberts, in his 'Social History of the People of the Southern Counties,' tells of 'the singular fate that attended many of our south coast towns' in the course of the eighteenth century. 'They died out as mercantile coast towns; and when near to a point of extinction, they rose, phoenix-like, under a metamorphosed appearance, and enabled a large and new class in Society to gratify their wishes and a novel taste.' 'Weymouth was a town that had fallen very low, and was the residence of fishermen and smugglers. Poverty was great, and tenements fell down from neglect... At Brighton a spot of ground was offered to a hairdresser in fee, upon condition of shaving the possessor. The terms were declined.' Then, in the middle of the eighteenth century, there came a remarkable change. 'Before the year 1759, the sea on our southern coast had ever been as pure; the hills and undercliffs as grand and captivating, still, no inland residents came to the fairyland. There is in history no record of any summer seaside pleasuretaking or health-seeking visits; not a word of bathing. There never had been any convenience for sea-bathing, nor any hot baths. In Queen Elizabeth's reign any scholar of Cambridge University who dared to bathe by day or night was set in the stocks all the day: and for the second offence, to be v'hipped with rods.' 'Whether,' asks Mr Roberts, 'is the more strange – the neglect of the seaside for bathing, or the change that now obtained? Persons of either sex living far from the sea deemed it necessary to rush to the coast so soon as the fine weather had set in. Like the anadromous fishes, a furious desire to migrate seized upon them, and they obeyed the instinctive call.' Dr Richard Russell, the son of a London bookseller, was 'the instigator of the seaside mania.' A treatise which he wrote had such an effect upon the medical faculty that 'sea water became the panacea for every ailment. Determination to the seaside was set up.' Not alone did he cause Brighton to rise, the 'metropolis of the sea-coast.' 'The fame of his practice led other medical men to raise the cry, 'to the seaside.' Dr Russell was to seaside visitors what Peter the Hermit was to the Crusades – the instigator, the genius that raised the latent spirit.'

'The rush to the coast to procure the benefit arising from the virtues of sea water' was followed by a similar movement to 'secure the curative

effects of the balmy sea air.' 'Much had to be done before the decayed
towns could be made to shake off, serpent-like, their old skin, and assume
their new character or metamorphose – that of watering places.' Royalty
'partook of the coastward movement,' and helped to make both Brighton
and Weymouth famous. Weymouth's success is said to have been due to
one Ralph Allen, of Bath (the original of Fielding's 'Allworthy' in 'Tom
Jones'). Allen invented the bathing machine and introduced it for his
own use at Weymouth. The fame of the new invention led to a visit from
the Duke of Gloucester in 1780, and that in turn led to the visit of the
King, who, according to Fanny Burney, bathed here with great success. 'A
machine follows the royal one into the sea, filled with fiddlers, who play
'God Save the King' as his Majesty takes his plunge.'

Southampton was another of the watering places which the eighteenth
century evolved. According to Miss Aubrey, the editor of Speed's 'History
of Southampton,' written in the latter part of the eighteenth century, it
was 'a watering place in both senses of the term.' Visitors came hither
alike to enjoy the sea bathing and attracted by the reputed value of the
mineral springs. 'Persons of quality' had made the discovery 'that its air
was salubrious, the scenery in the neighbourhood fine, and – greatest
attraction of all – that its society was very select.' According to a guide
book of the time, it merited the notice of the man of taste, claimed the
attention of the antiquary, and courted the admiration of the stranger,
'and there was no neighbourhood in Great Britain where politeness, good
breeding, harmony and friendship' reigned so universally, and were 'so
productive of undisguised confidence and undisturbed tranquility.'

Long after 'Dr Brighton' had become famous; after Southampton
had ceased to have among its town officials a Master of the Ceremonies
'second in importance to none except the Mayor'; after Mr William
Morton Pitt had made vain attempt to bring Swanage into notice; and
after Weymouth had entered upon the memorable era known as its 'King
days,' Bournemouth was unknown and unsought. In the early days of the
last century – before the coming of Mr Tregonwell – it was Mudeford,
lying to the east, not Bournemouth, to the west, of the 'mother town' of
Christchurch, which gave promise of renown as a health resort. 'This
admired spot, the favourite summer residence of numerous families
of distinction,' offered many attractions: a fine level sandy beach, good
boating and fishing, safe bathing, etc., whilst 'the remarkable pureness
and salubrity of the air, and the seclusion of the situation from the noise
and bustle of a thoroughfare town, rendered it no less desirable as a
quiet retreat for the invalid or literary student.' 'These qualities,' we are
told, 'were appreciated and emphatically remarked on, by his Majesty
George III., who with the royal family honoured Mr Rose with a visit

at Sandhills.' Hither came Sir Walter Scott, on a visit to Mr W. Stewart Rose, to whom the great 'Wizard of the North' dedicated one of the cantos of his delightful 'Lady of the Lake,' from whose works he quotes in his 'Peveril of the Peak,' and whose valet, David Hinves – 'as much a piece of Rose as 'Trim' was of 'Uncle Toby' – furnished Scott with hints for his picture of 'David Gellatly' in 'Waverley.' In a villa on the sea-front Scott wrote, or corrected, some of the pages of 'Marmion,' and he is said to have been not only delighted with the sea-coast, but to have been specially charmed with the hinterland around Holmesley, where the heathlands reminded him of his beloved Scotland, without a sight of which, at least once a year, he used pathetically to declare, he could not live. Here also, or in the immediate neighbourhood, for longer or shorter periods, sojourned Coleridge, Southey, Lamb, and others of literary fame, including the Italian patriot, Ugo Foscolo, the centenary of whose appointment as Professor of Literature in the University of Pavia has but recently been celebrated.

Hengistbury Head – bearing the name, but probably no other association with the great Saxon warrior – divides two bays – East and West – the former now generally denominated Christchurch Bay and the latter Bournemouth Bay – formerly Poole Bay. Mudeford looks out on the East Bay, Bournemouth on the West. When George III visited Mudeford in 1803, Bournemouth was unknown. 'Determination to the seaside' had set up – to use the expression of Mr Roberts – and Mudeford seemed in fair way to benefit by 'the craze,' and, perhaps, to become a place of considerable size and importance. It had three bathing machines, and these were laid in a row to permit his Majesty to reach the barge which conveyed him to the Royal Charlotte yacht – bound for Weymouth. On the shore witnessing this singular embarkation, 'were drawn up the Scots Greys, the Yeomanry, and the Loyal Christchurch Volunteer Artillery, under the command of Colonel Walcott, who fired three volleys, while the cannon on the Isle of Wight thundered a salute.' But Mudeford never made any very marked advance, and half a century later we find its enthusiastic admirer, the Hon. Grantley Berkeley, describing it as 'an unpretending little place' – a 'quiet little village, so retired that when ladies come there, they do not think it necessary in their walks to be followed by a footman caned and cocked- hatted.' 'Nor do they,' he adds, 'simulate the folly of those at the neighbouring sea-bathing place, Bournemouth, and bob about from dell to dell as if they thought every bush concealed a serpent and a tempting apple, and that they were never safe unless at church.' Though not directly concerned with Bournemouth, and dealing apparently with a period when the nineteenth century was well advanced, we quote from the 'Life and Recollections' of Mr Grantley Berkeley an 'illustration of watering place life' in the sister resort at a period when experience had

not definitely proved which of the two daughters of the 'mother town' of Christchurch would attain the greater dignity and importance. 'One amusement of the late Sir George Rose,' says the narrator, 'was to constitute himself constable of the shore at Mudeford, and preside over the decency he deemed requisite on a public beach. To this work he was peculiarly urged by one Jane West, who presided over the bathing temples, whether on wheels or sequestered beneath the inscription on her hut of 'Hot and cold water baths.' Any person who sought a lonely nook in the cliffs between Mudeford and Hurst Castle, about nine miles of shingly desert, there to indulge in the enjoyment of the bathing, was the object of this woman's detestation, because he or she avoided the twelve-penny tax. She applied to Sir George to protect her 'vested interests' in the beach, by the fine of a shilling against all such offenders, as she considered them. On learning this law, I cut steps in the cliff from my lawn to the sea, and bathed as I pleased, putting up a tent just above high-water mark for any ladies who were staying with me that they might do the same.

A very stout couple, man and wife, of the strictly-speaking agricultural class, came up to Mrs West. 'We want to bathe,' said the man; 'what do you charge for a machine?' 'One shilling each,' she replied. 'Each!' exclaimed the farmer; 'we only want one.' The bathing woman would not sanction such an impropriety, and indignantly declined to let her machine; so they went away up the more lonely strand beneath Beacon Lodge. One of the look-out men being on duty saw a fat couple walking beneath the cliffs, among the debris of some of the fallen blue clay in which there are fossils, and there they suddenly disappeared: but presently emerged in a state of nature. In spite of Sir George Rose and Jane West, they walked hand-in-hand in the sea, and proceeded to disport themselves among the billows.'

Mixed bathing, subject to regulation, has been one of the innovations of the last few years at Bournemouth. But it appears to have been practised in the East Bay three-quarters of a century ago. Mudeford's 'King Days,' as we have shown, were long before that. The period of its greatest fame was before the founding of Bournemouth! Whether it was the establishment and development of Bournemouth that occasioned the neglect of her elder sister we cannot definitely say; probably the attraction of the one did militate against the success of the other. But our present purpose is sufficiently served by showing that Mudeford preceded Bournemouth, and that this elder daughter of the 'mother town' of Christchurch, in the early days of the last century, when Bournemouth was but a wilderness – the haunt of wildfowl and the frequent resort of men of lawless disposition and habit – offered an irresistible attraction to many distinguished people afflicted with what Mr Roberts has described as the 'new craze' for sea-bathing and sea-air. Hither came Mr L. D. G. Tregonwell and his wife,

suffering under a heavy load of bereavement, and needing change of air, scenery and associations, to restore their shattered health. And it was from Mudeford they took that little afternoon drive which resulted in the discovery of Bournemouth – of which we shall have more to say in a future chapter. Possibly, had there been no Mudeford, the whole course of Bournemouth history might have been altered. Sooner or later, of course, it would have been 'discovered,' but the title of 'Founder of Bournemouth' might have fallen to some one other than Mr Tregonwell, and the developments which he effected might have been differently attempted, and quite another character have been impressed upon the early history of the place.

5

Formation

Common lands as then existed in all rural areas to remain uncultivated, and the general Act was passed as 'a means of increasing the national wealth.' A year later, and based on that Act, Parliament passed the Christchurch Enclosure Act – a statute which has in very marked and peculiar degree been 'a means of increasing the national wealth.'

For our record of local circumstances we are fortunately enabled to refer not merely to official documents, but to the testimony given some years ago by one who had personal recollection of the events referred to. At that time, stretching right away from Christchurch to Poole was a vast, desolate heath, covering an area of probably twenty square miles, 'with few, if any, other public roads over it than one from Longham to Poole, from Wimborne, from Corfe Mullen, and another from Wareham and Lytchett, all to Poole. Many wheel tracks there were, which were used almost exclusively for carting turf, to be used as fuel, from various parts of the heath to the nearest houses to which it was to be conveyed, within a few miles of that tract of country; and a few other, wheel-tracks or without wheel-tracks, were made for driving across the heath from the neighbouring towns and villages by parties resorting to Bournemouth for a sea bath, that being, even in those early times, a favourite excursion for that object, and for whose accommodation, and for smugglers, there was a small public-house and stables near to the sea. A few sheep, and occasionally small numbers of cattle, fed upon the common' when there was any grass for them, which often occurred during and after damp weather, but not in very dry seasons. The chief value of the whole district was, however, for its turf, cut from one inch to three or four inches thick, which constituted almost the only fuel used at nearly all houses within some miles of 4 the Heath.' Nevertheless, and regardless of its turf, with so much dearth of food as then existed throughout Great Britain, the enclosure of Poole Heath was determined upon.' For the purposes of this enclosure two Acts were obtained: the Canford Enclosure Act, dealing with such lands as were within the County of Dorset; and the Christchurch Enclosure Act, 1802' (42, George III.), described as an Act

for dividing, allotting and enclosing certain commonable lands and waste grounds within the Parish of Christchurch, and the Parish or Chapelry of Holdenhurst, in the County of Southampton.' In defining what is meant by a Common 'Chambers' Encyclopaedia' has the following:

> This is one of the numerous instances in which a different meaning is attached to the same term in the legal systems of England and Scotland. In England, the property in the Common land belongs to the Lord of the Manor, although rights over his Common lands are possessed by certain persons who hold land in the manor and are known as Commoners. Thus Blackstone defines a Common as 'the profit which a man hath in the land of another, as to feed his beasts, to catch fish, to cut turf, to cut wood, or the like.'

The problem which faced the Legislature in 1802 was to meet and recognise all existing rights, and at the same time to advance the general interests of the public: to add to the wealth of the community without the robbery of the individual. The happy solution of the problem, locally, seems to have been principally due to the co-operation of the Lord of the Manor of Westover, Sir George Ivison Tapps (an ancestor of the present Sir George Meyrick), and the advocacy of Mr William Clapcott, of Holdenhurst. Three Commissioners were appointed to carry out the requirements of the Act – Messrs. R. Richardson, of Lincoln's Inn Fields, London; J. Wickins, of Mapperton, Dorset; and W. Clapcott, of Holdenhurst, – and after three years their task was completed and the results recorded in what is known as the 'Christchurch Enclosure Award.'

The first care of the Commissioners was to lay out suitable roads, and most of these were formed on the sites of the old roads and tracks across the heath. The most important of these were the following: No. 1 – Between Christchurch and Poole, which is described as beginning at the south-west end of Poole Lane (about Pokesdown Hill), and going westward over the Great Plcath by the Decoy Pond Cottage, into Canford Heath; being part of the publick road from Christchurch to Poole' (the 'Decoy Pond Cottage' was west of the Square). No. 2 – The road from Great Dean, near Holdenhurst, to 'Bourne Mouth,' 'over Great Dean Common, westward to Dean Drove Gate, and thence in or near t.he present track to the last named road, and after passing the same,' then to the English Channel 'at Bourne Mouth.' (This is the Holdenhurst Road; the point at which it passes Road No 1 is Lansdowne, and the continuation to the sea is the Bath Road). No. 3 corresponds with the present road from Richmond Hill to Charminster; No. 4 with the Wimborne Road north of the Cemetery Corner; No. 5 is at Redhill; No. 6 the Sea Road, Boscombe; and No. 7 the Exeter Road from the Square to the Beach.

In order to meet the costs of the Private Act and the Award, and the expense of carrying the latter into effect, various portions of the land were sold. Thus 200 acres on the East Cliff were sold to Sir G. I. Tapps for £1,050 2s. 10d.; the land above the Bridge (now the Square) on the north side of the Brook went to Mr William Driver for £622 0s. 6d.; 400 acres on the West Cliff and 100 acres on the Holdenhurst Road were acquired by Mr William Dean for £639 1s. 2d.; and 141 acres in the district lying between Sea Road and Lord Abinger's were secured by Mr Philip Norris for £230 6s. 4d.; making a total of £2,541 10s. 10d. for the greater part of the sea frontage and adjacent land between Westbourne and Boscombe – much of it at the present time worth, irrespective of buildings, more per acre than was then paid for the whole. These parcels of land do not, of course, represent the whole of the district, only the parts sold. The allotment of pieces of land, in respect of various rights over the wastes, for which no payments were made, was as follows: Six large pieces on the south side of Christchurch, Old Christchurch, and Commercial Roads to Sir G. I. Tapps 'for fuel for ancient cottages, in lieu of the right of cutting turf in the Liberty of the West Stour' (Westover); nine allotments (Malmesbury Park and that district generally) to Lord Malmesbury, 'in lieu of tithes'; and five portions (Meyrick Park, etc.), to Sir Geo. I. Tapps, 'in respect of his rights in the soil of the waste grounds.' The land surrounding the Burlington Hotel was given to Lord Malmesbury in a similar way; the Boscombe Manor Estate was acquired by Mr John Sloman, of Wick House; and the land on the north side of Christchurch Road from the Lansdowne to the Salisbury Hotel, Boscombe, was given to Dr Farr, of Iford House. A large tract of land lying between the old Christchurch Road and Stewart Road, Malmesbury Park, was given to William Dean, and included in general allotments to 'the several owners, proprietors, lessees, and customary tenants, and other persons interested, in proportion to their several and respective lands, common rights, and all other rights whatsoever.'

The effect of the distribution of lands which passed under the provisions of the Act will be more readily appreciated by reference to the accompanying copy of the 'Award' map. The cheapest lot sold appears to have been the 600 acres purchased by Mr William Dean, including about 400 acres extending along the sea front right away from the Highcliff Hotel to Alum Chine, and about 200 acres in the vicinity of what is now King's Park. The price for the whole was but £639 1s. 2d. Portions of the land remain unbuilt upon; for such, we suppose, a thousand pounds an acre would be a very moderate estimate of value.

An incidental, but very important result of this Enclosure Act and the ensuing Award, should here be mentioned. It resulted in five tracts of land being kept in statu quo till very recent years, and then coming into the

hands of the Local Authority under easy terms and conditions. Three of these large tracts of land have become Meyrick Park, King's Park, and Queen's Park respectively; and two others – at Red Hill and Southbourne respectively – are awaiting municipal development for similar purposes of public recreation and enjoyment.

It was consequent also upon the Act of 1802 that the principal planting of the pine-woods began. But some pioneer work had already been attempted, and Sir George Meyrick has in his possession at Hinton Admiral accounts and statements relating to work done for Sir George Ivison Tapps in the closing years of the eighteenth century. Whoever may have been the originator of the tree-planting scheme, unquestionably he was a great public benefactor; he made the wilderness beautiful, he set into operation forces which had a modifying effect upon climate and produced conditions which subsequently gained for Bournemouth wide renown as a health resort, and ultimately his labours vested Bournemouth with a characteristic which gives it an entirely distinctive place among British watering places. Bournemouth, which a century ago had a resident population but little larger than the family which went into the Ark, today numbers nearly eighty thousand souls! Yet it still retains its pine-wood characteristic, and thousands of young trees are being planted annually to compensate for the wastage which results from building and other causes. An official report presented in 1907 showed that the number of fir trees planted by the Corporation in the past nine years had been 61,000. Since that period the average per annum has been considerably larger.

Since these pages were commenced evidence has reached us that the enclosure of the heathland and the subsequent tree-planting did not meet with the complete approval of all the parties interested. Mr Dale, of Tuckton, in 1871, communicated some interesting reminiscences to the late Dr James Kemp-Welch, of Christchurch, and from these we are permitted to make extract, as follow:

'I have one remark to make: that if man has made a great alteration in the appearance of the country, and of my native place, he has robbed it of one of its greatest beauties, and I fear deprived us to a certain extent of one of the greatest blessings. When I look back to the beginning of this century, when the wide extent of many thousand acres was clothed with the beautiful heather, and the millions of busy bees collecting the sweets from its lovely flowers, and storing them away for the use of man: when I reflect on the past and think of the present I can hardly feel that the world is progressing, but retrograding in these days. The bee garden was by the side of the common from Wick to Wimborne, on to Corfe and to Lytchett. The hives were placed, and they swarmed and stayed until September. Then some was taken for honey, and the other brought home to the

cottages until the May month, when they were taken back to their old quarters to enjoy and get the sweets from the same heather that fed and nourished them the last year. And from what I have been told the district was much healthier, and the inhabitants lived many more years then than now. I believe there is a cause of declining health in fir trees and rotten wood, and the fungus that is produced from it is the principal cause of the shortness of life now to what it was in the last century, for then we had the pure sea breeze sweeping over the cliffs and then across the beautiful plateau covered with flowers of various sweets And such is not to be seen now.'

The 'Award' map of 1805 shows 'Decoy Pond,' situated, as already explained, close to what is now known as the Square. The exact position of the pond was about three hundred yards from the Square, near the pathway leading across the Gardens by the Sanatorium. The dimensions were about 135 feet long and 66 feet wide. It was practically a widened part of the Brook. There was also in existence the Tapps Arms (afterwards re-built as the Tregonwell Arms), kept ostensibly for the accommodation of fishermen and picnic parties, but no doubt deriving its principal income from the patronage of the smugglers and the business which was carried out on their behalf or through their agency. Except, possibly, one or two small cottages, there were no other habitations in the vicinity of the Bourne. But away on the cliffs beyond 'Boscombe Bunny' – on or near the site of the old 'Copperas House' – there was Boscombe Cottage, or, as it is now known, Boscombe Manor. Its tenant was one Richard Norris, who, according to Mr Ferrey, gave 'a most praiseworthy donation of twenty guineas' for the repair of the beautiful Salisbury Chapel in Christchurch Priory; and at a later date Mr James Dover.

Just outside the radius of the Award map were Stourfield House, Iford House, and Wick House. Iford, by the way, affords another illustration of the 'new world within an old one,' previously referred to as one of the characteristics of Bournemouth. It is a village of great antiquity, being distinctly recorded by the Saxon Chronicler, who designates it as the spot where many skirmishes took place between the forces of Edward the Elder and those of Ethelwald, in their predatory excursions from Wimborne in 901. The name of the place is given as Yattingaford, but it is not improbable that at a later period it attained the name closely resembling that which it now bears, namely, Eaford, composed of two Saxon words, 'ea' and 'ford,' signifying a shallow place in a river, which name, by hasty colloquial pronounciation, and a slight change of orthography, became Iford. A neat erection, Iford House, circa 1800, presented to view through a vista formed by a double row of stately elms, was the residence of Dr W. D. Farr, the house, with the estate, occupying the intervening space

between the public road and the River Stour. Stourfield House – placed on an eminence whence it commanded views that were at once romantic and extensive, beautiful and varied – is said to have been erected by Edmund Bott, a relative of Chief Justice Bott, who wrote the Commentaries on the Poor Laws of England, and was the first mansion erected on the common between Christchurch Head and Poole. The Countess of Strathmore passed here, in retirement, the later years of her eventful life, and died here in 1800, whence her remains were removed to Westminster for interment. Wick House was occupied by Mr John Sloman, and its situation, we are told, afforded every facility for the gratification of his known predilection for angling and the various sports of the field.

With the exceptions we have named, the whole of the district now called Bournemouth was uninhabited prior to the coming of Mr Tregonwell. In 1811, indeed, the whole population of Holdenhurst, including various hamlets and a considerable area now within the County Borough of Bournemouth, was only 491. That number (with the Bournemouth additions) increased to 580 in 1821, to 733 in 1831, to 905 in 1841. In 1851 the population of Bournemouth itself was only 695.

One other quotation must suffice as showing the condition of things prior to 1810, and then we must go on to deal with the coming of Mr Tregonwell, and the great events which followed. In 'Observations on the Western Parts of England, relative chiefly to picturesque beauty,' by the Rev. W. Gilpin (the original of 'Dr Syntax'), written about 1778 and published in 1808, the author, referring to this district, says: 'Our route from Pool to Christchurch led us over a heath, wilder almost than any we had yet found; but it scarcely lasted four miles. It ended in agreeable lanes, through a country not unpleasant. At least, the contrast with the country we had just seen gave it a pleasant appearance. Here, whenever we had an opening on the right, we had views of the sea, the Isle of Wight and the Needles.' Gilpin noted the picturesque, but it was left to Mr Tregonwell to discover the fuller charm of the neighbourhood: the practical advantages which it offered as a seaside resort, – in a word, to discern that combination of beauty and salubrity which was afterwards to suggest the town's motto ('*Pulchritudo et Salubritas*').

The Founder and His Family

'The story of Bournemouth is not a history, but a romance.' So says the Rev. Telford Varley in his charming book on 'Hampshire.' Certainly there is much that is romantic in the circumstances of its discovery, the remarkable transformation that has been effected, and in the life history of some of the people who have been most prominently identified with it. The coming of Mr Tregonwell in 1810, as we shall show later on, was a mere day excursion from Mudeford; but it was fraught with magnificent consequences. It opened up a revelation of wonderful beauty. Mr Tregonwell was keen enough to see that a place with such physical characteristics as 'Bourne' presented must also be salubrious, and with commendable enterprise he 'grasped the skirts of happy chance,' purchased land, built houses, and did other pioneer work to 'bring Bournemouth into notice as a watering place.'

But before we proceed to deal with the founding of Bournemouth let us first direct attention to the Founder and his family. The name Tregonwell suggests a Cornish origin.

By Tre, Pol, Pen
You may always know the Cornish men.

The fact corresponds with the suggestion. Dorset was the home of the family for three centuries, but it derives its surname from its ancient seat, Tregonwell, in Cornwall, where, it is recorded, 'they budded many places, and had many lands and manors before the Norman Conquest.' The first Tregonwell who appears in the Dorset annals was Dr John Tregonwell, D.C.L., who is said to have at one time been the Principal of a small college now incorporated with Christ Church, Oxford, and who made his reputation by the support he gave Henry VIII. in connection with the divorce of Catharine of Arragon. For this he received a pension of £40 a year, and was soon afterwards made Chief Judge of the Admiralty. In 1538 he was appointed a Commissioner to receive the resignation of religious houses in England, and in the following year Henry granted him

the Milton Abbey Estate, in consideration of the payment of a sum of £1,000 and the forfeiture of the pension already mentioned. Subsequently he sat in Parliament as member lor Scarborough, received the honour of knighthood at the hands of Queen Mary, and was Sheriff both of Dorset and Somerset. He lived for many years at Milton, and in the Abbey Church there is a canopied monument of Purbeck marble with an inscription:

'Here lyeth buried Syr John Tregonwell, Knyght, Doctor of the Cyvill Lawes, and one of the Maisters of the Chauncerye, who Dyed the XHIth day of January, in the year of our Lorde 1565. Of whose soule God have m'ey.'

Hutchins suggests that 'he must have been a man of much ability and policy to pass through so many great employments in different reigns, and in very unsettled times,' while the Vicar of Milton Abbey (the Rev. Herbert Pentin, Hon. Secretary to the Dorset Field Club, from whose writings we have been permitted to make extract) says his memory is 'revered in Milton in that he was chiefly instrumental in preserving the Abbey Church for the use of the parishioners.'

Sir John was succeeded in the possession of Milton Manor by his grandson, and he in turn by his son, another John Tregonwell, who purchased the manor and farm of Abbot's Court, formerly the property of the Turberville family (the 'D'Urbervilles' of Thomas Hardy's 'Tess'), and some other estates, including Anderson Manor. Sir John got into trouble 'for deserting the Parliament and residing in the King's quarters,' but compounded for his estate by the payment of a fine of £3,735.'He and his elder son were neuter, but his second son Thomas in arms for the King. He was Sheriff of Dorset, 1604, 1615, 1627.' In 1620 he built the 'faire house' at Anderson, of which Inigo Jones is traditionally reported to have been the architect, and, on the marriage of his son John, took up his residence there in 1624. From this period dates the two branches of the family – the Tregonwells of Milton Abbey and the Tregonwells of Anderson.

At the beginning of the seventeenth century the heir of the Milton estates was John Tregonwell, born in 1598. When about five years old he was taken one day by his nurse to the roof of the south transept of the Abbey, where repairs were then going on. Some attraction appears to have diverted the nurse's attention from her charge, and the child took advantage of her carelessness by climbing the parapet, which alone fenced in the roof, to seize a wild rose growing out of the wall. In so doing he overbalanced himself, and fell right over, descending at one fall a depth of sixty feet. The nurse, seeing the result of her neglect, rushed down the turret steps, through the church into the churchyard, expecting as a matter of course to find the child dashed to pieces; but she could scarcely credit

her senses when she found him entirely unhurt, not even stunned, but busy picking daisies! The child -was wearing at the time a very full dress made of nankeen, and as there was a strong wind blowing, the dress, becoming inflated, acted as a parachute, completely breaking the force of the fall! Mrs Harkness, a granddaughter of the Founder of Bournemouth, has in her possession a portrait of the child – as he was at or about the time of his marvellous adventure.

This John Tregonwell afterwards became High Sheriff of Dorset, and died at the age of 82. At his death, in 1680, his widow, Jane, daughter of Sir Robert Fenn, Lord Mayor of London in 1638, put up a tablet in the Abbey commemorating the remarkable deliverance. The inscription reads as follows:

'To the memory of John Tregonwell, late of Milton Abbas, in the County Dorset, Esqr.; who dyed the 20th of January, 1680, and by his last will and testament gave all the bookes within this Vestry to the use of this Abbey Church for ever as a thankfuld acknowledgment of God's wonderfull mercy in his preservation when he fell from the top of this Church is this Monument erected at the proper cost and charges of Jane Tregonwell, his relict and executrix.'

The 'bookes' to which the tablet refers have also had a history and a deliverance. They formed a 'Chained Library,' and for more than eighty years remained in the vestry. Then, unfortunately, the Vicar of the day had them taken to his own house, and stowed away in a garret. They suffered considerable mutilation at the hands of domestics searching for curl-papers and fire-paper, chains were wrenched off and bindings damaged, and when rescue came it was found that seven of the volumes had perished altogether.

The last of the Tregonwells who lived at Milton was Mary, the beautiful and wealthy daughter of John Tregonwell, Esq. She was twice married, her first husband being Colonel Francis Luttrell, of Dunster Castle, Somerset. After his death she resided for a time in London. Her house was burnt to the ground, but she herself was rescued from the flames by the gentleman who became her second husband, Sir Jacob Banckes, a native of Stockholm. He came to England as Secretary to his uncle, John Birkman, Count of Lczen-burgh, Swedish Ambassador to the British Court in 1681. Banckes rendered distinguished service in the British Navy, was knighted in 1699, and was member of Parliament for Minehead, in Somerset. Hutchins says he was also 'a great patron of literary men, among whom he himself ranked. He erected a monument to Milton, and died at Wimbledon, 1724.' Through him we have another personal link between Milton and Bournemouth, for Sir Jacob was succeeded by his second son – another Jacob – who was twice elected M.P. for Christchurch, in succession to the Sir Peter Mews

who gave a letter or 'bond' to the burgesses insuring them against any claim for wages or other expenses on account of his services in Parliament. Hutchins writes of Mr Banckes in terms of glowing eulogy. He was, we are told, 'a most accomplished and well-read gentleman, his person graceful, his presence noble, his deportment and address engaging, polite, affable, and humane. He had a natural vivacity of spirit, and a peculiar sweetness of temper; and he studied to be agreeable without lessening his dignity.

He was a true lover of his country, a firm friend to the constitution in Church and State, and extremely popular in this county, in which his interest and reputation exceeded that of those who were his superiors only in point of fortune. His probity and integrity were inflexible, he was a lover of truth, a strict observer of his word and the exactest rules of honour, from which he never deviated. Open, candid, and sincere, he scorned the mean arts of cunning, dissimulation, and design, and tempered the plainness and simplicity of the ancient English with the politeness of the modern.' Hutchins' appreciation was not without good cause: he has put it on record that he revered Banckes alike 'on account of his public virtues' and because of 'many unmerited marks of his favour and friendship'; and the Rev. George Bingham, in his 'Biographical Anecdotes,' supplements this with a statement which adds a wonderful touch of romance to the story. Hutchins was Curate of Milton and assistant-master at the Grammar School. It was this engagement which 'first introduced him to the notice, then to the acquaintance, and soon to the friendship' of Mr Banckes; and it was the research which he made into the memoirs of Sir John Tregonwell which 'first engaged him in his inquiries into antiquity and laid the plan of his future history.' 'Great events,' we are told, 'from little causes flow.' It was comparatively a 'little' thing that Mr Banckes – erstwhile M.P. for Christchurch – in 1737 commissioned Hutchins to investigate the family history of the Tregonwells; the compiling and publication of Hutchins' monumental history of Dorset was certainly a 'great event.'

Sir Jacobs Banckes was succeeded by his son, who died intestate in 1737. Mr Thomas Tregonwell, of Anderson, claimed the large property of which Mr Banckes died seized, as his heir *ex parto materna*, and accordingly commenced a law suit against Mr Strahan, the heir to Mr Banckes, *ex parte paterna*. Protracted and, no doubt, costly proceedings ended in a compromise. Then a new claimant appeared, and another arrangement had to be made. Next, 'to prevent further trouble, as other claimants might appear from Sweden, and such wrere industriously sought for, Mr Strahan procured an Act of Parliament, 25 George II., to obviate doubts that might arise on an Act made 11-12 William III. to enable natural born subjects to inherit the estates of their ancestor, either lineal or collateral, though their father or mother were aliens.'

In the time of Charles II. one John Tregonwell was included in a list of persons designated for nomination as members of an Order of Knights of the Royal Oak, which the 'Merrie Monarch' intended to found as a reward to such as had distinguished themselves by their loyalty (see Hutchins' 'History of Dorset'). The Knights were to wear a silver medal with a device of the King in the royal oak. The proposal, however, was laid aside lest it should create animosities. Whether the John Tregonwell referred to belonged to the Anderson or Milton branch it is difficult to determine; the Christian name of John was common to both branches. Every generation in each had its own representative, and it was no uncommon thing for three, four, or more John Tregonwells to be living at the same time.

The Founder of Bournemouth – Mr Lewis Dymoke Grosvenor Tregonwell, who was a Justice of the Peace and Deputy-Lieutenant for Dorset – descended from the Anderson branch of the family, and was the son and heir of the Thomas Tregonwell who sued for the Milton Estate. His mother was Henrietta Eleonora, daughter of Michael Lister, Esq., and cousin of Lord Ribblesdale. He was born on the 14th February, 1758, and married, first, Katherine, daughter and sole heiress of St Barbe Sydenham, Esq., of Priory, Devon, and Coombe, Somerset; and, secondly, Henrietta, daughter of H. W. Portman, Esq., of Bryanstone, Blandford. By his first wife he had two daughters and one son; by his second two sons and one daughter. Mr St Barbe Tregonwell, who is still remembered by some Bournemouth residents, was a member of the first family. We shall have occasion to refer to him again later on; here it is sufficient to state that he was born in 1782, and died in 1859. He was never married. Of the two daughters of the Founder's first marriage, one died young, and the other – Helen Ellery – married, in 1814, Captain John Duff Markland, R.N. Her eldest daughter, Miss Sophia Markland, still survives, and has shown much interest in the arrangements for the celebration of the Centenary of the great watering-place founded by her grandfather. So also has Mrs Harkness, another of Mr Tregonwell's grand-daughters, to whom the compilers of this work are particularly indebted for interesting information, and who has taken infinite pains to render them such assistance as was within her power. Of the two sons born of the Founder's second marriage, one – Grosvenor Portman – died in infancy; the second was Mr John Tregonwell, who was personally and prominently associated with the early government of Bournemouth. He was born on the 26th September, 1811, and is described in the family pedigree given in 'Hutchins' History' as 'of Cranborne Lodge, Dorset, and Bournemouth, co. Southampton.' He married in 1836, Rachael, daughter of the Rev. Robert Lowth, and grand-daughter of the Rt. Rev. Robert Lowth, D.D., Bishop of London, by whom he had a family of three daughters. He died in 1885. Miss Henrietta Lewina

Tregonwell (born 1802), only daughter of the Founder of Bournemouth by his second marriage, in 1825 married Hector William Bower Monro, of Edmondsham, Dorset, and Ewell Castle, Surrey, eldest son of Lieutenant General Monro, some time Governor of Trinidad, and a descendant from the ancient family of Monro, of Foulis Castle, Ross-shire. Through this lady the Tregonwell estates in Bournemouth descended to her son Hector (J.P. and D.L. for Dorset and High Sheriff of the County in 1870), and from him to his son Mr Hector Edmond Monro, the present holder, who was born on the 30th August, 1855, and is High Sheriff of Dorset for the current year. The Anderson (Dorset) and Ashington (Somerset) estates passed through Mrs Markland (mentioned above) to the Markland family, and have since been sold.

Further details of the Founder's career are chronicled in the next chapter. But before proceeding to deal with that visit to the Evergreen Valley which he paid with Mrs Tregonwell in the summer of 1810, and which had such momentous results, it may be interesting to put on record the fact that his personal acquaintance with Bournemouth – or Bourne – was of a much earlier date. In the closing years of the eighteenth century, as mentioned in our Chapter on Coast Defence, the country was agog with expectation of an attempted invasion by the French; a great wave of patriotism swept over the country, and active, well organised, and timely preparations were made against such an eventuality. We have told on the testimony of Mr West, an old resident, now deceased, something of what was done in the neighbourhood of Bournemouth; we have now to supplement this by reference to work in which the Founder of Bournemouth took prominent and honourable part. On the initiation of Lord Milton, in the year 1794, a Corps of Light Infantry was formed in the County of Dorset, 'to serve during the war in the Volunteer Cavalry of Dorset.' The corps was designated the Dorset Rangers, and among the list of officers first enrolled appears the name of Lieutenant L. D. G. Tregonwell, of Cranborne. On the 17th September, 1794, the corps was reviewed at Maiden Castle by his Majesty the King, 'who returned them thanks and expressed much pleasure at seeing them all alert and forward in their manoeuvres.'

The 'Records of the Dorset Yeomanry' state that in the autumn of 1796, 'the Lord Lieutenant, with the advice of Government, thinking it right that precautions should be taken for driving the stock to some place of security in case of invasion, divided that part of the county which is situated on the coast into six districts, giving the care of a district to each Captain of the Yeomanry; and the farmers in each were desired to make a return of the number of cattle, etc., and acres of corn which they had, together with the number of men necessary to remove them.' These six districts were subsequently extended to nine, and to Mr Lewis Tregonwell,

who had become Captain in 1795, with his son, Mr St Barbe Tregonwell, as Lieutenant, was assigned responsibility for a district which not only comprised the easternmost part of the Dorset coast, but the very place where he subsequently founded a new seaside health resort.

Quoting again from the 'Records of the Dorset Yeomanry,' under date 1801 we get the following: 'In the course of this summer, fears of invasion became more prevalent from the enemy having collected great bodies of troops all along the coast of France from Dunkirk to Brest, and more regulations were accordingly made for the defence of the maritime counties. In Dorsetshire the Yeomanry Cavalry were in the first instance to remove the stock from the coast to the distance of about eight or ten miles inland, and afterwards to assemble in places of rendezvous to act against the enemy if occasion should require. Captain Tregonwell's division is formed from the eastern boundary of the county at a place called Bourne Chine along the north shore to Poole, and extends northwards from Poole along the turnpike road to Wimborne, from thence eastward along the Ringwood road to the 10th mile stone, and by a river called the Allen to a place called Sibbols, and from Sibbols in a direct line to Riddle's Ford, and from thence in a direct line to the 5th mile stone on the Christchurch-road; and from thence to Bourne Chine.' Captain Tregonwell's patrol, it appears, not only took in the easternmost seaboard of Dorset, but crossed the boundary and included part, at least, of the district now known as Bournemouth, and the actual site of the watering-place which he founded in 1810–11. No wonder need be expressed that the Dorset Men should thus take responsibility for a part, however small, of Hampshire, seeing that in the old maps Bournemouth almost invariably appears as within the County of Dorset.

According to tradition it was the band of the Dorset Rangers which, concealed in a bathing machine, 'struck up "God save great George our King,"' when his Majesty 'popped his royal head under water on the first occasion of his bathing in Weymouth Bay.'

Apparently the officers were very proud of their corps – as they had reason to be – for besides the written record of their service, extending over many years, there was got together a collection of portraits by Thomas Beach, one of the most distinguished portrait painters of the eighteenth century. Beach, we may add, was a pupil of Sir Joshua Reynolds, P.R.A., and an exhibitor at the Royal Academy and in connection with the Incorporated Society of Artists. Three of his pictures were included in the Exhibition of National Portraits in 1867. His most celebrated work is his picture of John Kemble and Mrs Siddons, in 'Macbeth,' of which the great tragic actress wrote, 'My brother's head is the finest I have ever seen.' He died at Dorchester in 1806, and his life work and association with the

county of Dorset are commemorated on a tablet in All Saints' Church, Dorchester.

The 'Dorset Ranger' portraits, some twelve in number, were formerly in the Came House Library. They were offered by the third Earl of Portarlington to the Dorchester Corporation, as a gift for the Town Hall, but declined. Captain Tregonwell's name is missing from the list, but the gallant captain was not excluded from the commission, or commissions, given to Beach. Indeed, it would have been a very curious circumstance had there been such an exception, for Beach was a native of Milton Abbey, and intimately as the Tregonwells were associated with Milton, they would not have been likely to overlook the claims of one who, eminent in his profession, must surely have been an acquaintance, and possibly a friend – an artist, too, who had received the patronage of his brother officers. The explanation why Captain Tregonwell's portrait was not included in the list offered to the Dorchester Corporation would appear to be due to family reasons. It was in the possession of the Portarlington family till 1889. Then, when Colonel Dawson Darner – of Portman Lodge, Bournemouth – succeeded to the peerage, inquiry as to the picture was made by the late Mrs J. Tregonwell, and it was found at Emo Park, in Ireland, which Lord Portarlington had given over to his son. Lord Carlow. The latter agreed to sell the picture for a sum of £250. Mrs Tregonwell purchased it, and it is now in the possession of her daughter, Mrs Harkness.

Having acquired possession of the original portrait, Mrs J. Tregonwell thought it would be an appropriate thing to present the copy, which had hitherto been kept at Cranborne, to the town of Bournemouth. Accordingly, early in 1890 she sent a letter to the Commissioners making them an offer of the picture. It was, of course, accepted, and the gift was formally received at a meeting on the 13th June, the presentation being made on behalf of Mrs Tregonwell by the Rev. Canon P. F. Eliot (now Dean of Windsor), who briefly reviewed the circumstances of Mr Tregonwell's visit to Bournemouth in 1810 and his claim to be regarded as the Founder, adding that Mrs Tregonwell hoped the Commissioners would accept the gift and place it among other historic portraits of the town.

The picture, which has a classic background, shows a gentleman of very amiable appearance – with none of that fierceness of aspect which we associate with the soldier as depicted in, say, Shakespeare's 'Seven Ages.' He is arrayed in uniform, as are all the officers in the Came House collection. The uniform was dark green, with a crimson silk girdle and white leather breeches. The helmet was of black bear skin with peak, with a black and white check band round the base bearing the words 'Dorset Rangers,' and surmounted with red and white ostrich plumes. The portrait, no doubt, is a fine presentment of Captain Tregonwell as he appeared in real life in the

closing days of the eighteenth century and the beginning of the nineteenth. It is not seen to advantage in the Council Chamber. It needs a strong light to reveal its merits. Then it is found to be not only a clever drawing, but a fine piece of colouring. The richness of its tone is entirely lost unless a strong light is upon it, and, of course, much of its detail is similarly sacrificed.

In the right-hand bottom corner of the picture appears the name 'Lewis Tregonwell, Cranborne Lodge,' and a tablet on the frame is inscribed: 'L. D. G. Tregonwell, Esq., Founder of Bournemouth, 1810–11. Presented to the town of Bournemouth by Mrs Tregonwell, widow of John Tregonwell, son of the above; February, 1890.'

7

The Building of the Mansion

An amusing and fanciful picture of the Founder and the founding of Bournemouth was given many years ago by the late Mr Grantley Berkeley. It is not entirely in accordance with historic fact, but it is entertaining, and quotation here may not be inappropriate or unwelcome:

It's an odd place, and of strange history. Listen! I knew it when it was in its wild state of heather, and its name was only known from the juncture of the little rivulet of Bourne, at that particular spot, with the sea. On a dark night, a lord of the soil drove up in his carriage, and, halting on a slight eminence, he exclaimed to his steward, 'How far am I from the sea?'

'Close, sir,' was the reply; 'you will hear the surf if you listen.'

'Good,' said the great man, 'let there be houses here; and mind, as people at watering places love shaded and sequestered spots, plant – plant, sir, well with the Scotch fir – fir, d'ye mind me, nothing else will grow.'

'Where shall we plant, sir?'

'Here, here,' said the great man, waving his hand in the murky air, and turning round till he forgot his position as regarded the whereabouts of the vasty deep, and ordered the trees to be planted in front of the row of houses.

The lord of the soil who commanded this was a gentleman of the old school, of a warm heart and an open hand, and one whom to know was but to like; his word was a law against which there was no appeal, so his steward obeyed him to the letter.

House upon house, no two of them at all alike, soon reared their walls over the dreary heather, till the village or watering place assumed the likeness of a Chinese puzzle.

The houses had scarce been raised by their proprietors before wise men were found to take them; an inn was built, baths sprang up, bathing machines of different patterns spotted the beach, fat women were found to attend them, and there was nothing wanted but a parson, a butcher, a baker, and an hostler; the doctor and the lawyer were regarded as sure to follow of their own free will, as Satan may be supposed finally to attend a congregation of sinners.

Mr Grantley Berkeley's story, as we have said, is a fanciful one. But it was written, nevertheless, with a knowledge and due appreciation of the forces which have made Bournemouth: the planting of the pine trees, – the adoption of a policy which eventuated in a 'Pleasure City of Detached Mansions.'

It was not on a dark and stormy night, but one day in the month of July, 1810, that the Founder of Bournemouth paid the visit which resulted in the purchase of land, the building of a mansion, the laying out of an estate, and the forming of a new centre of seaside resort. Mr Tregonwell, as has already been shown, must have been acquainted with 'Bourne Chine' for some years before 1810; but probably his mind had been too occupied with military plans and other matters to think of it as a desirable place of residence. He had been Sheriff of the county, was one of the leaders of Dorset society, and infected, perhaps, by what Mr Roberts has described as the 'seaside mania,' he had gone to Mudeford – then a place of high repute for its sea-bathing, whither had come royal and other distinguished visitors, and which had shown its enterprise by the provision of no less than seven bathing machines! Mrs Tregonwell had accompanied him, driving over from their Dorset home with the big, strong horses and chariot which afterwards became so familiar. No doubt, like Sir Walter Scott, while they made Mudeford their temporary home, they wandered east and west, – inland as well as along the beach. At all events, one July day they drove over to Bourne Chine, and put up at the little wayside inn then known as the Tapps Arms, standing in what is now the Old Christchurch Road, and on the land now occupied by Post Office Road at its junction with the Old Christchurch Road. From the inn they no doubt wandered down the Chine to the sea-shore, and they appear to have been greatly impressed with the beauty and the possibilities of the place. The family tradition is that it was upon Mrs Tregonwell that the greater impression was made: to her, no doubt, it presented more novelty than it did to her husband, and she probably saw it under most favourable conditions. Some time before, Mrs Tregonwell had lost her infant son Grosvenor – who died on the very day of his christening. An event so sad naturally affected her very greatly; she could not forget it, she could not cease to trouble about it. When she suggested she would like to build a house at Bournemouth, Mr Tregonwell, anxious to do anything to distract her mind from trouble, readily fell in with her wish, and negotiations were soon in progress for the acquirement of land. Mrs Tregonwell kept a diary. That diary is still in existence, – and it shows that following the visit to 'Bourne' on the 14th July, there was another on the 30th, and further and frequent visits in September, October, November and December. There was much going to and fro again in March and April of 1811; in June they came over from Christchurch every day

for a week – a fact significant not of pleasure-taking alone, but of business. The erection of 'the Mansion' had been determined upon and commenced. But, apparently, it was not completed till the spring of the following year, for the entry in Mrs Tregonwell's Diary under date April 24th, 1812, reads as follows:m'Went to Bourne. Slept there for the first time.'

At this period Bournemouth is said to have been an 'unreclaimed solitude.' The valley was a swamp; the broad heathlands were not broken up with pine woods as they became some years later; the place was the haunt of wild fowl, and except for occasional picnic-parties in the summertime, the only visitors were fishermen from Poole or Christchurch and the smugglers engaged in contraband trade with France, to whom, of course, its solitude was a recommendation.

Mr Tregonwell obtained land for building from Sir George Tapps, purchasing part of what was Lot 31 of the Enclosure Award, described in the title deeds as 'all that piece or parcel of common land or heath land situate, lying, being, at or near Bourn, in the Parish of Holdenhurst, containing by estimation eight acres and two roods and eight perches, bounded by a footpath or way leading from the Decoy and Cottage by the Decoy Enclosures on the east, by a public carriage way leading from the said Decoy Cottage, to the sea on the west,' etc. For this he paid £179 11s., in 'lawful English money.' It was upon this land that Mr Tregonwell built the mansion subsequently known as Exeter House. The footway may be identified as Exeter Lane, the carriage way as Exeter Road. It has been sometimes assumed that Mr Tregonwell made the Decoy Pond; in a previous chapter, however, it was shown that the Decoy Pond and the 'Decoy Pond House' were in existence in 1762, and the Award map of 1805 marks the Pond's position as to the west of the Brook, some little way above what is now the Square. The extract from Mr Tregomvcll's title deeds, quoted above, further indicates its former position, and that it must have been a well-known spot. The present Coy Pond – far up the valley – dates from a much later period, after the valley had been drained and the original Decoy Pond had disappeared.

Mr Tregonwell made subsequent purchases of Sir George Tapps in 1814 and in 1822, paying in the former instance at the rate of about £40 per acre, and in the latter £60 per acre. Exeter Park cost little more than £20 an acre! The accompanying plan shows Bourne Tregonwell as it was some few years after the Founder's settlement. He owned, it will be seen, the stretch of land from the Square nearly, but not quite, down to the sea-front – Sir George Tapps still retaining possession of the meadow, now the Lower Pleasure Gardens – and the Earl of Malmesbury being the owner of a large plot on the immediate sea-front. Mr Erie Drax was in possession of the West Cliff front up to where the Coastguard Station now is – the former

haunt of the gipsies. Mr Tregonwell had obtained possession of practically the whole of the land between Exeter Road and what is now Tregonwell Road, but Sir George Tapps retained a small portion on the western side of the Square – just opposite the point where the Brook then meandered over the roadway. Another block owned by Mr Tregonwell extended from the foot of Richmond Hill up that thoroughfare as far as Yelverton Road, bounded on the other side by the Old Christchurch Road, and including the present site of Southbourne Terrace, the Young Women's Christian Association, the Town Hall Avenue, the Post Office, the Theatre Royal, and other valuable properties. The Founder also acquired the Tapps Arms, which he re-built and named the Tregonwell Arms. After Mr Tregonwell's death his widow sold part of this land at the rate of £800 an acre. When it came into the market again some thirty years later another enormous accretion of value was shown, and in 1886 the corner site at the foot of Richmond Hill, whereon St Andrew's Presbyterian Church formerly stood, was sold for £7,000, a price equivalent to nearly £100,000 an acre. For a plot of land in the Post Office Road offered to the Borough Education Authority in 1903 the sum of £10,000 was asked, though the area of the land was less than a quarter of an acre. And this in what is practically a side street!

The first conveyance of land from Sir George Ivison Tapps to Mr Tregonwell was dated the 25th September, 1810. The building of the Mansion was commenced in 1811, and the house was in occupation early in 1812. Henceforward, Mr and Mrs Tregonwell spent some considerable part of every year at Bournemouth. Soon they gathered friends around them, and other building was commenced. The little colony at first was made up of relatives, but it quickly extended. The thatched house now known as Portman Lodge is an extension of a four-roomed cottage erected in 1810, and formerly known as Symes' Cottage, Symes being the name of the butler, who lived there, and who probably looked after the erection of 'the Mansion.' The original plan of the cottage is still in existence, and in the possession of Mr Monro. It is inscribed 'A Bourne Plan, 1810. Done for Bourne. Symes' Cottage. Drawn by Mr Evans.' Other buildings provided at that early stage included Terrace Cottage – a predecessor of the present house of that name – which was put up for the accommodation of the gardener, who had the charge not only of the gardens but of 'the Orchard' – which ran from Terrace Road down into Commercial Road, and which is commemorated in the names of Orchard Street and Orchard Lane. The coach-house, incorporated in a modern villa, still stands in Exeter Road. The name Exeter Road commemorates the visit – early in the last century – of the Marchioness of Exeter, who was the first tenant to whom Mr Tregonwell let his original Mansion. That house, by the way, still stands

– incorporated in the Royal Exeter Hotel. That was the first residence of Bournemouth's first 'proprietor resident.'

The following, taken from an old newspaper, is the text of an advertisement published in 1820 – an advertisement which secured the first letting of the Mansion:

A MARINE RESIDENCE LOOKING TO THE SEA.

TO BE LET (furnished), a modern detached convenient HOUSE at Bourne Mouth, midway between Poole and Christchurch, consisting of three parlours, 16ft. and 17ft. each, nearly square, fronting the sea, six or seven bedrooms, kitchen, scullery, housekeeper's room, servants' hall, larder, etc. Also a coach-house, stable for two horses, a garden full cropped, a well of good water, and a bathing machine.

The situation is particularly airy and healthy, in the centre of a fine open bay between Christchurch Head and Branksea Castle; there is an easy approach to a very beautiful beach of several miles extent.

The house stands on a green near the high road and a small Inn, where carriers stop daily on their way to the two nearest market towns. A butcher and a baker will bring provisions. Cows are kept on the spot. The terms are moderate, and may be known by a letter, addressed to the Post Office, Cranhorne, Dorset, or to H. Hayter, Bourne Cliff, near Christchurch, Hants.

Sir Tregonwell soon commenced tree-planting, and otherwise developing his estate, devoting particular care to the beautiful glen which he called the Cranborne Gardens – now the Winter Gardens. Here he spent a considerable part of his time, and here, on his death, his widow erected a cenotaph – a massive pedestal surmounted by an urn, and bearing the following inscription:

THIS URN Marks the Favourite Spot of L. U. G. TREGONWELL,
Late of Cbanborne Lodge, Dorset, Esq.,
The First Proprietor Resident at Bournemouth,
And to His Beloved Memory Is Dedicated,
By His Widow Henrietta,
Daughter of Henry William Portman, Esq.,
1832.

Mr Tregonwell lived, it will be noticed, some twenty years after he became the first proprietor-resident of Bournemouth. He divided his time between residence at his new country-seat at Cranborne and sojourning by the sea-side. Tradition says the yearly migration was accomplished in two stages; his first stage was from Cranborne to a now defunct but

formerly well-known old coaching establishment called the Crown Inn, at Oakley, near Wimborne; there he used to lunch and rest the horses, and then on to Bournemouth. On Sundays the family used to drive over to Poole, and attend service at St James' Church – for, till years after the Founder's death, Bournemouth had no place of worship of its own. Mr William Hibbs, now in his 89th year, remembers the time when he used to be summoned from Wimborne to Cranborne to drive Mrs Tregonwell to Bournemouth. Mr Hibbs is probably the oldest living 'post boy,' and has recollections of Bournemouth extending over three-quarters of a century.

The records of the family life at Bournemouth are very scanty, but such as they are suggest happiness and simple enjoyment. They bathed, of course – and the quaint machines which they used, of singular circular construction, remained in existence till far into the latter half of the century, and are depicted in our illustration showing the wooden jetty. And they had other innocent amusement – as revealed in a very entertaining and prophetic document compiled by Mrs Drax Grosvenor, for perusal of which we are indebted to the courtesy of Mrs Harkness. It suggests that in the early history of the family's settlement, Bourne – Bourne Tregonwell as it came to be called – was 'a lonely and rather desolate spot – the only neighbours a gang of gipsies and the smugglers.' But the writer saw the possibility of, and predicted, great developments – some of which have happened, and some have not.

The play is entitled 'A Peep into Futurity; or, Small Talk at Bourne some GO years hence, between the Dandies and Elegants of the day' (the 'sixty years hence' would mean 1876). It is accompanied by a number of very amusing drawings, and dedicated to the 'Most excellent Governor' Tregonwell, with an intimation that it is 'meant as a frontispiece to a new work now in hand, entitled 'The History of the Bourne Colony from its first inhabitants and the present times, with a sketch of the manners, customs and food of the inhabitants, describing their winter and summer dress, and their amusements,' etc., by 'A Settler.' We extract the following:

'Do observe that old man seated on the bench before the Library, with his open and good-natured countenance, with his daughter Harriet beside him.'Tis old John Tregonwell, son of the late Governor, whose house is that fine one in the centre of the town. It was built by his father, and was then considered as a lonely and rather desolate spot; the only neighbours were a gang of gipsies and smugglers. How times are altered! For now, the good man goes to sleep every night to the sound of the waltzes and Italian music, and with watchmen crying the hour under his window.'

It is a singular coincidence that it was in the year 1876 – the year indicated by Mrs Drax's 'prophecy' – that the Italian Band actually settled in Bournemouth.

In the same scene we have the following, which possibly details an item of local history as well as gives an anticipation of sartorial developments which have not been fully realised.

'Lady Georgina Gossamer: Oh, how hot it is! Even my transparent passe-partout incommodes me on these sands. Do you think, my dear, that I shall be quizzed in the 'Bourne Gazette' if I drop it? Why not? But I have heard that even the thinness of the passe-partout was treated with scorn by our ancestors, and they say the old gipsy, formerly the only inhabitant of Meg's Hill, used to make pitfalls and lay snares to catch any struggling Poole belles who dared sometimes on Sundays to frequent her cliffs, if with petticoats shorter or thinner than her old worn-out camblet petticoat. But these old days are past, thank my stars, and this wild and uncouth class of beings are driven by our refinement to seek unsophisticated nature in more remote parts.

'Miss Penelope Parasite: My dear friend and chaperon, you are always so entertaining with all your wild eccentricities. No one abounds with them as you do. My advice is, Drop your passe-partout boldly; be the first this year to start a Bourne fashion.'

The Founder of Bournemouth enjoyed the personal friendship of the Prince Regent (afterwards George IV.), and an amusing story is told of an incident which is said to have happened during the period of his Royal Highness's residence at Crichel. The story is told with many variations, but the version which appears below is the one generally accepted by the family, and supported by the best internal evidence. His Royal Highness kept a pack of hounds, and Mr Tregonwell frequently hunted with him and several times had the honour of dining at the royal table at Crichel. The Prince had what is called a 'strong head,' and hard drinking was at that time regarded with no disfavour, but accepted rather as an accomplishment. Frequently he saw his guests go 'under the table' – and probably he was amused rather than disgusted with the sight. But Mr Tregonwell was permitted to keep to 'toast and water,' a decanter of which was obligingly placed by his side when he dined with the Prince. 'I'll come over and dine with you some day,' said the Prince to Mr Tregonwell, and the promise was again and again repeated. At last came the more definite statement that his Royal Highness would come tomorrow. Mr Tregonwell expressed his pleasure, returned home, and ordered the necessary preparations to be made. The Founder was at that time a widower – for the incident occurred between the death of the first Mrs Tregonwell and his marriage with the second

– and the housekeeper was appalled by the unwonted call made upon her housekeeping. But she managed to secure the cooking of a good dinner, and to make other arrangements for the due entertainment of the distinguished visitor. His Royal Highness was known to be particularly fond of cherry brandy, and always had a glass of that liqueur after dinner. As luck would have it, there was at that time living in Cranborne a Mrs Stillingfleet, who had been Mistress of the Robes to the Princesses, and was renowned for her manufacture of cherry brandy. Mr Tregonwell begged for a bottle for his guest, and of course it was sent to him. All went well through the dinner, and then the host got up and himself poured out the cherry brandy for the Prince. His Royal Highness sipped it, and then, without a word, set down his glass. No remark was made, but on leaving the room Mr Tregonwell told the butler to put the glass aside. The company adjourned to the drawing room, and after some time the Prince said, 'I tell you, Tregonwell, you have made us so comfortable we will stop here to-night.' Such an offer was of course an honour; but it was an honour for which Mr Tregonwell was not prepared, and which filled him with alarm. He communicated his feeling to a member of the suite, and a hint of the unpreparedness of the household was quietly given to the Prince, who, after an interval sufficient to suggest entirely spontaneous action on his own behalf, suddenly exclaimed, 'By-the-bye, though, Tregonwell, we must return to Crichel to-night, as we have an engagement early tomorrow morning. So, kindly order the carriage.' The Royal party returned accordingly. Then, after their departure, Mr Tregonwell discovered the secret why it was his Royal Highness only sipped the cherry brandy. Mrs Stillingfleet not only made cherry brandy, but manufactured her own writing ink, and a bottle of writing ink had been sent in mistake for the cherry brandy!

Mr Lewis Tregonwell, as already mentioned, died in 1832, and was buried at the old Dorset home, where his remains rested till February, 1846, when his widow had them removed to a vault newly constructed in St Peter's Churchyard, Bournemouth – consecrated in the previous year. A few weeks later Mrs Tregonwell was laid by his side. She died at Portman Lodge, and from an obituary notice published at the time we take the following:

'The late L. D. G. Tregonwell, Esq., was the first who noticed the peculiar advantages of Bournemouth, and while the neighbourhood was an unreclaimed solitude, was induced by an appreciation of its natural beauties and advantages to build a mansion here, in which he passed the greater part of his life; and since his death his widow, the late lamented Mrs Tregonwell, has spent nearly the whole of her time, and died much regretted by a numerous circle of friends and relatives.'

Neither the death of the Founder nor of his widow broke the personal association of the family with Bournemouth.

Mr St Barbe Tregonwell, the eldest son, remained a resident till 1859, and is personally remembered by some old residents. We have heard of the courtesy with which he carried a horn lantern guiding the footsteps of his sister and other friends from St Peter's Church on dark Sunday evenings; and it is said of him that on the passing of the Cruelty to Animals Act, 1849, whereby the use of dogs for draft purposes became prohibited, he constituted himself the watchman of Bournemouth, and effectually prevented any such breach of the law here. The Poole fishermen had been accustomed to use dogs for drawing their fish-trucks; but Mr St Barbe Tregonwell posted himself at the top of Commercial Road, then known as Poole Road, and as that was the only way into the village, he soon succeeded in securing cessation of a practise which had been popularly condemned and rendered illegal.

Mr John Tregonwell was born the year after the visit of 1810, and a few months before Mr and Mrs Tregonwell first took up residence in the Evergreen Valley. He remained associated with the place till his death in 1885, and took a prominent part in the town's affairs – helping to secure the Improvement Act of 1856, and himself filling the office of Improvement Commissioner for some years. The official records show that he was a member of the first Board in 1856, and continued a member till 1867, occasionally acting as Chairman at the Board meetings, though never, it would seem, formally elected as Chairman for the year. In April, 1867, he tendered his resignation, which was 'accepted with much regret.' At the next meeting, his nephew, Mr Hector Monro, was elected to fill the vacancy, and continued to hold office till 1873. He was Chairman in 1871–2, but in 1873 there was a contested election, with a large number of candidates, and he lost his seat.

The monument which formerly stood in the Cranborne Gardens has disappeared – no one knows where. But over the Founder's grave in St Peter's Churchyard there is a large altar tomb, with a variety of inscriptions. First, we have the following:

'Sacred to the memory of Lewis Dymoke Grosvenor Tregonwell, Esquire, of Anderson, and Cranborne Lodge, in the County of Dorset, who departed this life at the latter of these residences on the 18th day of January, 1832, aged 73 years. Also of Grosvenor Portman Tregonwell, his son, who died an infant, on the 29th May, 1807. Their remains were removed from Anderson to this spot on the 26th of February, 1846, Bournemouth, which Mr Tregonwell was the first to bring into notice as a watering place by erecting a mansion for his own occupation, having been his favourite retreat for many years before his death.'

Above this central inscription, and immediately below the slab, is another plate, bearing the following:

'In this vault lie the remains of St Barbe Tregonwell, eldest son of Lewis D. G. Tregonwell, of Anderson, Cranborne, and Bournemouth. Born at Clyst St George, in 1782. Died at Bournemouth in 1859.'

A similar plate lower down on the same front is thus inscribed:

'In this vault lie the remains of Henrietta Lewina Monro, widow of the late Hector W. Monro, Esq., of Edmondsham, Dorset, and Ewell Castle, and daughter of the late Lewis D. G. Tregonwell, Esq., who died at Bournemouth, January 13th, 1864, aged 62 years.'

On the other side of the tomb are also three inscriptions, their text, reading from top to bottom, being as follows:

'Also in loving memory of John Tregonwell, son of L. D. G. Tregonwell, and Henrietta, his wife, of Anderson, and Cranborne Lodge, Dorset, and Bournemouth, who departed this life October 12th, 1885, aged 74.'

'Sacred to the memory of Henrietta, relict of L. D. G. Tregonwell, Esq., of Anderson and Cranborne Lodge, in the County of Dorset, and daughter of Henry William Portman, Esq., and Ann, his wife, of Bryanstone House, Dorset, who departed this life at her residence in Bournemouth on the 15th of April, 1846, aged 76 years. Sincerely regretted by a large circle of friends.'

'Also in memory of Rachael, widow of John Tregonwell, of Cranborne Lodge, and Anderson, Dorset, daughter of the Rev. Robert Lowth, who entered into life 13th February, 1901, aged 85.'

Six persons are thus commemorated: the Founder and his wife, three of his sons and one of his daughters.

8

'The Marine Village of Bourne'

When Mr. Lewis Tregonwell died in 1832, Bournemouth – or Bourne Tregonwell – though a place of great and increasing natural beauty, had still but a very small population. The third Earl of Malmesbury (friend and colleague of Lord Beaconsfield) has told the story of how in 1826 he 'shot an old black-cock on the very spot where St Peter's Church at Bournemouth now stands,' and in 1827 the Hon. Charles Harris knocked down a guillemot with a riding whip near Boscombe. It yet remained a 'wild country,' abounding with game, and Lord Malmesbury and Lord Shaftesbury (famed as 'the good Earl') came here as to 'the most secluded spot in England' to study for their degrees. 'In 1830 there were not more than half a dozen houses and cottages where now one of our largest and most fashionable seaside places stands.' Even subsequent to this period the late Mr W. Clapcott Dean, who kept a pack of harriers at Littledown, is said to have taken part in a run which ended in a kill in what is now St Peter's Churchyard.

It has already been recorded that Mr Tregonwell acquired his estate by purchase from Sir George Ivison Tapps, Lord of the Manor of Westover. But Sir George had retained in his own hands the whole of the land on the sea-front, stretching right away from the mouth of the Brook to Boscombe Chine, as well as some considerable tracts in other parts of the district. An opportunity for the advantageous utilization of these lands came in 1836, from which period dates a most important development – initiated by Sir George W. Tapps-Gervis, Bart., the only son of the original owner.

Sir George Ivison Tapps, who was created a baronet in 1792, became entitled to the original part of the Meyrick Estate in Hampshire under the will of his cousin, Mr Joseph Jervis Clerke, who died in April, 1778. The Manor of Christchurch and Liberty of Westover, in which Bournemouth is situated, had been bought by Sir Peter Mews, from the Earl of Clarendon and his trustees, and these properties descended from Sir Peter Mews to the Clerke family, from whom they passed, as stated, to Sir George Ivison Tapps. Sir George subsequently sold the 'Manor of the Borough of Christchurch' to the Rt. Hon. George Rose, Treasurer

of the Navy, but the Manor of Christchurch and Liberty of Westover has remained in the possession of the family down to the present time. The mansion at Hinton Admiral, it may here be mentioned, was built by Sir Peter Mews, who was at one time M.P. for Christchurch – the old borough, of course, including no part of what is now Bournemouth. Under the Christchurch Enclosure Award, relating to the land in the Liberty of Westover, part of the enclosed land was awarded to Sir George Ivison Tapps as Lord of the Manor. As already shown, he bought up other parts (sold to defray expenses) – mostly abutting on the sea. He was largely responsible for planting the property with pine trees, being apparently the originator of that splendid work which, continued and extended by other owners, has made Bournemouth unique among seaside places – a 'Forest City by the Southern Sea.' Sir George died in March, 1835, and was succeeded by his son (born 1795), who assumed by sign-manual the surname of Gervis, in addition to his patronymic. He had, in 1826, in his father's lifetime been (as Mr George William Tapps) elected M.P. for New Romney. On the passing of the Reform Bill in 1832 he became M.P. for Christchurch, which he continued to represent up till 1837. Prior to 1832 Christchurch had sent two representatives to Parliament; from 1832 onward it sent but one, and the representative chosen for the first two Parliaments was the same Mr George William Tapps (afterwards Sir George William Tapps-Gervis), who upon each occasion was returned without opposition.

On succession, as absolute owner, to his father's estates, Sir Geo. W. Tapps-Gervis gave what has been described as an 'efficient impetus' to Bournemouth improvements. He became satisfied, it is said,

'that Bournemouth was endowed by nature with those special features and circumstances which eminently fitted it to become an approved resort of those who, at the termination of the London season, seek on the coast that invigorating repose, and that commixture of fashion and retirement, which afford the best protection against ennui, and are most conducive to the restoration of that freshness and activity, both in the physical and mental functions, which the constant excitements of town life have so great a tendency to undermine. Under his auspices, therefore, and directed by the acknowledged talent and personal superintendence of Mr B. Ferrey, the eminent architect, many plans for the improvement of the estate were laid down, and some of them immediately realised. Thus on spots where, before, the foot of man rarely pressed, but the lowly heath flower blossomed and faded in unnoticed solitude – where no sound was heard but the rustling of rank grass and the wild shrub, as they waved in the light sea-breeze – there a number of detached villas, each marked by distinct and peculiar architectural features, sprang into existence, affording accommodation

of varying extent, so as to be suited to the convenience of either large or small families, and adapted, some for extended, others for confined, establishments.'

'The Visitors' Guide to Bournemouth,' 1812

Thus originated the 'marine village of Bourne' – laid out on the eastern side of the valley, just as Bourne Tregonwell was laid out on the west. The plan published herewith shows the scheme of contemplated development – not fully realised in all its details. Sir George Gervis put 'a portion of his immense wealth in requisition, for the formation of a complete and extensive watering-place,' and at that early stage laid down the rule of having every residence detached – each standing in its own grounds, shaded by trees and beautified by flowering shrubs and other plant life. The houses first erected were those still known as the Westover Villas, facing the beautiful pine-wood which from the earliest days has been set apart for the convenience and enjoyment of the people. No. 1 was erected by Mr David Tuck, whose lease was dated the 27th March, 1837, and was for a period of eighty years. The ground rent was £8 per annum. It was stipulated that the house should cost at least £500, that it should be ready for occupation in twelve months, and also that in case the ground landlord should erect a church or chapel, and so soon as divine service should be performed according to the rites of the Church of England, then the lessee should pay 'on the 29th September yearly, and every year during the said term, the sum of one pound sterling as rent for the use of a pew or three sittings for his family, in the church, chapel, or place of worship.' The Bath Hotel was built in 1837, and opened on Coronation Day in 1838. We find it described in 1842 as 'a very elegant, spacious, and convenient structure, capable of affording accommodation to a great number of inmates.' The manageress was a Miss Toomer, and the regulations and arrangements of the establishment, under her 'active superintendence and careful management,' were such as 'ensured the comfort and tended to the satisfaction of the visitors.' For 'the appropriate accommodation' of visitors 'preferring the retired and quiet mode of life available in such establishments,' the Belle Vue Boarding House was built close to the Beach, and fitted up 'with every regard to elegance and comfort.' In addition to the ordinary advantages of such an institution, Mrs Slidle, 'the conductress,' provided 'accommodations for the more casual visitor,' including 'every requisite' for picnics. Even a billiard table was provided, whereon the visitor might enjoy his '50' or '100 up'! In a western wing of the same block of building, and immediately adjoining the meadows, since known as the Lower Pleasure Grounds, Mr Sydenham established a Library and Reading Room, where 'a plentiful supply of books, magazines, and newspapers proffered information as to the course of the busy world and presented sources of intellectual amusement and recreation.' The proprietor vended 'stationery of every description'; new and fashionable

music; soda water, lemonade, and ginger beer; tea and coffee; and there were pianofortes for sale or on hire! There was a receiving box for letters.

The original architect to the estate, as already mentioned, was Mr Ferrey, whose plans laid down principles which, though not followed in their entirety, gave Bournemouth much of the peculiar attraction which it has since possessed. They included the laying out and reservation of the Pleasure Gardens – that great central feature of Bournemouth which is the admiration of all visitors. Mr Decimus Burton, the architect of the Wellington Memorial at Hyde Park Corner, was subsequently employed.

Sir George Gervis had but a very brief career in the ownership of the property. He died in the year 1842, having entailed the property on his eldest son (afterwards Sir George Eliott Meyrick Tapps-Gervis-Meyrick) who at the time of his father's death was 'an infant' of about fifteen years of age. For the further development of the estate a private Act of Parliament – 9 and 10 Vic., Cap. 29 – was obtained, and during the minority of the owner the estate was administered by Trustees.

Mr Ferrey not merely prepared a scheme of development, but he was responsible also for the preparation of a large number of house-plans, including the whole of the Westover Villas, plans for a series of villas for a crescent to be called Poole Crescent, and Greek, Italian, Elizabethan and Gothic villas proposed to be erected along the cliff-front. Sir George appears himself to have taken a very active part in connection with the development of the 'new marine village,' for there are records in existence showing that he purchased some of the furniture for the Bath Hotel! Indeed, he seems to have retained a large interest in the general development, himself making arrangements for the purchase of bricks, lime, cement, etc., 'for his buildings at Bourne.' Long before his death the Bath Hotel had been completed; the roads in the 'new marine village' were well advanced; the Westover Gardens had been planted, and paths laid out and gravelled; and some preliminary steps had been taken for providing for the spiritual needs of the growing population.

In the Private Act already referred to, obtained in order that the Trustees which he had nominated might continue, during his son's minority, the good work which he had commenced, it is set out that 'a considerable part of the lands and hereditaments' mentioned and described in the 1st Schedule, are 'situate upon or near the sea-coast at Bournemouth,' and that 'the situation thereof, by reason of the salubrity of the air and its proximity to the sea-coast, is well adapted for a watering place.' Further, it is stated that

'the testator, in his lifetime, with a view to its becoming a fashionable place of resort, granted building leases of certain portions of the said lands and

hereditaments, for the erection of detached villas, of which nineteen have been built; and he also expended considerable sums of money in the erection of an hotel for the accommodation of visitors and in the construction of a church, which is now endowed with a rent charge issuing out of the hereditaments devised by the said will of the said testator, or some part thereof.'

The Trustees were urged to action by the lessees, who called attention to various features of the plan of this 'new marine village of Bourne' which had not been carried into effect. The 'Pleasure Gardens Pagoda,' for instance, had not been erected. And it never was. It was the fore-runner of a whole host of Pavilion schemes – which have appeared on paper only. The Trustees were reminded that the provision of a Pier 'is very essential to those who are desirous of water excursions,' etc., 'as the waves are so high, except when the wind is moderate to the northward, that it is frequently impracticable to approach the shore from a boat without being swamped, and at other times it is very difficult to get out or into a boat without being annoyed by the surf.' Though, as we shall show in a subsequent chapter, a Pier was ultimately provided by the Local Authority, a contribution of £500 towards the cost was originally offered by the Gervis Estate. The lessees further called attention to 'the necessity of clearing away the underwood and furze and heaths in the plantations surrounding Bourne, so as to prevent their destruction by fire.' Their prayer was acceded to; the underwood was cleared away; the Westover Gardens were enclosed within a rustic fence, preventing trespass and injury by cattle; and two rustic bridges were constructed across the Brook.

In the 'Hampshire Advertiser' of June 16th, 1838, appeared a statement that 'the new romantic watering place called Bourne is progressing at a railway pace. The splendid hotel is all but completed, and in a few short years it is conjectured that it will compete with the renown of Southampton.' A week later there was an announcement of a prospective sale by auction of 'marine villas.' The auctioneer was Mr George Cranston, and the sale was to take place at the Bath Hotel. The advertisement set forth that these houses were 'five unfurnished villas situate at Bournemouth, and numbered respectively 4, 9, 10, 11, and 12; 4, 9, and 10 are in great forwardness, and may in a few weeks be perfected for habitation. Hotel just completed; also a new chapel for public worship, and Baths, etc., are in progress.' The 'new chapel' for public worship was a building erected in the Square – on a site now occupied by Messrs. Leverett and Frye; and the method of erection appears to have been the throwing of two cottages into one large room, and making the upper floor serve the purposes of a gallery. Here services were held and the singing led by a village choir with instrumental accompaniments of the varied and now obsolete character depicted in some of the Wessex stories of Mr Thomas Hardy.

The advertisement columns of old county newspapers give various other evidences of Bournemouth's progress at this early time. Even as far back as 1826 we find in the 'Salisbury and Winchester Journal' an announcement of two 'modern detached houses' to let, with the following allurements: 'A bathing machine and a warm bath. A baker attends four days a week. A coach passes daily from Southampton to Weymouth, and several carriers.'

A news paragraph in the same journal in July, 1836, ran as follows: 'The projected range of villas at Bourne Mouth are in a state of active progress, including a large and commodious hotel, with baths, etc. It is also intended to erect a number of large and elegant buildings on the cliff in a line with Boscombe Mouth.' Two years later a long advertisement appeared with an appeal to 'gentlemen, builders and others desirous of investing capital advantageously.' Sites of freehold building land were for sale, 'immediately adjoining the new marine neighbourhood now fast progressing called Bourne Mouth.' With glowing enthusiasm the auctioneer described the charms of the neighbourhood – the 'advantages of country retirement with the pleasures of the sea coast,' the proverbial mildness of the climate, and the very favourable prices at which building materials could be obtained. Publicity only was necessary 'to insure the patronage of rank and respectability – especially of the lovers of rural and marine scenery.'

In 1838 'furnished and papered villas,' 'with every requisite,' were being advertised at a rent of four guineas per week – if taken by the month; 'if taken for six or twelve months, considerable allowance will be made.' In 1839 a mansion was advertised at eight guineas a week. It was described as 'the property of a lady, and suitable for a family of distinction.' It was sheltered by plantations, and 'a kitchen garden and two cows' might be rented. Other attractions included three bathing machines, with 'a guide' in attendance. Applications were to be made to Mr George Fox or Miss Toomer; 'if by letter, post-paid'! No doubt the Mansion referred to was that owned by Mrs Tregonwell.

1838 was a year of great activity, and even of festivity. From a contemporary record, under date May 19th, we take the following:

'On Tuesday last a large party of Conservative gentlemen from Poole and Christchurch partook of an excellent dinner, got up by Fox, at the Tregonwell Arms, Bourne Mouth, Henry Rowden, Esq., in the chair. A number of Conservative friends at Poole and Christchurch propose meeting annually at Bourne to dine together in celebration of their mutual principles. Bourne being delightfully situated midway between these towns, and being one of the pleasantest spots in the country.'

Describing Bournemouth generally as it appeared in 1842, an authority before quoted thus depicts it: 'Midway between Christchurch and Poole, the road conducts the traveller into a narrow vale winding into the land and opening directly upon the seashore, and on entering which he is delighted with the prospect of social life, animated retirement, and a combination of the elegancies of nature and of art, spread before his view, detached villas, indicating every variety of style that the fancy and ingenuity of the architect could devise, and admirably associating with the local natural features, rows of stately edifices, relieved by the dark-foliage of dense plantations; extensive walks, and tastefully arranged shrubberies are the objects that first strike the eye in this pleasing retreat; whilst the whole is softened by an air of tranquil repose and a quietude of character eminently grateful to those who seek a relaxation from the fatigue and excitement of fashionable life, or a respite from the turmoils and anxieties of rough intercourse with the world. This pleasing spot the beauties of which are enhanced by the contrast afforded by the surrounding scenery, is Bournemouth, where, in a season, the magic hand of enterprise has converted the silent and unfrequented vale into the gay resort of fashion and the favoured retreat of the invalid.'

The part which the Tapps-Gervis-Meyrick family have played in the evolution of Bournemouth is so important – extending over the whole of the century – that the brief biographical facts mentioned above may, we think, here be appropriately supplemented by some fuller details.

The Lord of the Manor of Christchurch and Liberty of Wes lover represents families of great antiquity and distinction. The Rev. Mackenzie Walcott attributes the rise of Bournemouth to the enterprise of Sir George Gervis, grandfather of the present Lord. We have shown that to Mr Lewis Tregonwell belongs the title of 'Founder of Bournemouth' – a title which has been recognised from the earliest period and never seriously challenged. But much credit also attaches to Sir George Gervis; his enterprise gave impetus to the movement which Mr Tregonwell initiated, and further established Bournemouth's claim upon public attention at a time when it was but little known.

George Gervis (or Jarvis), who died in 1718, left three daughters and co-heiresses, the eldest of whom, Lydia,.Marini married Sir Peter Slews, M.P. for Christchurch, son of the Right Rev. Peter Mews, D.D., Bishop of Winchester – an eminent prelate who distinguished himself not only by his great sacrifices and large contributions for the cause of King Charles I., but having been a soldier before his ordination, resumed the sword, and when a bishop, commanded a regiment in defence of his Church and King, and received a wound, the scar of which remained on his face to his death. Lady Slews died at Hinton Admiral in 1751, without issue. The

estates descended to the son of her younger sister, who had married one William Clerke, of Buckland and Cromer Hall, Herts. The third sister, Catherine, married Richard Tapps, whose son and grandson were both named George Gervis Tapps. The latter, who was a barrister, married a daughter of J. Ivison, of Carlisle, and died in 1774, leaving as his successor his son George Ivison, who was father of the first Baronet, Sir George Ivison Tapps, Lord of the Manor of Westover at the time of the passing of the Christchurch Enclosure Act. The latter's son, George William Tapps, as already mentioned, was M.P. for Christchurch from 1S32 to 1837 – and he it was who, on accession to the estates in 1835, gave that impetus to Bournemouth's development which resulted from the erection of the 'marine village of Bourne' on the eastward side of the Evergreen Valley. Sir George married a daughter of Augustus Eliott Fuller, of Rosehill Park, Sussex – who came of the Meyrick family and had assumed that name in addition to that of Fuller.

The Meyricks trace their origin from Roderic the Great, King of All Wales, who began to reign in 843 and fell in battle in 876. They have possessed the same ancestral residence and estates at Bodorgan, Anglesey, without interruption for a thousand years. From Roderic the Great descended (among others) Owen Gwynedd, Prince of Wales, AD 1136, and Llowarch ap Bran, Lord of Monau (Menai) and founder of 'the II. noble tribe of North Wales and Powys.' It is not necessary to give in full the details of the family fortunes right down through the centuries, but it is interesting to note, en passant, that one Llewellyn ap Heylin fought at the battle of Bosworth on the side of Henry VII., and his two-handed sword and salt-cellar are still preserved at Bodorgan, where also his saddle was a few years back. His son, Meyrick ap Llewellyn, was captain of the guard at the Coronation of Henry VIII. He was the first High Sheriff of the County of Anglesey, which office he held till his death. From him the name Meyrick, signifying 'guardian,' is derived, as a surname, in pursuance of the Act of Henry VIII., requiring that the name of every man at that time should be borne by his descendants as a surname, there being no surnames before that time in Wales.

We go back now to Sir George William Tapps-Gcrvis, the second Baronet. Sir George had three sons and one daughter, his eldest son being George Eliott Meyrick, who succeeded him as third Baronet, and who, in compliance with the will of his great-grandfather, Owen Rutland Meyrick, assumed the names and arms of Meyrick, in addition to his other names, on succeeding his uncle, Mr Augustus Eliott Fuller Meyrick. Sir George Eliott Meyrick Tapps-Gervis- Meyrick, who was High Sheriff of Anglesey in 1878, was born in 1827, and married Fanny, daughter of Christopher Har- land, of Ashbourne, Derbyshire, and by her had three daughters

and one son – the present and fourth Baronet, Sir George Augustus Eliott Tapps-Gervis-Meyrick, who is a J.P. and Deputy Lieutenant for Anglesey, and was High Sheriff for the County of Southampton in 1900. Sir George, who was born in 1855, married, in 1884, Jacintha, youngest daughter of Charles Paul Phipps, M.P., of Chalcot, Wilts, and has two sons and two daughters.

As the above biographical statement is necessarily somewhat complicated, we summarise as follows with regard to the four Baronets directly associated with the history of Bournemouth:

1. George Ivison Tapps, first baronet, born 1753, died 1835, was Lord of the Manor of Christchurch and Liberty of Westover at the time of the passing of the Christchurch Enclosure Act and the making of the subsequent Award.

2. George W'illiam Tapps-Gervis, son of the above, and second baronet, born 1795, died 1842, gave 'efficient impetus' to Bournemouth improvements and originated the 'new Marine Village of Bourne.'

3. George Eliott Meyrick Tapps-Gervis-Meyrick, third baronet, born 1827, died 1896, succeeded his father when but a lad of fifteen years of age.

4. George Augustus Eliott Tapps-Gervis-Meyrick, fourth and present baronet, born 1855. Granted to the Corporation the lease and powers under which the Undercliff Drive has been constructed and other improvements are projected for the further development and perfecting of the health and pleasure resort which as 'the Marine Village of Bourne' claimed so much of the attention of his father and grandfather. Sir George, in addition to distinctions already mentioned, quarters the Arms and bears the Crest of Sir Francis Drake, claiming (through the Eliotts) descent from Thomas Drake, brother of the great Elizabethan Admiral, and also from Lord Heathfield, who conducted the famous defence of Gibraltar. On the shield of Sir George the baronies of Eliott and Drake are combined, and constitute an heraldic record of which any family might well be proud.

9

A 'Perfect Discovery':
A 'Sea Nook' for the Real Invalid

'Of all seaside cities, watering places, retreats, hospitals, convalescent houses, or bathing places, Bournemouth is the most remarkable. There was once a forest of pines. Somebody made a clearing and built a house just as if he was in Canada. Then another man made another clearing and built another house, and so on. The pines stand still between the houses, along the roads, in the gardens, on the hills, and round the town. The air is heavy with the breath of the pine. The sea is nothing; you are on the seashore, but there is no fierce sea-breeze, no curling line of waves, no dash of foam and spray. The waters creep lazily along the Beach, and on the Pier the fragrance of the pines crushes out the smell of the salt sea.

'When the settlements were cleared, and the houses built, and rows of shops run up, there arose a great unknown genius who said, 'We have slopes, streams and woods; we have a town planted in a forest by the seaside; let us make a garden in our midst.' And they did so; a Garden of Eden. Hither come, when the rest of the world is still battling with the east wind and frost, hollow cheeked young men and drooping maidens to look for the tree of life in that garden, and to breathe those airs. They do not find that tree, but the air revives them for a while, and they linger on a little longer, and have time to lie in the sunshine and see the flowers come again before they die. This is the city of Youth and Death. Every house amid these pines is sacred to the memory of some long agony, some bitter wrench of parting, some ruthless trampling down of hope and joy. From every house has been poured the gloomy pageant of death, with mourners who followed the bier of the widow's only son, the father's cherished daughter.

> Then that great genius who laid out the garden said: 'They come here to die: let us make death beautiful.' And they did so. They built a church upon a hill; they left the pines to stand as cypresses; they ran winding walks and planted flowering shrubs; they put up marble crosses on the graves of the youthful dead; they brought flowers of every season, and all sorts of trees which are sweet and graceful to look upon; they refused to have any rude and vulgar monuments;

they would have nothing but white marble crosses. Some stand in rows all together on an open slope, bounded and sheltered by the whispering pines with saffron-coloured cones; some stand each in its own little oblong, surrounded by plants and trees, shaded and guarded for ever. They bear the names of those who lie beneath; they are all of them young men and girls: one is twenty-four, one is eighteen, one is twenty. Here and there you find an old man who has stumbled into the graveyard by accident. It jars upon the sense of right; it is a disgrace for him to have lived till seventy; he ought not to be here; he should have been carried five miles away, to the acre where the venerable pile of Christchurch guards the heaped- up dusty of thirty generations, and the river runs swiftly below; but not here, not among the weeping girls and sadfaced boys. Let them all rise together, at the end, this army of young martyrs, with never an old man among them, to find with joyful eyes a fuller life than that from which they were so soon snatched away.

The above extract will be recognised by many readers as taken from the story entitled 'The Seamy Side,' by Walter Besant and James Rice. The description was applied to a period of a later date than we have yet reached in these records, but it illustrates a phase of history which Bournemouth entered upon in the second quarter of the last century. Soon after its establishment in 1858, we find the 'Directory' uttering a warning to Bournemouth against being 'content to regard itself only as a valetudinarian's retreat'. 'It would satisfy neither our interest nor our ambition were Bournemouth to become the very Metropolis of Bath Chairs. We desire that these may be the appendages only of a cheerful and pleasure-taking resort.' But regard for accuracy compels us to state that, for a time, Bournemouth really was little more than a 'Colony of Invalids.' That, at all events, was the pre-eminent characteristic of its population during the years immediately following the visit of an eminent medical authority, from whom some of the more enterprising of the 'Colonists' succeeded in extracting a very glowing report in 1841. The story of that visit we have now to tell.

Dr A. B. Granville, the author of a celebrated work on 'The Spas of England,' happened in February of 1841 to be in the neighbourhood of Bournemouth, and being there 'was requested by several gentlemen connected with that almost unknown sea watering place' to visit and give his professional opinion respecting it. He was entertained at a public dinner given at what he describes as the 'Great Hotel,' and Chapter X. of the volume which he issued the same year is devoted entirely to an appreciation of 'Bournemouth and its yet unformed colony' –'a perfect discovery among the sea-nooks one longs to have for a real invalid.' The Doctor reproduces the speech which he delivered at the dinner, and

from that time down to the present it has appeared, in whole or in part, in practically every Bournemouth guide-book. Time has not robbed his testimony of any of its value, though Bournemouth has developed along lines, and to an extent, which he never imagined, its attraction as an invalid health resort being rivalled by its claim as a holiday centre. Adopting the picturesque phrasing of Sir James Crichton Browne: a 'Stately Pleasure Dome' has been erected side by side with the 'Temple of Ilygeia.'

'I have examined Bourne in all its parts,' said the speaker,

'under sunshine as well as during the prevalence of wet and high wind. I have seen what has been done, and have heard of what it is intended to do, in order to profit of the many advantages which the situation of Bourne offers as a watering place; and I have no hesitation in stating, as the conclusion of all my observations, around as well as within the place – that no situation that I have had occasion to examine along the whole Southern Coast possesses so many capabilities of being made the very first invalid sea-watering place in England; and not only a watering place, but what is still more important, a winter residence for the delicate constitutions requiring a warm and sheltered locality at this season of the year (February)... I hardly need touch upon its superiority as a bathing-place to any in the neighbourhood, or along these coasts. It is an inland sheltered haven for the most tender invalids, however, that I would call your attention to the great capabilities of Bourne; for we look in vain elsewhere for that singular advantage which Bourne possesses, of presenting two banks of cliffs, clothed with verdure even at this inclement season, running from the sea inland, with a smiling vale, watered by a rapid brook or bourne, dividing them just enough to allow of a most complete ventilation, with coolness in the summer, and yet affording a most protected succession of ridges upon which to erect residences not only for convalescents, free from positive disease, but also for patients in the most delicate state of health as to lungs.'

Remarking that they had here a spot which they might 'convert into a perfect blessing' – 'to those who do not like to tear themselves from home to go in search of foreign and salubrious climates,' Dr Granville added a warning against the blunders which had been perpetrated in other places. 'You must not let in strangers and brick-and-mortar contractors, to build up whole streets of lodging houses, or parades and terraces interminable, in straight lines facing the sea, the roaring sea, and the severe gales, that make the frames of an invalid's bedroom casement rattle five days in the wreek at least, and shake his own frame in bed also.' There is a suggestion that the warning was necessary, for following the quotation from the speech at the 'Great Hotel' we have a hint that by the people 'not properly using their resources, their very first beginning

a few years back proved a failure, until two or three other spirited and judicious proprietors stepped in to the rescue.' From warning he went on to prophecy as to the future of the 'incipient settlement' 'which has as yet no definite or permanent population.' 'So insignificant has it hitherto been considered by the topographer that we find in the adjoining county's map an indication set down that a particular road from Dorsetshire leads 'to Christchurch,' without mentioning to Bournemouth, albeit the identical road passes through it. But the day is at hand when the latter indication will be substituted for the former.'

The description of Bournemouth which follows is too long for full quotation. Incidentally, reference is made to white pipe-clay being found near the cliffs to the east of Boscombe and at Durley Chine, 'where it is worked out and sent to the potteries in Staffordshire as the purest and best material for the celebrated porcelains of that district.' The peculiarity of Bourne's formation is referred to as constituting one of the great merits of the locality as a retreat for invalids, 'while the chance circumstance of a gentleman retreating to this spot some thirty or forty years ago, and planting all the sandhills to the westward of the Bourne, or brook, with trees of the Pine tribe, whereby the district has been converted, in the course of time, into a sort of tiny Black Forest, is the cause of another and most important advantage of the place.' The writer describes the 'range of sandhills' west of the Bourne, 'once barren and naked, and now covered with luxurious and dense forests of fir trees, the work of the late Mr Tregonwell, of Edmondsham, Dorsetshire, whose relict even now occupies the mansion he originally built for his permanent residence, at present surrounded with lawns and shrubberies, and embosomed amidst dense plantations,' and he adds that it was by exploring this ridge 'on a few points of which only an isolated private dwelling-house has as yet been erected, that I discovered three or four retired glens, so lovely from their verdure, so tranquil from their position, and so warm from their sheltered aspect that I did not hesitate a moment in declaring such spots to be the very thing that was wanted in this country, to render the South Coast really and truly available on behalf of those who are afflicted with consumption... Here then the great desideratum for consumptive invalids is found; and if the proprietress of this blessed region is properly advised, instead of parting to speculating purchasers with her lord's estate (who, in planting it, and throwing the shelter and balsamic effluvia of a forest of firs around so many natural glens, probably looked forward to the destination for which I am the first to declare it to be fitter than any other place in England), she will apply herself to build insulated villas of different sizes and properly located with gardens, and a general walk through the intended woods, enclosing the whole territory by fences, and making a

handsome entrance into it near the wooden bridge or head of the valley, denominating henceforth the establishment, Bournemouth Park, and the dwelling-houses of the valetudinarians in it, the Park Villas; with a perfect assurance that they will become celebrated all over the country as the best, the most promising, and the only real asylums for consumptive people of the higher order... An opportunity is now offered of establishing a real Montpellier on the South Coast of England, and a something better than a Montpellier in point of beauty for the upper and wealthier classes of society, who ought to be encouraged and enticed to remain at home and spend their income in husbanding their health in England.'

Dr Granville repeated his warning against making Bournemouth 'just as tolerable and common' as twenty other places, and this was his criticism upon one of the plans of development which seems to have been submitted to him: 'It is well to study effect, and to try to cover in concentric circles the whole face of the hill, which towers over the east sea cliff, and at the back of the present villas, with lines of lodging and other dwelling-houses, and crowning the whole with a Gothic church, placed in the centre of the summit, like a diadem – to serve as a beacon to mariners; but it will not do for invalids with delicate chests and damaged lungs to climb up the Capitol, either to return home after a walk on the sea-shore, or to attend at church on a Sunday, to be blown away in endeavouring to reach the House of God, or blown upon on coming out of it by the boisterous south-wester – and so, chilled into a pleurisy or an additional vomica, thereby destroying the benefit which Bournemouth is calculated to yield to the sick.'

'In a colony of invalids,' he goes on,

'the Temple of God should be in a quiet, secluded and rural spot. It should be easily accessible to all – to the villagers in health, who are occupied to the last minute with household affairs – to the valetudinarian who cannot walk far – to the feeble and the cripple who can only creep or must be carried; and all of whom ought, above all things, to eschew exposure of every description. Such a spot I pointed out for that purpose, on the estate of Mistress Tregonwell on the eastern bank. There a plain, unassuming, but spacious and well-built rural church, without any pretensions to Gothic naiseries (for who can bear a church in a Gothic dress that is not as big as Lincoln, Wells or York Minster?) should be erected near the entrance to the Park Villas, whereby the invalid inhabitants of the Park Villas would have it near to them; close to a spot where the villagers' community would be principally settled, on the margin of the brook at the foot of Gordon Villas, that attendance may be made easy to the dwellers therein as well as to the villagers; and lastly, not far removed from the present and any other detached villas along the lower and upper roads; thus leaving no excuse to

any class of inhabitants and visitors (as they will have, if the church is built on the top of the hill) for not attending service. From the high character for charity and liberality which the lady nobly connected who owns the Bournemouth Park, as I have called it, bears in this place, and among all who have the honour of knowing her, no doubt can be entertained that a site, such as I have pointed out, would be granted by her. Let the rest of the landowners who take a true interest in the success of Bournemouth, and the spiritual welfare of its future inhabitants, contribute materials and money as part of their tribute for the erection of a suitable temple, and their charity will be blessed. Any other worldly or selfish view in this affair ought to be set aside, and not allowed to have any sway.'

Everything, it will be noticed, was to be done for the consumptive invalid. But the doctor admitted that 'there are many other classes of people in easy circumstances who require, and may be benefitted by, the pure and invigorating, yet mild and temperate air of the place.' 'For such as these provision should be made in gay and airy regions, calculated to serve as much for the summer as the houses before alluded to are essentially destined for the winter season; for it is as a winter residence to a select community of invalids and visitors that Bournemouth must become chiefly celebrated.' He advised the erection of detached villas on the cliffs – the making of 'ample provision' for those who, 'being otherwise well in health, like a retired rather than a bustling and noisy sea watering place.' 'Bournemouth,' he added, 'combines, to an eminent degree, the character of beautiful and sheltered rusticity with that of an open seaside residence. To be near the sea and to be able to have recourse to its water or its breezes when necessary, yet not to be always and for ever saturated with either; to have it in one's power to turn to spots where its shingle-rustling, or the more loud roaring of its waves, cannot disturb you – to be, in fine, on the threshold between sea and land life, so as to take to each alternately as required, as a means of recovery from disease, or for the restoration of lost strength (and those means of the very best description) these are the advantages which, in my estimation, nature affords to an extent and of a character unequalled in any other place I am acquainted with on the South Coast of England.

'To render its superiority to the generality of sea-watering places still more conspicuous, the Vale of the Bourne – beginning at the present insignificant wooden bridge, which ought to be replaced by a handsome stone one, down to the Beach, a species of narrow flat prairie, which divides the two banks before described – should be converted into a regular promenade garden all the way, with parterres and beds of flowers by the sides of the brook. That imaginative and skilful agronomist, Mr Loudon, would soon make the prettiest thing in

England of such a place, and he ought by all means to be consulted. At present, the Vale consists of a narrow belt of peat earth lying over sand, on which a few miserable sheep are allowed to feed, or a scanty coarse grass is cut. It divides the west from the east banks, which are the inland prolongations, before adverted to, of the corresponding cliffs on the shore, and which slope down to the margin of the brook, both of them clothed by evergreen plantations and shrubberies, and crested with the rows of detached villas or single houses previously mentioned. The little brook itself, perfectly wild, shallow and tortuous, and of no great width, meanders down the middle; but a little judicious management, by swelling out the banks in parts, contracting them in others, and deepening the bed here, or raising it there, so as to create a rustling fall or cascade, would readily convert an insignificant streamlet into a pleasing ornamental water-feature in the landscape. The garden, with suitable gravel walks, would afford to the weakest and most delicate among the real invalids at Bournemouth the means of taking exercise on foot whenever any other wind but the north prevails; for to that and that alone would the garden promenade be exposed. At the mouth of the river a small estuary or cove, to admit a few pleasure boats, might be established readily, and a short pier, sans pretension, yet convenient for landing on the beach in favourable weather, ought to be added.'

We have quoted Dr Granville at great length, because we regard both his speech and his more deliberate report in the 'Spas of England' as being epoch-making. The report claims notice also because of its detailed description of Bournemouth as he saw it in the first half of the last century, and because of his criticisms upon plans which were brought under his notice. Mr Ferrey's plan for the 'marine village of Bourne,' covering the face of the eastern slope with 'concentric circles,' crowned with a Gothic church, was afterwards modified; the plot of land which Dr Granville pointed out to 'Mistress Tregonwell' as a suitable site for 'a plain, unassuming, but spacious and well-built rural church' appears to be the identical spot afterwards chosen, not for St Peter's, but for the old Scotch Presbyterian Church at the foot of Richmond Hill. The 'narrow flat prairie' which he advised should be 'converted into a regular promenade garden' all the way down the valley, with 'parterres and beds of flowers' by the side of the Brook, has become the Lower Pleasure Gardens; the 'wild, shallow tortuous Brook' has not received all the 'judicious' manipulation that he advocated, but it been has beautified and made a never-ending attraction to children.

Dr Granville's very favourable report was supported by Dr Aitken, of Poole, and also by Dr Salter, an 'old and experienced general practitioner,' also of Poole and father of Mr Clavell Salter, M.P., the present Recorder for that borough. Dr Salter's testimony to the 'healthfulness of that

interesting place Bournemouth,' was that it is 'peculiarly fitted for the residence of invalids, and adapted equally to every season of the year.' The concluding phrase is specially interesting – remembering that from that time down to the present Bournemouth has always advertised itself as having a 'double season' – summer and winter – with but very short intervals between.

Dr Aitken, who is described as 'a scientific and painstaking physician,' had in the previous year read 'a very valuable essay on the medical topography of the district of which Bournemouth is the centre, at the general meeting of the Provincial Medical Association, speaking 'very favourably of the climate of Bourne for warmth, equability of temperature, and dryness.' This paper, we assume, is incorporated in the very substantial appendix which Dr Aitken in 1842 contributed to 'The Visitors' Guide to Bournemouth and its neighbourhood,' published by Mr J. Sydenham. The 'dissertation' extends over a hundred pages, and marshalling his evidence the writer expresses the hope 'that it will be deemed sufficient to establish a high character for the climate of Bournemouth and its vicinity, for the three great requisites of a healthy situation, namely – dryness, equability, and mildness of temperature. The great advantages to be obtained from so fortunate a combination of causes as have been detailed can indeed only be duly appreciated by a well-informed medical man, or by those who have had personal experience of them.' Readers will have noticed the phrase 'Bournemouth and its vicinity.' Dr Aitken concludes with an expression of his gratification that her Majesty the Queen Dowager has been, 'with a view to health, advised to try the air of this district. Highcliffe, although not included within the precise limits we have prescribed, is the only mansion in the immediate vicinity fitted as a residence for so exalted a personage; and as it possesses the principal features that have been insisted upon in these pages, the selection appears to us to be in every way a judicious one.' Highcliffe, it may here be added, was in 1900 the residence for a short time of the late King Edward VII., and in 1907 was visited by H.I.M. the Emperor of Germany.

Following Dr Granville, other interesting medical testimony as to Bournemouth's climatological and other advantages was given by the late Sir James Clark, physician to the late Queen Victoria, who, in his famous work on 'Climate,' has the following:

'From an attentive consideration of its position, its soil, and the configuration of the surrounding country, there can be no doubt that Bournemouth deserves a place among our best climates, and for a certain class of invalids capable of taking exercise in the open air, affords a very favourable winter residence.'

Thus Bournemouth was advertised to the world as an Invalid's Paradise. New attractions were added, and in the 'Salisbury and Winchester Journal' of May 16th, 1842, appeared the announcement that

'a resident surgeon now affords the patients at Bourne what was before much needed, the opportunity of a skilful hand. For the domestic comforts required, there are likewise settled a grocer, a baker, and a butcher, in addition to which there is a daily supply of fish, butter, milk and vegetables from the neighbouring markets and villages.'

In Woodward's 'History of Hampshire,' published at a somewhat later day, Bournemouth was thus described: 'A valley somewhat accidente, and abounding in peat bog and sandy soil, on which pines, ferns, and rhododendrons flourish; all sorts of appliances for such people, and the usual watering place delicise make up Bournemouth.' Bournemouth had – and has – such merit as a health resort, was of such supreme advantage to consumptive patients particularly, and attracted so much notice as 'a sheltered haven for the most tender invalids,' that false impression was created with regard to it – an impression which was accentuated by the establishment of 'the National Sanatorium for Consumption and Diseases of the Chest' and by the naming of the popular pinewood parade as the Invalids' Walk. So it came to be suggested that at Bournemouth every other person wore a respirator, and that the place, though a Paradise for invalids, was terribly depressing for people who merely desired change of air amid pleasant surroundings. But Bournemouth was 'not content to regard itself as only a valetudinarian's retreat' or 'an invalids' colony.' How it emerged from that phase of its history may be shown more fully in subsequent chapters. We need but say now that other visitors increased in greater proportions than the 'tender invalids'; fashion also changed; bath chairs and respirators went out of vogue, the parade of invalidism ceased, and as facilities of travel improved, so increased the tendency of the people to repair to the seaside, not so much under the compulsion of 'doctor's orders,' as for pleasurable recreation.

The Development of the 'Marine Village'

Although we dealt with the laying out of the Gervis Estate in Chapter VIII., it may be of interest to again refer to certain interesting matters in connection with Sir George Gervis' judicious planning. Through the courtesy of Sir George Meyrick we have been privileged to examine many of the original documents relating to the estate. In one of these we find that the following constituted the whole of the buildings and the tenants of the 'Bourne Property' in 1841–2 Westover Villas; The Bath Hotel; the Belle Vue Boarding House; land on the West Cliff, leased by Mr Samuel Greatheed and Mr J. S. W. Erie Drax; land near Bussell's Cottage, rented by Mr David Tuck, who also had land near Nurse Hill (afterwards Gordon's Estate, Richmond Hill); land adjoining Poole Hill, Mr George Berry, Messrs. Berry and Tuck, and Mr John Hibidage; land for the Baths, Messrs. Conway, Bayly, and Lampard; Preventive Station House; Decoy Pond Meadow, Mr Polhill, Mr Edward Castleman, Mr James Lampard, Mr John Best (house and land), and Mr James Allen (house, brick-kilns and land). Respecting one of the last mentioned lands it was reported by Mr Dccimus Burton, in 1848, that 'having no wish to throw any obstacle in the way of the trustees' proposed improvements in the 'Bournemouth Park,' Mr Castleman would relinquish possession of the piece of garden ground in the valley on being paid £50.' As Mr Castleman had incurred heavy expense in making the garden the proposal was agreed upon.' Decoy Pond Meadow was the name of the Upper Pleasure Gardens up to the year 1851, when a little over 30 acres were sold to Mr Durrant for £2,600. The major portion of the conveyed land was described as 'all that dwelling house and 25 acres of heath and moorland, formerly the Decoy Pond, with the appurtenances in Boorn Bottom, in the Parish of Holden- hurst, in tenure of Edward Beake.'

By the Private Act already referred to the Trustees of the late Sir G. W. T. Gervis were empowered to expend the sum of £5,000 on the improvement of the estate, in continuance of the deceased baronet's scheme, to which he devoted so much time and energy in his lifetime. Sir George fully realised, even at the early date of 1835, that the position had great possibilities

as a future health resort; but, much as he anticipated the success of his plans, it is scarcely probable that the present prosperous watering place had even a position in his imagination. During his lifetime he instituted developments on every part of his 'Bourne' property, as we have shown in a previous chapter. When in 1836 he engaged Mr Ferrey, the Christchurch architect, that gentleman submitted for Sir George's approval a large number of plans, designed with situations in many cases quite different from the present road formations. For instance, the present Hinton Road (then called Church Road) was wholly set out as 'sites for shops.' Behind this road, and perched on the high ground at the back of the Upper Hinton Road, two schemes were devised to form Crescents, with Italian and Gothic double villas at either end and one in the centre. One of the Crescents the architect called 'Poole Crescent.' Besides the whole of the Westover Villas Mr Ferrey designed the original Baths, and some large houses on the East Cliff; and on the 19th July, 1836, he sent to Sir George, at Hinton Admiral, a 'general design, consisting of ground plan, 1st floor, and 2nd floor plans, with elevations for the Hotel.' Many other schemes were formulated, and would, in all probability, have been proceeded with had our enterprising ground landlord been spared to see the completion of his and his architect's ideas. Had Sir George lived the whole character of the land lying between the East Cliff and the Old Christchurch Road would now present a different aspect. The very land on which Mr Ferrey devoted most of his attention remains unbuilt upon to this day.

For the further development of the Estate, the new Baronet being a minor, the Act 9 and 10 Viet., Cap. 29, was obtained, and the records of the proceedings taken under it show many interesting facts regarding the powers sought by Sir G. E. M. T. Gervis, through his Trustees.

Mr Decimus Burton, who succeeded Mr Ferrey as architect and estate agent, presented a long series of reports, some of which are of most interesting character, embodying important suggestions, the carrying into effect of which has had considerable influence in the fortunes of Bournemouth. Mr Burton had, it appears, visited Bournemouth in 1840, at the instance of Mr Gordon, the then owner of property on what is now Richmond Hill. In 1845, in a report addressed to Mr Crawley (solicitor to the Trustees of the Gervis Estate), he mentions that 'houses of a large scale are particularly enquired for, from which it may be argued, that the place is in good repute with the higher classes.'

'The wooded valley through which the Bourne rivulet flows to the sea is and must always constitute the principal object in the landscape, and therefore any work undertaken there should be most jealously watched, and every endeavour made to preserve the natural beauty of the valley.' As Mrs Tregonwell owned land on the west side of the valley, he advised

that she should be invited to co-operate in 'a general plan for laying out this portion of the ground.' He recommended also, 'as a general principle, 'that in designing a building plan for Bournemouth, formality should be carefully avoided.' 'The characteristic which distinguishes Bournemouth from most other watering places is its rusticity. This individuality should be maintained, and a class of visitors will be thus attracted who cannot find the same elsewhere.' He advised that further caution should be used in thinning the plantations, so that the best grown trees should be preserved; that walks and drives should be liberally provided; that there should be 'a wide Esplanade on the Cliff,' extending from Boscombe Chine to the county boundary westward, and even farther if it could be effected; that the bottom of the Bourne Valley should be laid out as ornamental pleasure grounds from the Beach to the Bridge on the Poole Road (to what is now the Square) – and he hinted at the possibility of further extension in the future, with a view of adding yet more to the attractions of the place.

Later reports show how effect was given to the principles thus laid down, and indicate from time to time the advances made. Thus, in a report dated May, 1849, we get the following:

'The fir plantation between the Westover Road and the sea, together with a portion of the sandy waste purchased of Lord Malmesbury, at the north of the valley, has been laid out as pleasure grounds by contract entered into with Mr Ramsay; the brambles and rubbish have been cleared away, glades formed, paths made, a turf bank enclosure fence raised along the south-western boundary, and many thousands of ornamental shrubs planted. This spot has by this means been rendered a most agreeable and convenient promenade to visitors, and will be a means of attracting families of respectability to Bournemouth.'

The Westover Gardens, it may be added, were placed under the direction of a Committee of Management, and a small yearly charge was made to householders in respect of their use.

These reports also disclose negotiations which took place with the owners of the Branksome Estate with regard to an exchange of lands with a view, as mentioned above, of facilitating the improvement of the valley, and under date 21st May, 1853, we get the following: 'I called on Mr Hudson, the agent for the Branksome Estate, and with him saw Sir. Winter, sen., who gave me information as to improvements projected on this estate, some of which have already been effected. A new road has been made from Poole Hill along the south side of the valley westward, and several houses have been built there. The marshy bottom of the Valley is now drained and made dry pasture land, across which a public path has been made from Poole Hill to a new road on the north side of the valley which is intended

to enter Poole Road, at the County boundary, a branch from which opens on the Poole Road about a quarter of a mile from Bournemouth, where two entrance lodges are in progress, and another branch turns north and re-enters the Wimborne Road above Richmond Villas. The Sanatorium is about to be erected here. An Independent Chapel, with minister's house, are about to be built, and a Burial Ground made on two acres given for the purpose by the proprietors of the Estate... A Pottery on a large scale is being built on the extreme West end of the Branksome Estate and a new brickyard between that and Bournemouth. The portion of the Estate south of the Poole Road has been sold to Mr Packe, M.P., and the beautiful knoll or wooded hill above Richmond Villas to Mr Tuck. Mr Winter expressed his opinion that a Local Act for Bournemouth is required, and will communicate with Mr Crawley on the subject.'

In Mr Burton's report of the 9th May, 1848, reference is made to the letting of land on the East Cliff for houses to be built by David Tuck and John Hibidage for the Rev. W. Timson and Mr Mainwaring (the first resident doctor), with the huge dimensions of 160 by 300ft., and 210 by 330ft., at the absurdly low ground rent of £11. Mr David Tuck, being the first purchaser of the East Cliff Estate, had a slight advantage in ground rent charge, by taking the larger plot on the same terms as the smaller.

As yet Bournemouth had been, on the whole, preserved from the error of building terraces and townlike houses and dwellings arranged in streets. The mention of streets reminds us of a curious fact which should be placed on record, viz., that even at the date of writing the only thoroughfare so called in the whole County Borough of Bournemouth is Orchard Street. How it came to be called a 'street' we are unable to say. This we can vouch for, it was formerly Orchard Lane, and led from the orchard situated at the back of the Commercial Road, and is so shown on the map of 'Bourne Tregonwell.' The thoroughfare in question is really only an unimposing lane, about twelve feet wide, although it has many historical associations connected with it. Some errors were made in the designs of a house here and there; but generally speaking, the styles of architecture were in most cases faithfully adhered to. The designs were very various, chiefly Italian, thatched and Elizabethan cottages, or rather in mock Gothic – an architectural critic of the time called it the 'Bourne style.' Some there were who maintained that in the erection of a new place like this it was much to be regretted that one mind could not have planned and regulated the building sites, and made the houses on a more definite plan than was done. Be that as it may, the numerous detached villas constructed on the slopes, crests and retired dells present, without doubt, a handsome and unique position, and constitute one of the most delightful charms of Beautiful Bournemouth. Spots but recently covered with fir trees became

cleared, and lodging houses of a superior class, surrounded with neat gardens and shrubberies, quickly sprang up thereon one after another, and Bournemouth steadily increased in popularity. As locally reported at the time, 'there was not now monotonous quiet felt here, as was once the case, the long evenings being relieved by many parties amongst the distinguished residents and visitors.' During the winter of 1848–9, what had been a wilderness of fir plantations and underwood, between the Westover Villas and the seashore, was greatly altered and tastefully laid out, the underwood cleared away, great numbers of fir trees cut down, and in their places evergreens, American and other ornamental shrubs, thickly planted; the surface levelled, turfed, and serpentine walks, offering a delightful promenade, such as is rarely met with at a watering place so close to the beach, were created. Needless to point out, that we refer to the Westover Pleasure Gardens, or, as they were then known, the Westover Shrubberies. We may say here that this delightful part of the Gardens has maintained, in spite of attempts made to 'beautify' it by the erection of public and private buildings, most of the attractiveness it had sixty years ago. May the Westover Gardens be always preserved as an 'open space'!

It will probably be of interest to record that Mr David Tuck, as well as being the builder of the first houses on the Gervis Estate, was also road-maker and general contractor; Mr James Ingram was frequently employed as estate carpenter; Mr J. Piper and Mr David Ramsay were the nurserymen who laid out all the strips of plantation, and the Westover Pleasure Grounds; Mr Wilme, surveyor, made a detailed survey and plan of the estate; Mr Henry Holloway was also an Estate Surveyor; Mr Leet was Clerk of the Works; and Mr Decimus Burton we have already referred to.

Respecting Mr David Tuck it may be said that, until the arrival of Mr Hibidage, he had the monopoly of the work under Sir George Gervis, and afterwards the Trustees acting for the young baronet. Mr Tuck, who died in 1860, was succeeded by his son Peter, although Mr McWilliam, who was the former's foreman, carried on the unfinished contracts which were entered into in 1857 and 1858.

A proposal was made in 1858 by Mr Matcham to improve the front of the Belle Vue Hotel, and lay it out as a lawn and garden 'as soon as the proposed bridge and road required in the locality to connect the east and wrest sides of the valley are carried into effect.' For the sum of £14 10s. the gradient of the Bath Road was improved: 'Mr Bayly having given up to the Trustees the Mews Road on the west side of the hotel.'

This brings us to a very important point in our history, namely the making of the Bridge, the situation of which is now styled The Square. The part of the Borough generally spoken of as being the centre of the town

– The Square – is very far from being so geographically; in fact, the actual centre of Bournemouth's sea front is the Pleasure Gardens on the cliff beyond Boscombe Pier. Be that as it may, everything seems to have always been reckoned as from The Square. The only time it could reasonably be called the centre of the town was at the period of the passing of the Act of 1856, and then it was usually referred to as The Bridge. In the old coaching days there was only a very narrow passage here, and the brook ran across the road, more or less at will. Crossing for foot passengers was only by means of a plank laid across the brook, although it is recorded that 'Mr Tregonwell made a road here, but it is now [1848] obliterated by the sand.' There has been so much conjecture respecting the building of the Bridge that it gives us pleasure to be able to give the actual facts in connection with this erstwhile important feature of the town. In the same report of 1848 made by Mr Burton, from which we have already quoted, he states that 'the erection of a carriage bridge over the Bourne stream, and the formation of the road through Mr Tregonwell's property to the Poole road,' he considers to be an improvement essentially required for the convenience of visitors at Bournemouth.'

Of the 111 acres mentioned in the 1805 Award as allotments, Mr Tregonwell owned about 40 acres, and the Gervis Estate the remainder, excepting a few acres held by Mr Erie Drax.

'There is no mention, however,' continues Mr Burton, 'in the Award of a Bridge, although it is absolutely necessary. Mr Tuck offers to build a brick bridge suitable for the purpose for £70, and to make a road for £30, together £100. Providing the remainder is forthcoming, I recommend the Estate to subscribe £50.' Mr John Tregonwell, it is believed, made a liberal donation towards the cost, and Mr Matcham and Mr Bayly subscribed £10 each. 'As the road will be on an embankment it would form an excellent south boundary, and in great measure shelter the proposed public park in the Bourne Valley.' This very practical proposal was carried out, for on the 1st August, 1849, it is recorded that 'a bridge has been built, by subscription, over the Bourne rivulet, and roads leading thereto, the Gervis Estate contributing towards this work £50.'

This narrow pathway and road did duty until the first widening took place early in 1869, which work, it is interesting to record, was executed by Mr J. K. Nethercoate. The cost being only £26, it may be assumed that the roadway was not very considerably widened. The next widening was done by Messrs. Hoare and Walden in 1873, when both sides were set back. Since that date The Square has been improved from time to time, until we now have an imposing open space, looking its best on a summer morning, when the coaches are assembling or leaving for the delightful drives of the neighbourhood. There was very good reason for the appellation 'Bridge,'

as it actually bridged the stream, and was to all intents and purposes an aqueduct, but why and how it became to be styled the 'Square' passes our comprehension. Such, however, is the local acceptation, and we suppose the misnomer will be perpetuated. Our first record of the Square being referred to by that name is November, 1858.

Various transfers of land had taken place since 1805, and at the time to which we are now referring not only had many attractive villas been erected on the Tregonwell and Gervis Estates, but developments were proceeding also on property which now forms part of the extensive Durrant Estate. A range of stately houses, in which a dignified exterior was combined with the most complete internal accommodation, was erected, environed by plantations intersected by walks and drives of extreme length and imposing character. These improvements were undertaken by Mr William Gordon, the purchaser of the estate. The district referred to is Richmond Terrace, Richmond Hill (west side) and St Stephen's Road. On the map of the 'Marine Village of Bourne' this road is called Gordon Grove – no doubt after the gentleman mentioned. Richmond Hill used to be called Nurse Hill, or Nurses' Hill, just as at a later stage of the town's history a beautiful pine wood walk on the East Cliff was called Cupid's Grove. The reason may be imagined by the reader. The two Elizabethan mansions – Forest House and Little Forest House – apparently date from about the same period. The latter was the home of the late Mr W. E. Gladstone during his brief stay in Bournemouth shortly before his death, and both are noble edifices, and in the past, more so than in the present, they occupied a singularly commanding position, with magnificent sea views. Fairly large houses were also erected in the vicinity of the Old Christchurch Road, the principal being Adelaide Cottage, Ashley Cottages (on the site now occupied by the Criterion Hotel), Verulam House, Hampstead House, Yelverton House, Albert House (once the temporary home of Ex-Queen Marie-Amelie of France), Church House (where the Fancy Fair now stands), etc. On the death of Miss Bruce, the extensive estate of Branksome, stretching up through the valley to the Poole Road, right down to the Dorset sea front, along the Poole Road as far as the old Award Road, and inland right out to Talbot Woods, was sold to different purchasers. The portion lying west of Broad Chine (now called Branksome Chine) was purchased by Mr C. W. Packe, M.P., who built near the cliffs the picturesque mansion of Branksome Tower. Land at Westbourne, including the glens west of Alum Chine, was acquired by the late Mr R. Kerley. The large tract of land north of the Poole Road – at one time thickly covered with pine trees – still retains the title of the 'Branksome Estate,' just as the district south of the Poole Road keeps to the title of Branksome Park. The Bourne Valley Pottery and Clay Works, the Gas Company's Works,

and the Electricity Supply Company's Works have all been erected on part of the estate. The throwing open of this property cleared the way for a new extension of Bournemouth, and the establishment of the Sanatorium added to the renown of the place as a health resort.

As far back as 1849 a regatta was held here, for the record is in existence of the holding of the Poole and Bournemouth Regatta on Friday, the 16th August, 1849, when the place was much enlivened by the event, which was carried on with very great spirit. Numerous races for yachts were held, and the competitions were followed with keen interest by a large company on board the steamship Atlanta; a number of people from the neighbouring towns and villages came in full force, and our small health resort was a scene of great excitement. The Regatta Ball was held at 'Matcham's Belle Vue Hotel' on Tuesday, 14th August, 1849, and was 'attended by about 40 fashionables of Bournemouth, Parkstone, Poole, etc.,' and Targett's Band was in attendance. An excellent supper was done full justice to, and dancing continued until 4.30 a.m., the party regretting that 'for Matcham's sake' the company was not larger. Small as the population of the place was, the inhabitants were evidently determined to enjoy themselves, and make up for the deficiency of 'counter attractions.' A tradesmen's ball was held at Matcham's Belle Vue Hotel at Christmas, 1849, when Mr Finley acted as M.C. over a company of 50. It was evidently an 'all night,' as the company dispersed at 6 a.m.

A large hollow at the foot of Commercial Road was filled up in 1851, giving a wider and more level entrance to the Exeter Road. Some few shops were opened at the bottom of Commercial Road – then called Poole Hill – and these were succeeded by others further up the road. The number of visitors and residents continued to increase, and the population in 1851 numbered 695. The Bath Hotel and the Belle Vue were always spoken of as 'The Hotel' and 'The Boarding House,' although at later periods the latter became 'Matcham's Belle Vue Hotel' and 'Macey's Belle Vue Hotel.' The only other hotel in existence in 1850 was the London Hotel, frequently referred to as 'The London and Commercial Inn,' kept by Mr Henry Aldridge. Numerous boarding houses were built about this time, including Windsor Cottages (on the site of the Roman Catholic Church), Heathfield Lodge, Bourne Villa, Willow Cottage, Eagle's Nest, Essex Cottage, Granville Cottage, Heath Villa, Rose Cottage, Sea View House, Morley House, and Clarence Cottage. These, and the houses in Richmond Terrace, the Westover Villas, and a few cottages erected at an earlier period, with a few private residences and shops, made up the Bournemouth of that period. Many distinguished visitors came regularly every winter, among the most notable being Lord and Lady Bulwer Lytton, who resided at Adelaide Cottage, at the south-west corner of Yelverton

Road, during the winter of 1849; the Duke and Duchess of Montrose, the Marquis and Marchioness of Westminster, the late Duke of Argyll, Lord St Maur, and many others. Bournemouth was, in fact, the resort of a select and fashionable assembly.

Further evidence of the development of the district is afforded in the following extract from an advertisement which appeared in the 'Poole Herald' of May, 1852:

'There has long been a demand for houses, as well for residents as for visitors, but there has not been any adequate supply of sites suitable for building purposes until the present time. The proprietors of the Branksome Estate, Avhich comprises both sides of the Bourne Valley to the extent of more than two miles in length, are now prepared to offer to the public most eligible sites for building, either immediately contiguous to the spot selected for the Sanatorium, or in its neighbourhood, or at a greater distance from it, as may be preferred. Roads have been formed and various other important improvements have been made and are now in progress, for bringing into notice the capabilities of this lovely locality, which, for all purposes of health or enjoyment, is not to be surpassed in England.'

Editorial reference is made to the advertisement, and we find the following, which is both illuminating and entertaining:

'As regards the progress of this watering place, we have not been without fear of injury from the overcrowding of the buildings; we are, however, relieved from what must be admitted to have been a well-founded alarm, by the judicious plans of the owners of the Branksome Estate. These gentlemen have clearly apprehended the necessities of the case, and forthwith proceeded to carry them into execution. The rising grounds on either side of the valley of the Bourne afford sites for building of unequalled beauty, and in the greatest variety; nor is this all, the roads, which are in course of making, amongst these hills, will bring into view all that diversity of scenery with which the country abounds. It may not be out of place to notice, incidentally, that the demand for labour is so large in the neighbourhood that none but the wilfully idle need lack employment.'

Happy little village of Bourne! What a Paradise it must have been!

Another interesting fact to be noted in connection with the period now under review is that the inhabitants themselves had begun to display a keen interest in the place, and to meditate plans for its improvement. One of Mr Burton's reports shows that in 1847 ten gentlemen – including Sir John Guise, General Boyd, Mr J. Tregonwell, the Rev. A. M. Bennett, Mr Elgie, Mr Bayly, and others – met him at the Bath Hotel, when Sir

John stated 'that the parties considered that no improvement was more wanted than a pier or jetty at which boats might embark and disembark passengers. They then came to a resolution that a memorial signed by all the inhabitants should be forwarded to the Trustees on the subject,' and they expressed the hope that Mr Burton would 'advocate the measure.' Presumably he did. On the 3rd December in the same year, a meeting was held at the Bath Hotel 'for the purpose of considering what steps should be taken towards erecting a Pier on the Beach at Bournemouth,' and a series of resolutions were passed with the view of facilitating progress. Thanks, in the first place, were tendered to Sir George Gervis' Trustees for their 'attention to a memorial from the inhabitants' first pile of the 1861 or 'wooden Pier' was driven, – under circumstances which are narrated in a subsequent chapter.

A short time previous to the erection of the 'Jetty' – namely, in March, 1855 – a ketch named the 'Elizabeth and Ann' was driven ashore right upon what is now the Pier Approach. It should be mentioned, however, that at the time when this apparently impossible event took place the outlet of the Bourne was under a rustic bridge, and on a level with the Beach. Some years later the whole of the approach to the Pier, from the Bath Road to the West Cliff, was raised, and the brook, instead of being allowed to meander over the sands, was eventually turned into the main sewer. It finishes its career by flushing the main outfall! Even after the removal of the rustic bridge, on occasions when the tide was exceptionally high, the sea ran into the meadows, now the Pleasure Gardens. Boats have been floated into the Gardens from the sea, and a well-known resident avers that he has frequently caught trout in the brook, more especially from the rustic bridge over the outlet, then about the centre of the present Pier Approach. We fear there are no trout in the stream now, and the rustic bridge fell in in October, 1859, and was cleared away by permission of Sir George Gervis.

On the 26th December, 1852, a barque named the William Glen Anderson was driven ashore near Boscombe. That very night Sir Percy and Lady Shelley were giving a dramatic entertainment at Boscombe Manor, and the play selected for representation was one entitled 'The Wreck Ashore.' While the company were playing came intelligence of a dramatic realisation of fact, and soon after a poor Norwegian sailor was carried in an unconscious condition to the Manor. He received all the kind treatment that his unfortunate state seemed to require, and was left sleeping. When morning came he had disappeared, and was never seen or heard of again! The barque stuck fast on the sands, and eventually broke up. In January, 1853 – some two or three weeks after the wreck – an interesting sequel took place in Bournemouth, when the 'Institution for the Preservation of Life

from Shipwreck' presented their silver medal to Lieutenant Parsons, R.N., chief of the Coastguard, and a reward of £4 to his men for their gallant services rendered to the stranded vessel and her crew. We may remark, en 'passant, that in various other instances vessels have been driven high and dry upon Bournemouth Beach. Ordinarily, ours is not a stormy coast, but occasionally circumstances do justify Dr Granville's phrase as to the 'roaring sea.'

In 1850 'increased travelling accommodation to those famed watering places, Bournemouth and Mudeford,' was offered by the Avon coach, which left Christchurch for Salisbury 'at a quarter before eight in the morning, returning to Christchurch for Mudeford and Bournemouth at five in the afternoon.' This was announced as 'a good opportunity' for persons living to the north of Christchurch 'to visit these delightful and invigorating watering places, at both of which lodgings of every description may be obtained, as well as most superior accommodation at the hotels, at moderate charges.' Later in the same year the inhabitants of Christchurch 'unanimously resolved to introduce portable gas lighting into the public street,' upon 'a very partial scale,' and it was suggested as 'worth consideration' whether 'a connection might not be effected with Poole, extending the benefit to be derived from this lighting to Parkstone and Bournemouth'! Some six years later the 'Poole Herald' made the further suggestion that gas might be supplied from 'enlarged works at Poole.' 'Bournemouth will then have the advantage of gas light without the nuisance of gas works.' Half a century or so later Bournemouth was actually supplied with gas manufactured at 'enlarged works at Poole.'

In connection with a scheme for bringing Christchurch into association with the South Western Railway the suggestion had been made that 'Bournemouth would prefer the line being brought to about Iford Bridge, which also might be made the Christchurch Station. It doesn't desire a second station close into its own district'!

Reserving for our next chapter a chronicle of the efforts which eventuated in the passing of the Bournemouth Improvement Act of 1856, and the establishment of the first Local Government Authority in Bournemouth, we conclude our present chronicle with mention of the fact that during the Great Exhibition of 1851 the local Press complained bitterly of the harm done to the great majority of watering places, and especially to Bournemouth, which was then struggling hard to maintain a reputation for progress. Curiously enough, a similar outcry was raised against the 'White City' in 1908.

The Bournemouth Improvement Act, 1856

For nearly half a century after the historic visit of Mr Tregonwell and the erection of 'the Mansion' occupied by the first proprietor-resident, Bournemouth was but a village community, depending almost entirely upon its neighbours for the necessities and the amenities of life. Even as late as 1858, when the number of visitors was large enough to justify the Poole Cornopean Band coming over to give a promenade concert outside the Bath Hotel, and when its first newspaper had been duly established, so dependent was it that one of the earliest advertisements in the 'Directory' was an announcement that Mr W. Attewcll, 'hair cutter and dresser,' of Christchurch, 'attends at Bournemouth every Tuesday and Friday,' and that orders for his services might be left at the Post Office or at the Tregonwell Arms. Every birth and death within the district had to be registered at Christchurch, and not till late in the last quarter of the century could any marriage be celebrated in a Nonconformist place of worship, without one or other, or both, the parties making pilgrimage to the 'mother town.' Any 'villager' so poor as to need assistance from the rates had to apply to a Believing Officer who lived at Christchurch, and, perhaps, go before the Board of Guardians sitting within the shadow of the grand old Priory. If the parish doctor was required he had to be sent for from his residence in the same place, where also dwelt the public vaccinator and the coroner (or one of his deputies). Thither the Bournemouthians had to proceed for all County Court, licensing, or police business, for all registration work, and to record a vote in any Parliamentary election. In Bournemouth itself there was no place of temporary detention for offenders against public order or morality, no place of rest for any 'Weary Willies' taking a summer tour through the county, and only the most microscopic search revealed the presence of a policeman.

The first important change came with the passing of the Improvement Act of 1856, when Bournemouth entered upon a new phase of history. It is from this period, indeed, that we must date its career as a town. Prior to that time it had been a watering place and health resort – picturesque, salubrious, and of increasing attraction – but it had no civic organisation

of even the most elementary character: no machinery for co-operative effort in the material interests of the community. But as landowner after landowner began to put land upon the market and develop his estates, as house after house was built, and the population came to be numbered by hundreds, the necessity for considering the welfare of the community as well as that of the individual forced itself upon the attention of the residents, and action became imperative. Questions of water supply and sanitation had to be considered; lighting and road improvement had become desirable; and the erection of a pier or landing-stage was regarded as essential to complete summer enjoyment.

On the 29th August, 1854, a meeting was held at the Belle Vue Hotel, when it was unanimously resolved to apply to Parliament for an Act authorising the carrying out of various public improvements by and at the cost of the inhabitants. A committee was appointed, and the co-operation of the various landowners Avas sought. The Trustees of Sir George Gervis were sympathetic, but apparently powerless without the approAml of the Court. They petitioned the Court, however, and obtained authority 'to raise by a sale of Exchequer Bills or Consolidated Bank Annuities held by them, or standing in their name, and out of any monies in their hands arising from the proceeds of the sale of real estates devised by the will of the testator, the sum of £250,' and 'to apply the same in part discharge of the expenses of obtaining the said Bournemouth Improvement Bill.' According to the petition, 'it was proposed by the inhabitants of and owners of property in Bournemouth to apply for an Act of Parliament for the improvement of Bournemouth,' and to enable the Commissioners to be thereby appointed to do various things under the Act, 'and that such Commissioners shall have power to levy rates on all the property within the limits of the Bill, such rates not to exceed in any one year 2s. 6d. in the £.' The amount proposed to be raised by the Bill was £4,000, 'to be laid out in paying the expenses, paying interest on borrowed money, and setting apart a Sinking Fund.' It was estimated that the cost of obtaining the Act would be £600, and the Trustees asked for powers to contribute £250, 'inasmuch as the greater part of Bournemouth was subject to the trusts of the will of Sir George William Tapps Gervis.' As a matter of fact, the cost of the Act was not £600, but £1,118 9s. 3d.!

The Bill was duly presented to Parliament in 1856, and provided for the appointment and incorporation of a Board of Commissioners, armed with powers to construct roads, sewers and drains, to pave, light, watch, drain, cleanse, water and improve the streets, roadways and other public passages, to remove and prevent nuisances and encroachments; 'to supply and also to contract for a supply of water and gas to the said district and the neighbourhood thereof'; to establish and maintain fire engines; to

erect, establish, maintain and regulate a Market or Market Place for the
sale of marketable commodities; to construct a pier, jetty or landing place;
and to purchase by agreement, or to rent, ground which they might think
desirable 'for the purpose of ornament, recreation, or improvement.' Other
incidental powers were also sought, including, of course, the power to levy
rates and tolls. The Bill was generally approved, and in May, 1856, we find
the 'Poole Herald' rejoicing over its success. 'No doubt Bournemouth will
now have good water, good sewerage, proper footpaths, and a pier which
will give visitors a delightful promenade.' The Bill 'weathered the usual
perils of opposition,' and, with some important modifications, was duly
passed through both Houses of Parliament, and received the Royal Assent
in time for the first meeting of the new Authority to be held in the month
of July. In the 'Herald' of the 31st of that month an editorial opinion was
expressed that 'Bournemouth, now that it ceases to be so emphatically
retired, has become intensely dull,' the suggestion being made that 'it must
not now be considered simply for the invalided and the convalescent,' and
that a pier would be an immense advantage, an object of attraction in
itself, and an answer to the ever-recurring question, 'Where shall we go?'
'A pier will advantageously decide this question, probably seven times per
week for at least a thousand persons.'

On the 14th July, the Bill received the Royal Assent, and became the
'Bournemouth Improvement Act, 1856.' It provided for the incorporation
of a body of thirteen Commissioners, under the name of the Bournemouth
Improvement Commissioners, and the district assigned to them was limited
to an area 'within the circle of the radius of a mile, whereof the centre is
the front door of the Belle Vue Hotel' – a district which excluded the whole
of Westbourne, Winton, Springbourne, Malmesbury Park, and Boscombe.
The boundary line crossed the Christchurch Road a little westward of
the junction with the Derby Road, the Holdenhurst Road just beyond the
railway, the Wimborne Road west of the Cemetery, and the Poole Road
just beyond the Hospital. The Act provided that the first Commissioners
should be the 'Lord of the Manor of Westover for the time being, a person
to be nominated by him in writing,' and Messrs. Samuel Bayly, William
Clapcott Dean, Robert Kerley, George Ledgard, Charles William Packe,
William Robson, Thomas Shettle, David Tuck, John Tregonwell, Samuel
Thompson and Wrilliam Esdaile Winter.

The Commissioners were given the general powers sought for with
regard to 'the more efficient paving, sewering, drainage, lighting, cleansing,
watching and otherwise improving the district,' and special powers for the
provision of a pier and of a market or markets, the levying of tolls, etc. But
they were given no powers with regard to water supply, and in the matter
of lighting they were restricted to the entering into contracts for any period

not exceeding three years, with any person or company for the supply of gas, oil, and other means of lighting the streets and public buildings within the limits of the Act. They were authorised to borrow a sum not exceeding £5,000 for the erection of a pier, and a sum of £5,000 for other purposes within the meaning of the Act, and to levy a General Improvement Rate not exceeding, in any one year, 'three shillings in the pound on the annual value of the property assessed thereto.'

At the first meeting on the 30th July, 1856, there were present: Sir. George Ledgard (in the chair), Messrs. Shettle, Tuck, Bayly, Kerley, Thompson and Robson. Mr George Ledgard was appointed Chairman for the year 1856–7; Mr Richard Ledgard, Treasurer; Mr Thomas Kingdon, Clerk; and Mr Christopher Crabb Creeke, Surveyor and Inspector of Nuisances.

After the election of Chairman and officers, three other important matters were decided upon, viz.: the designing of a suitable seal, the making of a map of the district, and the opening up of negotiations with the Gervis Estate respecting the Pleasure Grounds and plantations – marking the commencement of a correspondence with one of the principal landowners which has lasted until this day. Respecting the seal, Mr Creeke, the Surveyor, submitted at a later meeting a drawing which received the entire approval of the Commissioners, and that badge of authenticity was ordered to be engraved. The design was plain, having in the centre a Hampshire rose surmounted by a crown, around which appeared, 'Improvement and Pier Act – Incor. 19-20 Vic., chap. 30.' Outside this was simply 'Bournemouth Commissioners, A.D. 1856.' In shape the seal was almost round. The map of the district was duly made upon a scale required by the Commissioners' Clauses Act.

The first Clerk – Mr Thomas Kingdon – received the princely salary of £25 per annum, 'to include all general business.' He was required to attend all meetings of the Commissioners, whether ordinary or special, as well as of all committees appointed, and the annual election of Commissioners; to keep the minutes and accounts, and attend at the office of the Commissioners as required by the 54th Clause of the Commissioners' Act, either in person or by some person authorised by the Commissioners,' and 'no bill will be allowed for extra charges except upon special resolution of the Commissioners.' Mr Kingdon – owing to a dispute relating to the full meaning of the foregoing – resigned in June, 1858, and he was succeeded by Mr Edward Robinson, who acted as Clerk under the same conditions and at the same salary until the 2nd July, 1861, when, in consequence of a similar grievance, he too resigned, and Mr J. Druitt, of Christchurch, was chosen. The last named gentleman continued in office until the 4th September, 1877, when he was succeeded by his son (now Alderman J.

Druitt), who remained the principal adviser to the Commissioners down to the year 1890, when the Board was dissolved and a Town Council appointed. Mr Druitt then became the first Town Clerk, which office he continued till his resignation in 1902, when he was succeeded by the present Town Clerk, Mr George Wm. Bailey, who resigned a similar appointment at St Helens to come south. The Commissioners in 1869 increased their Clerk's salary to £75, later on they advanced it to £150; then, in 1877, to £200, later it was raised to £250, but out of this Mr Druitt was required to pay the expenses of his office staff.

At the critical period of the town's history to which we have been referring an appointment wras made governing the fortunes and future of the district in so many ways that it is difficult to enumerate them in detail. When the Commissioners made Mr Christopher Crabb Creeke their first Surveyor and Inspector of Nuisances, they secured a gentleman capable in every way for work in connection with the formation of a new town. To his wise, thoughtful, and far-seeing instinct we owe a good deal. Consider for a moment what a difficult task was his. There was no proper system of drainage, neither was there an adequate outfall; the roads were in a condition bordering on the chaotic, though it is true the roads principally consisted of the main road through to Poole and Christchurch, Holdenhurst Road, Bath Road, Wimborne Road and Richmond Hill, Exeter Road and Westover Road. To put these satisfactorily in order took the Surveyor some years before they were reduced to anything like a state of efficiency. A considerable part of Mr Creeke's early years under the Commissioners was devoted to levelling the surface of the roads – lowering here, raising there – gravelling, channelling and curbing; all spare soil being thrown over the cliffs. With an eye for the artistic, Mr Creeke in setting out the district on his first map, designed the winding, tortuous side and back roads visitors sometimes grumble about, especially so after a first visit, say, to the Dean Park Cricket Ground, and an attempt, without guidance, is made to get to the station, or, indeed, to arrive at any definite point at the first essay, from this most confusing of roads. Parenthetically, we may remark that Mr Creeke was not only Surveyor to the Commissioners, but also Surveyor and expert adviser to Mr Clapcott Dean, the owner of large estates in both the eastern and western parts of the town. Numberless similar cases could be quoted, but this is sufficient to point out that Mr Creeke's main idea evidently was to avoid a straight road, that being against his view of the canons of the picturesque. We cannot admit that Mr Creeke was other than right; we do regret that when planning the district he did not widen the Old Christchurch Road, already made, by at least 20 feet. Had Mr Creeke ever thought that Bournemouth would develop so rapidly as it has done, it is certain we should have had a main thoroughfare from

East to West of ample proportions, with a subsidiary side road as an outlet for traffic at busy times. Now this gentleman, on whom largely rested the destinies of the future prosperous health resort, was willing to undertake the following work for the sum of £50 per annum:

'To advise, report on and prepare estimates for any works from time to time contemplated by the Commissioners relating to the profession of Surveyor, Architect, and Civil Engineer; to provide all the requisite plans, specifications, and superintendence of works carried out in such manner that there should be no extra charge for such drawings, specifications, or superintendence. As Inspector of Nuisances to carry out the duties prescribed by the 'Nuisances Removal Act' and supervision of sanitary matters as laid down by the Acts, so that the Commissioners should not be at any extra expense or charge for supervision.'

All this Sir. Creeke himself suggested, as well as the rate of remuneration he considered sufficient. He would make no extra charge for the required survey he was then preparing, except for actual materials for the plan and duplicate. Any professional services in designing the pier were not to be included in this agreement; and Mr Creeke further suggested that if the duties should become lighter or less important than attending on the first outlay he was willing that his salary of £50 should be reduced accordingly! Mr Creeke's salary remained at this ridiculously low figure until July, 1868, when it was increased to £150, to include the provision of a competent road foreman and inspector. He was also, at the same time, voted an honorarium of £100 for his past professional services, which, owing to an almost total absence of funds, he did not receive until October, 1869. The Commissioners themselves in 1864 placed on record that 'the conduct of the Surveyor in the performance of his duties both at their meetings and otherwise has been entirely satisfactory to the Commissioners.' In January, 1876, Mr Creeke's salary was increased to £300, and he resigned on the 27th May, 1879, at a time when the Board were plunged into a number of difficulties and anxieties caused mainly by the non-fulfilment of certain works by the contractors. In spite of certain differences it is now needless to explain Mr Creeke was held in very high esteem by the ratepayers, and in 1883, on his seeking election as a Commissioner, he was returned at the head of the poll. He died in May, 1886.

The meetings of the Commissioners were held at the Belle Vue Hotel until the end of 1857, when rooms were rented from Mr Creeke at Lainston Villa (now the Garden Tea House), at £20 per annum. Here the business of the town was transacted until January, 1875, when a Town Hall having been erected on the site of the present Town Hall Avenue a suite of rooms was occupied by the Commissioners and officials. The Corporation premises in Yelverton Road were leased in 1892.

In 1868 an attempt was made to provide suitable accommodation in a permanent building, plans being submitted by Mr Kerley, whose scheme was, however, rejected, although the Commissioners paid £21 for the cost of preparing the plans, executed, wc believe, by Mr Peter Tuck. At the same time, the Surveyor produced plans of offices to be erected on Mr Durrant's Estate in the Oval Block, and of stables, etc., on the same estate on Poole Hill, the rent of the former to be £60, and of the latter £27 10s.; the term to be seven years, and the Commissioners to have the option of purchasing the stables plot for £550. Notwithstanding the adoption and confirmation of this scheme, the idea was abandoned. The position of the 'Oval Block' being unknown to most people, we may say that the situation is the north side of the Commercial Road and the west side of the Triangle.

As we have said, almost the first decision arrived at was the inquiry to be made as to the terms on which Sir George M. Tapps Gervis would hand over the Westover Pleasure Grounds to the Commissioners, 'including the meadows south of the Holdenhurst Bridge.' As has been previously mentioned, the Westover Pleasure Grounds had been planted with evergreens and ornamental shrubs, and the whole place put into something like the order in which we find it today. The meadows, or Lower Pleasure Gardens, were not open to the public to the extent they are now, owing mainly to the very swampy state of the ground. It was not till March, 1873, that the meadows were converted into public pleasure gardens. The draining, done by men employed by the Commissioners, and superintended by Mr Proudley, was a long and somewhat costly undertaking.

The offices of Surveyor and Inspector of Nuisances were separated in August, 1866, when Mark Revel was appointed to the minor post, with the added title of foreman, for which he received £1 per week. The office of Inspector, to all intents and purposes Sanitary Inspector, was held successively by George Light (1867), William Macey (1869), William Cowley (1871), and Maurice O'Connell (appointed in 1871, remained an official of the Board for many years). O'Connell came to Bournemouth in 1860 as Drill Sergeant to the Rifle Volunteers, then newly established.

Shortly after taking office the Commissioners ascertained the legal net value of the property within the district as a basis of an Improvement Rate, and re-assessed and re-valued the whole of the buildings. Until a permanent loan was arranged for a temporary loan of £200 was obtained from the Treasurer with which to carry out those improvements most necessary and of urgent importance. The intention of the Commissioners to negotiate for a loan of £5,000 raised the ire of the principal residents, who rose up as one man and held a meeting at the Belle Vue Hotel to protest against this and the increased assessment. This meeting was held in less than three months after the first meeting of the Commissioners,

Colonel Simmonds presiding over what was then a large and influential meeting. After a long discussion it was resolved 'that the meeting viewed with alarm such a proposition as tending to depreciate the properly at Bournemouth, and in other respects prove highly prejudicial to the interests of the ratepayers.' They made respectful representation to the Commissioners to confine their improvements to the repairing of roads, drainage and lighting, other works contemplated by the Act (principally the Pier) to be for the present left in abeyance. £3,000 was considered to be a sufficient sum for all necessary improvements and discharging one moiety of the expenses attending the procuring of the Act. The outcome of this was the abandonment of the principle of a low rate and a high assessment, viz., 1s. in the pound, to produce £282 13s. on £5,653. Before the Commissioners reverted to the old assessment, counsel's opinion was obtained, when they found that they had no power to alter or rescind the rate made, so it was allowed to stand for that year. In August, 1857, a new rate of 3s. in the pound on the basis of the last Holdenhurst Poor Rate was made, and produced £592 10s. 9d., the assessable property being £3,950 5s. In contrast to this we may mention that the Borough and District rates just approved for the year 1910–11 provide for the raising of a sum of upwards of £161,000!

Small as the income was – apart from borrowed money – it evidently answered for all purposes of administrative expenditure, and as each year passed the Commissioners depended largely on the number of houses and shops erected to increase their income. But, in one or two years – in 1868 particularly – the Commissioners were in dire straits for money sufficient to pay their way. In the year mentioned the Board were in a complete state of bankruptcy, and were inundated with appeals and threats for settlement of accounts. In an ordinary way, however, a 3s. rate was sufficient for all purposes; for many years it remained at that amount. It is interesting to note that Mr McWilliam was appointed the first Rate Collector, with a remuneration of £5 for collecting the first rate, and £7 10s. for the second (or 3s.) rate. We may also add that the second collector was Mr W. E. Rebbeck (February, 1861, to November, 1866); the third Mr Henry John Aish (February, 1867, to October, 1871); the fourth, Mr William Bell, was appointed in November, 1871, and disappeared in a mysterious manner in December, 1876. The next to hold the office was Mr Alexander McEwan Brown, who served from early in 1877 till August, 1881, when his future partner, Mr C. W. Wyatt, was appointed, he in turn being succeeded in October, 1883, by Mr James Phillips, who still holds the office in conjunction with his son, Mr, F. J. Phillips.

As it probably will interest many to know a little more of the financial condition of the town, and make comparisons with the present state of

affairs, we give here a brief outline of the statement of estimated income and expenditure after the adoption of the 3s. rate. That rate was estimated to produce £592 10s. 9d., from which was deducted £90 17s. 3d., to be returned on the 1s. rate previously abandoned. Apart from the balance due on account of law expenses in connection with the initial outlay the total expenditure was estimated to be: Salaries, one year, £75; tradesmen's bills, £75; general improvements, maintenance of the walks, and expenses of the Commissioners, £135 14s. 3d. The liabilities of the Board at the end of the first year amounted to £338 10s. 2d.; the second year £1,560; and in the third year, 1859–60, they totalled £2,100. To enable the Commissioners to carry on the work small loans were raised, namely, from Messrs. Fearon and Clabon, £600; and Mr Kingdon, the Clerk, £350. Both loans were repayable in 1859. Another of £500 was advanced by Mr Henry Dickinson, and was repaid by February, 1863. Comparing the liabilities of a little over £338 at the end of the first year with the town's indebtedness at the 31st March, 1909, of £1,361,241 7s. 4d., we have a clear and practical illustration of the town's growth in 51 years.

There is one matter worthy of record, which, had it been carried out, would have completely altered the character of the Lower Pleasure Gardens, and prevented the enjoyment of the countless thousands of children who have since derived untold pleasure from its shallow and meandering stream. In 1857, when the Surveyor was bravely trying to cope with the incomplete drainage system, he very strongly urged on the Commissioners the desirability of conveying the brook to the sea in pipes put underground, joined on to the sewer at the bridge; the consequent extra flow of water, he maintained, would give great assistance in conveying the sewage to the sea. Fortunately for the town, this advice was not acted upon – though it would undoubtedly have materially assisted in the object Mr Creeke had in view – and the 'Children's Corner' has been handed down to us for the perpetual enjoyment of our youngsters. How strange that part of the Gardens would look without the pleasant sight of the children bent on trying the capabilities of their frail craft! Oftentimes we are led to think that the Beach – generally supposed to be the crowning joy of all children – frequently takes second place to the charming and sheltered spot where miniature 'Dreadnoughts' are launched and jealously guarded.

The district in 1856 was in a more or less chaotic state in matters relating to roads, footpaths, and especially drainage. Looking at it with the knowledge of history, the whole place seems to have got quite out of hand, and the necessity for the formation of a local governing body was, indeed, imperative if the budding health resort was to be put in proper order to meet the requirements of the time. There must have been, even in those days, a great and undefinable charm about the place which actually

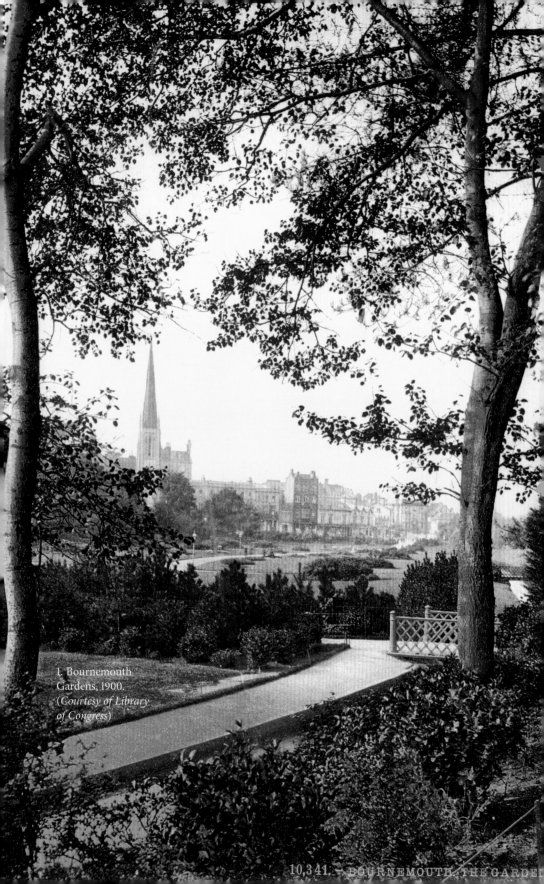

1. Bournemouth
Gardens, 1900.
(*Courtesy of Library
of Congress*)

10,341. — BOURNEMOUTH. THE GARDEN

2. General view of Bournemouth, *c.* 1900. (*Courtesy of Library of Congress*)

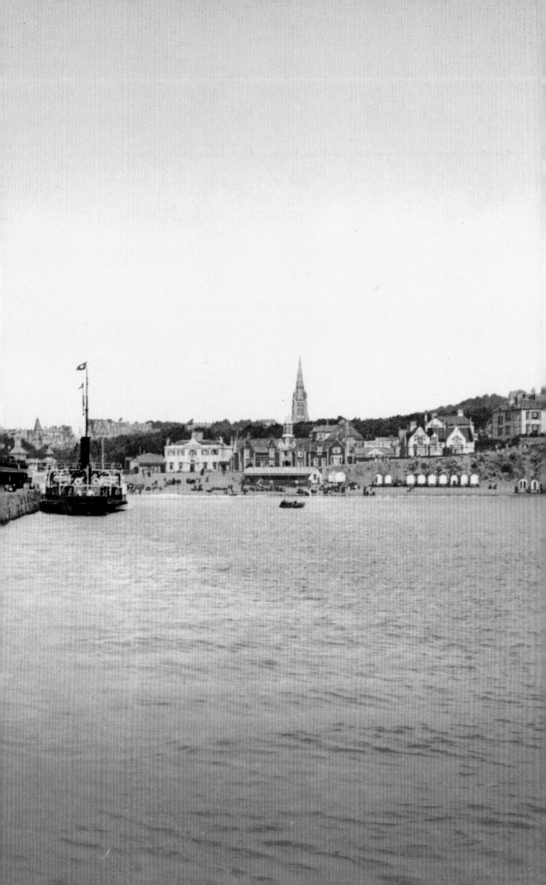

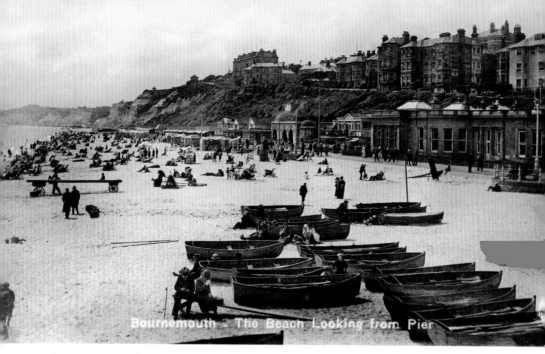

Above: 3. A view of Bournemouth from the Pier.

Below: 4. A postcard of Bournemouth, viewed at night.

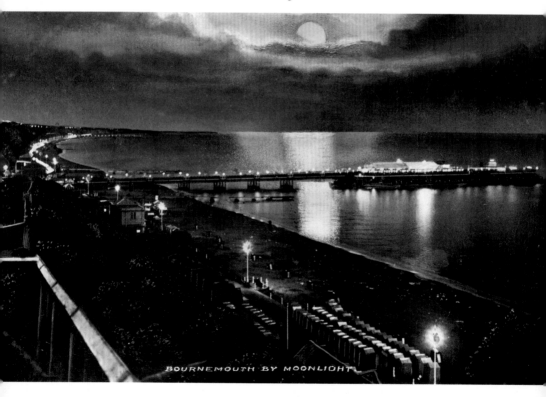

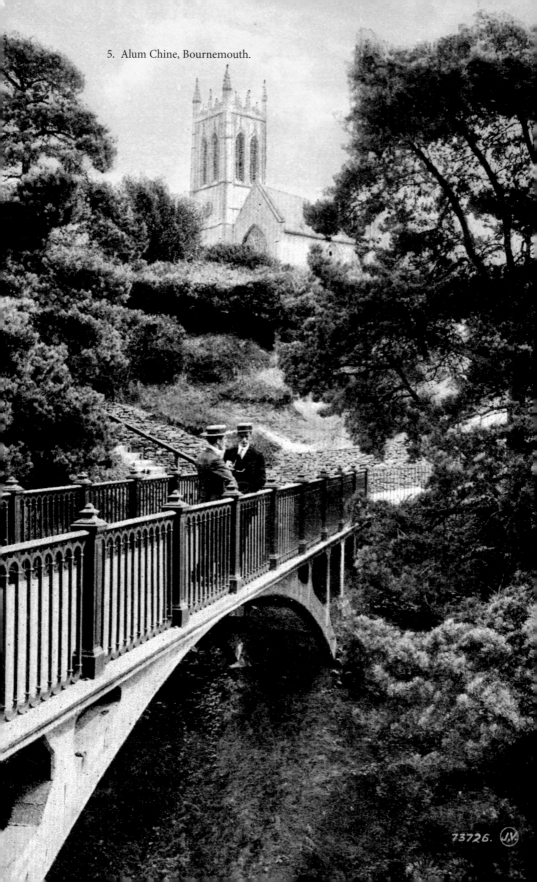

5. Alum Chine, Bournemouth.

73726. J.V.

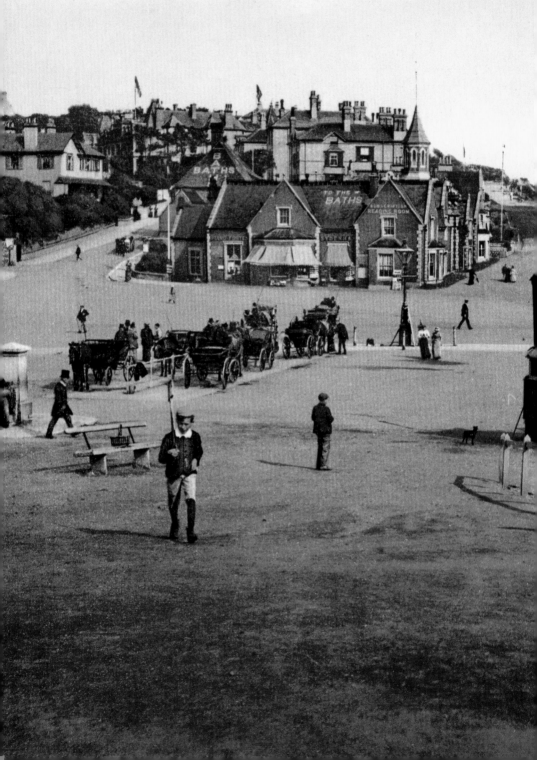

6. The entrance to the pier, *c.* 1900. (*Courtesy of Library of Congress*)

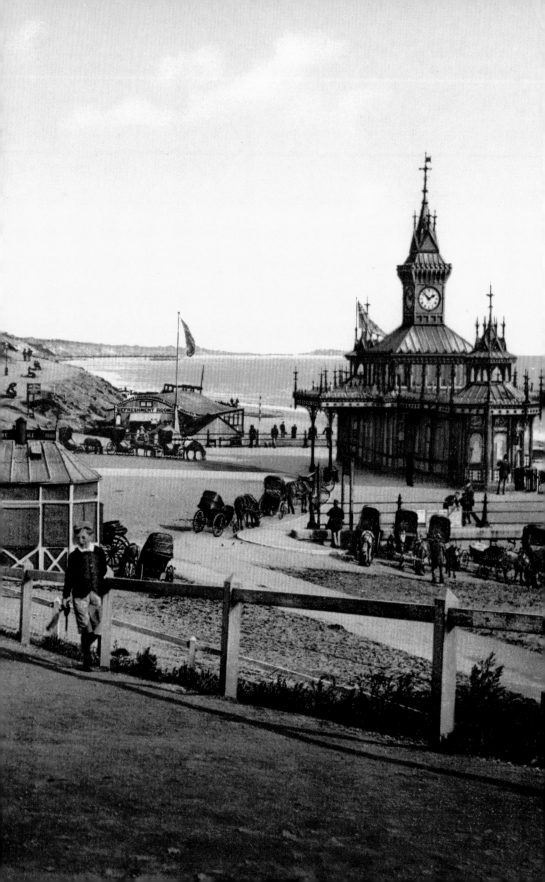

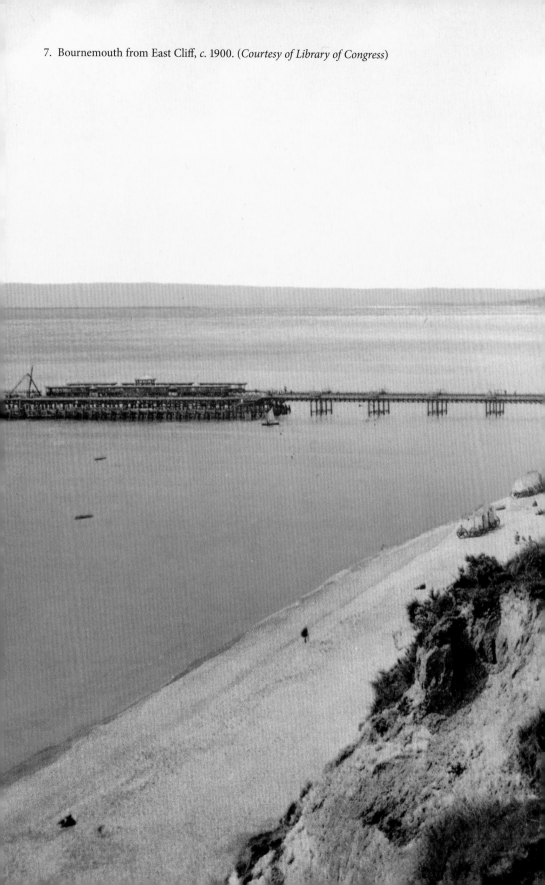

7. Bournemouth from East Cliff, *c.* 1900. (*Courtesy of Library of Congress*)

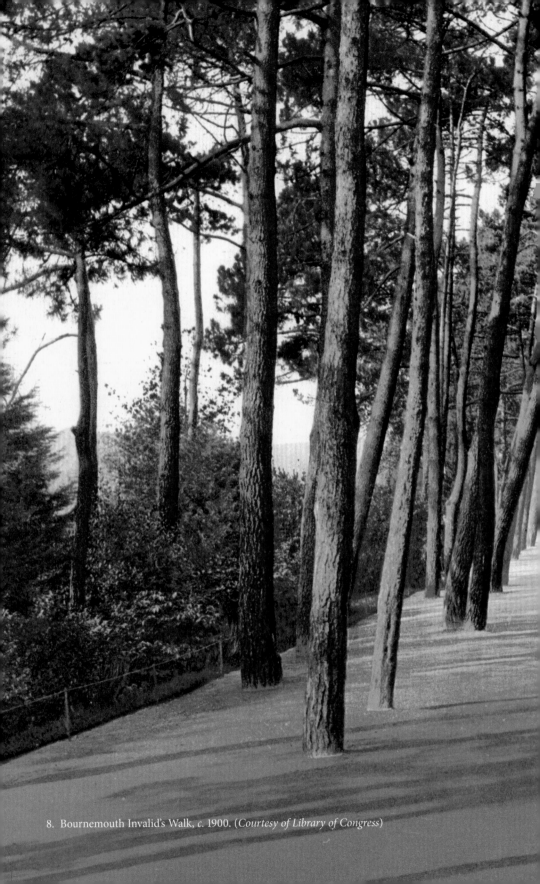

8. Bournemouth Invalid's Walk, *c.* 1900. (*Courtesy of Library of Congress*)

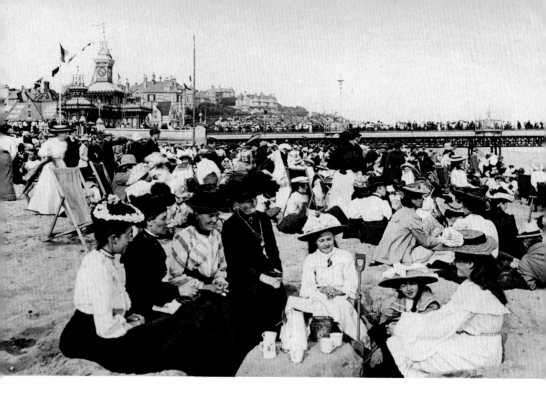

Above and below: 9. & 10. Busy beach scenes from the turn of the century.

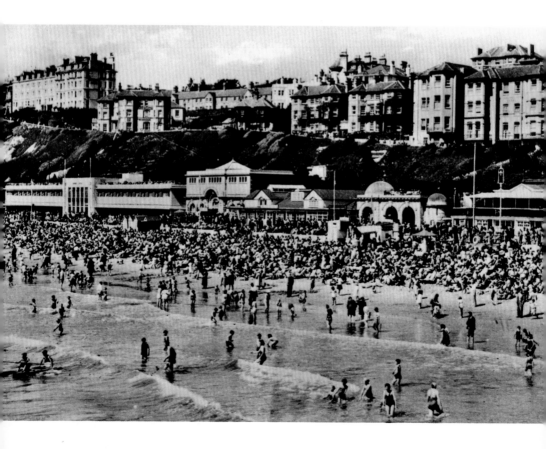

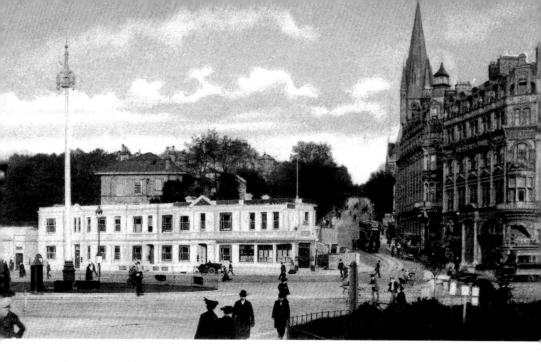

Above: 11. Looking across from Exeter Road towards Richmond Hill, *c.* 1905.

Right: 12. A humorous postcard from Bournemouth.

"Yes, I always go South for Sunshine by SOUTHERN"

Left: 13. An advert for the 'Sunshine Express'.

Below: 14. Boscombe, Chine Gardens.

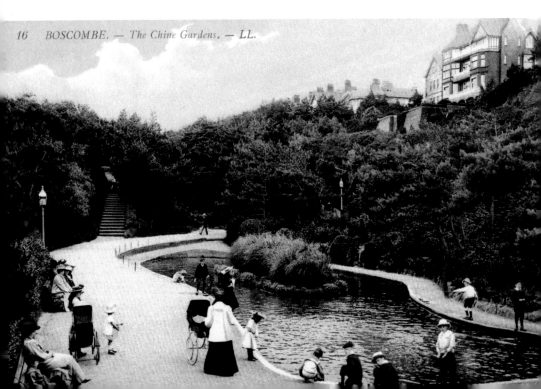

16 BOSCOMBE. — *The Chine Gardens.* — LL.

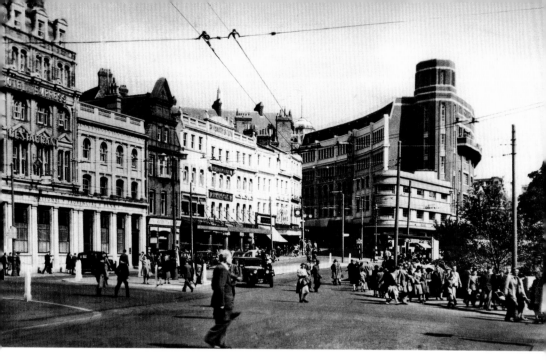

Above: 15. Old Christchurch Road from the Square.

Below: 16. The Winter Gardens.

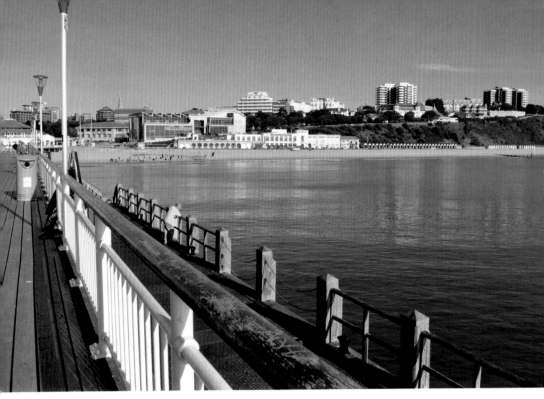

Above: 17. Bournemouth from the pier today.

Below: 18. Bournemouth Pier today.

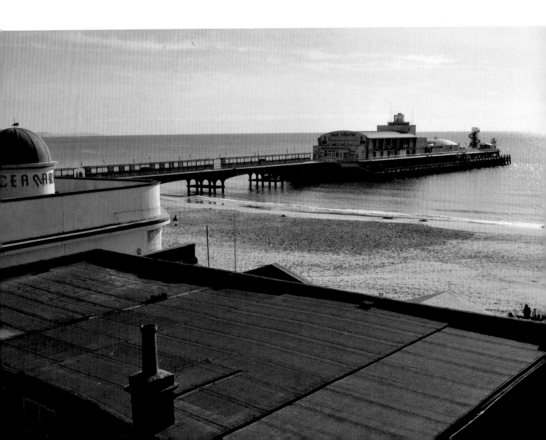

forced itself into prominence, and it only required guiding hands, imbued with the proper spirit, for the town to be re-organised for the reception of the class of visitors it was anticipated would come. The history of the drainage of the town, the temporary means adopted to cope with the rapid growth, the establishment of main drainage schemes, completed bit by bit, and the consequent abolition of cesspools, are matters we do not purpose entering into very largely. Suffice it to say, that there was very much trouble in the fifties, sixties, and even seventies with the various drainage schemes adopted. There is little necessity to deal here with this matter, except to remark in passing that for years the unsatisfactory state of things in this respect was a source of much worry and concern to the Local Authority.

Although it is not our intention at this point to go into the most interesting history of the religious life of the town, there is a matter that is perhaps expedient should be recorded at this juncture. At the end of 1857, when the first Scotch Church, built of galvanized iron, was opened at the foot of Richmond Hill, it was found that the erection encroached on the building line of the main road. A report was called for, and the Christchurch Award of 1805 was examined, when it was found that both the Scotch Church and Mr Fox's dwelling house (situated a little higher up the Old Christchurch Road) were encroachments on the public highway. Wishing to avoid litigation, the Commissioners compromised the matter by the proprietors of the land in question giving up all claim to their land beyond the front of the buildings. The amount of ground in dispute only measured six feet in depth, but that extra width continued right up that part of the Old Christchurch Road on the north side would have considerably enhanced the value of it as a main thoroughfare.

From a description of the district written in 1856, we quote the following, which relates to the opportunities of travelling at that time:

Lastly as to the position of Bournemouth in respect to the great lines of 'Passenger and Traffic Transit.' At a time when the pretended humanity, but really unprincipled cupidity of railway companies, has provided extraordinary temptations of Sunday travelling – so that termini of railways do not even enjoy the grateful peace and propriety of the Sabbath Day, one of the greatest sources of gratification and pride to the Englishman – it becomes a matter of the greatest importance in seeking a place of retirement to find one sufficiently far from a terminus to be relieved from this source of annoyance, yet without being so far distant as to occasion inconvenience in travelling. This is happily the case with Bournemouth. There is a regular communication by omnibus several times a day with Poole, the nearest rail way station from hence to London is five hours, and to Southampton… is but two hours travelling by rail.

When the Commissioners took over their responsibilities of government the roads, as we have said, were in a parlous state; but under Mr Creeke's able direction a small, though systematic method was adopted to make the thoroughfares at least presentable. The first road attended to was, of course, that in the principal residential quarter, Westover Road. Here were employed six labourers laying down gravel obtained from the Holdenhurst Road, and from the gravel pit on the Poole Road (nearly opposite St Michael's). The Surveyor found at a sudden rise in the Holdenhurst Road, at its junction with the Christchurch Road, a bench of good gravel, but like many other good 'finds' this became unpromising, and had to be abandoned. Recourse was then had to Mr Clapcott Dean's gravel pit on Poole Hill (now Road). Gravel for road surfacing was also, in 1857, taken from under the road fronting the Tregonwell Arms (on the site of Plummer Roddis' premises), and the pits filled in with the refuse from other excavations. The wages of labourers averaged less than 12s. per week, and the men employed in 1857 were W. Gollop, C. Fall, F. Fall, J. Troke and G. Hamblin (garden keeper), the last named at 10s. per week, his work being the repairing of fences and railings, and assisting in roadmaking. After the completion of the Westover Road, the roadway was shaped and curbed from the villas to the end of Gervis Place, and on to the Bridge, Commercial Road, Exeter Road and the Pier Approach. Richmond Hill was in places raised, in others lowered, and made more uniform than it apparently used to be. The cartage was done by Mr Aldridge, who was appointed public scavenger, for sweeping, watering and cleansing the roads. Even so late as 1869 the average weekly wages bill was only £4 8s.! Today it amounts to something substantial in four figures!

There are numerous ways in which we can guage the size and importance of any district, but none more than by the number of official guardians of the peace. When the Commissioners were appointed, one policeman was considered sufficient to look after the life and property of the district. It occurs to us that here was a golden opportunity for any evilly-disposed person to carefully prepare his plans, take advantage of the policeman's night off, and make a good haul. Indeed, something of the kind actually occurred, for in October, 1856, the Chief Constable of the County was written to draw his attention to the fact that several depredations of property had recently been committed in different houses in Bournemouth, and the inquiry was made if he would allow a constable to be permanently attached to the place during the night. Up to 1858, however, P.C. Smith was the sole guardian of the peace! Perhaps Sir W. S. Gilbert had this policeman in mind when he wrote the well-known humourous song for 'The Pirates of Penzance.' In the years previous to 1856 Bournemouth had no separate jurisdiction, but was part of the Ringwood Petty Sessional Division, with

headquarters at Ringwood. After that year all prisoners were taken to Christchurch for magisterial examination. By the year 1877 the town had grown in importance to such an extent that Sergt. Alexander (afterwards Inspector) was stationed here with six constables. This force was increased in 1888 to one inspector, two sergeants and nineteen constables, and the last increase decided upon – in May, 1910 – brought the total force for the borough area up to 94, made up as follows: one Superintendent, three Inspectors, eleven Sergeants, and seventy-nine Constables. These periodical advances illustrate in a striking manner the remarkable growth of the town.

As far back as January, 1864, a deputation was appointed to wait on the magistrates at Christchurch, asking their assistance in procuring the establishment of a Police Station at Bournemouth; and in 1866 the three principal ground landlords, Sir George Gervis, Mr Durrant, and Mr Clapcott Dean, were applied to for a grant of land for this purpose. In the following year a memorial was sent to the Justices in session, pointing out the extreme urgency of the matter. It was not until 1869, however, that the present building was erected, to give place at no distant date to a building more in keeping with the dignity and aspirations of a County Borough.

The Wooden Pier –
And Some Other Enterprises

In Chapter X. we have referred to efforts made as far back as 1847 with the view of securing a pier, and it has been shown that even before that day the provision of a pier was one of the improvements contemplated by the Lord of the Manor of Westover. These efforts eventuated in the erection of a jetty or landing-stage in 1855, and in the promotion of the Bournemouth Improvement Act. On the 7th December, 1858, on the motion of Mr Henry Dickinson, seconded by Mr R. Kerley, the Commissioners passed a resolution 'That it is desirable that a pier should be erected in accordance with the provisions of the Bournemouth Improvement Act, and that the Clerk be instructed to advertise for a loan of £5,000 to enable the Commissioners to carry out the object.' The Surveyor reported on the requirements of the Act, and confirmed the accuracy of the survey and soundings which Captain Denham had made, some years previous, at the instance and expense of Sir George Gervis. A public meeting held at the Belle Vue Assembly Rooms on the 17th January, 1859, under the presidency of Mr George Ledgard, also passed a resolution affirming the desirability of action, with this important addition: 'That, inasmuch as there now only remains two years and a half in which a Pier can be erected by the Commissioners, this meeting requests the Commissioners forthwith to proceed to carry out the above object.' The mandate was obeyed, and on the 1st March, 1859, Mr Rennie, C.E., was asked to make a survey and submit a report and design, which he did in due course. He recommended the construction of a pier 1,000 feet in length and of an estimated cost of £4,000. On the 3rd May his plan was approved and sealed, and the Board (very much to their subsequent regret) decided that the Pier should be constructed of wood. The necessary assent to plans, etc., was obtained from the Admiralty, and on the 15th June a tender was accepted from Mr David Thornbury, of Newcastle-on-Tyne, who undertook to erect the pier for a sum of £3,415. A loan of £5,000, repayable in thirty annual instalments, was obtained from the Royal Exchange Assurance Company, charged on the pier tolls and the General District Rate. The seal of the Commissioners was affixed to the contract on the 19th August, 1859. The

actual work, however, was commenced even earlier. Mr Thornbury – who was an engineer of some repute – was taking holiday at Bournemouth at the time, and, according to his own statement, it was a 'trifling occupation' for him to 'knock off the pier.'

The driving of the first pile – or rather pair of piles – described in the 'Directory' as 'the inauguration of a new state of affairs for Bournemouth,' took place on the 25th July, with appropriate ceremonial and festivity. The plans, as stated, provided for the erection of a timber structure, about 1,000 feet long, with a T end, which, it was suggested, would serve as a breakwater and shelter for vessels. Before the work had proceeded far there came a great gale, which 'swept away the whole thing, making the pier look as small as the Commissioners felt,' and necessitating a recommencement. That was but the first of a series of misfortunes. The Commissioners ere long found themselves involved in controversy, both with the engineer and the contractor; when this was settled, the work again in full swing, and large payment due to the contractor, Ledgard's Bank stopped payment, which affected the whole financial position of the Board. The Pier funds had been deposited at the Bank, and consequent upon the failure the Commissioners were unable to meet Mr Thornbury's claim. In their dilemma they opened negotiations with the Poole a thousand applications for tickets. Lady Gervis and Lady Shelley were amongst those who presided at the tables – others including Mrs Burslem, wife of the Dr Burslem who has already been referred to as a pioneer advocate for the erection of a Pavilion. The Ursa Major steamboat, with Harman's Band on board, is reported to have brought visitors from Poole, and the Prince steam yacht (Captain Cosens) made an excursion from Weymouth with 'a numerous and respectable party.' The day concluded with 'fireworks in the meadow, opposite the Telegraph Office.' The Commissioners by resolution had restricted their expenditure on opening to a sum not exceeding £40. The amount privately subscribed must, it is obvious, have been very considerably larger.

At the dinner we have referred to, Mr Shettle described the new Pier as 'handsome and adequate,' but wisely added that 'he would be a bold man who would say it would be equal to the wants of forty years hence.' It did not remain equal to public requirements for half that time, for the misfortunes which attended its construction were followed by others of still more serious character and of lasting effect. Within less than six months after its opening a committee 'was instructed to repair the Pier.' Disaster came again in January, 1867, when a terrific gale swept along the coast, and the Pier, described in a contemporary record as that 'refreshing place of refuge from the heat, in the sultry evenings of summer' – was very seriously damaged. That was, in more respects than one, a memorable

storm, for no less than six ships went ashore in Studland Bay and one on
the Hook Sands. The whole of the massive transverse body of the Pier was
wrenched away, broken up, and cast upon the shore, where, a few days
later, it made material for a sale by auction. In a monthly magazine called
'The Hawk,' published at Ringwood, a contributor – evidently a student
of Longfellow – chronicled as follows:

> A rough south-easterly gale, combined with wonderful spring tides,
> Over the shores of the south coast raged with wonderful fury;
> Mountains high ran the waves, each covered with snow like a white fleece.
> Stirring the depths of the sea and bearding old Father Neptune;
> Causing destruction alike to our merchant navies and seamen.
> Such was the storm on the ill-fated night of the fifth of the first month.
> Long will men talk of that gale in spinning their yarns to the youngsters;
> How as gay Phoebus arose the'strength of the tempest abated;
> Many a town and village witnessed the terrible havoc
> Bums and Neptune had wrought while darkness mantled their dwellings.
> Part of the beautiful Pier was lost to the village of Bournemouth;
> High on the Beach it was thrown like a stranded wreck on a sandbank;
> Tall piles wrested in twain, and iron twisted like packthread.
> Covered the yellow strand of the sun-loving village of Bournemouth.

About £4,000 had been originally spent on the Pier, and the Commissioners
now had to face further expense and gradually to replace the timber piles
with iron. The structure, however, was permitted to remain some 300 feet
shorter than its original length – being in its mutilated state about 600 feet
long, with a deck 15 feet wide. The Commissioners must have been almost
at their wits' end with trouble. They tried every possible means to keep the
Pier together, but were it not vouched for by one whose veracity is beyond
question, we should hesitate to credit the story told by an old resident, that
White, the diver, was instructed to go down into the water, take out the
bolts of the iron piles, which in many places had been put in substitution
for damaged wooden piles, oil, and replace them! In November, 1876,
came another great gale, with the loss of another 100 feet or so, leaving
the structure too short to be serviceable for steamboat traffic. A temporary
landing stage was consequently erected in 1877 from plans submitted
by Mr E. Birch, C.E., the eminent engineer who afterwards designed the
present Pier. A sum of between £600 and £700 was expended, and the
work was completed in time for use by the steamers in the month of July.
The Criterion was the first boat to make use of it. Mr Hill, of Gosport,
was the contractor. In November of the same year it was decided to make
application to the Local Government Board for powers for the provision

of an entirely new Pier at a cost not to exceed £40,000 – a figure which was reduced to £30,000 in the following June. The story of the new Pier must, however, form the subject of another chapter.

Some of the wreckage from the damaged Pier drifted in 1876 to Swanage, and in February, 1877, the Commissioners passed a resolution that 'if no acceptance is received from Mr Brown of the offer made to him respecting the Pier piles drifted to Swanage before Thursday, the piles be demanded and brought to Bournemouth, and £3 10s. offered to him as salvage.' Following on this an item appears in the accounts dated the 4th September, 1877: 'W. Hill, – Recovery of wreckage to Pier, £175 19s. 11d.'!

The Pier experiences of the Commissioners had been exceedingly discouraging, and remembering all the circumstances – the repeated mishaps, the continuous expenditure, and the fact that the district, though rapidly extending, was still of comparatively small rateable value, and had much prospective outlay to meet – it is not, perhaps, surprising that there were inhabitants who felt they would be glad to get rid of the wrhole thing, and leave the provision of a Pier to private enterprise. Certain private adventurers did, indeed, come forward With a proposal to relieve the Local Authority from its responsibilities, and they actually secured a Provisional Order from the Board of Trade, which was duly confirmed by Parliament early in 1875. But the Commissioners seem to have very effectively protected the town's interest. They secured the insertion of a provision that the Order should lapse if, within two years, there was not a substantial commencement of works. They succeeded also in getting a clause inserted that the Company must buy out their interests in the old Pier. Negotiations went on from 1875 to 1877, but without effect. The Commissioners were willing to sell, and the Company apparently were willing to buy; but all the latter were willing to pay was a sum equal to the then outstanding debt. In April, 1877, one month before the expiration of the Company's powers, the Commissioners passed a resolution breaking off all negotiations unless £1,000 were paid by a certain day. The money was not forthcoming, and the Commissioners then wisely determined themselves to 'proceed as if no overtures had been made by the Promenade Pier Company.'

Some particulars with regard to the administration of the Pier after it was erected may not be uninteresting. We have referred to some of the troubles of the Commissioners. These did not all arise from storms or Bank failure. Early in 1864 the Finance Committee received instructions to inspect the Pier where it had been injured by 'the worm,' and to take such measures as appeared necessary! A curious item appears in their accounts for the same year: Mr Bridge, for beer to men tarring the Pier, £3 13s. 6d. We wonder what the tar cost! And the labour! When the Pier had to be painted in

1872, Mr Dacombe was asked on what terms he would do the work if the Commissioners found the whitelead! We have no report of his answer. The earliest record of seats on the Pier occurs in 1869, when tenders were obtained from three tradesmen, and that of Mr Edmunds, at £6 each, was accepted. Two seats were ordered! Seats were luxuries in those days. Three years later, when giving permission for the erection of a Cabmen's Shelter on the Beach, the Board made the stipulation that 'under no circumstances must it be used as a sleeping apartment.' It is a pity their conditions were not more stringent, for the place remained an eyesore till a few years ago. In 1872, the Gas and Water Company were asked to submit an estimate for lighting the Pier, and following on this eight lamps were placed there, after the sanction of the Trinity Board had been obtained.

When the Pier was first opened a toll collector, Thomas Burt, was appointed, at the princely wage of 12s. per week, with two suits of clothes and two hats annually, and a greatcoat once in two years. The charge for annual tickets was based on rateable value; thus we find that a ratepayer and his family rated at a less rateable value than £15 could obtain a yearly ticket for 5s.; up to a rateable value of £50 the charge was 10s. 6d.; over £.50 the ticket cost £1 1s. 'Family' included near relations residing with the ratepayer, and servants. Non-ratepayers were charged 2s. 6d. each or 10s. 6d. for a family of not exceeding six persons, for one month; three months, £1 1s.; six months, £1 10s.; twelve months, £2 2s.; single entry. 1d. With two years' experience the Commissioners decided to let the tolls, and the tenders received in September, 1863, were: Mr G. J. R. Goodden, 25 per cent, above the last year's net receipts; and Mr W. Roberts, £170 a year. The latter appearing to be the highest, it was accepted. In September, 1866, on the re-issue of the tenders, that of Mr Goodden at £235 was accepted, which – due to the storm in January, 1867 – the Commissioners reduced by £60. Mr Goodden placed a toll-house at the Pier entrance, which the Commissioners decided they would purchase at a valuation at the end of his term. In 1869 this house (including the stove) was purchased for £30. In 1869 Mr Roberts was once more successful, with a bid this time of £245 10s., his nearest competitor being Mr Mundy at £171. Mr Roberts died in 1871, the Pier for many years afterwards being managed by his widow. (In 1872 Mrs Roberts' tender of £305 10s. was accepted, although lower than Goodden's, because 'the difference was small, and the management was acceptable to the frequenters of the Pier and the Commissioners.') In 1874, Mrs Roberts' accepted tender was £485, and in 1878 Mr Goodden's tender for one year was preferred to Mr Alfred Roberts' offer of £530. The arrangement – the last in connection with the old Pier – ended in a dispute which led to Police Court proceedings for the recovery of a balance of rent.

During Mr Goodden's tenure as lessee he had at one time a collector (Mr Llewellyn, we believe) who engaged in some semi-professional taxidermy, much to the annoyance of visitors, who complained of the 'stench' at the toll-house. In 1868 the Commissioners directed Mr Goodden's attention 'to the nuisance occasioned by the practice of bird stuffing.' We presume it stopped.

In connection with the question of the Pier site, there had at an earlier date been a little difficulty which had to be adjusted with one of the Government departments. The Office of Woods and Forests refused to convey a greater frontage than 100 feet – insufficient on account of the peculiar shape of the Pier-head – unless Sir George Gervis conveyed a greater frontage. This was eventually arranged satisfactorily, and a cheque for the purchase money and costs was signed, 'and ordered to be paid if there was sufficient funds at the Treasurer's.' The amount was only a little over £100, and the date 1864. In the conveyance the Commissioners covenanted not to erect any building exceeding 20ft. in height to the highest part of the roof from the level of the Pier, which limit of height the Commissioners considered to be ample to protect the sea view of the houses. The limitation was unfortunate; it is one of the restrictions which have led the Local Authority into heavy expenditure. Mr Roberts, proprietor of the Baths, having an interest in the Beach, volunteered to resign all such interest in return for the privilege of placing bathing machines on the sands, at a distance of not less than 200 yards on either side of the Pier, which offer was accepted by the Board.

The Commissioners were very enthusiastic in their work in connection with the Pier. This was one of the special objects for which they had been incorporated, and they realised that, lacking a place where passengers might land or embark from pleasure boats, etc., Bournemouth was without one of the essentials of a seaside watering place, however moderate its pretensions might be. But they did not allow the Pier to absorb all their energies. They early turned their attention to the general improvement of the sea-front: the laying out of cliff walks, etc. They asked permission from the Admiralty to dig clay from the Beach, and commencing operations before assent was obtained they were promptly stopped by Lieutenant Parsons, Chief of the Coastguard. This was in 1858. For the work then carried out Mr J. McWilliam was the contractor, and the sum expended £50. Not only was the cliff-front laid out, but by arrangement with Sir George Gervis two footpaths leading from the Bath Hotel to the Cliff were gravelled. Sir George Gervis at the same time completed the central walk through the Pleasure Grounds – the beautiful pinewood which subsequentty became known as the Invalids' Walk.

From this period also dates the first proposals for the establishment of a Winter Garden or Pavilion. Dr Burslem, a well-known local physician,

with some others, entered into negotiation with Sir George Gervis with the intention of acquiring the Westover Gardens on a ninety-nine years' lease, and erecting Public Reading Rooms and a Winter Garden. They put forward the suggestion that the Commissioners should take a sub-lease from them of land not required for their proposed buildings. The Commissioners declined to entertain the matter unless Dr Burslem first revealed the names of the persons forming the Company. What names were disclosed in consequence of this hint does not appear, but some of the subsequent correspondence was with Dr W. S. Falls, another physician who acquired great influence in the district. The promoters apparently were very much in earnest, and in November, 1860, it was reported that the funds necessary for building had been raised. Further communications passed, and a suggestion was made by the Commissioners that, instead of building in the Pleasure Grounds, the promoters should utilise a site on the sea-front between the Bath Hotel and the Baths, in which case they would be prepared to take an under-lease from Sir George Gervis and pay three-fourths of the entire rent. Further, they were prepared to rent offices in the proposed buildings. Before going further, however, the Commissioners took counsel's opinion as to their powers, and this resulted in the whole project of a Winter Garden being dropped.

We turn now to an enterprise of a different character: the establishment of Bournemouth's first newspaper. It will have been noticed that our extracts from newspaper reports, etc., for some years preceding the incorporation of the Commissioners are mainly from the 'Poole Herald.' This newspaper was founded in 1846, the first registered proprietors being the late Mr John Sydenham, jun., and Mr David Sydenham, now of the Royal Marine Library, Bournemouth. In 1850 the business passed into the hands of Mr Martin Kemp-Welch and Mr Henry Mooring Aldridge, from whom in 1853 it was transferred to Mr James Tribbett and Mr William Mate, both of whom had been members of the staff for some years previous, and who then entered into a partnership which lasted for more than a quarter of a century. Mr David Sydenham had filled the editorial chair. On the change of proprietorship, which took place in March, 1853, he relinquished that post, and for many years onward responsibility rested mainly with Mr W. Mate. The 'Herald' is one of the various publications subject to the direction of his eldest son, and it will not, we hope, be deemed inappropriate or uninteresting if we mention that in the preparation of these 'Chapters of Local History' the Editor of 1853 and the Editor of 1910 have been able to join hands and meet in friendly conference. In 1858, Mr W. Mate thought the time had come when Bournemouth should have a newspaper of its own, and on the 5th June of that year appeared No. 1 of the 'Bournemouth Visitors' Directory,' established with the

object of protecting and advancing the town's interests, and of keeping Bournemouth and its claims continuously before the public notice. It was not anticipated that the paper would be immediately remunerative; but it 'took on' at once, with the result that the tiny four-page sheet which made its first timid appearance on the 5th July, 1858, as a fortnightly visitors' list, within a few months was enlarged, by the beginning of 1859 was issued with a supplement, and speedily became a weekly publication. Many later enlargements followed, the paper was issued twice a week, and the printing, as well as the publishing offices, were removed to Bournemouth.

In 1860 Mr W. Mate was the Secretary of a Limited Liability Company known as the Poole, Bournemouth and South Coast Printing Telegraph Co., formed for the purpose of giving the public 'cheap telegraphic communication.' Bournemouth at that time was so shut off from the world that the nearest railway stations were Holmesley (then called Christchurch Road) on the one hand, and Hamworthy on the other. The telegraph line was laid from Messrs. Rebbeck's Estate Office, opposite Southbourne Terrace, to the 'Herald' Office at Poole, Mr A. Potter carrying out the work on behalf of the Company. Every message from Bournemouth to, say, London, had first to be telegraphed to Poole; it was then transcribed, despatched by messenger to Hamworthy, and once again the 'electric telegraph' clicked and sent it speeding on its way. The Company continued for some years – till the whole Telegraph system was taken over by the Government. We have before us as we write a summarised statement of receipts and expenditure from the opening of the system in 1860 down to July, 1864. The total receipts during that period came to £587 17s., and the total payments to £441 12s. 5d., showing a balance of £146 4s. 7d. The receipts at the Poole end of the line were £207 4s. 2d.; those at Bournemouth £380 12s. 10d. These figures cover, it will be noticed, a period of over four years! For the half-year ended July, 1863, the total receipts at Poole appear to have been only £6 15s. 6d.; the lowest half-yearly total at Bournemouth was £27 8s. 5d. for the period ended in July, 1862. The business grew in the following years, and the shareholders received a reasonable return on their investment. But the total capital expenditure, it should be mentioned, was only £312 12s. 7d. In July, 1861, it only required the sum of £7 19s. to pay a six per cent, dividend. To this little Poole and Bournemouth Company belongs the credit of being the pioneer of sixpenny telegrams. Throughout its career, the charge for telegraphing between Bournemouth and Poole, and vice versa, was sixpence for ten words, excluding addresses. When the undertaking was taken over by the Government, local traders and others had to face some disadvantages, for the charges went up, and many years passed before sixpenny telegrams were again in operation here.

Another interesting development described in current records as 'the inauguration of a new era' occurred about the same time. On the 17th August, 1860, Mr C. A. King laid the foundation stone of Branksome Dene – the beautiful marine mansion at Westbourne now owned by Lord Wim- borne. Respecting it we read: 'The wild scenery which stretches out in front of the site of the mansion is both bold and picturesque. Across the ravine a rustic bridge, made of timber and iron rods, has been thrown by C. W. Packe, Esq., of Branksome Tower, whose estate joins that of Branksome Dene, and who is the owner of the greater portion of the ravine.' Besides the bridge, an embankment was built, and this was subsequently the cause of contention and litigation. The land on both sides at the seaward end of the ravine belonged to Mr Packe; the land at the upper end was the property of Mr King. The latter's view of the sea was obstructed, and hence the trouble. Both bridge and embankment have long since disappeared. The conservatory subsequently erected at Branksome Dene was one brought from the Exhibition in London in 1862. Commenting on the stone-laying ceremony referred to above, the 'Directory' had the following: 'We regard with peculiar gratification the erection of such noble mansions as Branksome Dene Hall, Branksome Tower (C. W. Packe, Esq., M.P.), and Boscombe Lodge (Sir Percy Shelley). They may be considered as the inauguration of a new era, and the first instalment of similar buildings which shall give Bournemouth an influential neighbourhood.'

Reference having been already made to the Belle Vue Boarding House, we may mention that this establishment became the Belle Vue and Pier Hotel about sixty years or more ago. As has been said, the first proprietress was Mrs Slidle; the next that we can trace was a Miss Robbins in 1846; Mr Bayly in 1847; then Mr Matcham, from the Royal Hotel, Southampton, was proprietor, 1850 to 1853; Mr Macey, 1853 to 1857; Mr S. Newlyn, 1857 to 1858; Mr Bill, 1858 to 1859; Miss Toomer, November, 1859. In later years the property was owned by Mr T. Beechey; afterwards it was acquired by Mr Dore, and has since been purchased by the Corporation in order to prevent the operation of restrictive covenants against them and to facilitate a project for the erection of a Pavilion near the sea front. The Assembly Rooms attached to the hotel were used for a great number of purposes: as a place of worship for various denominations, for concerts and entertainments, for public meetings and political assemblies, for dances and conversaziones, and for many official and semi-official gatherings.

In a previous chapter we have quoted a remark that, fifty years or so ago, Bournemouth was 'intensely dull.' Perhaps it was its dullness that provoked some restless spirits to hilarious festivity on the 5th November – the day sacred to the memory of the discovery of the infamous plot of Guido Faux. Mr Grantley Berkeley, whom we have before quoted, has

described Bournemouth as he saw it at that time. We are afraid he was not altogether an unprejudiced observer; but he had a racy style, and is worth further quotation, with the caution that his remarks must be taken cum grano salis. In that same work from which we have quoted in Chapter IV., and in which he describes the ladies of Bournemouth as bobbing 'about from dell to dell as if they thought every bush concealed a serpent and a tempting apple, and that they were never safe unless at church,' while admitting to have seen 'much fun' here, he describes Bournemouth as 'the prettiest, most pretending, but generally stupidest place' he was ever in. The adjectives, it will be noted, are not all depreciative. 'At Bournemouth,' he says, 'man has no amusement of any kind; and what is stranger still, when men and women meet at this watering place there is no association, no promenade, as at other places, where the people walk; and not an opportunity sought in which to exchange an idea.' That Winter Garden evidently was badly wanted! 'Nature,' he adds, 'has been most prodigal in her gifts to this secluded spot.' 'Every prospect pleases.' But that did not satisfy him – the inhabitants were too decorous and unsocial. 'Bournemouth seems made for social enjoyment, and to waken the heart to genial sympathy; yet the visitors apparently shrink within themselves, remaining in their lodgings or hotels, or secreting themselves in the cover afforded by the neighbouring bushes. It is a very quiet place for sedentary or literary occupations. But were it not for the advantages of the adjoining wilds, and a fir-wood still bearing the suggestive title of Cupid's Grove – because there was a time Avhen to my certain knowledge lovers used to meet there – no one at this fashionable watering place would be able to speak to his friend, to walk out, possibly not to sneeze, without its being known to and canvassed by the community in their various hiding-places.

Bournemouth is, as I have said, a very pretty place; it is also a very strange place. It has more Divine service in it, and the churches are more crowded and better attended than in any place I ever saw. Week-day as well as Sunday the apparently religious flock to their places of meeting, and then only can you judge of the number of people who between whiles secrete themselves in the bushes, or occupy themselves in their seclusion at home in illuminating lengthened scraps of paper with gaudy letters that make a Scriptural quotation. When completed, these are stuck up in drawing-rooms and bedrooms, to the special disfiguring of the walls. From the way the churches were thronged, and the frequency of Divine service, I had thought at first that Bournemouth must rank high in sanctity and decorum, but on inspecting the visitors' list kept at the Library, I therein saw that no less than twenty-seven fresh clergymen had arrived in one week. What then means this advent of religious men? Surely there must be some reason for their flocking here. Either the place has been very wicked,

or it must become good. I have been told that it is a nursery for Puseyism, and that this class of visitors come to learn its attractive ceremonial previously to introducing it to their own congregations.'

An exceptionally interesting event which occurred on September 1st, 1863, was the visit of H.R.H. the Princess Louise (now Duchess of Argyll), by invitation of Sir James Clark, one of the physicians to Queen Victoria and an enthusiastic admirer of Bournemouth. Her Royal Highness steamed down from the Isle of Wight in the yacht Elfin, landed at the Pier, dined with Sir James Clark at 'Eagle's Nest,' visited the Cranborne Gardens, 'now so great an ornament to the place,' and proceeded to the Flag-staff at the Coastguard Station, 'from which one of the best, if not the very best, views of the place is to be obtained.' The contemporary report states that the Princess and her suite expressed themselves 'pleased with the general appearance of the place,' some of the party, who had visited Bournemouth before, being surprised at the progress which had been made. Thirty years later her Royal Highness visited Bournemouth again, 'admired the natural beauties of the town and neighbourhood,' and found it 'very pleasing to see the wonderful advance in prosperity and importance made by the Forest City of our Southern Sea.' Our extract is from the letter written by his Grace the Duke of Argyll – that letter in which, as will be noticed, occurs the notable phrase expressive of Bournemouth's distinctive characteristic and of the ideal which its best friends hope it will endeavour to maintain.

Here we may add the remark that seven years previous, in 1856, Bournemouth was honoured with a visit from the late King Edward VII., then Prince of Wales, who was touring the country in. cog. with his tutor, Mr Gibbs, and among other places visited Bournemouth and Poole, Wimborne and Swanage. His Royal Highness walked along the Beach from the Bath Hotel to Sandbanks, crossed the water to Branksea, and spent considerable time in inspecting the Island and Castle – interesting alike on account of their romantic and picturesque situation and their historic association.

A Period of Immense Growth & Extension

A Magazine writer in 1859 described Bournemouth as a place that had 'had no origin whatever': that 'was born of nothing' and had 'hardly grown one brick since its birth.' His article was evidently written in humorous mood, but the humour met with little local appreciation. Bournemouth, indeed, was at that time adding brick to brick, and giving promise of remarkable extension. The Board of Improvement Commissioners had been established; they had done much preliminary work, and more was in contemplation, to meet the needs of what it was apparent must soon become, in fact as well as in name, an urban community. In 1851 the population of Bournemouth was enumerated as 695, the Census of 1861 showed that it had increased to 1707. In 1871 the population in the same area was more than three times that total, the Census return placing the number at 5,896. Already the fruits of enterprise were being reaped. But there was an era of still greater expansion coming, and the return for 1881 showed a population of 16,859. There had been some slight increase in the area of the district in the interval, but even when allowance is made for that fact, the population is seen to have more than doubled in the decade, and to be nearly twenty-five times as great as it was in 1851! In 1851, by the way, the population of the whole of the Christchurch Union was but 8,482. Fifty years previous it was 5,102. Fifty years later – in 1901 – it was 69,340. Various causes contributed to produce this marvellous expansion. We have referred to the work of the Commissioners and the general enterprise of the inhabitants – the provision of the Pier and some other 'attractions' for the pleasure seeker and that other treasure-hunter who came in quest of health. Among other causes which led to the building of 'brick' upon 'brick' – particularly during the decade 1871–1881 – were the creation of new facilities of travel – the opening up of the railway system – the provision of gas and water supplies, and the general advance in the standard of comfort aud convenience which Bournemouth was able to offer to its patrons.

At a meeting held at Christchurch in December 1858, Admiral Walcott, M.P., said he 'was 66 years of age, and from the time of his childhood

until that moment he had never seen an increase in the wealth or any improvement in that town and neighbourhood. And why? They were stuck into a corner with great natural advantages, but had never been able to make proper use of them! There was a good beach, two rivers, no turnpikes, and a beautiful country round, but the chief thing had up to that time been wanting, and that was a railway. He considered the present station was useless to them.' The 'present station' was at Holmesley, then called Christchurch Road, five miles away! Bournemouth was still more heavily handicapped, for it was five miles further from 'the iron road.' Its seclusion was a charm, no doubt, to some people; but the lack of facilities of access prevented many more from realising its advantages, and restricted its growth. Yet there was always opposition to any railway advance. We have referred in a previous chapter to a suggestion once made that a railway station at Iford would serve the purposes both of Christchurch and Bournemouth. Even as late as 1882, at a public meeting to consider certain improvements then under discussion, we find one of the speakers quoting the following lines:

"'Tis well from far to hear the railway scream.
And watch the curling, lingering clouds of steam;
But let not Bournemouth – health's approved abode.
Court the near presence of the iron road.'

The rev. gentleman who quoted the above, was asked if he would like an organ accompaniment for his recitation; but he spoke apparently in all sincerity, and represented a feeling with regard to the railway which was long entertained by many people, and which proved an effectual block to various schemes from time to time put forward. The story of the Bournemouth railway service would of itself fill a small volume. We can only afford space for a summary of important facts. In 1862 a branch line was opened from Ringwood to Christchurch, and henceforth the omnibuses ceased to ply between Bournemouth and Holmesley. But it was not till eight years later that they were entirely taken off the road, and Bournemouth was first placed in direct communication with London and the railway systems generally. March 14th, 1870, was the date of the opening of the first railway station in Bournemouth itself – the running of the first trains into and out of the district. The station was in what is now the goods yard, Holdenhurst Road, on the very fringe of the Commissioners' district, the opposition of the lovers of seclusion having forced the company to keep back – 'out by the brickfields.' The Station Master was the late Mr Leach, and Mr J. Phillips, now the Borough Collector, was booking clerk and issued the first ticket. The Company signalised the opening of

the line by carrying passengers between Bournemouth and Christchurch free of charge. In 1872 another new line of railway was opened between Broadstone Junction and Poole, and two years later this was extended to Bournemouth, which then became possessed of two railway stations, East and West, with no track communication between the two except by a circuitous route of about twenty-five miles. This condition of things lasted till 1888, when the South-Western Railway Company completed the construction of a new Direct line between Brockenhurst and Christchurch, and linked their Western with their new Eastern (now the Central) Station. Later improvements have included the construction of a line from Broadstone to Bailey Gate, giving better access to the Somerset and Dorset and the Midland systems, and another new line across the backwater of Poole Harbour, greatly advancing the convenience and the facilities of travel between Bournemouth and Weymouth. Pullman cars and corridor trains came in due course, with such increase in speed that the non-stop expresses now do the journey between London and Bournemouth in two hours and ten minutes. Additional stations have been provided at Boscombe and Pokesdowr., and in connection with the motor train service a 'halt' has also been established at Mevrick Park.

On the occasion of the opening of the 'Direct Line' it was officially stated that the Company had spent over £600,000 on the new line, station accommodation, and junction line between the East and West Stations. Since that time there has been still further and very considerable new capital expenditure to meet Bournemouth's needs. Further evidence of the Company's enterprise and development may be found in the fact that, whereas, in 1871 they were assessed at only £100, their four stations, lines, etc., within Bournemouth, are now assessed at upwards of £7,000 – and this exclusive of charges on stables, cottages, offices, and some other properties.

We come now to the record of a private enterprise which, at first looked upon with suspicion and distrust, within a few years achieved remarkable success. Where now stands the Gervis Arcade – generally known as 'The Arcade' wasformerly a pretty glen, crossed by a rustic bridge. The late Mr Henry Joy, who was an astute and practical business man, conceived the idea of making this a great shopping centre, and in spite of much opposition, of protest against his vandalism, and ridicule of his work ('Joy's Folly' was what it was designated), he carried out his scheme, which eventuated in a popular public rendezvous – a main thoroughfare from the Christchurch Road to the Westover Gardens and the sea.

Covered with ivy and other climbing plants, and in the summer time with wild roses, the rustic bridge which the new arcade displaced was undoubtedly a beauty spot. Many happy recollections are recounted by

those now living who can remember the keen appreciation of the delight and charm of this bridge with the glen below. Situated in exactly the same position as the Arcade, the bridge, built of rough fir poles, faced at the north end a group of pseudo-Elizabethan and thatched cottages ('Ashley' and other cottages, the sites of which are now occupied by the Town Hall Avenue), and at the south side the entrance to the Westover Gardens and Westover Road. On the east of the bridge, on the site of the 'Fancy Fair,' stood Church House; the whole of the land on the east and west being named Church Glen. About 20 or more feet below the bridge ran a tiny brook, which came from the vicinity of the Lans downe, and flowed behind the site of the houses and shops in the Old Christchurch Road; in front of the Grand Hotel site, St Peter's Road, under the old Post Office, lately demolished, so down the glen under the bridge, and finally into the Bourne. The glen was not filled in, consequently the basements of the Arcade shops are in most cases double. The Rustic Bridge was erected by Mr Thomas Shettle in 1853, for the benefit of his tenants in the Old Christchurch Road, and afterwards for that of the general public, and a charge of one halfpenny was made for its use; the grounds in the valley were also laid out.

The Arcade, commenced in 1866, took seven years to complete. The two sides and the four 'pepper castors' were erected some time before the roof was put on. Owing to the difficulty of erection, mainly due to the great depth and unsatisfactory nature of the foundation, the project threatened to ruin the intrepid builder. He lived to see the day, however, when his former 'Folly' became one of the town's most valuable assets. It is interesting to relate that so little was thought of the value of the premises that, in 1868 a shop and residence could be had for £40 per annum; in fact, some of the premises went a-begging for a long time. Today Arcade shops are assessed at from £200 to £240 per annum, showing a value six or seven times as great as when first erected.

In the Arcade was established in 1870 what we choose to term our fifth Post Office, and the institution for the first time of the telegraph under the care of the postal authorities. Reference has already been made to the establishment of the Post Office at the Tregonwell Arms in 1839; on the removal of Mr Fox from the Tregonwell Arms to a house on the site of the National Provincial Bank, near the Square, in 1848, the work of the Post Office was carried on till, at a later period, it was established at the foot of Commercial Road, when Miss Bell was Postmistress, and where money orders were first issued in 1851. When Southbourne Terrace was built in 1863, the office was installed in a building adjoining the Terrace occupied by Mr Fox, who acted as Postmaster. There was a Postmistress again in 1868, for we have a record that her salary was increased from £60 to £80.

When the Post Office was established at the right hand corner of the Arcade in the Old Christchurch Road, the work was in the charge of Mr W. Dunn, who managed to meet the rapidly increasing requirements of the place from time to time, and, as it is recorded, 'a single youngster was enough to assist him in the manipulation of all the letters that found their way either to or from Bournemouth.' If a telegram was received which was apparently of extreme urgency, it was not an unknown event for the Clerk to close the office and deliver the message! The postal staff was increased in 1873 to one inspector and six postmen, the latter receiving 15s. per week. The 'round' of one of the postmen was from Bournemouth to Muscliff – away beyond Moordown – delivering letters to the houses on his way, and for this he was rewarded by a grateful country with 16s. per week! In 1883 a handsome building was erected near St Peter's Church – making the sixth office – which did duty until its seventh and present home was erected and opened on the 1st August, 1896, extended in June, 1904, and now inadequate for the enormous amount of work transacted. A contrast of the present staff and that of 40 years ago shows in a striking manner another phase of abnormal growth in, comparatively, so short a time. The present Postmaster is Mr C. E. Tennant – succeeding Mr Millard – and the staff under his charge numbers 404. The indoor staff has increased from 'one youngster' in 1870 to 96 at the present time. The staff of postmen in 1873 was six, it is now 203. There are also 29 sub-postmasters, and 63 telegraph messengers, as well as seven inspectors and assistant inspectors, and six minor officials.

Two interesting souvenirs of an early period when one letter carrier from Poole did all the Postal work of Bournemouth, lie before us. The first reads as follows:

PARKSTONE AND BOURNE POST OFFICE.

The inhabitants of Parkstone and Bourne are respectfully informed, that the Post Town appointed for the delivery of Letters for the above places, is Poole; and that there is a Receiving House at Parkstone, which has been established five years; and that I, as the regularly appointed Postman, deliver and receive the Post Letters at Parkstone, Bourne, and the Immediate Neighbourhood, and call at the Bath Hotel, and the Tregonwell Arms, Bourne, every day.

Charles Satchell.

Parkstone, May 6th, 1839.

The second note suggests that, like the policeman's of comic opera, the 'postman's lot' was not always happy:

I, the undersigned, Thomas Ws, do hereby express my sorrow and contrition, for having in a state of intoxication, and without any provocation, assaulted and abused, Mr Charles Satchell, the Bourne Postman, whilst in the discharge of his duty, and I am very thankful to Mr Satchell, for accepting this apology, instead of Prosecuting me.

Thomas W

Dated this 12th day of June, 1841.

At another period one William Kidner –'Billy Kidner' he was generally called – was the letter carrier. He also came from Poole, and at one time was a constable in that town. The story is told that he incurred the displeasure of a big, powerful fisherman, who, passing along the street one day, in freakish mood, caught Kidner up in his arms, dropped him into a box, hoisted the box on his shoulders, and walked off with him, 'Billy' shouting the while: 'Bill H, Bill H you don't put me down, I'll take you up'!

As many references have been made to the Tregonwell Arms, it will be interesting at this point to give a few particulars respecting this old landmark, which was taken down in 1884. In the Autumn of 1832 an agreement for renting the Inn was signed by Mrs Tregonwell (who evidently was a practical business woman) and Mr George Fox; with Lord Portman, of Bryanstone, as a witness. In 1837 Mr Fox purchased the Inn, and afterwards the land since known as the Beckford Estate – extending from the Inn to the Square, up Richmond Hill to Windsor Cottages (the present site of the Catholic Church). In 1839 Mr Fox made a successful application for the establishment of the Receiving Post Office, to which we have already referred. The tea gardens adjoining the Inn were frequented by summer visitors from the country, there being then a beautiful view of the Bay Stables were built at the rear of the house, and bathing machines were provided on the Beach. The Inn also owned a skittle-alley, in which contests were frequent between the visitors and the tradesmen. The Postmaster acted as referee upon all sorts of matters, Mr Fox being looked upon as a kind of general authority. The Inn was much frequented by smugglers, and many a rollicking song was no doubt heard within its walls, in spite of the watchful preventive officers. Before St Peter's Church was built a daughter was born to Mr Fox at the 'Tregonwell'; she became Mrs Albert Dawes, her husband being a well known music dealer of the town. It is said that in order that the child should be christened the journey was made to Christchurch by water, and the late Mr W. E. Rebbeck, who was one of the party, acted as godfather. During the numerous building operations the 'Tregonwell' was, naturally, much resorted to by workmen and others for necessary refreshment, and the landlord, who was much respected, received at

all times great kindness from the Tregonwell family and the late Miss Frances Strangways, a relative of the Earl of Uchester, who used to stay at Terrace Cottage, and who stood sponsor at the christening of Mrs Dawes. It is recorded that Miss Strangways herself dressed the little baby for the ceremony in a robe she presented. The ground known as the Beckford Estate was purchased in 1837 by Mr Fox for £560. A sale was held at the Criterion Hotel on the 15th April, 1883, when there was keen competition for the land. The site, including the adjoining Wesleyan Chapel, realised upwards of £20,000. £800 was given for the site at the foot of Richmond Hill in 1866; £3,000 for the Tregonwell Arms and site of Southbourne Terrace in 1863; and £6,500 for the same site in 1877. The price of the portion sold in 1883, having a frontage of 200 feet to the Richmond Hill and totalling about 3,630 square yards, was £5,640. Mr Fox resided at the Tregonwell Arms from 1832 to 1848, subsequent tenants being Mrs Butler, Mr Thorne, Mr Bartlett, and lastly, Mr C. Hayball from 1879 to 1884, when it passed into the hands of the Bournemouth Blue Ribbon Gospel Temperance Union, the license having been allowed to lapse. Some time afterwards the 'Tregonwell' and Church adjoining were pulled down and a new roadway made called Beckford, or (latterly) Post Office Road.

When Mr Tregonwell built his residence the district covered by the grounds of the Winter Gardens was in a delightfully wild yet pleasant state. Here in this spot he was in the habit of taking daily exercise whenever he was at 'Bourne.' Undoubtedly deriving its name from that of the Founder's country residence, 'Cranborne Gardens' became the title of the district lying west of the Exeter Road. The first public use made of the Gardens was that of an Archery Meeting in August, 1862, the place afterwards being known as the Archery Grounds.

Archery, ascribed to Apollo, who communicated it to the Cretans, became more or less the fashion sometime after the Toxophilites established themselves in 1781, which society eventually took grounds in the inner circle of Regent's Park in 1834. This form of sport, never very exciting, has occasionally been revived in Bournemouth, an archery meeting being now and again held in the Dean Park.

Little beyond the meeting above mentioned was done in this favoured spot, until in 1875 a company was formed – the Bournemouth Winter Garden Company – with the object of erecting a place of greater pretensions than the Town Hall and the Belle Vue Assembly Rooms, which latter had done duty for so many years. Before the building was finished the company inaugurated a skating rink in the grounds, on the site now partly occupied by the lawn used for the al fresco concerts. But here we may remark, en parentheses, that the first skating rink to be established in the district was

that managed by Mr John Cunnington, early in 1875, in the Palmerston Gardens, Boscombe, where morning and afternoon assemblies were held on four days of the week.

There was a numerous assemblage at the Cranborne Gardens on Saturday morning, the 15th January, 1876, on the occasion of the opening of the Bournemouth Rink, and the band of the 4th Hants A.V., by the kind permission of Captain Rebbeck (now Colonel E. W. Rebbeck, V.D.), discoursed sweet music to the company as they glided about on their little runners or wheels, gracefully or otherwise. The proceedings were under the management of Mr W. J. A. Knowles, Secretary of the Belgrave Skating Rink, London; and accompanying him was a young lady named Miss Watkins, whose easy and graceful evolutions were the very 'poetry of motion.' The surface of the rink was of cement, hard as iron and perfectly smooth; and the rules were framed on those of the Belgrave Skating Rink Club. Racing, use of sticks or strings, and hand-in-hand skating of more than three were forbidden. After dark the Rink was lit up by torches, and an animated scene was witnessed. The dimensions of the Rink were 104 feet by 50 feet.

During the Skating Rink's first season the completion of the Winter Gardens was pushed forward, as the contractors were under an obligation to finish within the year. The fact that it was mainly intended as a large greenhouse or winter garden is suggested by its being designed by a firm of horticultural builders – Messrs. Fletcher, Lowndes and Co., of Great George Street, Westminster. The erection was superintended by Messrs. Tuck and Cumber, of Bournemouth, and it cost upwards of £12,000. The gallery, then consisting of three sides only, was intended to be used, like the Crystal Palace, for stalls, fancy ware, etc. The 'Old Curiosity Shop' and Messrs. Wood and Impey's exhibit were the only spaces utilised at the opening, the latter meeting with the decided approval of the directors. £100 was offered for the west end of the building as a picture gallery, which offer was accepted. It was this portion which was designed as the permanent concert room, having floor accommodation for 500 chairs. Altogether offers for space amounting to £300 per annum had been accepted as soon as the building was opened. The opening ceremony was performed by Sir Henry Drummond Wolff, K.C.M.G., M.P., who was supported by Mr T. J. Hankinson, Chairman of the Commissioners, and others, on the 16th January, 1877, and about 550 persons were present. The building was never a success, and in spite of frequent exhibitions and shows of various kinds, it was found necessary to close the place. It was re-opened on the 19th February, 1884, when another attempt was made to make it a popular rendezvous. Once more the doors were closed owing to lack of support, till in 1893 the Corporation leased the building and

opened it as a temple of music. Having high ideals as to the nature of the enter tainments to be provided by the municipal purse, the Corporation engaged Mr Dan Godfrey, jun., then a young man of 25 years only, though with a wide experience of his profession. From that time we can safely say that the Bournemouth Winter Gardens have been a most valuable asset to the town. Through the instrumentality of the Corporation and their talented conductor, the fame of the Bournemouth Municipal Orchestra has spread to almost all quarters of the Globe. The alterations to the building are of comparatively recent date and hardly call for enumeration. It should be mentioned, however, that an organ was situated at the back of the platform; and the fourth side of the gallery has been added, making a continuous promenade. The beautiful palm trees were gradually removed from the central hall to the east wing, and eventually displaced almost entirely, until the name Winter Gardens became a misnomer. When the acquirement of the property was under consideration, the place was advocated as a 'Rendezvous.' But the title 'Bournemouth Rendezvous' never took on – nor were the Corporation ever able to make it a Rendezvous in its fullest sense. It is a Temple of Harmony, but not a daily meeting place – a rendezvous – for visitors and residents, irrespective of the concerts and entertainments.

Before concluding this record it should be mentioned that the salaries of the bandsmen for the Winter Gardens alone amount to £4,312. The total annual cost of the Municipal Orchestra, excluding the salary of the Musical Director, is £8,600. The musicians included in this amount perform in the Winter Gardens, on the Piers, as well as in the public Gardens of the borough. The total expenditure on the Winter Gardens for the year 1908-9 amounted to £14,535. Bournemouth was the first municipality to provide music, and while other towns have followed this excellent lead, hardly any are able to maintain an orchestra all the year round.

Though the Commissioners were able, as early as 1860, to open a pier, they were not at once able to give all the facilities needed for aquatic excursions. Indeed, it was not till late in 'the seventies' that there was such accommodation as permitted, and secured, the running of regular excursions throughout the summer months. Poole steam tugs made frequent trips between that town and Swanage, but to get to Poole meant a long omnibus ride, which considerably discounted the pleasure of the boating trip. From Poole also there was during some substantial period a passenger and goods traffic to and from Cherbourg, worked by a local company. Great things were anticipated from the inauguration of this international trade, civic courtesies were exchanged, and an entente cordiale was established. In 1865, the Mayor and Corporation of Poole attended an 'international banquet' given at the French seaport, and before

the season ended there was a return banquet given at Poole, when the Corporation, not content with utilising their Guild Hall, built a temporary erection in the Market Place, so that their guests might be received with all the honour and dignity befitting what they vainly believed would prove an event of international importance. But the scheme failed – largely through the lack of adequate railway facilities for distribution. At that time, as already indicated, Bournemouth was cut off from railway communication with its neighbours, and consequently did not offer as good a market for the French produce as it would otherwise have done.

The first pleasure excursion from Bournemouth of which we have any record was in 1868, on the occasion of the visit of the Shah of Persia to this country, when Mr David Sydenham chartered a Southampton steamer named the Fawn, for a trip to Spithead, where a review of the Fleet was held in honour and in the presence of the monarch we have named. This was followed by further speculations in solitary excursions in the following year, and then by the formation of a small company under Mr Sydenham's management. This company ran a steamboat named the Pearl, and afterwards one called the Aid; but the result was a pecuniary loss. Then in 1871, the late Mr George Burt, of Swanage, purchased the Heather Bell (whose memory lingers in the pages of Besant and Rice, and of Thomas Hardy), Mr Sydenham acting as his Bournemouth manager, and Mr George Hale as Captain. She was a Clyde-built steamer, credited with a carrying capacity of 246, and capable of steaming nine miles an hour! A contemporary description of her says that 'spacious saloons were fitted up with every regard to comfort,' though 'a coat of paint' was required 'to complete the handsomeness of the craft.' While the painting was going on a small boat named the Lothair did duty. The Bournemouth Promenade Band usually accompanied the Heather Bell on her excursions, and every reasonable effort was made to render the service popular. But at the end of 1876 Mr Burt intimated his wish to retire from responsibility, and withdrew the vessel, whereupon a town's meeting was held (under the presidency of the late Mr J. McWilliam), and a committee of five appointed to confer 'with the Weymouth and any other company as to the best arrangement that can be made to supply steam communication in succession to the Heather Bell.' This eventuated in the formation of a new company, and the chartering of a vessel called the Criterion, with a Board of Trade certificate for 137 passengers. An interesting fact in connection with this vessel is that she was the first to make use of the landing stage erected consequent upon the partial destruction of the Pier in 1876. Prior to that there had been steps at the side of the Pier, and accommodation for landing from small boats, but no proper means of going from Pier to steamboat, or vice versa. In the summer of 1878, the Lord Collingwood

took the place of the Criterion, and then in the early summer of 1879, there was the Transit, with a competing boat named the Royal Saxon, run by Messrs. Sharp Brothers. Competition became so keen that you could go to the Isle of Wight and back for 41d., and subsidiary attractions were provided. 'The Transit was advertised to carry the Royal Italian Band, who were to play a choice selection of operatic airs on board, whilst the special attraction advertised for the Royal Saxon was that the boat would carry on the occasion Messrs. Roberts and Archer's Dramatic Company.' 'What the talented members were to do on board, the bills announcing the excursion did not set forth,' but, adds the chronicler, 'the farce of "Beggar my Neighbour" is, however, being enacted by the rival companies and is causing some amusement to the visitors and residents.' The running of Sunday excursions was attempted, but the Commissioners put up the Pier tolls; so it cost the Sunday trippers more for pier tolls than steamer fares, and the experiment failed. In August, Messrs. Sharp announced that 'in consequence of the disadvantages attending the passenger traffic from the pier, owing to its dilapidated and unfinished condition,' they intended to withdraw the boat for the remainder of the season. In 1880 the Local Company ran the steamboat Carham. In connection with a boat named the Florence, which was also 'on the station,' a very sad accident happened. Backing out from the Pier on the conclusion of her day's work on Saturday, 4th September, she ran into a pleasure boat named the Kittiwake, under the charge of a boatman named Jesse Cutler, and four lives were lost – a lady visitor, two young girls, and the boatman's little boy. The Local Company being wound up, Mr Sydenham in 1881 transferred his services to Messrs. Cosens and Co., of Weymouth, who have from that time down to the present maintained a fleet of popular vessels, including the Monarch, the Emperor of India, the Majestic and others. In 1881 the 'Bournemouth, Poole and Swanage Steam Packet Company' was established, and purchased the 'fast and magnificent saloon steamship Lord Elgin' for which it was claimed she was 'the largest and most powerful vessel on the station,' her average speed being thirteen miles an hour. 'The directors, however, having regard for the comfort of their patrons, have given instructions to their captain on no account whatever to attempt racing.' The Lord Elgin was so successful that the directors proceeded to acquire a new boat, which was specially built for the service and named the Bournemouth, the intention being to use her for long journey trips. She had, however, a most unfortunate career. On the 20th August, 1884, one man was killed and many persons injured through a firework explosion in connection with the Regatta Day festivities, and on the 27th August, 1886, she ran ashore on Portland Bill during a dense fog, and became a total wreck. Fortunately there was no panic among passengers or crew,

and no loss of life. Other boats subsequently owned by the company were the Brodick Castle and the Windsor Castle. The Company itself, after a chequered career, was wound up in 1908, the business being taken over by the Southampton and Isle of Wight Steamship Company, who had themselves been running excursions to and from Bournemouth, as had also the Messrs. Campbell, of Bristol. Mr Edward Bicker was Secretary of the Bournemouth Company from 1883 to 1908.

Extensions of Area

The district assigned to the Bournemouth Improvement Commissioners, under the Act of 1856, as we have already shown, was a comparatively small one, and its boundaries were determined under a peculiar system. The ecclesiastical district of St Peter's had been formed some years previous – carved out of the ancient parishes of Christchurch and Holdenhurst. The Commissioners' district comprised only part of the district of St Peter's, but in that part was included portions of both the old parishes, with the result that for certain parochial work Bournemouth remained attached to these two old centres. In the election of Overseers, for instance, and of Guardians of the Poor, one section of its population found representation through Holdenhurst, another through Christchurch.

Even before the passing of the Improvement Act – but mainly consequent upon the Founding of Bournemouth – there had sprung up new and growing centres of population on the surrounding heathlands: artizan suburbs, if we may so describe them. And here we ought to put on record the fact that, from the earliest date, the people of Bournemouth – led in this matter, as in so many.others, by the late Rev. A. M. Bennett, the Founder of St Peter's – recognised a responsibility for the spiritual care and education of the people of these artizan areas, and bore noble part in the provision of churches and schools. This remark applies, not to Churchmen alone, but to Nonconformists as well, and now that all these districts have been brought within the domain of the Parish and County Borough of Bournemouth, the circumstance of this early and voluntary recognition of responsibility ought not to be overlooked. Bournemouth has extended its boundaries many times – but these annexations have never been dictated by mere greed of territory. Each step has, indeed, been justified by the broadest, most comprehensive review of attendant circumstances and public interests.

The first extension took place in 1876, and had the effect of bringing into the Commissioners' area Boscombe, Spring- bourne, and a tract of pinewood property known at the time as the Seventy Acres, lying between Boscombe Chine and Derby Road. Boscombe, as we have already

shown, had its 'Copperas works' in the time of Queen Elizabeth- just as Bournemouth had, and never probably was wholly without inhabitants. The Award map of 1805 shows Boscombe Cottage, but the mulberry trees still standing in Lord Abinger's grounds at Boscombe Manor date back to the time of the Stuarts, and suggest an occupation of Boscombe at least as remote as that period. The late Sir Percy and Lady F. Shelley settled here some sixty years ago – at a time when Boscombe comprised only a few thatched cottages and a wayside inn, then known as 'The Ragged Cat,' and afterwards as the 'Palmerston Arms.' Then came the erection of artizan dwellings to meet the needs of Bournemouth, in which there was no working class quarter. A big development came some years later, and Boscombe assumed such importance as threatened to make it a rival watering place to Bournemouth. The 'boom' in its fortune originated in the purchase of 'a small estate' of land by the late Sir Henry Drummond Wolff, lying between the Christchurch Road and the sea, east of Boscombe Chine. To this estate was given the name of Boscombe Spa, from the circumstance of there being on it a supposed impregnated mineral spring which it was said possessed properties similar to those of the Harrogate waters. The greater part of this area was at one time pine wood; you stepped from the Christchurch Road right into a squirrel-haunted wood which bordered the thoroughfare from Sea Road westward to the Chine. Sir Henry laid out the estate, built a house for his own occupation, and named the principal roads after literary colleagues of 'The Owl' – a socio-political newspaper, the pioneer of Society journals, of which he was one of the earliest contributors. He had as a neighbour Sir Algernon Borthwick (now Lord Glenesk), whose association with the neighbourhood continued for many years, and helped not a little to promote the renown of Boscombe. Sir Henry's house was a charming villa known as Boscombe Tower. 'Tankerville,' another house owned by Sir Henry, became in later years famous as the temporary residence (and scene of extradition proceedings) of Dr Hertz, of Panama fame. Part of Sir Henry's work for Boscombe included the demolition of the old brick-kiln in the Chine, and the substitution therefor of a rustic building for the accommodation of tennis players, some other pioneer work of transformation, and the construction of a rustic wooden bridge spanning the valley from Boscombe Cliff. A contemporary description of Boscombe as it appeared some time prior to 1875 was 'a scene of indescribable desolation.' In its early years land was of even less than the 'prairie' value which prevailed in Bournemouth, and the story is told of a man named Holloway who was engaged to do some turnip hoeing. He asked 4s. for his day's work. His employer thought that was too much, and suggested that he should take an acre of land instead! But the man

wanted money, and was not inclined for speculation. Some years after the land fetched £275 an acre!

In 1875, when the question of extending the Commissioners' district was raised, Boscombe organised a strong opposition, and presented a counter petition to the Local Government Board asking for the formation of a new Urban Sanitary District, to include both Boscombe and Springbourne and adjoining areas. Mr C. T. Miles, who at that time and for some years afterwards acted as agent to Sir H. D. Wolff, was engaged to make a plan of the district, Mr R. D. Sharp acted as legal adviser to the committee, and Messrs. Wicks and McEwan Brown were Secretaries. The Local Government Board, in accordance with their usual practice, held a local inquiry, and in May, 1876, intimated their assent to the scheme of the Commissioners, the new district to have the privilege of electing three representatives to sit on the Board. The Boscombe Committee protested against this ruling, but in due course a Provisional Order was made and the annexation consummated, Boscombe receiving some concession in the way of differential rating. The election of Commissioners for the new area took place on the 10th October, 1876, when Mr Henry Joy, Mr John Cunnington, and Mr William Toogood were returned out of six candidates, one of whom, it may be mentioned, received only six votes.

Boscombe development went on apace – notwithstanding some not inconsiderable handicap. Up till 1885 it had no railway station of its own; it was an outlying district, and it had no Pier – no eentre of attraction for its visitors, and no facilities for taking part in those acquatic excursions which had now become one of the delightful features of the summer season. In 1885, the advisability of erecting a Pier was pressed upon the attention of the Commissioners, and a resolution was actually passed affirming the desirability of the Board applying to erect and maintain Piers both at Boscombe Chine and Alum Chine. But nothing came of these expressions of pious opinion. Boseombe, however, was preparing to help itself. At that very time, proposals were afoot for promoting the formation of a Pier Company, and shares to the amount of £3,000 were said to have been applied for. But it was not till 1888 that there was an actual commencement of works. Then, on the 17th' October, Boscombe had a 'gala day,' and the first pile was fixed by the late Lady Shelley. The length of the Pier was 600 feet, with a landing stage on each side, and the usual accessories. The cost was put at £12,000, and the directorate of the Pier Company included Sir H. D. Wolff, Mr G. M. Saunders, Colonel Pott, Mr C. R. Hutchings, Dr Deans, Mr T. H. Phillips (succeeded by Dr De Landfort), and Mr W. Hoare, with Messrs. McEwan Brown and Wyatt as Secretaries. The opening ceremony took place on the 29th July, 1889, and was performed by his Grace the late Duke of Argyll, who was accompanied on the occasion by his

son, the present Duke (then Marquis of Lome). In an address of welcome which was presented by the Commissioners, as the Local Authority for the district, his Grace was reminded that he was 'no stranger to the beauties and advantages of Bournemouth,' and informed that 'during the twelve years that Boscombe has formed part of the town of Bournemouth, it has shared in the prosperity of the town generally and has greatly increased in extent and population, and this new Pier will doubtless greatly enhance its attractiveness and tend to still greater increase in its development.' His Grace was presented also with two other addresses, besides an album of views – 'a memento of Boscombe' – the first address being from the Pier Company, intimating that 'the Boscombe population will recall to memory with delight in after years the great favour conferred on them this day'; and the second being one from Scotsmen in the neighbourhood, 'where very many of your countrymen have found a sanatorium.'

His Grace's reply to these addresses is worth recalling, for, as suggested, he was 'no stranger,' but had reminiscences of Bournemouth which, as he showed, went back to a period long before the establishment of the Commissioners, and when the combined population of Bournemouth and Boscombe was, at the most, only a few hundreds. It was, said his Grace, in the year 1846, that, being in a rather low state of health, he was recommended by a medical friend, who had written a book called 'Notes of a Wanderer in Search of Health,' to come to Bournemouth, being told he would never get well unless he did. He asked, 'Bournemouth! Where is it?' The reply was, 'It is a place I have seen in my wanderings in search of health, and I have never met with any place on the coast of England that eclipses Bournemouth.' So his Grace took train to Winchester (the nearest point to Bournemouth which was then reached by the South-Western line); and from Winchester he posted through the New Forest, 'and at length arrived at Bournemouth.' And this is the picture which his Grace gave of Bournemouth, as he then saw it: There was the Bath Hotel and there were a few houses in the immediate neighbourhood, and there was almost nothing else. There was a large fir wood which extended all the way from the Bath Hotel in the direction of Boscombe, and he and his friend used to take interminable walks through these fir woods without meeting a single human being. The only living things they could see were some squirrels. After staying at Bournemouth ten days or a fortnight he was perfectly well. His Grace's second visit is equally interesting to recall. He was, he said, 'rather fond of geology,' and happened to discover on the western coast of Argyllshire some very curious fossil leaves, which threw considerable light upon the history of the volcanic rocks in that neighbourhood. The discovery was chronicled in all the books of geology as having given a data for the probable age of those rocks. Soon after that he came down

to Bournemouth, and he found these sands full of almost similar leaves to those he discovered in Argyllshire – curious, remains of the ancient world. His Grace added that he knew no place in the three Kingdoms which presented problems of geology so curious and so interesting as Bournemouth, and mentioned as among the exhibits of the Bournemouth leaf-beds auracarias, now only to be found in New South Wales; cacti, now existing only in North America; and palms, existing only in the tropics. From this interesting speech we extract one other personal note. When his Grace first came to Bournemouth, his friend took him down to the Brook and showed him a solitary trout. 'At that time the valley of the Bourne was one long, marshy, rushy hollow, entirely unprotected, and having no hedge on either side.' His Grace's reference is to a 'solitary trout.' But the writer of a guide book of 1859 was so impressed with 'the Fishery,' that after advocating the deepening and widening of the bed of the Brook, the deposit of clean shingle, and the construction of occasional dams and ledges to produce a greater body of water and better effect, he went on to suggest that 'it would be an additional attraction to Bournemouth if, in the above arrangements with the stream, the fish were preserved, and the liberty of angling only let out to visitors.' The returns thus obtained might, he suggested, 'go to liquidate some of the expenses incurred by improving plantations and setting apart this valley.'

The provision of the Pier was, of course, a great addition to the social amenities of Boscombe; but the structure gave a great deal of trouble and anxiety to its promoters, and was never financially remunerative. In 1903, in response to many appeals, the Corporation purchased the undertaking and brought it under municipal direction. They effected substantial improvements, and the Pier is steadily gaining in popularity. It is not a profit-producing concern – but the deficits which so far have had to be met year by year are more than compensated for by other advantages conferred upon the ratepayers.

Another important factor in the development of Boscombe was the erection of the Boscombe Arcade, Theatre, and other buildings by the late Mr Archibald Beckett. The Arcade was formally opened by H.R.H. the Duke of Connaught on the 19th December, 1892. Further impetus to the advance of the district was given by the provision of the various recreation grounds – including the delightful Cliff Garden overlooking the Bay – the development of a portion of the Boscombe Manor Estate, and the laying out of building estates north of the Christchurch Road.

In 1884 there was a second extension of the Commissioners' district, eastward, northward, and westward, to the amount of 771 acres, and in 1885 a further increase north-eastwards to the extent of 178 acres, the districts thus annexed including Freemantle, Malmesbury Park, Meyrick

Park, and West- bourne. The last named had, like Boscombe, become a centre of population, with the prospect of large development, though with little hope of ever being sufficiently large to become a self-governing area of itself. It was wedged in between Bournemouth on the east and the Dorset boundary on the west; it was part of the Rural District of Christchurch, but could only be approached through Bournemouth. Annexation to Bournemouth was both natural and inevitable, and came in due course in 1884. A quarter of a century earlier Westbourne comprised only some half a dozen houses, including one on the Poole Road occupied as a boarding school. The mansion at Alum Chine now owned by Lord Wimborne, knowm as Branksome Dene, was built, as already shown, in 1860, and the Herbert Convalescent Home was erected in 1865. At that time an open heatliland stretched right away from the top of Poole Hill – where the Pembroke Hotel now stands – to Alum Chine, without a house intervening, and land in what is now the Middle Road was let out in allotments. Mr Henry Joy repeated his experiment in Arcade building, but not with the same phenomenal success that rewarded his effort in the centre of the town. The laying out of the Chines and Pleasure Gardens, and the construction of the West Cliff Drive, have helped the district immensely. The various suggestions for the erection of a Pier have all been set aside, but the Centenary year sees the provision of a landing place for small boats.

Malmesbury Park takes its name after its ground landlord. Under the Enclosure Award of 1805 certain lands lying between Holdenhurst Road and Charminster Road were allotted to James, Earl of Malmesbury, in lieu of tithes, and additions were subsequently made to the estate by purchase and exchange. During the life time of the third Earl an artizan district was established between the two thoroughfares named. Since that period important additions have been made, and the title of Malmesbury Park has been given to one of the municipal wards, which also includes lands on the estate of Mr Cooper Dean. The ward stretches away to Queen's Park, and between Malmesbury Park proper and that popular resort there has latterly grown up a very fine residential neighbourhood, the amenities of which have been considerably advanced by the proximity of the Golf Links, by the liberality of the present Earl of Malmesbury in the transfer to the Corporation of lands for the further extension of the Queen's Park, and by the very favourable terms upon which the Council were able to acquire, from the same noble owner, the large tract of land now known as the Winton Recreation Ground, with its football and cricket grounds, its tennis courts, its bowling green, and other facilities for healthy recreation. The development of his lordship's estate is now extending beyond Queen's Park, and the magnificent pine wood avenue which has been constructed from Charminster Road to Littledown forms one of the most delightful

drives of the neighbourhood. It skirts the Park, and gives the traveller – pedestrian or equestrian, and the equestrian must not be forgotten, for there is a good trotting ground here – the opportunity to watch some of the most interesting play.

When they gave up the reins of office in 1890, the Commissioners handed over to their successors the care of an area comprising 2,592 acres. This remained the area of the new municipal borough down to 1901 – a year after Bournemouth had become a County Borough – when a new extension took place which more than doubled the total area – bringing it up to 5,850 acres. The districts thus incorporated were Pokesdown, Winton, and Southbourne. Pokesdown was the centre of one of those artizan communities which we have already referred to as springing up on the confines of the borough in the middle of the last century. On the passing of the Local Government Act of 1894, it elected its first Parish Council, which a year later was superseded by an Urban District Council. Long before that there had been agitation for the inclusion of Pokesdown within the Borough of Bournemouth, and in 1892, the Town Council, by ten votes to three (six not voting) passed a resolution favouring the inclusion of both Pokesdown and Winton. But having done that, they waited so long that the Pokesdown people became impatient, and petitioned for the establishment of an Urban Council of their own, which they secured, as stated, in 1895. To the credit of that Authority it may be mentioned, that they so improved the amenities of the district that the population considerably more than doubled itself in the decade – 1891 to 1901 – for whereas at the former Census the emuneration showed 2,239 souls, at the latter the total was no less than 4,930.

The district of Winton, like Pokesdown, came under the direction of a Parish Council in 1894, but it was not till four years later that it secured the larger powers of an Urban District Council. In 1893, the Bournemouth Town Council, by the casting vote of the Mayor, negatived a proposition for the inclusion of Winton within the borough area. Three years later they made application for authority to annex the Talbot Woods, but this was vigorously resisted by the people of Winton, and promptly sat upon by the Local Government Board, who refused to sanction any scheme which did not comprise the whole district – a policy which they had previously, but without effect, pressed upon the Corporation. So matters remained till Bournemouth became a County Borough in 1900, when a resolution was carried for the inclusion of Winton, as well as of Pokesdown and Southbourne, and a large tract of land just then ripe for development at Richmond Park. This extension was duly effected in November, 1901.

In connection with this chronicle of Winton, it is but right we should mention how much this and the adjacent district was indebted to the late

Miss Georgina Talbot, of Hinton Wood House, Bournemouth, who more than half a century ago, built a number of model cottages and established the model village which bears her name. As set forth on the memorial cross in St Mark's Churchyard, Talbot Village, 'she came of an ancient race, and possessed in herself that nobility of mind which delighted in the happiness of her fellow creatures... In the neighbourhood of the village, she passed 25 years of a blameless life, giving up time and fortune to bettering the condition of the poorer classes, seeking to minister to their temporal and spiritual welfare, and erecting habitations suitable to their position in life, herself enjoying a peaceful and happy existence in doing good, awaiting the end.' Her sister followed in her steps, and on succeeding to the estates the late Earl of Leven and Melville (and afterwards his son, the present Earl) continued the generous policy which has for so long given the public free enjoyment of the beautiful Talbot Woods – the largest and most characteristic of the pine woods standing within the borough. The time has arrived now for some considerable development as a building estate, but a bold, enlightened policy is being followed, and the magnificent avenue leading off the Wimborne Road to the Talbot Road – with its strips of pines and rhododendrons interposed between the side walks and the carriage road – will, in the future, go a long way to compensate for the inevitable loss occasioned by building.

Southbourne had its Parish Council from 1894, but never got beyond that stage till it was incorporated with the borough, when it had the honour of giving its name to one of the new municipal wards, comprising not only South- bourne itself, but the populous district of Pokesdown. Southbourne had long been 'boomed' as a peculiarly bracing and delightful neighbourhood for residential purposes. But it was slow in coming to its own – notwithstanding the enterprise of certain of its landed proprietors (particularly Dr Compton), the provision of a Winter Garden as a place of entertainment and assembly, the construction of an Undercliff Esplanade and the provision of a small Promenade Pier. These two last undertakings were very unfortunate: the Esplanade was eventually broken up by the sea, the houses built on the Undercliff Drive had to be taken down, and the Pier was damaged again and again, and at last entirely destroyed. But Southbourne itself within the last few years has prospered amazingly. Its growth has only been equalled by that of the Malmesbury Park district. With the means of communication, both with the centre of Bournemouth and with Christchurch, which the Municipal Tramways now provide, combined with its own natural advantages, it is year by year becoming increasingly popular, and is the district in which the greatest increase of population must be looked for in the near future. The ward has an exceptionally long sea frontage; with a broad, breezy

tableland which slopes away to the east into the valley of the Stour. For a considerable portion of its course – from a point above Tuckton Bridge, right down to Hengistbury Head, the borough boundary is an imaginary line running down the centre of the stream. The little village on the banks of the Bourne has so spread itself out that it has become a Great Town on the Stour – far and away the largest and most important centre of population in the district watered by that stream in its course through the counties of Wilts, Dorset, and Hants. The Stour, we may add, like the Avon, has long been renowned for its salmon – in former times found here in such abundance that there is local tradition that in the indentures of Christchurch apprentices provision was commonly made that they should not be required to eat salmon more than twice a week. The Rev. Richard Warner says that at Claypool, where the Stour meets the Avon, he once saw 95 salmon taken at a draught! Wonderful are the chronicles of the fisherman, but nothing to equal this has been paralleled within the last half century. In 1851, however, a sturgeon was caught in the Stour at Iford, measuring over 7ft. in length and weighing 109lbs.

The Pier – And Other Sea-Front Developments

In a previous chapter we have told the story of the chequered career of the 'Wooden Pier,' which, opened in 1861, was again and again wrecked, encountering such a series of misfortunes that the Commissioners eventually came to the conclusion the only thing to be done was to erect a new structure of more substantial character, fixed more firmly in the bed of the sea, better equipped for the buffetings of wintry storms, and adequate to the new demands which were continually being made by the rapidly increasing population of Bournemouth. As we have already chronicled, a Promenade Pier Company was promoted, and a Provisional Order actually obtained in 1875. But the Company and the Commissioners were unable to come to terms with regard to the old structure, the powers of the former lapsed, and the Commissioners came to the conclusion that the interest of the community which they represented would be best served by prompt and energetic action on their part. Accordingly, in 1878, they obtained new Parliamentary powers, and the same year the present Pier was commenced. The engineer was the late Mr E. Birch, who submitted three sets of plans, the first for a pier (60 feet in width) costing £52,382; the second for one (45 feet in width) costing £38,075; and the third for one estimated at £27,500. The Board decided to accept Scheme No. 2, with modifications; they elected, for instance, to omit the proposed pavilion, but they agreed to obtain Parliamentary powers to add such a structure if required at a later date. They obtained authority to spend a sum not exceeding £40,000, though their present proposal was for an outlay of about £20,000. The Company's scheme had been for the erection of a Pier at a cost not exceeding £17,000, and there were some leading townsmen who regarded the Commissioners' proposals as grossly extravagant and likely to be burdensome to the ratepayers. At the Local Government Board Inquiry one gentleman gravely declared that 'an extra rate of 1s. in the £ would be necessary to pay the cost,' and another made himself responsible for a statement that 'almost all the best plots of land were now built upon at Bournemouth'! Even in 1879, we find one of the old Commissioners in an election address declaring that 'the construction of this Pier would have

been better left to the venturesome enterprise of a private company. In that case those residents who might use the Pier would have had to pay no more than the tolls fixed by the Company.'

But the Commissioners went forward, the new Pier was erected, and on the 11th August, 1880, it was formally opened by the Right Hon. the Lord Mayor of London (the late Sir Francis Wyatt Truscott), who paid Bournemouth a state visit for the occasion, accompanied by the Sheriffs of London and Middlesex (described by one of themselves as the 'satellites of the Lord Mayor'). Memories of that interesting event were revived last year (1909), when Bournemouth was again honoured with a visit from the Lord Mayor and Sheriffs of London, and, by a happy coincidence, the Lord Mayor of 1909 (Sir George Wyatt Truscott), who opened the Pier extension of that day, was a son of the Lord Mayor who, with so much state and ceremony, opened the Pier in 1880. Sir Francis Truscott in 1880 described Bournemouth as 'the Garden City of the South.' His son, Sir George, visiting the place in 1909 – not for the first time – was able to declare that that reputation has been maintained. 'In spite of the fact that the town has grown, you have known how to preserve its sylvan beauties. You have made it a City of Villa Residences, surrounded with beautiful gardens.' Of the growth of Bournemouth in the interval illustration was given in a memorial presented to Sir George by the Corporation: 'The population of Bournemouth at that time was 18,000. Today it is 76,000. Its rateable value was £117,000. It is now £617,000. And we venture to believe that with all this growth and extension, unequalled, so far as we are aware, in the United Kingdom, Bournemouth has not lost its right to the name given to it by his lordship. It is still, and, we believe, will ever remain, a Garden City.' Other personal incidents were recalled. The gold key presented in 1880 has become an heirloom in the family, to be treasured up with the corresponding gift made by the Corporation of Bournemouth on the 5th June, 1909. The key was, in fact, produced at the ceremony on the Pier-head. But, perhaps, the most interesting reminiscence evolved by the occasion was the reference by the son to one of the speeches of the father. In 1880, replying to a toast on behalf of the Lady Mayoress, Sir Francis Truscott said: 'The Lady Mayoress has a lively recollection of Bournemouth some fifteen years ago, when one of her children was very ill. I believe it was mainly due to the air of this place that he regained his health, and was, 1 believe, saved under the blessing of God.' 'That child' (said Sir George Truscott, speaking at the luncheon party at the Winter Gardens on the 5th June, 1909) 'stands before you today – a testimonial to Bournemouth and an example of the devotion of an ideal mother.'

Passing over other details of these later events, we may mention that the Pier, as erected in 1880, had a total length of 835 feet, with a width

for about 650 feet of 35 feet, and of 110 feet for the remainder. Since that date the broad seaward end has been extended, making the total length nearly 1,000 feet; shelters have been erected, and the new and improved landing-stage, more adequate to the growing demands of our large steamboat traffic, added last year, has brought the total expenditure upon the structure up to approximately £50,000.

At the meeting held at the Belle Vue Assembly Rooms in January, 1859, when Bournemouth ratepayers gave their first formal assent to the Commissioners' proposal for the establishment of a Pier, there was a 'prophetic' declaration that a Pier would never pay, together with some reasoned argument that a Pier was not wanted, that it would destroy the privacy and retirement which attracted many people hither, and that it would result in the coming of excursionists and the strewing of the whole place with 'paper and chicken bones.' Experience has falsified the prophecy. As we have shown, one Pier has followed another, and there has been steady and continuous advance, both in popularity and utility. Its popularity may be illustrated by a few figures, which will show how groundless were the fears of those who imagined the Pier would be in any sense a burden to the town. For the year ended in March, 1882, the first complete year after the opening of the new structure, the receipts totalled £2,225; by 1890 they had gone up to £5,101, and by 1900 the total reached £8,621. Since that period there has been further steady and continuous progress, and the total for the last two years has been nearly £10,000 per annum. The new landing-stages have wonderfully improved the facilities for steamboat traffic, and the laying of a teak floor has added the attraction of a place for roller-skating in the early and late months of the year, when such sport can be enjoyed without undue interference with the use of the Pier as a place of popular promenade.

Reference has been made in some previous chapters to early efforts to secure popular promenades on the Cliff front. As far back as 1845, Mr Decimus Burton, in one of his many reports to Sir George Gervis, advised that 'walks and drives' should be liberally provided, and suggested 'a vide Esplanade on the Cliff,' extending from Boscombe Chine to the county boundary westward, and 'even farther if it could be effected.' A subsequent document shows it was intended there should be a width of 100ft. from property enclosures to the edge of the cliff, 'which is constantly crumbling away.' Paths were laid, but down to a comparatively recent period the greater part of the Cliff front, both East and West, was retained in a state of nature, the sand dunes forming picturesque objects in the landscape, and the heather adding welcome touches of colour to the scene. But with the growth of the population changes became necessary, walks and drives of more formal character had to be provided. The late Mr Clapcott Dean planted part of the West Cliff

– where certain pine-wood walks were designated as 'The Maze' – and there were paths both East and West. Subsequently the Local Authority acquired control of Durley Chine, and opened up a new means of access to the sea. As a later stage the East Cliff Promenade was extended and a Drive carried right along the Cliff front to a point overlooking Boscombe Chine, where – if foreshadowed proposals are carried into effect – it will some day be brought into association with an eastward extension of the Undercliff Drive. In 1901–2 another great development took place in the construction of the West Overcliff Drive, extending from Durley Chine on the East to Alum Chine on the West – a total length of about a mile. The Drive winds along the western bank of Durley Chine, passes inland along the eastern side of Middle Chine, crosses the upper part of the Chine on a broad, ornamental iron bridge, then along the western bank of Middle Chine and by the Cliff front, a last inland turn leading along the eastern bank of Alum Chine to Westbourne. This important work was carried out by the Corporation, with the co-operation of the ground landlord, Mr Cooper Dean, who granted them a 999 years' lease of the Cliff and Chine slopes and all the land necessary for the Drive. At the same time he leased them two acres of land for a recreation ground – now known as the Argyll Pleasure Garden – at a rental of £50 per annum. The Council likewise acquired the right, if and when found desirable, to construct a bridge across Durley Chine, and to continue the Drive eastward to the end of St Michael's Road – a point not very far from the Pier. These, however, are developments which it has not yet been found expedient to press forward. The opening of the new Drive took place with appropriate civic ceremonial on the 6th November, 1902, Mr Cooper Dean handing the formal dedication to the Mayor (Councillor G. Frost), and the Mayor declaring the Drive open for the use and enjoyment of the public. The attractions of the Drive, and its utility – so far as concerns large sections of the population – were subsequently increased by the construction of a Suspension Bridge (for foot passengers only) over Alum Chine. Other sea-front developments of important character have included the laying out of the various Chines as Pleasure Gardens; the provision of delightful Cliff Gardens at Boscombc and Alum Chine; the throwing open of some acres of Cliff frontage at Southbourne, with a zig-zag path from the end of Fisherman's Walk to the Beach; and last, but certainly not least, the construction of the Undcrcliff Drive and Promenade.

It may be convenient, perhaps, at this stage to make some personal reference to the part which the successive owners of the Dean Estate have borne in the development of Bournemouth. Reference has been made to the leading part which Mr William Clapcott took in connection with the Enclosure Act and Award, and more could be quoted, were it necessary,

to show the influence which he exercised in the neighbourhood. Mr Clapcott was a member of the firm of Dean, Clapcott, and Castleman, who were bankers at Wimborne – and one of the counters of the old Bank, transformed into a sideboard, now does duty in the house of Mr Cooper Dean at Littledown. Mr Clapcott's son William took the old family name of Dean, and succeeded to property which his uncle (Mr Wm. Dean) had acquired in Bournemouth and neighbourhood. He settled at Littledown, within a mile or so of his birthplace, and there passed a long and honoured life. He was noted, particularly, for his extreme love of animals, and when he died it was found that his will contained provision for the care of all his horses and dogs till natural death should overtake them. Mr Clapcott Dean became one of the largest land-proprietors in the Bournemouth area, his estate, as shown elsewhere, including large tracts of valuable land on the West Cliff, east of the Square, along Holdenhurst Road, and also in the Wimborne and Charminster Road. His Surveyor was Mr C. C. Creeke, and the policy laid down for the Estate by Mr Clapcott Dean, under Mr Creeke's advice, was one which aimed at steady development, with judicious tree-planting, and no overcrowding. It was consistently followed throughout the whole of Mr Clapcott Dean's life, and is still the rule of the Estate. Various incidental references have been made to the assistance given to public institutions, churches, etc. Of equal if not of greater moment to the interests of the town as a whole was the reservation of the large tract of land in the Christchurch Road, known as the Horse Shoe. That has now passed into the control of the Corporation, and the only 'development' that can proceed there is limited to the erection of Municipal Offices, etc. The whole of the remaining part of that large area must be maintained as a Pleasure Garden. On Mr Clapcott Dean's death, he was succeeded by his nephew, Mr Cooper Dean, and it was through that gentleman's enterprise and co-operation, as we have explained, that the Undercliff Drive was constructed. Mr Clapcott Dean, by the way, had many years before, in reply to a petition presented by Mr Joseph Cutler, promised to consider a plan for a Cliff Drive to Westbourne, and some substantial progress was made in the consideration of plans when the scheme dropped through the opposition of a section of ratepayers. But the work was completed at last, and Mr Cooper Dean signalised the opening by giving a large luncheon party at Bourne Hall.

The provision of an Undercliff Drive was a matter of animated controversy in Bournemouth for more than thirty years; not till November, 1907, was the town placed in possession and enjoyment of the first instalment of the scheme. We ought not, perhaps, to speak of 'the scheme,' for there have been schemes many and various: schemes formulated by successive engineers to the Local Authority, the late Mr C. C. Creeke, the

late Mr G. R. Andrews, and Mr F. W. Lacey; schemes fathered by engineers of wider renown, like the late Sir Joseph Bazalgette and the late Mr E. Birch; suggestions, proposals, and criticisms by all sorts of amateur engineers; and, to mention no others, the grandiose, comprehensive scheme put forward by the late Mr Archibald Beckett, based on plans by Messrs. Lawson and Reynolds, backed with the professional authority of Sir Douglas Fox, C.E., and others. The records of the local Press show that the Undercliff Drive – its desirability and its feasibility – was under discussion by the Local Authority, the old Board of Improvement Commissioners, as far back as 1878, and we find it reported that the majority of the Commissioners were in favour of the proposal. The 'scheme' of that day was one 'contrived a double debt to pay.' There was to be a fore-shore esplanade – which, it was argued, would be a great attraction and benefit both to winter and summer visitors; and beneath the esplanade there was to be a sewer, serving the utilitarian purpose of conveying the town's sewage along under the cliff-front to a new outfall which it was proposed to take out to sea from a point midway between Bournemouth Pier and Bos- cornbe Chine. A majority of Commissioners, as we have said, favoured the scheme; but there was a strong minority, and a considerable section of townspeople rose in rebellion against, the whole thing. They memorialised the Local Government Board, and they held an indignation meeting in the town itself; the 'Directory' report describes it as a 'great meeting.' There was a 'crowded attendance, and it was of a 'stormy character.' The late Mr John Tregonwell moved a resolution expressing disapproval of the proposal 'as involving an unnecessary and wasteful addition to the debts and liabilities which have already been contracted by the Commissioners at the expense of the ratepayers and to the detriment of house property in this place'! He carried his resolution, and the plan was dropped.

In 1882, the late Mr E. Birch, C.E., who had recently constructed the Bournemouth Pier, came on the scene with a scheme for providing an Undercliff Drive, Promenade and other attractions, without cost to the ratepayers, but this, too, failed to secure the requisite support. Mr Birch unfolded his plans at a meeting held early in the year. The scheme, he explained, was one for the construction of a pleasure Drive along the Beach from the Pier to Durley Chine, with certain buildings on the landward side such as would be remunerative and enable the promoters to pay for the sea-wall and the Drive in front. These buildings were to include an 'efficient bathing establishment,' a museum, boathouse, and the establishment of a court devoted to science and art and gymnastic exercises. For none of these things were the ratepayers of Bournemouth expected to contribute a penny; they were asked to give the scheme their benediction and moral support. Everything else was to be accomplished by the kind co-operation

of the ground landlords and the enterprise of investors in the Money
Market. An inclined liftway from the Cliff to the Beach, near the Highcliff
Mansions, was to be one of the features of the scheme, but Mr Birch gave
warning that, 'if a large price were asked for the land it would simply
destroy the chance of carrying out the plan.' We don't know that the land-
owners asked 'a large price,' but they were unsympathetic, and this scheme
also fell to the ground. The promoters' estimate of probable cost, we may
remark, was from £70,000 to £100,000, and among other advantages, it
was urged that the scheme would preserve the cliffs without destroying
their picturesqueness. The need of 'saving the cliff' had, even at that time,
been appreciated by the Local Authority, and serious representation had
been made to the ground landlords.

In 1884, the Commissioners were again considering the desirability of
action, being moved thereto not merely by the view that an Undercliff
Drive would be a valuable acquisition – a new attraction to visitors and
residents – but by the almost daily recurring evidence of the. necessity of
protective measures for securing the cliffs. This became a 'test question'
at local elections, and discussion assumed a serious phase. The late Sir
George Meyrick, the principal ground landlord, offered to contribute a
sum of £4,000 towards the capital cost. The late Mr Clapcott Dean, the
owner of the cliffs westward of the Highcliff, resolutely opposed the whole
project, and his opposition and, later on, that of his successor, Mr Cooper
Dean, led to the abandonment of any idea of carrying a Drive westward
of the Highcliff. But the schemes of the early eighties contemplated a
Drive extending right away from Alum Chine to Boscombe – a distance of
something like two and a half miles. The Commissioners showed that they
meant business by offering substantial premiums for competitive plans.
The plans were duly received; they were examined and approved by the
late Sir George Meyrick, and then there came another wave of antagonistic
feeling – and everything was shunted. The plan contemplated at that time
would have entailed a cost of about £35,000 – but it was set aside. Even
when the South Western Railway Company secured Parliamentary powers
to contribute a sum of £10,000 to the cost, there was not sufficient 'driving
power' to secure progress. The Undercliff Drive still remained the stock
subject of local controversy.

In 1892 Mr F. W. Lacev, the Borough Engineer, presented a new scheme
– for a Drive costing £60,000 – and there were renewed negociations with
the ground landlords, new protests and expostulations, new organisations
formed to advance or to prevent the work. So things went on till 1897,
when the Town Council, by a majority of twelve to nine, passed the
following resolution: 'That the scheme submitted by the Surveyor for the
preservation of the cliffs and construction of the Undercliff Drive, be and

is hereby approved, and that it be submitted to Sir George Meyrick for his approval, and that Sir George Meyrick and the directors of the London and South-Western Railway Company be approached, to secure their co-operation in carrying it out.' Then came further trouble: Sir George Meyrick, like the Town Council, was anxious to preserve the cliffs, but his lessees made representation that an Undercliff Drive was not essential to effective cliff preservation, and the Council's own, and frequent, wavering seems to have led Sir George to hesitate as to his final reply.

At the end of the year the 'Directory' made the sudden and startling announcement that the late Mr Beckett had made a provisional arrangement with Sir George, whereby Mr Beckett was to have the right – subject to the approval of plans and conditions – to construct an Undercliff Drive right away from the Highcliff Hotel to Boscombe Pier, with shops and other buildings along such portions as it might be thought desirable so to develop. A remarkable change of opinion soon manifested itself. Many of the most strenuous opponents saw that an Undercliff Drive – for weal or woe – was bound to come, and the scheme foreshadowed by Mr Beckett included so many objectionable features that they themselves memorialised the Council to re-open negociations with Sir George, submitting that 'the control of any Undercliff Drive should be entirely in the hands of the Town Authority,' and respectfully asking them to take such steps as in their judgment might 'seem most fitting to protect the best interests of the town in this matter.' The Council appealed to Sir George accordingly, and after protracted correspondence an arrangement was made whereby Mr Beckett abandoned his claim, the Council, through Sir George, paying a sum sufficient to cover his disbursements – and the whole control of the cliff and foreshore was vested in the Council, with the 'exclusive right,' within a definite period, to make an Undercliff Drive from Bournemouth Pier to Boscombe. In pursuance of the powers thus obtained the Council extended the old East Cliff (Overcliff) Promenade from what used to be known as the Manor Plot to Boscombe; erected shelters, refreshment pavilions and public conveniences on the Beath; undertook the regulation of amusements, etc., on the foreshore; effected substantial improvement in the general amenities of the sea front, securing ownership and control of the bathing machines; and, at last, constructed the first – 'experimental' – section of the long talked of Undercliff Drive from Bournemouth Pier to Boscombe.

But before the last mentioned and most important step was taken, the Council appointed a deputation – a 'Flying Squadron' as it was called – to visit various Continental and other resorts where sea-defence and cliff protection works had been constructed, and this deputation, after visiting Belgium and Holland, placed on record their opinion that 'as regards

sea walls the difficulties to be faced in Bournemouth are much less than those successfully overcome at other places,' and chronicled the fact that 'the practice of other seaside resorts shows a unanimous consensus of opinion that, even where they are Overcliff Drives, it is worth while to spend large sums on Undercliff Promenades, and where, as here, there is space, Undercliff Drives – at the sea level – in order to get within sight, sound, and smell of the breaking sea.' And 'as the general result of their experience,' they expressed their strong opinion that, if the Council decided to fulfil their obligations to Sir George Mcyrick, 'to protect the cliffs and render possible Overcliff Drives, by a comprehensive Undercliff Drive scheme,' they would 'not only be following the universal practice at seaside places which have to protect their cliffs,' but would, as compared with other places, 'do so at far less cost, with far greater security, and with the certainty of a far more valuable return in the shape of attraction to visitors.'

In August, 1904, the Council gave instructions to Mr Lacey to prepare a scheme and approximate estimate of cost for an Undercliff Drive along that part of the sea front where the ground landlords had given their sanction, and in due course the Borough Engineer submitted a scheme providing for a Carriage Drive 30ft. wide and a Promenade 20ft. wide, with a sea wall seven feet above high water mark, or about ten feet above mean tide level. Notwithstanding all the expert advice that had been obtained, old fears were revived, and argument was again pressed that work such as was recommended would entail unknown expenditure, would be doubtful in its result as a means of cliff protection, would certainly spoil the Beach, and instead of advancing would be gravely prejudicial to the interests of the borough. To meet objection and secure progress the Council decided to proceed with a section of the work only, and accepted a tender from Messrs. J. W. Harrison and Co. for the construction of a Drive and Promenade extending eastward from the Pier to a point just below the end of Meyrick Road. This was formally opened by the late Alderman J. A. Parsons, J.P., Mayor of the Borough, on the 6th November, 1907 – a day which is memorable in local annals, not only because it saw the actual completion of a work so long advocated, but because of two remarkable gifts made to the town by Mr and Mrs Merton Russell Cotes (now Sir Merton and Lady Russell Cotes). The former had been one of the foremost and most persistent advocates of the Drive; he regarded its accomplishment as a personal triumph, and he signalised the occasion by presenting the town noth the collection of paintings and other works of art, curiosities, etc., which he had collected from all parts of the world, his wife at the same time asking the town's acceptance ol' the residence, East Cliff Hall, where these valuable works are at present housed. Sir Merton and Lady

Russell Cotes are to have possession during their life-time, but on their death the gifts will be free for the full enjoyment of the public. They are already vested in trustees. This is not the occasion, or the place, for eulogy – but a history of Bournemouth which lacked mention of such beneficence as this would be imperfect and unjust. Official appreciation was shown by the presentation of the honorary freedom of the borough to both Mr and Mrs Merton Russell Cotes, and at a later stage the burgesses were able to congratulate them on the former having received the distinction of knighthood and the accolade of his Majesty King Edward VII.

We may add that within a few days of the opening of the Drive it was visited by his Imperial Majesty the Emperor of Germany, then staying at Ilighcliff.

After the construction of the Undercliff Drive, the Town Council proceeded with other work for the preservation of the Cliffs, and the provision of Lifts, so that the public convenience might be met as fully as circumstances would permit. The cliff works included the making of a new zigzag path from the top of the East Cliff to the Drive, and an electric lift for conveying passengers from the end of Meyrick Road to the Drive, and vice versa. The Lift was formally opened by Lady Meyrick on the 16th April, 1908, and on August 1st, in the same year, a similar Lift was opened on the West Cliff, in association with the Undercliff Promenade west of the Pier.

The plans of the Council have not provided for any Undercliff Drive west of the Pier, but the success which attended a temporary Undercliff Promenade led in 1909 to a decision to make that work permanent, and that has now heen carried out. Refreshment Pavilions, shelter accommodation, and puhlic lavatories have been provided, and another very interesting development has been the construction of small wooden huts along the Promenades. For these there has been good demand, at reasonable rentals. These places have, indeed, become immensely popular with that class of people who, in the summer months particularly, like to spend their whole time by the seaside. Here they are ahle to establish little homes where, if in but a modest way, they can supply their own requirements from morning till evening, and meet their friends and acquaintances. The huts – located at various points between Alum Chine and Boscombe Chine – all of uniform size and pattern, but furnishing and decoration afford fine scope for the display of the taste and individuality of the different tenants.

An examination of the published accounts of the Corporation shows the capital expenditure in connection with the various works enumerated above to have been as follows: East Overcliff Drive, £3,328; West Overcliff Drive (including the laying out of Middle Chine, the construction of the carriage bridge, the laying out of the Argyll Pleasure Garden, and other

incidental work), £15,233; the Undercliff Drive, £17,955, and the Cliff
Lifts, £7,626, while the (estimated) cost of the Undercliff Promenade is
put at £7,000.

16

The Municipal Tramways

The Bournemouth Municipal Tramways give employment to four hundred and fifty men, produce an income approximating £90,000 per annum, and constitute not only the largest commercial undertaking under the direction of the County Borough Council, but also one of the most important organisations of its class in the South of England. Consequent upon certain circumstances in its history, leading both to litigation and to legislation, and because also of experiments of a peculiarly interesting character, it has attracted an amount of public attention which its mileage and revenues would not alone have obtained, and its fortunes are carefully followed by the representatives of many other Tramway Authorities as well as by the burgesses of Bournemouth.

The first definite proposal for the establishment of Tramways in Bournemouth was made nearly thirty years ago, and in November, 1881, the late Mr W. Mate presided over a meeting held at the London Hotel, Poole, in support of a scheme which a firm of London Engineers were then submitting to the Local Authorities of Poole and Bournemouth, the idea being the running of a line from the 'East' Station through the centre of Bournemouth and on to Poole. The view at that time apparently was that Tramways were more required as a means of communication between the two towns than between the various parts of Bournemouth itself. Nothing came of the proposal. Some few years later other promoters came on the scene and succeeded in obtaining powers – their scheme also being one for a line between Poole and Bournemouth. Still, nothing was done: the Order was again and again extended, but capitalists seemed to be shy of the venture, and after a long interval the promoters abandoned their scheme, and withdrew the deposit which they had lodged with the Board of Trade.

In 1897 that well known and powerful organisation, the British Electric Traction Company, appeared and commenced an energetic and organized propaganda. Public opinion at that time was very much divided; it was admitted, of course, that Tramways would afford a convenient means of getting from place to place, but, on the other hand, there were many objections urged: the streets were too narrow and Tramways would,

it was argued, work more to the detriment than to the advantage of Bournemouth. The Town Council opposed the scheme, passing a resolution that Tramways were unsuitable to Bournemouth, and hinting that, if and when required, they would desire to themselves supply the demand. Rival competitors submitted schemes, and the Light Railway Commissioners held two distinct local inquiries. On the first occasion they rejected all the schemes; on the second they approved of a line from Poole to the County Gates, Westbourne, the Poole and Branksome Authorities supporting the proposal, and the Commissioners seeing no reason to penalise those districts because the Bournemouth Council objected to Tramways within the Borough of Bournemouth. The British Electric Traction Company in due course obtained their Order, and a Subsidiary Company was formed under the title of the Poole and District Light Railway Company, Limited. The 'Light Railway' was constructed in 1900 and opened in April, 1901.

Repulsed in their efforts to secure an Order under the Light Railways Act for the construction of lines within Bournemouth, the Traction Company promoted a Bill in Parliament, their scheme including a line from Christchurch to the Hotel Metropole. Realising the danger of this attack, the Town Council formulated a comprehensive scheme of their own, with the result that the session of 1900 saw a big fight in the Parliamentary Committee rooms. In the result the Corporation secured their complete scheme, while the Company obtained all the necessary powers for the construction of their proposed lines outside the borough, and the right to extend their system westward from the borough boundary at Boscombe to the Metropole, if the Council did not, within two years, complete and equip the line which they were promoting. 'Running powers' over each other's undertakings were given both to the Council and the Company.

Early in 1902, the Company intimated to the Corporation that as they had not made a 'substantial commencement of works' within the period required by Section 18 of the Tramways Act, their powers had lapsed, and the Company asked for an undertaking that the Corporation would not proceed with the laying of tramways in the roads until they had come to an agreement – in view of the rights which would be theirs when the suspensory clause ceased to operate. As the Council had entered into contracts involving expenditure running up to nearly £200,000, they considered they had made a 'substantial commencement of works,' and refused to enter into any agreement. Then litigation commenced. On the case being taken to the Divisional Court, Mr Justice Swinfen Eadv ruled in favour of the Corporation; the Company, however, appealed, and the Court of Appeal, consisting of Lord Justices Vaughan Williams, Romer, and Stirling reversed the decision. The Council at once consulted the burgesses, who gave them such substantial backing that steps were taken

for appeal to the House of Lords, and, if necessary, for seeking redress by means of a Parliamentary Bill. The sympathy of other Municipal Corporations was sought, and preparations made for a determined struggle with what was realised to be an organisation of colossal power. But this great fight never came off; arrangement wras made for the purchase of the Company's undertaking and privileges, and eventually an agreement was completed whereby the Bournemouth Corporation acquired all the rights and privileges of the Company as regards Bournemouth and the district east of the borough, and the Poole Corporation became the purchasers of the lines, etc., within the Poole and Branksome area, the Bournemouth Authority undertaking to lease the same on specified terms. These results, however, were not achieved till after arbitration proceedings, in which the Company claimed a sum of upwards of £400,000! The award of the arbitrator was for £112,000 – exclusive of certain minor claims which had subsequently to be adjusted.

The scheme of Tramways adopted by the Corporation was one of a comprehensive character, designed, as far as practicable, to meet the requirements of all parts of the borough area. It included through communication from Boscombe East to the County Gates at Westbourne, and the Council resolutely faced the question of street widening and other improvements and arranged that these should be carried out in conjunction with the Tramway work. From Lansdowne they provided for a line traversing Holdenhurst Road and Ashley Road, to the main line at Boscombe, and a further line from Holdenhurst Road to Wimborne Road near the Cemetery Gates. From the Square they provided lines running to Winton and Moordown; to Charminster Road and Holdenhurst Road (via Capstone Road). At a later period – after the settlement of affairs with the Traction Company – they constructed an extension from Boscombe East through Pokesdown and Southbourne to Christchurch – building a new bridge at Tuckton, to carry traffic over the Stour. They linked up their system with the Poole and Branksome line at Westbourne, and later on constructed a new line from Bourne Valley, through Lower Parkstone, to a junction with the existing line at Park Gates East (Poole).

The Overhead Trolley system of traction was adopted for the greater part of the route, with the side-slot conduit system for about two and three-quarter miles of track through the central parts of the town. A generating station was provided in the Southcote Road, equipped with dynamos, motor generators, and other powerful machinery; and ear sheds were erected at Southcote Road, Pokesdown, and Winton. On taking over the Company's undertaking the Corporation acquired the cars, sheds, etc., which had been erected at Upper Parkstone, and took the benefit of the agreement for current which the Electricity Supply Company had entered

into. The scheme was designed by the Borough Engineer (Mr F. W. Lacey) in conjunction with Messrs. Lacey, Clirehugh, and Sillar, electrical and tramway engineers. From the generating station in the Southcote Road is supplied, not only current for the cars, but also for the electric lighting of some of the principal thoroughfares. The cars – and, indeed, the services generally – have been designed -with the view of meeting the special circumstances of Bournemouth as a high-class health and pleasure resort.

The first section of the Tramways – from Boscombe East to the Metropole – was opened in July, 1902; the conduit system and the extension to Westbourne in December of the same year; and the Winton and other lines within the borough shortly afterwards. The extension to Christchurch was completed in 1905, and the Lower Parkstone line in 1908. The Authority's career has been a somewhat chequered one. Speaking generally, the Tramways have been exceedingly popular; but there has been almost endless controversy with regard to fares, and also as to the advisability or otherwise of a Sunday service. As already shown, there has been costly litigation, and though the arbitration settled the dispute with the Traction Company, the Corporation were left with charges in respect of the outside services which are not fully met by the revenues from these parts of the undertaking. Then, in May, 1908, there was a serious accident by which seven persons lost their lives, and others were seriously injured.

The Tramway system covers a total length of nearly thirty miles of track, with a route mileage of rather less than twenty-three miles. The number of passengers carried totals about fourteen million per annum, and the last report of mileage traversed gives a total of 1,795,000, with average receipts of 11d. per car mile. Upwards of eighty cars are used for the service, the large bogie cars having a carrying capacity of 62 and the smaller cars 42 passengers. The Corporation works are fitted up with great completeness; not only can all repairs be satisfactorily executed on the premises, but new cars constructed, if required.

Now as to the question of cost. The Capital expenditure to 31st March, 1910, for the Tramways owned as well as worked by the Corporation, has been £363,407 12s. 11d., to which has to be added the sum of £29,020 7s. 6d. in respect of arbitration expenses, the purchase of powers acquired by the Traction Company and the discharge of outstanding liabilities, making up the gross amount £392,438 0s. 5d. Discount and costs in the issue of Stock have entailed a further liability of £30,371 0s. 11d., but that, of course, is an expenditure for which the Authority receive advantage in the shape of reduced charge for interest, with the probability also of being able to re-purchase for extinction at less than par value. The total loan charges on the undertaking amount to £24,334 13s. 8d. per annum. The total cost of the Poole undertaking, including the Lower Parkstone extension, has

been £130,330, and the rent charge which the Corporation paid to the Poole Town Council in the year ended March, 1910, was £7,737 8s.

In connection with the institution of Tramways, the Town Council, as already explained, embarked on a large scheme of street improvement, including the purchase of a considerable amount of property. The charge remaining on the books at the end of March, 1910 (exclusive of the discount on Stock) was £40,313 9s. 5d., in respect of nonproductive street improvements, and a further net sum of £56,499 15s. in respect of house and other properties under the administration of the Estates Committee, and from which substantial revenues are being realised.

The Tramways are under the direction of a Standing Committee of the Town Council – the Tramways and Parliamentary Committee – of which Councillor F. J. Bell is Chairman. The General Manager of the undertaking is Mr C. W. Hill, A.M.I.E.E.

17

Other Public Services

The need of a good water supply for Bournemouth was early recognised, and in 1858 a company was projected under the title of the Poole and Bournemouth Waterworks Company, the idea being the establishment of an undertaking to serve the joint purposes of the two towns. Four sources of supply were to be utilised, 'if found expedient': the conduit piece on Constitution Hill, the springs cropping out further up on the west and north side of the same range of hills, the mill-stream at Parkstone, and the Bourne stream at or near one of its sources adjoining the Bourne Valley Pottery. The Commissioners, however, passed a resolution that they 'could not but view with serious misgiving any intention to connect the Bournemouth stream with a water supply to Poole, Parkstone, and Bournemouth,' and their opposition led to such a modification as left the way clear for other effort.

In 1859 a Mr Wansbrocht submitted a scheme for providing Bournemouth with gas, but was informed that unless the Company also undertook the supply of water the suggestion could not be entertained. Another scheme was put forward by a Mr Bennett in 1861, but the Commissioners regretted that the means at their disposal did not permit them to provide public lights for the district, and, presumably from this lack of encouragement, this scheme also passed away. In the following year a draft agreement was prepared with Messrs. Stears, but the firm could not undertake the provision of water, and the opposition of the Commissioners led to that being also abandoned. It was not long, however, before substantial progress was made, the Bournemouth Gas and Water Company being established in 1863, and making such excellent progress that by the 16th September, 1864 – exactly fifty years after the introduction of gaslight in London – Bournemouth was placed in enjoyment of the same illuminant.

The Company's original works were situate at Bourne Valley, and the water was first derived from brooks supplied by springs rising on the moors above the works. This supply was afterwards supplemented by means of a well, about 60 feet deep, sunk in the gravel on the works. For years this

satisfied the needs of the neighbourhood, but in 1885, to meet growing requirements, the Company went to Longham, where they expended a large sum in obtaining an excellent supply from the water-bearing gravel beds adjoining the river Stour. At the same time the existing reservoir and filter station at Alderney was established, and the supply from the brooks entirely discontinued. In 1896, the population of Bournemouth was increasing so rapidly that the directors of the Company decided to take steps to secure such a supply as would safeguard the town for all time, and they therefore commenced operations with a view to obtaining a supply of water from the chalk. With this end in view a site at Walsford, some mile or so beyond Wimborne, was obtained, and a boring was sunk into the chalk, 10 feet diameter by 200 feet deep, and lined with iron tubes to a depth of 170 feet to prevent any chance of surface water entering the boring. The water from this well is lifted by means of large pumps, which also force the water right up to the filter and reservoir station at Alderney, some eight miles away, from whence it flows into the town by gravitation. This chalk water is of great organic purity. As it comes from the well it is somewhat hard, but before it is sent to the reservoirs this hardness is reduced to less than ten degrees, by means of one of the largest water softening plants in the country. Bournemouth has the distinction of being the first watering place to soften its water supply. At the present time over 800 million gallons of water are supplied to Bournemouth per annum. The Company's charges to consumers are as follows: Where the rateable value does not exceed £12 per annum, 2d. per week; premises rated at £12 but not exceeding £20 per annum, 4 per cent, on rateable value; above £20 per annum, 5 per cent.

The gas supply side of the undertaking has increased even more rapidly than the water undertaking. During the first few years after its establishment the growth was very slow, and in the year 1880 the gas made was only 47 million cubic feet; this had increased to 172 millions in 1890, to 357 millions in 1900, and in 1909 the gas made was 779 million cubic feet.

The price of gas in 1878 was 6s. 6d. per 1,000 cubic feet, but in 1887 this had been reduced to 4s. per 1,000, while at the present time the price is only 2s. 7d. per 1,000, which figure will compare very favourably with any town of the size of Bournemouth situated at a corresponding distance from the coal-fields.

In 1903 the Company purchased the undertaking of the Poole Gas Co., and in 1906 erected a complete new and up-to-date Gasworks, fully equipped with the latest machinery, on the site of the old Poole Gasworks, the proximity of which to Poole Quay gives great facilities for the economical and rapid handling of coal and other material, while the

possibility of obtaining goods by sea and so saving the cost of railway carriage enables the Company to supply gas cheaply.

The capital of the Company, which stood at £125,000 in 1878, has now reached the substantial figure of £651,000.

The Company's district of supply has been extended from time to time and now covers an area stretching from Southbourne on the east to Broadstone on the west for gas, and from Pokesdown to Longham and Ferndown in the case of water. The General Manager to the Company is Mr H. W. Woodall.

The Local Authority, it should here be mentioned, have always kept very keen watch on the water supply; from the first they have taken care to have frequent analyses made, and the vigilance of their Medical Officer of Health (Dr Nunn) has always been appreciated, alike by the Company and the public. In 1889, the question of the Local Authority acquiring the Company's undertaking – 'lock, stock and barrel' – was under public discussion, and terms of purchase – now generally admitted to have been very fair – were provisionally arranged. A poll of the town was however, demanded, and by a small majority the agreement was set aside.

Associated with this matter of water supply, reference may here be appropriately made to the town's provision for the suppression and extinction of fire, the first essential for which is, of course, an abundance of water. As far back as June, 1858, a proposal was made for the acquirement of a fire engine, but there was then no water supply other than what could be obtained from the Brook or from various wells. The matter came up again in 1868, but nothing tangible was done respecting the establishment of a Fire Brigade until April, 1870, when Mr McWilliam was authorised to purchase a hose and reel, and make enquiries as to the best means of obtaining a fire engine. Once the idea was started much energy was displayed, for we find that in the following month a hose and reel was purchased for £67 13s. 6d., and a good engine was offered for £65, which it was resolved to secure; and later, 'that belts, axes, hose wrenches and life lines should be procured to equip 20 'superintendents' of the Fire Brigade.' Long after that there were still occasional difficulties as regards water supply. But the Fire Brigade quickly became a very useful institution, and the good work voluntarily undertaken by officers and men was, and is now, done in a whole-hearted and loyal manner, deserving the very highest praise. The Bournemouth Brigade stands high in the ranks of similar volunteer organisations, and in most years is eminently successful in national and other competitions. During the early years the cost was not very considerable, for we find that the disbursements were only £6 17s. for the whole of the year 1874. The first Captain was Mr J. McWilliam, who acted from 1870 to January, 1875, when he resigned, his place being

taken by Mr W. B. Rogers, who was succeeded in 1882 by the late Mr W. J. Worth. The present chief of the Brigade is Mr E. L. Lane, with Alderman Robson as Second, and Mr C. R. Welch as Third Officer.

Electric Lighting was first introduced to the notice of the people of Bournemouth in 1878, through the enterprise of Messrs. O. C. Mootham and E. Barnes, who arranged for a grand exhibition of arc lighting at the Dean Park Cricket Ground, on the 25th and 26th November. Nearly 8,000 persons are reported to have attended to witness 'the latest scientific novelty,' and for the first evening Messrs. Mootham and Barnes provided the additional attraction of a series of cycle races. On the second evening there was a football match between teams representing Bournemouth and Christchurch respectively, the Bournemouth men being captained by Mr J. A. Nethercoate and the Christchurch team by Mr A. H. Milledge. The 'Rovers' scored four goals to their opponents two, and were each presented with a silver medal inscribed: 'In commemoration of the first electric light exhibition in Bournemouth, November, 1878.'

In 1889, an electric light undertaking for Bournemouth was initiated, and in the following year two Provisional Orders were obtained. The Bournemouth and District Electric Lighting Company was duly formed in 1891, and the chronicles of that year show that the Company then had approximately 3,000 8 c.p. lamps, with 60 consumers. Developments proceeded steadily, and in 1897 the Town Council negotiated for the acquirement of the undertaking. The Company asked for the sum of £135,000; this was declined, and the matter of purchase dropped for some years. When it was revived, the Company asked for a very much larger price – for the undertaking, of course, had developed, and had huge possibilities before it. Again the negotiations fell through. In 1897 the number of consumers was 300, and the number of lamps connected 23,000. The capital expenditure at that date was approximately £83,000, with a gross income of £8,250. With the rapid increase in population the last few years have shown a very marked advance, and the capital expenditure throughout the Company's area of supply – which covers about 42 square miles, and includes Poole, Bournemouth, Christchurch, Winton and district – at the end of last year amounted to £443,000, the revenue from the sale of current in the district being £50,000.

The Bournemouth and District Company was taken over by the Bournemouth and Poole Electricity Supply Company at the latter end of 1897, and is now concerned, not only with lighting, but with power supply, its largest customer being the Bournemouth Corporation, for power for the working of the Tramways outside the borough area. Mr A. H. Sanderson, J.P., has been Chairman of the Company since its formation, and Dr J. A. Hosker a Director for the same period.

For the first experimental and practical demonstration of Telephony, as of Electric Lighting, Bournemouth was also indebted to individual enterprise, the pioneers in this case being Messrs. Bayley and Sons, of Bournemouth and Poole. That firm carried out experimental works of their own in 1884, and in the following year they had, among others, a line from the printing and publishing offices of Messrs. Mate and Sons at Bournemouth to their offices at Poole. Messrs. Bayley had given some notable electric lighting demonstrations at Poole, and they developed a fairly considerable telephonic business, meeting public convenience till a more powerful organisation appeared on the scene. Here we may remark that some few years ago the Bournemouth Corporation seriously contemplated the establishment of a Municipal Telephone Exchange, and went so far as to secure expert advice as to the cost of installation, methods of working, and the prospects of success. Developments were, however, foreshadowed by the Postal Authorities which gave occasion for second thoughts, and the project dropped.

Bournemouth is now included in the Hants and Dorset District of the National Telephone Company, and is the centre of a system which includes Exchanges at Southbourne, Christchurch, and Highcliffe; at Longham and Ferndown; at Wimborne and Broadstone; at Poole, Parkstone and Lilliput; at Wareham and Swanage. It is making rapid extension year by year, and the thirteen Exchanges cover an area of upwards of 80 square miles. An electrophone service is provided to the Winter Gardens, the Theatre, and some of the leading Churches.

18

Municipal Government

Bournemouth dates its history as 'a watering place' from the visit of Mr Lewis Tregonwell in 1810, and the erection of the first 'Mansion' in what has since become, in the memorable phrase of the great Wessex novelist – a 'Pleasure City of Detached Mansions.' But Bournemouth's history as a town dates only from 1856 – from the period of the establishment of the Board of Improvement Commissioners, the first body to whom was committed power and responsibility for the administration of local affairs within the very restricted area of the 'marine village of Bourne,' then steadily creeping into public favour, but still numbering a population of only a few hundreds. Prior to 1856, the residents of Bournemouth had less of the privileges of local self-government than the meanest village in the land now possesses. The smallest area now, at least, has its Parish Meeting, with opportunity, at all events, for the ventilation of public grievance; Bournemouth before 1856 had not even that, nor anything corresponding to it. Householders had, it is true, the right to attend the Vestries at Holdenhurst or Christchurch; but the exercise of this privilege, meant a journey from 'the place' and could not be counted as of much, if any, value.

Then, in 1856, the Improvement Commissioners were established, and then began Bournemouth's history as a town. We have already chronicled the circumstances under which the Board was inaugurated, and told something of its trials and difficulties, its work and achievement; we have given illustration of the remarkable progress which the town made under its earnest and judicious administration; and wre have show'n how, time after time, the area of its district was extended and its responsibilities increased – in short, how the way was prepared for the eventual vesting of the town's affairs in the hands of an Authority with larger powers and privileges, and for Bournemouth to take an honoured place among the municipalities of the United Kingdom.

A great change came in 1890, when a Charter of Incorporation was received and the town became a Municipal Borough. Incorporation had been advocated for a period of some seven or eight years, and various

petitions had been addressed to the Queen in Council praying for a Charter. An Incorporation Association was formed, and, of course, there was a rival organisation, which, by the way, had not only large but specially influential support. In consequence of the opposition, for a long time no success crowned the efforts of the promoters, and not till after the matter had been made a test question at various elections, the Commissioners had endorsed the application, and the opinion of the ratepayers been shown to be overwhelmingly in favour of the desired change, was the petition granted. There is no need to review in detail the arguments either of promoters or opponents; briefly stated, they came to this: the promoters believed that Incorporation was the natural evolution of a growing town and that Bournemouth's continued development and prosperity demanded the larger administrative powers, improved status, and more direct representation of the popular will that Incorporation alone could secure; the opponents thought that, if change would be ultimately desirable, the time was not yet ripe. The Incorporation Association had at one period a considerable membership; very few remain associated directly or indirectly with the public life of today, but, referring to old 'Directory' records, we find, among others, the names of Messrs. C. T. Miles, J. Donkin, J. G. Lawson, C. H. Mate, W. Mattocks, C. A. D. George, W. Dunn, D. Sydenham, H. Newman, and A. J. Abbott.

The Charter was signed by her Majesty the late Queen Victoria on the '.10th June, 1890, and was brought to Bournemouth by a specially appointed deputation on Wednesday, the 27th August, which day was observed as a public holiday and made an occasion of rejoicing and festivity. The late Mr J. McWilliam was nominated in the Charter as Provisional Mayor, and the first municipal elections in the borough of Bournemouth were carried out under his direction, with Mr J. Druitt, the Clerk of the Commissioners, acting as his legal adviser. Provision was made dividing the town into six wards, and the system of election was entirely revolutionised. In the early days of the Commissioners the system of election had been one of open voting, with the plural vote, and there is record of a contest in September, 1868, when, though there were six candidates pressing for their suffrages, less than fifty electors went to the poll! Later, the system was changed; polling papers were taken to the houses of the electors – ratepayers and owners of property – who had one or more votes, according to their assessment. Incorporation altered all that: it introduced the system of the Ballot, with separate elections in each ward, instead of one for the whole area. The ownership franchise passed away, and the rule for the newly-created burgesses was 'one man, one vote,' 'man' in this case including 'woman.' And the ladies, we may remark,

have always formed a very considerable proportion of the Bournemouth municipal electorate.

In an Appendix we give a complete list of gentlemen who at various periods held office as Commissioners, but it may be convenient and appropriate here to mention that the last Board comprised the following 'Messrs. W. Fisher (Chairman), T. J. Hankinson, E. W. Rebbeck, H. W. Jenkins, H. T. Trevanion, T. Beechcy, R. Sworn, J. R. Ridley, H. Newlyn, J. Cutler, J. H. Moore, H. N. Jenkins, G. M. Hirons, C. A. D. George and J. C. Webber, with the Lord of the Manor (Sir George Meyrick) and his nominee (Mr T. Arnold).

The first election of Councillors took place on the 1 November, 1890, and the candidates elected were West Cliff Ward – Messrs. H. T. Trevanion, M. J. Roker and S. Brown; Branksome Ward – Messrs. T. J. Hankinson, J. A. Fyler and A. Davis; Central Ward – Messrs. E. W. Rebbeck, H. N. Jenkins and H. Newlyn; East Cliff Ward – Messrs. W. Fisher, E. Dyke and H. Ellison; Boscombe Ward – Messrs. J. A. Hosker, H. C. Stockler and G. M. Hirons; and Springbourne Ward – Messrs. W. Hoare, G. J. Lawson and J. C. Webber. At their first meeting the Councillors elected Mr T. J. Hankinson as the first Mayor of the borough, and Messrs. G. M. Hirons, T. Beechev, H. Newlyn, H. W. Jenkins, C. A. D. George and J. R. Ridley were appointed as the first Aldermen. The vacancies created in the ranks of the Councillors were filled by the election of Messrs. E. Offer (Central) and G. Mitchell (Boscombe).

The Town Council had, of course, to provide new machinery of administration. They 'took over,' however, all the officers of the old Board, and Mr Druitt, the legal adviser to the Commissioners, became the first Town Clerk, his appointment being not only a personal compliment and fitting recognition of long and faithful service, but an indication of the new Authority's desire to observe a continuity of policy, and not needlessly to interfere with any of the work initiated by their predecessors. After much deliberation, and some criticism, the Council adopted as the town's motto, 'Pulchritudo et Salubritas' – indicating two of its chief characteristics and principal claims to renown. Application was made to the Heralds College for a grant of arms, and after due investigation of local circumstances and history, the grant asked for was made. Heraldry in England, as being an exact science, is always held to express some leading facts in the history of an individual or locality, and, in the case of the latter, to display some distinctive features which mark it out from other places around it. In accord with these principles the Arms of Bournemouth were constructed.

The whole district in which Bournemouth stands was originally a Royal Demesne of King Edward the Confessor. As this is the first existing item of authentic history relative to the place, it was felt that the Arms of that

Monarch would properly form the field or basis of the Corporate shield. This consisted of a 'Gold cross fleurie,' or floriated at the ends, upon a field of azure. In heraldly, however, such a shield could not correctly be adopted by any other than the original without important change, styled 'Differencing.' This change must be such as will still render its origin clear to the Heralds. In the Bournemouth shield there is a division into four parts, termed 'Quarterly.' This gives the opportunity for a beautiful change or 'Difference.' The cross of Edward the Confessor and the field are 'Counterchanged.' Thus, the first and the fourth quarters of the shield are gold (or) and the parts of the cross falling in that division are azure; while in the second and third quarters the process is reversed. This also enables the four divisions to become more completely historical. The British Lion is displayed upon the first and fourth quarters, but it is 'Differenced,' as it is a Royal charge. It is shown 'Rampant,' as indicating the constant calls to arms necessary in all that coast during the middle ages; and on the rules of 'Differencing' is Azure, thus following the principle of 'Counterchanging' adopted throughout the shield. The Lion holds in his prepaws a rose relating the shield to the crest. In the second quartering an interesting use is made of the 'Martlets' which are given in the ancient, shield of Edward the Confessor. They are grouped, and one added as a variation; so that while still reminding a student of heraldry of the source from which they come, they suggest important local features. The sand-cliffs of Bournemouth are distinct sources of its beauty, and thus the group of sand-martins, or 'Martlets' as they are styled in heraldry, fitly indicates this. The azure field may express the blue sky, while the third quarter below as fitly suggests the blue sea beneath, an idea which the fishes (salmon) moving upon it completes.

The crest is a pine tree (proper) on a green mountain (mount vert) with, in front, four roses (or), the whole being on a wreath of the colours – gold and blue (or ami azure). The pine tree on the green mountain may be taken as indicating the salubrity of the climate and the rose is not only a Royal Emblem and the emblem of Hampshire, in which County Bournemouth is geographically situate, but as the queen of flowers, emphasises the motto 'For beauty and salubrity.' Thus crest and motto combine to state the claims of Bournemouth upon the British public as a resort for health and pleasure.

No charge upon public funds was needed for the provision of civic regalia: all the requirements of the time were met – and very handsomely met – by private liberality. The members of the Council themselves subscribed for an 18-carat gold chain of office, for the use of the Mayor. This comprises twenty-four links of equal size, being pointed oval shields attached to each other by a representation of the Hampshire Rose, each

shield bearing the name of one of the original Aldermen or Councillors, or of the Town Clerk, and a large centre link, with sword, mace, and mural crown, and the letters 'B.B.' raised upon a ground of blue enamel. This link is engraved upon the back: 'T. J. Hankinson, S.I., first Mayor, 1890–91,' and was given by that gentleman. The 18-carat gold and enamel badge – worn either attached to the chain or separately with a ribbon – was the gift of Mrs Merton Russell Cotes, whose husband (now Sir Merton Russell Cotes) on the same occasion presented the borough with a handsome silver-gilt mace. The mace is 32 inches in length, and is in three parts, the shaft having a terminal in the form of a pine cone and bosses of fern and cones. The head is cup-shaped and finely engraved with the royal and borough arms, with representations also of ferns, pine branches and cones. The top forms an open crown, and is removable in order that the head may be used as a loving cup – if required. The Mayoress' chain was the gift of the Aldermen and Councillors (with the Town Clerk and Borough Surveyor) of the first Council of Greater Bournemouth – as extended in 1901 – and is composed of links representing respectively the English and the Hampshire Rose, connected with a rope pattern. The English Rose is enamelled in true heraldic colours, red and white alternately, and the Hampshire Rose is of gold. The centre link comprises an artistic shield, on which is engraved: 'County Borough of Bourn mouth,' surrounded by dolphins resting on the civic emblems (mace, sword, and battleaxe). The outline of the badge is formed by a graceful line of dolphins, correctly modelled. Oil the lower part is introduced an anchor and trident combined – indicating the nautical character of the district. On the anchor appears the letter 'B.' set with diamonds, and the trident occupies a position at the top. A mural crown, symbolical of civic dignity, surmounts the badge, and in the centre are the arms, motto, and crest of Bournemouth, richly enamelled in heraldic colours, and the whole is richly enwreathed in gold. The badge is further festooned with pearls and rubies, the whole forming a very handsome pendant. The back of the civic link is engraved: 'Presented by the Mayor (Councillor Frost, M.D.), 1901.' On the back of the badge the inscription is as follows: 'Given by the first eleven Aldermen of the enlarged Borough, 1901,' with the names of the respective Aldermen. The names of the Councillors and of the two subscribing officials appear on the links. Except as otherwise indicated above, the chain and badge are entirely of solid 18-carat gold.

The new Municipal Borough was of the same area as the Commissioners' district at the time of the transfer – 2,593 acres, as against the 1,140 acres when the Board was first established in 1856. With the exception of the addition of a smaller area of about 178 acres in 1895, there was no further addition of area till the great extension of 1901 – of which more

anon. Some very important changes with regard to local administration were, however, effected by legislation. Under the provisions of the Local Government Act of 1888, the Hampshire County Council was established, and Bournemouth, in common with other places, for the first time became entitled to some representative control of County affairs. The borough was divided into three divisions, each to elect one representative, and a Westover Division was similarly established – including the districts of Winton, Pokesdown, Southbourne and Holdenhurst. The first County Councillors elected for Bournemouth were: East Cliff – Dr J. Roberts Thomson, J.P.; West Cliff – Mr W. W. Moore, J.P.; and Boscombe, Springbourne and Malmesbury Park – Mr G. J. Lawson; the late Mr J. McWilliam being at the same time returned as the representative of Westover. In 1901, Mr J. C. Webber displaced Mr Lawson in the representation of Boscombe, Springbourne and Malmesbury Park, but the latter recaptured the seat three years later, and held it till the division of the district in 1899, when he elected to sit for the new Springbourne and Malmesbury Park division, and Dr J. A. Hosker was returned to represent the Boscombe area. Mr Moore retired in 1891, and his place was taken by Mr C. Gifford, who remained a representative of the division till Bournemouth became a County Borough in 1900. Dr Roberts Thomson, after his first election, was never called upon to face a contest; in 1900, he was appointed a County Alderman, and, notwithstanding that Bournemouth has long since ceased to have any claim upon the County Authority, he still occupies that honourable position, having been re-appointed in 1904, and again in 1910.

Another important measure affecting the administration of local affairs was the Local Government Act of 1894 – commonly known as the Parish Councils Act. Under this Act Winton and Pokesdown came each under the direction, first of a Parish Council, and afterwards of an Urban District Council, and Bournemouth itself, for the first time, was constituted a civil parish. Prior to that period, as explained elsewhere, Christchurch and Holdenhurst were the two centres for all parochial business. But on the 30th October, 1894, the Local Government Board issued an Order constituting Bournemouth a separate parish, with six Wards (corresponding with the municipal wards of the borough), each to return three representatives to the Board of Guardians. In March of the following year a further Order was made, transferring to the Town Council the power and duty of appointing Overseers for the parish, and in the following November yet another Order was issued, giving the Council the power of appointing Assistant Overseers.

Still, the town's local government was far from simple. The Civil Vestries were abolished, but many and various were the Authorities exercising jurisdiction within the borough area. First of all, there was

the Town Council. There was the Board of Guardians responsible for the administration of the Poor Laws. There was the old Burial Board (established in 1872), supplemented from 1891 onward by the Town Council (through their Cemetery Committee) managing the Burial Ground established under the Bournemouth East Cemetery Act, 1891. There was the County Council responsible for the maintenance of main roads, the provision and maintenance of asylum accommodation for lunatics, the organisation and aid of technical and secondary education, and a great variety of other matters. There was a Standing Joint Committee – partly appointed by the County Council and partly by the Court of Quarter Sessions – controlling the County Police. There was the Court of Quarter Sessions itself responsible for the administration of justice and acting as a Licensing Appeal Authority. And Bournemouth, notwithstanding its large development, for magisterial purposes, was still but a sub-division of the Ringwood Division of the County. Progress had been made, but much yet remained to be accomplished. Simplification was necessary, – and Bournemouth had reached such a stage that it might well demand the more extended powers and improved status – in short, 'the highest form of government and the most complete local autonomy' secured to County Boroughs. There was dissatisfaction with the degree of representation given to the town on the County Authority; but there was, it was thought, ground for action quite apart from that. The records of the Council show that on the 28th July, 1898, Councillor Mate accordingly moved: 'That a Special Committee be appointed to consider the desirability of taking such steps as may be necessary for securing for Bournemouth, at an early date, the status and privileges of a County Borough, and the advantages of a Court of Quarter Sessions.' The Council approved, a Special Committee, of which Councillor Lawson was nominated Chairman, was appointed, the advisability of action was affirmed, and in due course three petitions were prepared, formally sealed, and presented. The first was to the Local Government Board, praying that Bournemouth might be constituted a County Borough; the second to her Majesty the Queen, asking for a separate Commission of the Peace; and the third to the Privy Council, praying that 'a separate Court of Quarter Sessions be holden in and for the Borough of Bournemouth,' it being 'the wish of the inhabitants to secure the most ample forms of self-government.' A favourable response was received to each appeal. A separate Commission of the Peace was issued on the 16th June, 1899, on the 29th August the borough was granted the further privilege of having its own Court of Quarter Sessions, and on the 1st April, 1900, Bournemouth became a County Borough – thereby realising its ambition of securing 'the most ample forms of self-government.'

Accession to the status of a County Borough made no change in the constitution of the Municipal Authority; it added, however, to their duties, privileges, and responsibilities, and indirectly promoted the large extension of area which was brought about in the following year, when Winton and Moordown, Pokesdown and Southbourne, and some other districts, were all brought into the borough, under circumstances already narrated.

Various important changes were effected. The Pokesdown and Winton Urban Councils and the Southbourne Parish Council were abolished; there was a re-arrangement of wards, all seats on the Council were vacated, and provision was made for the election of a new Council of thirty-three members – three for each of eleven wards – supplemented by the appointment of eleven Aldermen. The election of the first Councillors for Greater Bournemouth took place on the 1st November, 1901; the election of Mayor and the appointment of Aldermen on the 9th of the same month. Under the provisions of the Order the work of the old Burial Board was transferred to the Council, and then placed under the direction of the Committee administering the East (or Boscombe) Cemetery, formed some years previous on land which was part of one of the old Turbary allotments. Here it may be convenient to add a remark with regard to the long service of the Burial Board and the many difficulties which they had to face in the early stages of their career. It was no easy matter to obtain land for their purpose. A proposal was mooted for the utilisation – subject, of course, to Parliamentary authority – of land which now forms part of Meyrick Park, and negotiations were conducted, and all but completed, for the acquirement of a large tract of land on the Poole Road, near the West Station! This had to be set aside on account of springs of water; but at last the Board were able to make arrangement for the purchase of suitable land at Rush Corner, Wimborne Road, from the late Mr W. Clapcott Dean, who, according to the Chairman of the Board, 'acted very handsomely towards them.' Mr C. C. Creeke, for so many years Surveyor to the Commissioners, was Architect and Surveyor also to the Burial Board, and the Bournemouth Cemetery – with its wonderful avenue of Auricarias – in a few years became one of the most beautiful places of its kind in the country. The East Cemetery was laid out by Mr F. W. Lacey, and the handsome stone buildings erected from his designs. The 'Bournemouth' Cemetery was opened in 1878; the 'East' Cemetery in 1897.

For the discharge of duties heretofore performed by the County Council it became necessary for the new County Borough Council to make other arrangement. They proceeded forthwith to nominate a Technical Instruction Committee, and they appointed their full body as the Authority for the 'licensing of houses or places for the public performance of stage plays,' music and dancing. Similarly, they became responsible for the

administration of the Explosives Act – including the issue of licenses for the sale or manufacture of gunpowder – and of the Food and Drugs Act; for regulations for the protection of wild birds, etc., for the issue of game licenses, the certifying and recording of places of religious worship, for registrations of various character – including the complete list of members of all secret societies – and a number of minor matters. They became the Police Authority for the area, but after due consideration, and discussion again and again renewed, have made arrangement for the policing of the Borough by the County Constabulary, on terms agreed upon, the Local Authority having the privilege of nominating four representatives to sit with the Standing Joint Committee and safeguard their interests. Joint action has also been discussed, and is in contemplation, with regard to the provision of Asylum accommodation and management. The 'financial adjustment' contemplated by the County Councils Act has not yet been effected, though more than nine years have passed since Bournemouth attained to its new dignity; the difficulties which for long blocked the way to a settlement, have, however, now been removed, and it is expected that the 'adjustment' will be amicably arranged.

Following upon the extension of the borough which took place in 1901 the County Justices ceased to sit in Bournemouth, and the Police Court in the Littledown Road was, by arrangement, handed over for the use of the Borough Bench. The accommodation for magisterial purposes is inadequate; no provision whatever is afforded for the Court of Quarter Sessions or the sittings of the County Court Judge, and there has been much complaint of the defect. But plans are now prepared and new buildings are to be erected which, it is hoped, will 'satisfy the requirements of the Courts, [though Bournemouth may still be left without those other Public Offices which the growing volume of its public affairs imperatively demands.

Within the last few years legislation has cast new burdens of important character upon the Council, as upon other Local Authorities, and the municipal machinery has needed adjustment to meet the new demands. A Libraries Committee – consisting, as regards one half, of members of the Local Authority, and, as regards the other, of persons nominated by them – was first appointed on the adoption of the Libraries Act in 1893. The establishment of an Education Committee superseding the old Technical Instruction Committee – came in 1903 – following the passing of the Education Act of 1902. The Committee consists of 24 members – including 16 members of the Local Authority and eight others selected on account of experience in connection with various phases of educational work. Under the Unemployed Workmen Act, 1905, a Distress Committee has been formed comprising 12 members of the Council, eight members

selected by the Board of Guardians, and five persons 'experienced in the relief of distress.' The whole body of the Council acts as the Committee under the Old Age Pensions Act, 1908, but the details of work are left to a sub-committee of nine, with Councillor Lickfold as Chairman. The Members of the Finance Committee are a Committee under the Small Holdings and Allotments Act. The variety and extent of the Council's work may, perhaps, be sufficiently emphasised by the enumeration of the Standing Committees as appointed on the 9th November, 1909. These are as follows Finance Committee (Alderman Youngman, Chairman); General Purposes Committee (The Mayor); Beach, Cliffs and Foreshore Committee (Alderman Robson); Buildings Committee (Alderman J. Allen); Estates Committee (Councillor W. Sheppard); Horse, Hackney Carriage and Diseases of Animals Act Committee (Councillor J. Trowbridge); Lighting Committee (Alderman T. Slade); Parks and Pleasure Grounds Committee (Councillor Mitchell); Pier, Winter Gardens and Band Committee (Alderman J. C. Webber); Roads Committee (Councillor W. E. Jones); Sanitary Committee (Alderman J. E. Beale); Tramways and Parliamentary Committee (Councillor F. J. Bell); Watch Committee (the Mayor); Public Libraries Committee (Alderman R. Y. Banks); and Education Committee (Alderman C. H. Mate). The Council nominates representatives to serve on the Governorship and Council of Hartley University College, Southampton; on the Standing Joint Committee for Hampshire; on the Hampshire Territorial Association; on the Southern Sea Fisheries District Committee; and on the Municipal Corporations Association. It has representation also on the School Management of Non-Provided Elementary Schools, under the Education Acts, and on various Secondary Schools, with the controlling power of 'Bournemouth School,' the majority of Governors being appointed by the Bournemouth Authority, through its Education Committee.

The position of legal adviser to the Corporation, as already mentioned, has since 1902 been filled by Mr G. W. Bailey, the Town Clerk, who fortunately had, before coming to Bournemouth, long and varied training in municipal work in some of the most enterprising boroughs of the north. He was consequently able to apply himself with great success to problems of most difficult character relative to the Tramway undertaking, the County Borough settlement, the general question of finance, and matters relating to various important schemes which from time to time have required the attention of the Town Council. Mr Bailey has as his 'lieutenants' Mr C. Stacey Hall, whose long service in connection with the town's affairs was appropriately acknowledged upon the reorganisation in 1802 by his appointment as Assistant Town Clerk, and Mr H. Gorringe Smith, the Assistant Solicitor to the Council. The chief executive officer

is Mr F. W. Lacey, the Borough Engineer and Architect, who entered the service of the Local Authority in 1889, and has had responsibility for much of the later development of Bournemouth. Comment has been made upon the good fortune of the Commissioners in securing Mr C. C. Creeke as their first Surveyor; in Mr Lacey the Town Council have found an official of equal versatility, with the same enthusiasm for artistic development, and for securing the highest practicable standard of comfort, convenience, and utility. Mr Creeke was able to render double service to the town's interest from the fact that he was not only Surveyor to the Commissioners, but Surveyor and adviser to some of the principal estates of the town and neighbourhood. The Corporation make exclusive demands upon Mr Lacey's time and attention, but his opportunities for impressing a distinctive character upon Bournemouth have not been less than those of his predecessor, nor have they been less ably or less fully responded to. The volume of his work was incidentally illustrated at a Local Government Board Inquiry in 1909, when it was mentioned that he had been concerned in the preparation and carrying out of schemes in Bournemouth involving an expenditure of about a million sterling! Under the Town Planning Act, the office which Mr Lacey holds will be one of yet greater power and responsibility. It is satisfactory to know that he appreciates the importance of maintaining the pinewood surroundings and other distinctive features which have made Bournemouth unique among British health resorts. Dr P. W. G. Nunn, the Medical Officer of Health, as the head of the Sanitary Department, through a long period of years, has had the responsibility of advising and directing all measures for the proper safeguarding of the health of the people, and the town's general healthfulness, as well as its wonderful immunity from zymotic disease, prove the wisdom, the appropriateness and the adequacy of the methods adopted. Bournemouth has grudged no expenditure on sanitary insurance, and it has reaped the reward of its liberality. Mr Dan Godfrey, as Musical Director, superintends another department of the town's administrative affairs; Mr F. W. Ibbett is Secretary to the Education Authority and adviser in all matters educational; and Mr C. W. Hill is the General Manager of the Tramways. To each of those officials, however, reference has already been made. Mr C. Riddle superintends the Library Department; Mr C. R. Haley is the Borough Accountant; and Mr A. Durance George (Manager of the Bournemouth branch of the National Provincial Bank), is the Borough Treasurer. Mr J. Selley is Clerk to the Borough Magistrates, and Mr C. J. Haydon is the Clerk of the Peace.

The Corporation of Bournemouth comprises 'the Mayor, Aldermen, and Burgesses.' But the municipal registers contain the record of yet another class – not necessarily Aldermen, Councillors, or Burgesses. We

refer to the Honorary Freemen appointed under the provisions of the Statute, 48 and 49 Vict., Cap. 29, intituled, 'An Act to enable Municipal Corporations to confer the Honorary Freedom of Boroughs upon Persons of Distinction.' The Bournemouth Council first availed themselves of the powers of this Act in 1902, when on the conclusion of the South African War they conferred the distinction of being their first Honorary Freeman upon Lord Roberts, 'in recognition and appreciation of the distinguished services which, during a long and brilliant military career, he has rendered to the nation, and in admiration and acknowledgment of the way in which, under circumstances of exceptional stress and difficulty, and setting aside all personal considerations, he undertook and carried to a successful issue the arduous operations in South Africa.' The second occasion of the conferment of this honour was in 1906, and the recipient on that occasion was Alderman J. E. Beale, J.P., the occasion of the presentation being the completion of three years' tenure 'of the important and honourable office of Mayor and Chief Magistrate' – a period which, according to the terms of the resolution, he had made 'memorable in the annals of the borough,' ensuring on his retirement 'the sincere and lasting regard and good will of all sections of the community.' This 'good will,' we may remark, was emphasised by a town's presentation, comprising a very fine portrait of Alderman Beale in Mayoral robes, by Mr W. Llewellyn, to hang in the Council Chamber, and a replica for Mr Beale's own house, with a corresponding picture of Mrs Beale (by Mr Frank Richards). The two other Honorary Freemen are Sir Merton and Lady Russell Cotes, and the honour in this case was prompted particularly by gratitude for the announcement made on the occasion of the opening of the Undercliff Drive. The resolution of the Council sets out that it is 'in recognition and appreciation of their great generosity and genuine and unselfish local patriotism in conjointly presenting to the Corporation, as a free gift, their valuable residence, East Cliff Hall, together with a splendid collection of pictures, curios, bric-a-brac, sculpture, and other art property therein, for use as an Art Gallery and Museum for the enjoyment of the public of Bournemouth, and visitors to the town, in perpetuity, and further, to signify the Council's feeling that so public- spirited an act of liberality entitles them to the lasting good will and regard of their fellow townspeople, and also to have their names recorded high upon the scroll of those whom the Council and town have been proud to honour.' In each case the certificate of freedom has been beautifully and appropriately illuminated and presented in a handsome and valuable casket. It may be added, as regards Sir Merton Russell Cotes, that he has been officially recognised as the first person who suggested the construction of the 'Direct' line of railway between Brockenhurst and Bournemouth, the source of so much of the town's recent prosperity.

The portrait of Alderman Beale now hangs in the Council Chamber, Yelverton Road, where also are paintings representing the Founder of Bournemouth; Mr C. C. Creeke, the first Surveyor to the Commissioners; Mr J. Cunnington, a former Commissioner; and Mr J. Cutler, who was both a Commissioner and a member of the Town Council. The walls are further adorned with a fine crayon drawing of his late Majesty King Edward VII., and other ornamentation of the Chamber is provided by busts of Queen Victoria and of Mr C. C. Creeke (presented by Sir Merton Russell Cotes), and of Sir Merton Russell Cotes (presented by Lady Cotes), and in the adjoining Mayor's Parlour is a complete series of photographic portraits of Mayors who have held office since the Incorporation of the borough in 1890.

19

Volunteers & Territorials

The Centenary of the 'founding' of Bournemouth is the Jubilee of the Local Volunteers, for it was in September, 1860, that the first Rifle Corps was formed. In an earlier chapter reference has been made to the spirited efforts made by dwellers along the Hants and Dorset coast – led by men like Mr Lewis Tregonwell, the Founder of Bournemouth – to prepare themselves to repel threatened attack by Napoleon Bonaparte. Half a century or so later, the great military and naval activity of France, under Louis Napoleon, the nephew of the 'great' Napoleon, again aroused the people of this country to the folly of unpreparedness for the dread eventuality of war. Then it was that by a popular impulse, the Volunteer Force in a permanent form was created, and the famous letter of General Peel, Secretary of State for War, was issued (May 12th, 1859) to Lords-Lieutenant of the various counties, authorising the formation of corps. Bournemouth at that time was a place of very moderate dimensions, but proposals for the forming of a local corps were immediately taken into consideration. A suggestion was made for the establishment of an Artillery Corps, but difficulties arose with regard to training and other matters, and the proposal was abandoned in favour of one for a Rifle Corps. The then Earl of Malmesbury, who had till recently been serving her Majesty Queen Victoria as Secretary of State for Foreign Affairs, undertook the organisation of a Christchurch and Bournemouth Company; but a little further consideration showed that the arrangement would be an inconvenient one, and that the better plan would be for Bournemouth to have a sub-division of its own. The change of plan occasioned some delay, with the result that while the Christchurch men took the oath of allegiance on the 23rd March (and became known as the 10th Hants Rifle Volunteers), it was not till the 4th September that the 19th Hants (Bournemouth) sub-division was formed. The 'swearing in' took place at the Belle Vue Assembly Rooms, before the late Mr W. Clapcott Dean, J.P. Mr C. A. King, of Branksome Dene, was elected to the command, with Mr H. Ledgard as Lieutenant, Dr W. Allis Smith as Hon. Surgeon, and the Rev. A. M. Bennett (the 'Founder' of St Peter's) as Chaplain. The last-named, by the way, was one of the most energetic

promoters of the movement; he presided at several of the meetings held, and is credited also with having done a considerable amount of personal recruiting. Of the thirty-five 'effective' members who were present at the meeting in September, 1860, there are, we believe, only two surviving – Dr Allis Smith, already referred to, and Mr E. W. Rebbeck (now Lieutenant-Colonel Rcbbeck, V.D.). Mr Rebbcck had his father, the late Mr W. E. Rebbeck – who, like his son, attained to the honoured place of Chairman of the Commissioners – as a 'brother-in-arms,' and the Captain Rebbeck who is now associated with the Territorials is a member of the same family. Thus we have three generations associated with one corps – an interesting and probably a unique record in Volunteer annals.

A few weeks later we find the 'Director' announcing that 'the Volunteers are most assiduous in their attention to drill. The bugle sounds daily, and the sound of its martial notes is quite a novel feature in this hitherto quiet place.' In February, 1861, there was a statement that 'the return of sunshine and fair weather will witness the Bournemouth Corps fully equipped and ready to take the field. This establishment of a Rifle Corps is another instance of what may be denominated the pluck of this place, many towns of considerable size not having been able to contribute to that highly popular branch of the National defence – the Volunteer Army.' Within less than a year the 'sub-division' became a full corps, and several ladies, with Mrs Bayly, Mrs Rogers, and Miss Rebbeck as chief collectors, started a subscription for the purpose of providing the gallant Riflemen with a Band 'to enliven their parades and marches, and at the same time testify the high appreciation in which the services of the Volunteers are held by the fair sex.' Mr C. C. Creeke succeeded Mr King as Commandant, Mr A. H. Parken took the post of Lieutenant, Mr John Jefferies – brother to the late Deputy Speaker of the House of Commons – became Ensign, Mr W. B. Rogers was made Quarter-Master-Sergeant, and Mr J. McWilliam, Colour-Sergeant.

But the first Volunteer parade in Bournemouth was not a parade of Bournemouth Volunteers. Poole had succeeded in establishing a Rifle Corps at a very early date, and on Easter Monday of 1860 the men marched over to Bournemouth under command of Captain Parr, Lieutenant Cox, and Ensign G. B. Aldridge, accompanied by two bands! They were 'greatly admired' and 'highly complimented,' and subsequently they visited Bournemouth again and again, taking part with the Bournemouth Volunteers and the Coastguard in various 'sham fights' in the meadows, now the Lower Pleasure Gardens.

An Artillery Corps was formed in 1866 under the Captaincy of Mr J. Haggard, and a body of men, about sixty in number, were sworn in by Lieutenant-Colonel Richards at a meeting held at the Belle Vue Assembly

Rooms on the 14th November. A site for the purpose of a Battery – at Tuckton – was given by Sir George Meyrick, and the corps rapidly increased in numbers and popularity. Mr E. W. Rcbbeck, who had been a member of the Rifle Corps, took a Lieutenancy under Captain Haggard, and subsequently attained to the local command, which he held for many years, retiring with the rank of Lieutenant-Colonel and with the much-prized 'V.D.' distinction. Mr C. F. Hawker similarly served for some thirty-six years, and retired with the rank of Captain and with the 'V.D.' decoration. The '4th' were for a long time brigaded with Hampshire; then came a transfer to the neighbouring county, and enrolment as companies of the Royal Dorset Garrison Artillery, blossoming forth at last as the 6th Hants Battery of the Royal Field Artillery under the new Territorial scheme, with Major D. D. Arderne as officer in command. The Victoria Drill Hall, Lansdowne Road, where the men assemble, is a capacious building, which was opened by Field-Marshall Lord Roberts on the occasion of his visit to receive the Freedom of the borough in 1902.

Going back again to the Rifles, we may mention that they, too, like the other arm of the Service, have undergone many changes. At first they were attached to the 4th Administration Battalion of Hampshire Rifle Volunteers, under the command of the late Sir Brooke Pechell, Bart. Subsequently the battalion became known as the 2nd Hants; then, in 1885, the Bournemouth and New Forest Companies were detached to form the nucleus of a new battalion – the 4th V.B. Hampshire Regiment, with the late Colonel J. O. Vandeleur as Commandant. To him succeeded Dr J. Roberts Thomson, who in 1899, on the occasion of a brigade camp at Ashey, in the Isle of Wight, had the honour of leading the corps past the late Queen Victoria, who had invited the Brigade over to Osborne for special review. On the retirement of Lieutenant-Colonel Thomson, V.D., Major George, V.D., succeeded to the command of the Bournemouth (Headquarters) Companies, and Lord Montagu of Beaulieu to the charge of the battalion. Major George, fey the way, joined the Corps as far back as 1869, and served for a record period of 45 years, whilst Captain Day, V.D., 'put in' a total of 36 years' service. The 'Rifles' are now incorporated with the Territorials, with Lord Montagu as Commandant of the 7th Battalion Hampshire Regiment, and Captain S. G. Smith as officer in charge of the headquarter companies.

At the time of the South African War, Bournemouth sent out two strong detachments. Lieutenant Thomson – a son of the gallant Colonel – accompanying them. The men had a somewhat strange experience. They were detailed for Avork in connection with the line of communications; this brought them under fire, though they never actually saw the enemy, and had no chance of making effective reply. Unfortunately, they were

involved in the Barberton railway accident, and one, at least, of them sustained serious injuries. On their return, they were given an official welcome by the Town Council, and a tablet recording their services has been placed on the walls of the Rifle Drill Hall, – which building, we may add, was the gift of a lady admirer of the Force, Miss Mitchel.

Besides a strong representation of Artillery and Infantry, Bournemouth also has its Troop of Cavalry, associated with the Hants Carabineers, and a local Company of the Legion of Frontiersmen was formed in January, 1908.

In connection with a review of local Volunteering, it is interesting to recall the fact that Sir John Bucknill, honoured as the founder of the modern Volunteer Force, spent his closing years at Bournemouth, which was also, and for a long period, the home of the late Admiral Sir James B. Sulivan, who as far back as December, 1851, at the late Professor Darwin's dinner table, pointed out to a party of country gentlemen the defenceless state of the country, and how easily a small invading force might overrun our southeastern counties – that nothing but the establishment of Volunteer Corps, in addition to a regular Militia force, would ensure safety. Those present urged him to write to the papers on the subject. He did so, his letters appearing in the 'Naval and Military Gazette' for January 10th and 31st, 1852. The outcome of this and some other correspondence – by Colonel Napier – was the offer of several Volunteer Corps to the Government, the first accepted being the South Devon one of Sir John Bucknill.

20

Music & Drama

To the late Sir Florence Percy and Lady Shelley belongs the credit of being the first to cater for the amusement of the people of Bournemouth and neighbourhood by means of dramatic entertainments. Sir Percy and Lady Shelley were both of them artistes of very considerable ability; they had a great enthusiasm for the Drama, and in dramatic circles they were both well known and highly esteemed. When he first settled at Boscombe, Sir Percy had the opportunity given him of acquiring the whole of the sea front from Boscombe Chine to Southbourne, but he thought an estate of 400 acres was enough for his purpose; and the delightful marine estate eastward of Boscombe Manor became the property of Lord Portman, by whom it is still held. In the garden, detached from the house, Sir Percy built a little theatre of his own; but later on this was superseded by a theatre attached to the house, which still stands, though now devoted to other purposes. Lord Abinger has in his possession at Boscombe Manor quite a large collection of play-bills, relating to entertainments given either at Boscombe Manor or at the Theatre which Sir Percy built for himself on the Thames Embankment. They are wonderfully interesting; they range from 1852 onward, and included among the actors we find, besides Sir Percy and Lady Shelley, the names of Captain Wingfield, Mr J. A. Rolls (now Lord Llangattock), Dr Gully (father of the late Speaker of the House of Commons), Mr Palgrave Simpson, Mr F. C. Burnand, Mr Herbert Gardner (now Lord Burghclere), Captain (afterwards Colonel) Scarlett, Admiral Sir William Wiseman, Sir Charles Young (author of 'Jim the Penman'), the Hon. Grantley Berkeley, Mr and Mrs German Reed, Mr Hamilton Aide, Mr Arthur a'Beckett, and others. Sir Percy was an author as well as an actor, for we find his name appearing as the writer of 'A Fairy Tale,' played at Easter, 1871, and 'A Hidden Treasure,' a melodrama in three acts, written by Mr Watkin Wingfield, and first produced in 1859, was remodelled and partially re-written by Sir Percy for performance in 1877. A Christmas annual, 'The Doom of San Querec,' written by the late Mr Arthur a'Beckett, was dramatised by Mr Herbert Gardner, and that also was presented, together with a number of other plays –'Caste' was

one which was particularly well given, – the performances providing most delightful entertainment for the friends invited to attend, and frequently also being made a means of raising money in aid of local institutions.

In a previous chapter reference has been made to the curious coincidence attending the presentation of 'The Wreck at Sea' on the 26th December, 1852, when a ship actually came ashore at the very time the play was proceeding. We may go on to refer to a play which, perhaps, was never presented – which may, indeed, never have been written, but which the Hon. Grantley Berkeley declared an intention to write, with a prologue addressed to the ladies of Bournemouth. Discussing traits of life at watering places in the middle of the last century, Mr Berkeley incidentally mentions Sheridan's 'Trip to Scarborough,' the prologue to which sets out the caprices of fashion nearly a hundred years earlier. He goes on: 'I have an idea in my head of writing a comedy, on the Sheridanean model, of course, illustrating seaside life. I shall call it 'A Trip to Bournemouth.' All the dramatis personce are in readiness – the scenes and situations of each of the five acts (the interest working up to an astonishing climax in the last) all carefully imagined, and not even the wildness of the residents forgotten.' He quotes his proposed Prologue, concluding with the following lines addressed to the ladies of Bournemouth:

'Cease to seem over fair or over good,
Care not to join the Pharisaic brood.
Laden with cross and rows of jetty beads,
Who glide like ghosts, restless from naughty deeds.
Slippers embroider not – nor paint on scrolls Gaudy appeals to
unrepentant souls.
Enjoy your bath, your walk, your croquet game,
And archery practise without fear or shame;
Have your flirtations in a harmless way,
Whether at concert, promenade, or play,
Pic-nic, or yacht, excursion in the Bay,
And cease to go to Church three times a day.
Eememb^r you need heed no harsh complaints.
Those who are Angels never need he Saints.

'I can fancy myself delivering this,' he says, 'to a crowded and fashionable audience (for I think it would be a pleasant innovation for an author thus to introduce his own plays) at my friend Sir Percy Shelley's new and very pretty theatre at Boscombe, an evergreen oasis in that desert of dulness, the fashionable watering place in its vicinity. I have more than once taken a modest share in the private theatricals there, so admirably got up by

Sir Percy and my lady, who both on the stage and in the house are hosts in themselves. And then I can fancy the glorious recompense I should be sure to receive from the fair enthusiasts who would be present, in being smothered under an avalanche of bouquets. To 'die of a rose in aromatic pain' may be ecstacy enough for small poets, but to die of a mountain of roses and lilies of the valley, verbenas, syringas, camellias, calceolarias, and choice exotics in endless variety of beauty and fragrance, must be a far more covetable form of annihilation, and I think I should like it considerably better than any of the fatal ills that flesh is heir to. However – sufficient for the day is the good thereof – when my comedy is announced we shall see, and so will Bournemouth; such a picture of the caprices of fashionable religion will then – I think I may venture to say – never have been exhibited before.

'There is a clergyman at a funeral in one of Hogarth's pictures, that I shall paint to the life in my play: there is one, did I say, there are indeed some dozens whom I shall make to strut their hour on the stage. Time was when congregations were content with one; now we must have a clerical regiment ranked on either side the way to the altar, all doing little bits of the service, as if sinners could not be saved unless by a ladder of divines on whom to ascend to heaven.

'There is a couplet in "Hudibras" which I never could quite comprehend:

'What makes a flea of thieves 1 A Dean, a Chapter, and lawn sleeves.'

"It has often entered my head at Bournemouth, I suppose of course in opposition to the established fact, that in Bournemouth there could not be a den of thieves, as, so to speak, our clergy, good men at times, have made it their den, and though not adopting the enmity of the fox to the badger, they have so washed the site with holy water that sin ought to have fled and virtue become triumphant.'

Mr Berkeley, as we have before shown, was not enamoured of Bournemouth; in the days when it was a High Church colony, he found it dull and much too prim, the ladies 'bobbing about from dell to dell as if they thought every bush concealed a serpent and a tempting apple, and that they were never safe unless at church.'

Thirty-five to forty years ago Bournemouth possessed two amateur societies who vied with each other in their musical and dramatic productions for the amusement and entertainment of the Bournemouth public. These two societies came to be known locally as the B.A.D.S. and the B.A.M.S., and we have pleasure in recording here a few particulars of their doings.

The Bournemouth Amateur Dramatic Society owed its inception to a meeting held at Mr Nesbit's Studio on the 18th September, 1876, under

the presidency of Mr James Stevens. Mr Harry Nash, whose services in all such matters were greatly esteemed, was asked to co-operate with the newly formed society, and assist in the commencement of a subscription list, whereby a fund should be raised by donations of one guinea for non-acting, and half a guinea for acting subscribers. At a later period the valuable services of Sir Percy Shelley were secured as President, and Sir Pl. D. Wolff, M.P., became Vice-President. Encouraged by the assistance of the former gentleman, himself a famous performer on the amateur stage, and borne along by the enthusiasm of a membership that included many influential residents, the aspirants to histrionic fame had, in a very short time in which to overcome the elementary difficulties, established themselves in a sound financial position, and prepared for a trying dramatic performance. Part of the properties were purchased, the remainder being kindly lent, by the President. The first performance duly took place, a contemporary critic describing it as being far above the average run of amateur work. The drama 'The Dream at Sea,' and the farce 'Turn Him Out' were acted by full casts, all members of the Society. The gentlemen taking the parts of 'Launce Lynwood' and 'William' in the former, and 'Nicodemus Nobbs' in the latter, are still well known and respected residents of the town. It is pleasing to record that the B.A.D.S. continued their performances in the Town Hall for some years, with varying success.

Many years afterwards the Bournemouth Lyric Club established themselves as a really first-class amateur society, but differing in this respect from the Society previously referred to, that the Society for which Mr Herbert Jennings and others worked so assiduously was more operatic, undertaking such difficult productions as 'The Gondoliers,' 'Dorothy,' 'Yeomen of the Guard,' 'Les Cloches de Corneville,' etc. It should be recorded in respect to the last production that the opinion was freely expressed by well-known critics that, if not approaching in merit the acting of Sheil Barry, Mr Jennings' impersonation of 'The Miser' was the best amateur production seen on the stage in any town. Similar compliment should be paid to Mr S. W. Riddett, who was the equal, sometimes the superior, of members of the legitimate stage. No matter how difficult a part in acting or in singing, whether male or female, the 'Lyrics' through their talented conductor found local talent equal to the difficulties to be surmounted. The present Society, with a slightly altered name, and quite different management, is a successor of the old Lyric Club, but without the array of talent which the old Society possessed, some of whom, it should be mentioned, have graduated on to the professional stage.

The fact of the existence of so much musical and dramatic talent in the town emphasised the necessity for a regular theatre where plays by well-known professional companies could be witnessed. Following on

periodical plays in the old Town Hall, the Bournemouth Theatre was erected. The opening taking place on the 7th December, 1882. The original building – the Theatre has been altered many times – was erected from plans prepared by Messrs. Kemp-Welch and Pinder, of Bournemouth, and Mr W. Nightingale, of London, and was built by Mr W. Stanley, of London, and cost about £10,000; the decorations were executed by Mr Walter Bevis, of Bournemouth, from the designs of Mr R. T. Sims, of London, and were described as being exceedingly beautiful. The building was estimated to accommodate 800 persons. The whole of the general arrangements, both of stage and theatre generally, were carried out under the direction of Mr Harry Nash, who had taken the most recently constructed theatres of London and the Continent as his model. The programme on the opening night commenced with Mr and Mrs German Reed's entertainment, after a few words of appropriate introduction had been said by Mr Corney Grain, in the course of which he paid a high compliment to Mr Nash and to the charming theatre. 'The Turquoise Ring' and a musical sketch entitled 'En Route' formed the entertainment occupying the remainder of the evening. An excellent orchestra was provided, under the conductorship of Signor E. Bertini. As we have said, many changes in the building have been made since 1882; the most recent addition – an innovation for provincial theatres – was that of a handsome and substantially furnished Foyer, which has proved an important acquisition, and tends to ensure the greater comfort of the patrons.

To provide entertainment for the east end of the town Mr Archibald Beckett conceived the idea of erecting, in conjunction with his large scheme of Arcade Buildings, a building capable of utilisation as a theatre, music hall, or circus, which was designed by Messrs. Lawson and Donkin on those lines. The building was opened on the 27th May, 1895, and for some years it had a varied career, eventually being purchased by Messrs. Morell and Mouillot, by whom it was run as a Music Hall, and later as a Hippodrome, which is probably a distinction without a difference. The interior was remodelled at the latter end of 1908, the building now being a handsome and commodious structure capable of seating 2,000 persons.

Previous to the opening of the Town Hall in 1875 musical performances were held periodically in the only hall in the town – the Belle Vue Assembly Rooms. Erected by Mr Creeke shortly before the institution of the Board of Commissioners, this building served for a multitude of purposes, all concerts and meetings of a public character being held there. Mr Sims Reeves and many other famous singers have used this hall, which it is scarcely necessary to point out is very small, and is now considered of no consequence as a public hall. At present it is in the occupation of the Jewish community, who use it as a temporary Synagogue.

As soon as a good hall was erected various Societies sprang into existence, and from that time (January, 1875) dates the actual commencement of the town's notoriety for good music, although there was an excellent Society established about 1870 – the Bournemouth Amateur Musical Society, locally known as the B.A.M.S. The Society, with a membership drawn from the principal residents, gave frequent concerts at the Town Hall. Mr T. A. Burton, the organist of St Peter's, and the Rev. A. S. Bennett took active parts in the entertainments, as also did Mr Charles Fletcher, the noted and talented local violinist, who has done so much for music in Bournemouth. The soloists were usually members of the Society, and the works attempted were always creditably performed.

The Bournemouth Philharmonic Society, more pretentious in their aims, undertook the performance of such works as the 'Messiah,' 'Elijah,' 'Rose Maiden,' and 'Creation.' The 'Messiah' was performed at the Town Hall on the 25th November, 1875, under the able management of Mr Harry Nash, and was pronounced a great success. The 'Creation' was given at least three times in the Town Hall, and twice in the Winter Gardens in the spring of 1877 – then recently opened. It may interest some to know that the choir consisted of 92 voices, with an orchestra of about twenty performers. This Society, as most musical societies generally do, ceased to exist, and for many years Bournemouth was without a good, regularly established philharmonic society, until the present organisation, established some years ago by Madame Newling, supplied a want that was keenly felt by the large number of local singers. Madame Newling's Choir has been very successful. Its members are mainly drawn from the choirs of the local churches. Many highly creditable and excellent performances have been given in the Winter Gardens of most difficult works, but, aided by the advice and the conductorship of Mr Dan Godfrey, and the instrumental assistance of the Municipal Orchestra, the occasions when oratorios are given are looked forward to with intense interest by Bournemouth people. Such a difficult work as Elgar's 'Dream of Gerontius' has twice been given with great credit to all concerned, considering the comparative meagreness of the Choir for so heavy a work.

Respecting the establishment of professional Orchestral Music, we must go back to the year 1876, when the Italian Band came here after completing an engagement at Bath. This visit marked the founding of concerted music by a regularly organised band of professional instrumentalists, and paved the way for our present Municipal Orchestra, for there has been an unbroken sequence of orchestral music since November, 1876, when the Band arrived here. The Band consisted of 16 performers, all of whom had served in the Italian Army, and were thus entitled to wear Italian military costumes. The original intention was to spend here the winter of 1876–77

only, but when appealed to the Bournemouth townspeople generously subscribed in various ways, which enabled them to retain the services of the Band right up to the time of the establishment of the Municipal Orchestra in 1892–3. Having been summoned to play at Crichel before his late Majesty King Edward VII. (then Prince of Wales), the title 'Royal' was assumed, a distinction which the members of the Band were naturally proud of. It is needless to record that the performers were all masters of their instruments; so that we can safely assert that Bournemouth has had a really first-class professional orchestra during the past 34 years. One of the instrumentalists. Signor Scacchi, was also an excellent vocalist, and very frequently the programme included a solo by that artiste. Signors Zanetti and Cantini are the only two survivors of the original 16, while several of those who came in 1878 and onwards still remain, some in the Municipal Orchestra and others as professional tutors.

While referring at length to the Royal Italian Band, we should not omit to refer to the excellent services rendered by the well organised Volunteer Bands of the same period, as well as the old Town Band which preceded the first-named.

Reference has already been made to the Corporation's ownership of the Winter Gardens and the establishment of the first Municipal Orchestra in the country. In further extension of that reference we wish to record that this is, undoubtedly, one of the town's greatest assets, and the Council's decision in 1893 to establish an Orchestra was a step that has never been regretted, for, despite the fact that financially the Winter Gardens are sometimes a slightly losing concern, municipally nothing but success has been the result of the local authority's efforts in the direction of the provision, of the highest and best in the musical world. There is scarcely any noted conductor, singer, or instrumentalist who has not appeared here. Apart from the purely musical portions of the programmes, ample provision is also made for entertainments of a higher character, as well as lectures by famous explorers and others of an equally interesting character. It is much to be regretted that Bournemouth does not possess a hall more suitable, more dignified, or more in keeping with the performances at the high-class entertainments we are accustomed to; and we trust that very shortly a hall more suited and with better acoustic properties, conducing to the better enjoyment of the excellent music, will be provided.

Many other excellent organisations have been in existence than those referred to, but it must be obvious that many matters, more or less important, must unavoidably be omitted, from this record of local history.

Parks & Pleasure Grounds: Municipal & Other Sports

From the earliest times the inhabitants of Bournemouth have had the undisturbed use of the Lower Pleasure Gardens – thanks to the successive owners of the Meyrick Estate. Negotiations for public control commenced in 1856, while the land was still in a boggy, undrained condition. The Westover Gardens, including the Invalids' Walk, were, however, as already shown, in good condition, and, subject to not very onerous restrictions, were open to the use of the people. Many attempts were made to complete the arrangements for acquiring the meadows, and so long ago as August, 1859, a provisional lease for 21 years was granted with the option of a 99 years' lease if the Commissioners would undertake, within a certain number of years, to expend a sum of £3,000 upon buildings of a public nature. On Counsel's opinion being obtained, it was found that the Commissioners had no power to accept a lease for the longer term for building purposes; however, as Sir George Gervis would grant, and the Board had power to take, a lease for 21 years on the terms previously proposed, the Commissioners assented to the shorter period. Shortly afterwards Dr Burslem's scheme already referred to was brought forward, which eventually meant the abandonment of negotiations for the time being. Draft leases were prepared in 1862 and 1864, the Commissioners' seal being affixed on the 7th February, 1865. In spite of the official sealing of the lease the matter was not amicably settled, and in fact the whole scheme was once more abandoned. In 1868 further proposals were made, without there being, however, any tangible result. With Sir George's consent footpaths were made on each side of the Brook in July, 1869; and in 1870 two seats were placed in the Pleasure Gardens! While not being finally agreed upon until 1873 matters were at least in a forward state in 1870, as in that year designs were invited for laying out the intended new Pleasure Gardens, and a premium of £30 was offered for the plan which the Commissioners decided to adopt, and £15 for the second. The designs were displayed at the Belle Vue Hotel for the inspection of the Board, when the first prize was awarded to Mr Philip Henry Tree, St Leonards-on-Sea, and the second to Mr Alexander Gordon Hemmell, Bedford

Row, London. In June, 1871, it was decided to take immediate steps to complete the negotiations respecting the lease, and later in that year a deputation was appointed to wait on Sir George Gervis to represent to him the wishes of the Bournemouth public on the subject, which resulted in a letter being received with Sir George's consent to the land in the valley being appropriated to the purposes of pleasure grounds. Even then the question was not definitely settled. The ratepayers became irritated at the delay, and sent a deputation to the Commissioners in February, 1872, following on which the Board, although disposed to accept the terms, hoped that they would be allowed, if they should wish it, to erect a building for public purposes on a part of the ground to be approved by Sir George. In June of the same year a good part of the Gardens was fenced, and it is an interesting fact to mention that much of the original fencing remains, in spite of the frequent alterations, surrounding the Lower and Upper Gardens, particularly in the neighbourhood of the Square. The drainage of the boggy land was next taken in hand, and proved a long and difficult task. Superintended by Mr Proudley, the work was executed by men employed by the Board. Previous to the final settlement of the lease, Mr John Tregonwell made a claim for £350, being for his interest in the meadows on the west side of the central walk, which amount was paid, and the surrender sealed, on the 12th August, 1873.

In December, 1864, Mr Durrant was asked to give to the public the roadway across his meadow (from the London Hotel), to which request he acceded. At the end of 1871 Mr Durrant through his agent, Mr T. J. Hankinson, asked the Commissioners what was their intention in respect to the Upper Pleasure Gardens, and in reply the Board expressed their willingness to take the land from Christmas, and immediately proceed to lay out the grounds as Pleasure Gardens. In February of the following year Mr Durrant made an excellent offer of his land, for the purpose named, at £3 an acre, on condition that the Grounds were formed within six months, and laid out in twelve months. It is needless to say that such an excellent offer was immediately accepted, and Mr Durrant received the special thanks of the Commissioners for his liberality. He was asked, however, if he would be so good as to extend the time limit, it being pointed out that it would be necessary to proceed by special order. The immediate response to this request was the granting of a lease of the land lying between the Sanatorium Bridge and the Square upon certain conditions. Again the thanks of the Commissioners were extended; and it was considered desirable the offer should be accepted. The counterpart of the lease was executed in July, 1872, and the land proposed to be taken over formed part of the Branksome Estate, previously Coy Pond Meadow, and consisted of over nine acres; also a further parcel of land higher up the valley,

amounting to more than five acres. The only reason for the negotiations not being at once completed was probably that the Commissioners were not quite in a position to lay out the Grounds in compliance with the covenants; the time limit was consequently extended to the 24th June, 1873. However, the seal of the Board was affixed to the conveyance and a cheque value £550 was signed for the purchase on the 18th June, 1873. The business-like manner in which this matter was negotiated calls for the highest praise to all concerned. The acquisition of the Upper Gardens was a piece of work showing clearly the foresight of the authorities, and now no more valuable open space is owned by the town. The part lying between the Square and the footpath leading to the Sanatorium Road has been beautifully laid out, and at all times is a veritable 'Paradise,' a name we have frequently heard given to it.

The Upper Pleasure Grounds – beyond the Queen's Road were laid out by the late Mr George Durrant, the generous proprietor of the Branksome Estate, and they have been maintained by him, and since his death by his daughter, Miss Durrant, without charge upon any public fund, though the public have practically unfettered use of them, and the Gardens are kept up to the highest standard of beauty and efficiency.

The principal open spaces owned and leased by the Corporation are the following:

Boscombe Gardens. – 9 acres. Held under leases from Sir H. D. Wolff and Sir George Meyrick at a total rental of £80.

Boscombe Cliff Gardens. – About 6 acres. Presented to the town by Mr R. B. S. Scarlett.

Lower and Upper Pleasure Gardens. – About 29 acres, under leases from Sir George Meyrick and the late Mr George Durrant at a total rental of £237.

Meyrick Park. – About 118 acres, acquired under Parliamentary powers on Sir George Meyrick presenting the town with his rights as Lord of the Manor.

King's Park. – 58 acres. Under the provisions of the Bournemouth Corporation Act, 1900.

Queen's Park. – 173 acres. Ditto.

Dean Park Horse Shoe. – 2 acres, freehold, 12 acres leasehold.

Knyveton Gardens. – 4 acres. Held under leases from Sir George Meyrick and tlie Trustees of Mr W. J. Trehearne at a total rental of £140.

Winton Pleasure Grounds. – 14 acres.

Redhill Common. – 45 acres.

The Chines (three). – 36 acres.

The approximate area of the Parks and Pleasure Grounds within the Borough is 620 acres.

The history of Cricket in Bournemouth, though somewhat scanty in certain periods, is of great interest to followers of the national pastime. About the year 1852 cricket matches were played in the meadows, now called the Upper Pleasure Gardens, the teams making the 'London and Commercial Hotel' their headquarters. In 1858, however, a regularly organised 'pitch' was used in connection with the Rev. J. H. Wanklyn's Collegiate School, Exeter House. Previous to the building of the houses in Exeter Park there was ample space for a cricket ground; indeed, regular matches were played from the first match on the 20th September, 1858, between elevens composed solely of inhabitants and styled Rev. J. H. Wanklyn's Pupils v. Allcomers. In the 29th of the same month the return match was played. Up to 1867 this ground was the only one available for local devotees of the game. On the 1st April of that year a meeting was held at 'The Glen,' there being present the Rev. J. H. Wanklyn, Rev. E. Wanklyn, Mr E. W. Rebbeck, and Mr Thickpenny. At that meeting an offer was made by Mr P. Tuck of a piece of ground at Springbourne for the purpose of a cricket field. The offer was accepted and resulted in the laying down of the first Cricket Ground at Bournemouth, in which ground the Bournemouth Cricket Club formed its home and centre of operations. The Springbourne ground was soon found to be too small, so negotiations were commenced in February, 1869, for the magnificent piece of land, about six and a half acres in extent, situated at the north east corner of the Dean Park Estate, the property of Mr Clapcott Dean, which is the present ground of the Club. It is a fine piece of table land, presenting almost a dead level surface, and having an excellent light. The laying-out, turfing, construction of bowling green (now non-existent), lawn tennis courts, and the erection of the pavilion (September, 1875) cost originally £800. Within recent years a handsome new pavilion and terrace, as well as many excellent improvements, have been added, which conduce to the comfort of visitors. The ground was used for the first time for athletic sports in connection with the B.C.C. in the spring of 1871; and the first match was played on the 30th June of that year against the Artillery Officers stationed at Christchurch. Since that time it has been in constant use for cricket, football, lawn tennis, athletic sports; and also for Volunteer Inspections, Drills, Sunday School Treats, Oddfellows' and Foresters' Fetes, and various other public recreations. It should be mentioned that co-incident with the Corporation's establishment of sports in the public parks the Dean Park Cricket Ground was only used for club and county cricket, lawn tennis, and croquet. Many years ago a cinder track was made, but after a comparatively short existence it was abolished. The excellence of the ground and its holding capacity eventually received its due reward, for in 1898 the county authorities, as an experiment, held a county match

here. In the previous year the Gentlemen of Philadelphia were entertained. The success attending that experiment was so great that the Hampshire County Cricket Club, from 1900, have given us at least two fixtures every year; and the annual 'Bournemouth Week' has become a permanent fixture. Important matches such as Gentlemen v. Players are occasionally played at Dean Park; while in the years 1902 and 1905 the Australians played against strong teams. An interesting fact worthy of record is that Prince Ranjitsinghi was a regular player at Dean Park; in fact, it is asserted that it was here he received the principal part of his early cricket training which ultimately made him the world's greatest exponent of the game.

Without going deeply into the further history of local cricket we should mention that various leagues are in active operation, thanks mainly to the opportunities afforded by a thoroughly practical and beneficent Town Council. On referring to the table of the provision made our meaning will be more fully appreciated.

The Town Council's decision to establish a precedent in the way of municipal sports, namely, that of the provision of Golf Links, marks an era in the history of the town worthy of notice. When in 1894, the Lord of the Manor, the late Sir George Eliott Meyrick Tapps-Gervis-Meyrick, presented the town with all his rights as Lord of the Manor in Common 59, the complimentary title of Meyrick Park was given to it. It was opened on the 28th November, 1894, by Mrs (now Lady) Meyrick. The establishment of Municipal Golf Links in England had up to that time never been attempted. Since the Bournemouth Links were opened, other municipalities have followed the example set, with varying success. We can safely assert, however, that no town owns two full golf courses (and one nine-hole course for ladies) under local control in the same way as those of the Bournemouth Corporation. The Meyrick Park Links were laid out by the late Mr Tom Dunn in 1894, and are three miles in extent. As well as a public pavilion, there are club houses belonging to the three clubs originally established. Recognising that the provision of golf for the visitors should be fostered and encouraged, the Corporation, in 1905, on acquiring the extensive Queen's Park engaged Mr J. H. Taylor, four times Open Champion, to lay out another full course of eighteen holes. These links, much more difficult than those at Meyrick Park, are 31 miles in extent, and are charmingly situated at the north-eastern part of the Borough. The course was opened by Alderman J. E. Beale, J.P., on the 25th October, 1905. It should be recorded that so popular is the game in Bournemouth that its provision makes no demand on the rates. A public pavilion is also provided for the use of visitors, erected at a cost of £3,000. The Meyrick and Queen's Park Club have a palatial Club House adjoining, fitted up with every regard to comfort. There are lawn

tennis and croquet grounds, as well as a full-size bowling green for the use of members.

The principal swimming club – the Bournemouth Swimming Club – was established in 1889, two years after the erection of the Swimming Baths so excellently and courteously managed by Mr A. H. Milledge, than whom no one has done more for swimming in Bournemouth. Previous to that year there was, of course, regular bathing from the Pier in the early morning, the Rowing Club Boathouse, and the Y.M.C.A. Boathouse. The B.S.C. has had an honourable career, claiming as its members many excellent swimmers and water polo players, many of whom have migrated to other parts of the country carrying with them that delightfully clean variety of the trudgeon stroke which is essentially the 'Bournemouth Stroke.' The Club has always been managed by keen supporters of the art of natation, and they have ungrudgingly devoted much time and energy to the teaching of the young in an art which should be in the curriculum of every Elementary School. Many exciting contests have been witnessed here, especially since water polo became the highly scientific game it has in recent years developed into. During the present year the Committee of the B.S.C. contemplate celebrating in a fitting manner the 21st anniversary of its existence.

The game of water polo had its commencement off the Bournemouth Pier by a number of ardent young swimmers forming themselves into the 'Bournemouth Handball Players.' A full account of the origin of the present-day scientific game is given in the Badminton 'Swimming,' to which we refer anyone interested in this form of sport.

In 1902 the Corporation acquired land in the Malmesbury Park district with the object of erecting Baths, which scheme, however, never matured, although it cannot be said that the project is finally abandoned. The local authority negotiated for the purchase of Messrs. Roberts and Co.'s Baths, previously referred to, without, however, coming to any definite agreement. The bathing machines were acquired from the same firm, the Corporation now controlling the whole of the sea bathing immediately contiguous to the Pier on either side.

Football in the district has been played regularly for years. Our earliest record of a club is that of the Bournemouth Football Club established in 1875.

Since that time the clubs of the town, without attaining greatness, have made a certain degree of fame for themselves by their appearances in competitions principally connected with the county. We cannot avoid expressing our pleasure that our local clubs are still amateur organisations and not professional. Geographically situated as we are it is very doubtful if a professional team of any consequence will ever be established here.

The history of rowing in the locality is practically a thing of the past. In the years 1870 to 1880 two strong clubs were in existence of which the principal residents wrere members. Rivalry was keen; in fact, at times the keenness became bitter and acrimonious, until at length peace was declared and an amalgamation decided on. From that time until about 1905 it can be safely said that our local oarsmen were able to hold their own with the best that could be found on the whole of the South Coast. It is a matter for extreme regret that, excepting the Y.M.C.A., the sport of rowing is nonexistent in Bournemouth.

When the Meyrick Park was opened in 1894 a bowling green was laid down by the Corporation, but beyond the spasmodic play by a few ardent enthusiasts for a season or two, the green was allowed to fall into desuetude. In 1904, on the formation of the Bournemouth Bowling Club, interest in the pastime became more popular, brought about by a direct result of friendly rivalry; and the establishment of greens in various parts of the Borough by the Corporation eventuated in the formation of the Bournemouth Bowling Association, composed of clubs playing on Corporation Greens in the Borough, although this year that limit has been extended to Poole, where the Corporation have laid down a green in Poole Park. It can be safely said that all the local clubs are successful, in point of numbers as well as in financial matters, so that bowling in Bournemouth is catered for and is indulged in by very large numbers of residents and visitors. The other local clubs are Richmond Park, playing on the Winton Recreation Ground; Boscombe Cliff, who use the green in the Cliff Recreation Grounds; King's Park, in the Park of that name; and Argyll, who play in the Argyll Gardens on the West Cliff Drive. Another club not in the Association utilises the Alum Chine Green.

The most successful club, owing no doubt to its ability to draw on a larger number of expert players, has been the B.B.C. Having won the B.B.A. Trophy (a 20 guinea cup) every year since its institution in 1906, despite the efforts made to wrest it from them, the Club has also held the Single handed Championship Shield on two of the three occasions it has been contested for, the only other Club to hold it being Boscombe Cliff. The Rink Competition for a silver cup was held by Richmond Park in 1908, and by the B.B.C. in 1909.

A very successful Tournament was held at Meyrick Park in 1909, entirely managed by the Senior Club; another, on a much larger scale, is this year to be under the auspices of the Bournemouth Bowling Association.

Roller Skating is catered for by the Corporation on the Piers, and at the Winter Gardens on certain evenings during the winter. There are many excellent opportunities for indulging in this pastime, and ample provision is made by private companies at their various rinks.

A Rifle Range is owned by the Council and is situated on the outskirts of the Borough adjacent to Queen's Park. Owing probably to its inaccessibility, this department of miniature rifle shooting is, it must be freely admitted, a great financial loss. Miniature rifle shooting is popular in Bournemouth among the different Clubs, especially in the League instituted for the purpose of competing for the Walter C. Clark Shield, which is contested by clubs whose ranges are on unlicensed premises.

Cycling and Athletics have always been popular in the district. The excellent ground at Dean Park has undoubtedly been the direct reason for this, and the Committee of the Bournemouth Cricket Club established Sports as far back as 1866 – five years before Dean Park was laid out. The Bournemouth Bicycle Club held sports for twenty-four years in succession, until the general waning of athletics and cycling – principally the latter – some years ago compelled their cessation.

22

Medical & Philanthropic Institutions

Probably Bournemouth is unique in its possession of so many philanthropic institutions. One reason for this is the undoubted curative properties of the Bournemouth air, and the sheltered situation of the town from the North and East winds. As will be seen from the following brief resume of the different Sanatoria, Bournemouth was selected in the early days by the most eminent medical authorities as the one spot in England where a Sanatorium should be established. Specially favoured by its visitors, the Bournemouth institutions have been liberally subscribed to by the numerous generous persons who, either out of the goodness of their hearts, or in thanksgiving for the restoration of that priceless treasure – health – to themselves or their relatives, it is unquestionably in a good measure due to the visiting population that many of the excellent homes and hospitals are maintained. It will readily be seen that no permanent community could be reasonably expected to wholly support so many institutions; in fact, the number and size of such places are out of all proportion to an ordinary population of a town similar in size to Bournemouth.

Nearly sixty years ago, recognising the peculiar advantages Bournemouth had towards the treatment of chest complaints, the Governors of the Brompton Hospital decided to establish a Sanatorium for consumption and diseases of the chest. The decision to erect a building was arrived at in January, 1852, and a local Committee was formed to carry on the work. To aid in the scheme concerts and bazaars were held in London, at Branksea Castle, at Boscombe Manor, to found the Bournemouth Public Dispensary, and to further its objects a Committee was appointed, who met on the 17th February at Eastington House. In June the Rules and Regulations were approved and a Committee of Management appointed, resulting in the establishment of this useful public institution at 2, Granville Cottages, on the 17th October, 1859. The Committee continued to do useful work until they found that to adequately cope with the needs of the district a new and more permanent building was required. In 1865 efforts were made to secure a site; but it was not till 1868 that a suitable site was purchased from Mr Robert Kerley on which a building was erected and

opened on the 19th May, 1869; the cost was £1,400, and by the aid of voluntary subscriptions the Institution was free of debt when the doors were opened.

Conveniently situated close to Holy Trinity Church, the Dispensary, which was practically a General Hospital, with wards for male and female patients, as well as accident cases, continued its excellent work until this building also was found to be unsuited to the requirements of a growing town. Meetings were held in November and December, 1886, in support of the building which was destined to become the Royal Victoria Hospital. The ladies of the district formed Committees with the object of collecting subscriptions; and while this good work was in progress the sterner sex were battling with the question of site, eventually overcome by the generous offer of Mr W. Clapcott Dean to give the site on which the Hospital now stands. Valued at £900 this gift was gratefully accepted and very keenly appreciated by the inhabitants. By the time the foundation stone was laid no less a sum than £5,164 had been subscribed by the public, much of it through the instrumentality of the hardworking ladies. The funds and property of the Committee of the Dispensary, estimated at between £4,000 and £5,000, passed into the hands of the Royal Victoria Hospital Committee, as agreed upon by the Joint Committee. A Bazaar held during Easter week, 1889, realised the substantial sum of £2,455 after all expenses were paid; and at a later sale of the surplus goods a further amount of £237 was raised. The plans of the building, drawn by Messrs. Creeke and to found the Bournemouth Public Dispensary, and to further its objects a Committee was appointed, who met on the 17th February at Eastington House. In June the Rules and Regulations were approved and a Committee of Management appointed, resulting in the establishment of this useful public institution at 2, Granville Cottages, on the 17th October, 1859. The Committee continued to do useful work until they found that to adequately cope with the needs of the district a new and more permanent building was required. In 1865 efforts were made to secure a site; but it was not till 1868 that a suitable site was purchased from Mr Robert Kerley on which a building was erected and opened on the 19th May, 1869; the cost was £1,400, and by the aid of voluntary subscriptions the Institution was free of debt when the doors were opened.

Conveniently situated close to Holy Trinity Church, the Dispensary, which was practically a General Hospital, with wards for male and female patients, as well as accident cases, continued its excellent work until this building also was found to be unsuited to the requirements of a growing town. Meetings were held in November and December, 1886, in support of the building which was destined to become the Royal Victoria Hospital. The ladies of the district formed Committees with the object of

collecting subscriptions; and while this good work was in progress the sterner sex were battling with the question of site, eventually overcome by the generous offer of Mr W. Clapcott Dean to give the site on which the Hospital now stands. Valued at £900 this gift was gratefully accepted and very keenly appreciated by the inhabitants. By the time the foundation stone was laid no less a sum than £5,164 had been subscribed by the public, much of it through the instrumentality of the hardworking ladies. The funds and property of the Committee of the Dispensary, estimated at between £4,000 and £5,000, passed into the hands of the Royal Victoria Hospital Committee, as agreed upon by the Joint Committee. A Bazaar held during Easter week, 1889, realised the substantial sum of £2,455 after all expenses were paid; and at a later sale of the surplus goods a further amount of £237 was raised. The plans of the building, drawn by Messrs. Creeke and Leonard, Pastor of the newly opened Baptist Church at Lansdowne. Finding that each was an inveterate smoker, pipes were lighted, and a conversation of a general character took place, but not a word of the controversy was spoken! The whole argument thus ended in smoke over the pipe of peace! The conversation turned on the provision of a Provident Hospital and Dispensary for Boscombe, which resulted in a meeting being called and held at Cunnington's Skating Rink. As we have said, rooms were taken in the main road; and shortly afterwards a building erected as a Fever Hospital in Shelley Road (but never used), was purchased by great efforts on the part of the Committee and opened as the Boscombe Hospital, with twelve beds. The Hospital has had a succession of seven or eight distinct titles, assuming the added title of 'Royal' by permission of her late Majesty Queen Victoria in 1900. The history of the progress of this humanitarian movement at the east end of the Borough is one of extreme interest, but which we regretfully are precluded, owing to exigency of space, from further dealing with. The Hospital has been nobly supported – in the past by, among others, Sir Frederick and Lady Wills; and at the present time by Mr Walter Child Clark, whose benefactions during recent years have been of a generous character.

Some years before her death, Lady Georgiana Fullerton established and maintained at Blenheim House, Lansdowne Road, a Convalescent Home for the sick and afflicted of all creeds. This was threatened with extinction on her decease in 1885. When the Dames de la Croix removed to Boscombe a band of nuns (Sisters of Mercy) came here from the well-known Hospital of St John, Great Ormond Street, London, and established themselves in the 'Convent of the Cross,' Branksome Wood Road, in August, 1887, and gradually transformed the old convent into its present form of St Joseph's Home, where, at the earnest invitation of Mr A. J. Fullerton, they continued to maintain on a sound basis a similar

Charitable Home to that commenced by his wife years before. Although conducted by Catholic nuns the Home is open to all those who can secure the requisite nomination.

In connection with the Oratory of the Sacred Heart Church a branch of the Society of St Vincent de Paul has been in existence for many years. The parent society was established in 1844 and the objects are the relief of the poor, without distinction of religion, in their own homes. The local society works in a very quiet and unostentatious manner yet doing much useful work in relief of the needy.

The Hahnemann Convalescent Home and Homoeopathic Dispensary was established for such consumptive patients as may be recommended to Bournemouth with a fair hope of restoration or considerable improvement; for such convalescent cases of a non-infectious character from the different Homeopathic Hospitals and Dispensaries as may seem to be suitable for admission into such an institution; and for any acute non-infectious cases as may occur in the practice of the Dispensary, and which the medical officers may recommend as suitable. Situated on the West Cliff, on a site granted for 999 years at a nominal ground rent by Mr W. Clapcott Dean, the Home was founded on the 4th January, 1878, the foundation stone being laid by the Right Hon. Earl Cairns, and the building opened by the same nobleman on the 3rd June, 1879.

The Herbert Home was built as a memorial to the late Lord Herbert of Lea, who, we should mention, was the first President of the National Volunteer Association, as well as being a great promoter of sanitary reform in the Army. The Home is a convalescent Hospital in conjunction with the Salisbury General Infirmary, the Governing Body of that Institution having the right to half of the beds provided in the Herbert Home. Founded in 1865, when the Foundation Stone was laid by the Earl of Pembroke, this Institution was opened in October, 1867. Miss Florence Nightingale had much to do with the establishment of the Home.

Most of the Homes referred to are for patients during their convalescence, but the Firs Home is an Institution primarily intended for consumptives whose cure at the Sanatorium is despaired of. Founded by the late Rev. S. R. Waddelow, it has proved of great usefulness to many invalids in poor circumstances. The work is carried on by the aid of voluntary subscriptions.

The St Mary's Home for Invalid Ladies, Dean Park Road, is limited to ten inmates. Founded as a home of rest for ladies with limited means who are in the early or curable stages of consumption and ideally situated adjoining the Horse Shoe Common, the Home has every appearance of an ordinary private house. The income is derived in part from the patients, the remainder being raised by subscriptions from the charitable.

The Victoria Home for Cripples, established at Alum Chine, is a branch of the work of the Ragged School Union, London, with which the Earl of Shaftesbury was so prominently identified and which is now conducted with so much wisdom and enthusiasm by Sir John Kirk.

The 'House Beautiful' is another Institution for London children – established in connection with the Sunday School Union. It is, perhaps, more in the nature of a holiday home than a hospital, but without question its work is a beneficent one.

There are several other Institutions in Bournemouth more or less in the nature of charity organisations, some of them being for the provision of nurses in medical and surgical cases.

Education and the Public Libraries

The public educational work of Bournemouth is in the hands of an Education Committee appointed by the County Borough Council under the Education Act of 1902, and given the full executive power permitted by that Statute. Prior to the Act of 1902 coming into operation, the whole of the educational work of the borough – with certain exceptions to be hereafter enumerated – was dependent upon voluntary enterprise.

The first Elementary School established in the town was that in connection with the Church and Parish of St Peter. The foundation stone was laid on the 30th June, 1850, by the Lady Louisa Ponsonby, and the school was opened soon afterwards. We have referred in a previous chapter to the support which St Peter's gave in the erection of churches and schools in what were then outlying districts, and we may mention here that a Church School was opened at Moordown as early as 1853. The first British School was also established in 'the fifties,' in a building just off the Commercial Road. It was conducted by a head mistress, and managed by a mixed committee of ladies and gentlemen, whose work some years later eventuated in the construction and opening of new buildings at Lansdowne. Holy Trinity Schools (now called the Central Schools), when first erected were described as being 'on the outskirts of the town, near Holdenhurst Road.' St Michael's School was first established in Orchard Street, and afterwards transferred to the present site in West Hill Road. Others came in due course – Church Schools at Southbourne, Boscombe, Winton, Pokesdown, Springbourne, and Malmesbury Park; British or other undenominational schools in the corresponding areas; and Catholic Schools in the centre of the town and at Boscombe Park. Up to 1877, however, the few Catholic children in the town received their schooling in one of the Windsor Cottages, standing on the site now occupied by the Oratory of the Sacred Heart. In 1877 a school was established at St- Joseph's Home, Lansdowne Road; two years later it was transferred to Avenue Road, and in January, 1880, the present site was obtained and St Walburga's was erected on a spot selected by the Lady Georgiana Fullerton.

The principal school of a higher grade character half a century or so ago was one kept by the Rev. J. H. Wanklyn at Exeter House (now the Royal Exeter Hotel); others follow'ed, and there has, of course, been very substantial development since. We cannot, however, without unduly expanding the limits of this volume, go into detail, either with regard to this or other school developments under private direction and management.

Some few years prior to the 'Appointed Day' for the Town Council taking up the duties and responsibilities imposed upon them by the Act of 1902, the Council, acting in conjunction with the Hants County Council, had established the Bournemouth School for Boys, and the School had already begun to make history. The School, which was opened by the late Earl of Northbrook in January, 1901, is under the direction of a Board of Governors appointed under the provisions of a 'Scheme' which has been twice amended to meet changes of local circumstances. The controlling power is practically in the hands of the Bournemouth Education Authority, urorking through its Education Committee and the Governors whom they nominate, but the County Council still retain a share in the representation, and county scholars still share in the privileges of the institution. Dr Fenwick has been the Head Master since the foundation of the School, and Dr J. Roberts Thomson, J.P., has held the post of Chairman of the Governors for the same period.

Science, Art, and Technical Schools and Classes were first established under voluntary agency. A short time prior to the 'Appointed Day' in July, 1903, the Town Council, through their Technical Instruction Committee, assumed a measure of responsibility, but they did not take complete direction of the work till a later stage. Now, the whole of the work has been thoroughly re-organised, with special regard to the educational needs of the borough, and brought into direct association with the other departments of public educational effort. From the basis of the Elementary Schools the Committee have built up a system extending through all grades upward to the Universities, and they are understood to be proud of their achievement in the few short years of their existence, and full of hope of what may be accomplished in the time to come. The Council and the burgesses have given them splendid support, and, besides important work in other departments, they are now building a large Central School of Science, Art, and Technical Instruction, with a Central Public Library attached to the same block. The whnle will form the most imposing block of public buildings in the town.

In 1903, as already stated, all the Elementary Schools were under voluntary management. The new Education Authority accepted the transfer of the Lansdowne British School, Malmesbury Park Free Church Council School, the VVinton British School, the Westbourne British School,

Pokesdown British School, and the Boscombe British School – assuming in some cases the responsibility for a balance of unpaid expenditure, but in the cases of Winton and Westbourne simply accepting the transfer of the school organisations. A large new school, with accommodation for upwards of a thousand children, has since been built at Alma Road, Winton, a new Mixed and Infants' School has been built and opened at Westbourne, and a new Girls' School has been built and opened at Boscombe; a large school with accommodation for 1,250 children (boys, girls, and infants) is in course of erection at Moordown, land has been obtained for a large school in the new district of Stourfield, and other extensions are in contemplation. The number of children at present under instruction in the Bournemouth Elementary Schools is between 8,000 and 9,000, and is, of course, continually increasing. The total capital expenditure to which the Council has committed itself for educational purposes since 1903 is upwards of £85,000. The Educational organisation gives employment – directly and indirectly – for upwards of 450 persons, and the Committee have the expenditure of a total sum (including Government grants, etc.) of more than £34,000 per annum. Alderman C. H. Mate, J.P., who had been previously Chairman of the Technical Instruction Committee, has been Chairman of the Committee from the date of its first meeting down to the present, and the important post of Secretary has during the same period been held by Mr F. W. Ibbett.

In an Appendix we give a complete list of all members who are on, or have at any previous period rendered service on the Town Council. It will be only fitting here to add the names of the 'selected' members of the Education Committee. Those at present serving comprise Dr J. Roberts Thomson, J.P., the Rev. A. E. Daldy, R.D., the Rev. Father Strappini, S.J., Mr C. J. Whitting, Mr D. E. Hillier, Mr A. J. Abbott, J.P., Miss Alice Carr, and Miss Dora Vipan. Former members have included Mrs J. J. Norton (resigned on account of ill health), Miss Punch (resigned on leaving the town); and the Revs. Canon Eliot, R.D., Father Greenan, S.J., G. D. Hooper, and W. Moncrieff, all of whom have passed from this world to the next.

The first meeting towards the establishment of a Public Library was held at Ascham House in May, 1885, when the Rev. G. H. West presided over a company of about thirty of the principal residents. A small sub-Committee was formed to obtain all information as to the working of the Public Libraries Acts in extension of the able account of the functions of a Library Authority written by Dr Martin Reed. Following this clear and concise description of the benefits to be derived by the adoption of the Act, the Committee placed the matter before the Commissioners on the 16th June, 1885, who at a later meeting agreed that the question should be decided by means of voting papers, a public meeting afterwards being

held to discuss the arrangements, Canon P. F. Eliot (now Dean of Windsor) presiding over a large and influential audience. The usual opposition was in evidence, and the stock arguments against public libraries were advanced. The voting papers were issued on the 24th July, 1885. Three days afterwards the Chairman of the Commissioners (Mr H. Newlyn) announced that there were 749 votes for the adoption and 914 against, 1,665 persons not voting. Losing by only 165 convinced the Committee that the canvassing in the poorer districts had not been thoroughly carried out. The subject was allowed to rest for some years, to be again re-opened on the 25th January, 1893, when a preliminary public meeting was held, at which Mr J. R. Ridley presided. An Executive Committee, composed of representatives from all parts of the Borough, immediately formulated a scheme of canvas, for, profiting by past experience, nothing was to be left to chance. Ward Committees were appointed, each with its Chairman and Hon. Secretary, the whole being presided over by Mr Leveson Scarth, with Mr C. J. Whitting as Hon. Secretary. These latter gentlemen marshalled their forces in such an efficient manner that the whole of the ground was covered, and statements were prepared to meet all possible objections. After two months of untiring labour the Mayor (Alderman H. Newlyn) announced on the 11th March, 1893, that 2,062 were in favour and only 704 against.

The first Committee was appointed on the same day; the present Librarian and Secretary (Mr C. Riddle) received his appointment in June, 1894; and the first temporary library was opened on the 1st January, 1895, at 6, Cumnor Terrace, Old Christchurch Road, by the Mayor (Mr Merton Russell Cotes). The work exceeded all anticipations, and the Committee were obliged to seek better accommodation at 2, Stanhope Gardens, Dean Park Road, which was opened by the Mayor, Alderman G. J. Lawson, on the 21st October, 1901. Up to the present time the work of the Central Library has been carried on under most disadvantageous circumstances, but fortunately this unsatisfactory condition is soon to be altered, the Town Council having recently sanctioned the erection of a Central Library on part of the site purchased for the new Science and Art School at Lansdowne. Securing the munificent offer of £10,000 for branches from Mr Andrew Carnegie in July, 1903, the Committee, although unable to immediately take advantage of the offer, were ultimately in a position to build the Winton Branch on a site generously given by the late Earl of Leven and Melville; the Springbourne Branch on a site given by the Corporation – part of the land purchased for Baths; and the Boscombe Branch, now approaching completion, on land purchased by public subscription, Mr Walter C. Clark and the late Sir Frederick Wills being the donors of two-fifths of the total cost. There now only remains the acquisition of a site

for Westbourne, and, notwithstanding difficulties which at present seem insurmountable, the Committee are hoping it will be secured at an early date. When the latter part of the scheme is an accomplished fact, and the Central Library erected, the whole of the Library System will be complete, and the work carried on under much better conditions. It should be recorded that all the Libraries are established on the 'Open Access' system. The Bournemouth Central Library was the first Library to open with Open Access, and the second to adopt it. Since May, 1894, when the system was introduced into the Clerkenwell Public Library (now Finsbury) over 100 libraries have adopted it.

The Town Council has annually nominated six of its own members to serve on the Libraries Committee. Each year also six non-Council members are appointed. Mr C. J. Whitting has had the distinction of serving on the Committee the whole period of its existence, occupying the post of Chairman for nearly 10 years. Other non-Council members have included Mr Leveson Scarth, (the first Chairman), the late Rev. Canon Eliot (also a former Chairman), Canon Toyne, the Rev. E. J. Kennedy, the Rev. W. Venis Robinson, the Rev. J. D. Jones, Messrs. E. Davies, H. H. Odling, G. Galpin, C. T. Miles, J. A. Toone, A. J. Abbott and W. C. Clark, Dr Dixon, Dr George, and Sir Matthew Dodsworth.

Religious Life of Bournemouth

The Religious life of Bournemouth enters very largely into its history as a health and pleasure resort, principally on account of the migratory character of the moving population. Church authorities in seaside towns are obliged to build churches of a much larger type than those towns where the population is purely residential, and of a more permanent nature. It should be said that visitors to Bournemouth have generously recognised this fact, and it is to a great extent due to them that so many handsome and commodious churches and chapels have been erected. In the following sketch of the growth of the religious life of the town, the whole of the information at our disposal has merely been summarised, for a full description of each church and chapel would be out of place in a work which aims at a general review of the whole history of the town. In every case the principal church of each denomination has been dealt with, and the remainder briefly noticed, despite the beauty of the majority, and the very interesting associations surrounding them.

The history of St Peter's Church is in many respects the history of the town, for as Bournemouth has grown, new portions have been added to the original Church, till we have the grand and stately structure which is one of the town's proudest possessions. To trace the growth of the Church we must go back to our earliest record, that being the year 1838, when it is known that at the foot of Commercial Road in the Square (present day names), there was a temporary structure fitted up by Sir G. W. Tapps Gervis, which, it is recorded in the family records, was not large enough to contain two-thirds of the residents and visitors. On the map of 'Bourne Tregonwell,' dated 1835, there is a building shown which corresponds with the position and dimensions of the temporary Church. Here, until the completion of the new Church, services were regularly held twice every Sunday, at 11 and 3, the officiating clergyman being the Rev. Hugh Wyndham, and occasionally the Rev. W. Timson. Sir George W. T. Gervis in the autumn of 1841 built the shell of a new church, the original of the present St Peter's, which was promised to be completed and consecrated in the month of May, 1842, but which still

remained unfinished at his death on the 26th August, 1842. The original scheme was, nevertheless, carried out at the sole expense of the Gervis Estate, and the Consecration ceremony was performed by the Bishop of Winchester on the 7th August, 1845. The Church was endowed, the rent charge on the Estate being £50 per annum. The accommodation provided for 270 worshippers, 150 on the floor and 90 in a gallery at the western end. Not only was the Church provided by Sir George Gervis, but the Churchyard adjoining, of most liberal and ample proportions, was the gift of the same generous benefactor. Being erected rather as a temporary structure, the Church was small and ill-suited to the requirements of the residents and visitors. The style of the architecture, mock Gothic, was severely criticised by one authority, who expressed the opinion that 'the local builders seem to have derived, if not ideas, at least sanction for various barbarisms of style.' The consecration ceremony co-incided with the appointment of the first Vicar, the Rev. A. Morden Bennett, of whom it may be safely said that to his energy and generosity not only St Peter's but the whole town and district owes a deep debt of gratitude. From the moment of his coming in 1845 till his death on the 19th January, 1880, the Vicar of St Peter's devoted his whole time and energy to the building up of the Church and town. No one was more zealous of the town's welfare, or more untiring in his efforts for its success. Reference having been made in previous chapters to Mr Bennett's work for the town, we need only say that he laboured for 35 years in a wholehearted and devoted manner, and when his death came in 1880 he was mourned by all. His death was not only a loss to the Church, it was a sad and heavy loss to the town.

Five years after its consecration the Church proved too small for the increasing congregation, as we find that in 1850 a fund was started for the first enlargement, which, through the efforts of the zealous incumbent, enabled the South aisle to be erected in May, 1851, the foundation stone being laid by Lady Gervis. A short time afterwards the North aisle was added. Then the nave was next lengthened and increased in height with a clerestory. When the question of enlargement was contemplated the Vicar and his wardens very wisely secured the services of that eminent architect, Mr G. E. Street, who designed the church as it would be when completed, in fact as it is at the present day. This, by the way, was called 'the old-fashioned way of building by degrees.' The fact of Mr Street having designed a complete Church accounts for so many incorrect engravings showing St Peter's with a spire in the years 1850 onwards. As the spire was not erected until 1879, it will be seen that no view of the Church is genuine which shows that addition on it previous to the latter year. The excellent plan, next to a complete Church at one operation, adopted by

the hardworking Vicar, was that no new portion was proceeded with until the money sufficient for its completion was forthcoming. In this way the Church authorities were enabled to build up the sacred edifice free of debt. By periodical additions the original fabric has been built around and up to, and converted into the magnificent structure, which is justly considered to be one of Mr Street's most successful works of ecclesiastical architecture. In July, 1860, a proposal for further extension, giving accommodation for 1,000 persons, was proceeded with; and on the 20th December, 1864, the new chancel and the extended burial ground were consecrated by the Bishop of Winchester. The foundation stone of the tower was laid on the 13th April, 1869; and a peal of bells was dedicated on the 6th June, 1871. A plate at the entrance, immediately under the tower, records that: 'To the glory of God, and as a mark of respect to the Rev. A. M. Bennett, M.A., Vicar of St Peter's district, these bells were hung in this tower by the inhabitants of Bournemouth.' The organ was opened in October, 1871; and the foundation stone of the Western transept was laid on the 21st April, 1874, and opened on the 6th December in the same year. The final portion – the spire – was commenced on the 25th March, 1879, the vane fixed in October, and the whole work completed on the 18th December, 1879. One month after the completion of the work of a lifetime the Rev. A. M. Bennett passed away. Shortly afterwards a memorial was promoted, which evenuated in the erection of St Stephen's, or the Bennett Memorial Church. Other additions to the Church of a more or less minor character have been made. In 1908, however, the important addition of the Keble Chapel was constructed.

A large window, illustrating the Te Deum, is a memorial to the author of the 'Christian Year,' St Peter's being the Church in which he worshipped during the last four months of his life. On the 7th August, 1880, Bishop Ryan was inducted to the vacancy caused by the resignation of Prebendary Harland, and an Ordination Service was held on the 19th December, 1880, when sixteen candidates were ordained, and thirteen were made deacons. The relations between Vicar and parishioners were somewhat peculiar at this period, owing to the differences of opinion on matters of ritual, which, however, it is not our intention to further investigate. Bishop Ryan resigned in September, 1881, being succeeded by the Rev. G. S. Ram, who remained until his death, which occurred in October, 1899. He was followed by Rev. Canon C. E. Fisher, who spent fourteen years at St Peter's, during the whole of which time he was an ardent worker in the Church's cause, and he resigned on the 1st June, 1904, when the present Vicar, the Rev. A. E. Daldy, was appointed, the latter being inducted by the Bishop of Southampton on the 28th July. The Mayor (Alderman J. E. Beale) and Corporation attended in state to witness the ceremony.

Enough has been said to show that the completed Church is a beautiful structure, and is a fitting memorial to the generosity of the congregation and visitors, as well as to the remarkable energy of its first Vicar. As this is not intended to be anything but a brief sketch of St Peter's, we are unable to enter more largely into its history, or give a fuller description of its plan, memorial windows and tablets; but before concluding mention should be made, however, of the windows erected 'In memory of Marianne Elizabeth Bennett, the beloved wife, and Elizabeth Ann Bennett, the only daughter, of Alexander Morden Bennett, Incumbent of this Church. These windows were presented to the Church by the congregation as a testimonial of esteem and token of sympathy towards their Pastor in a season of affliction, 1852'; also to the window 'In memory of Edmund Augustus Monro, Captain H.E.I.C.S., second son of the late Lieutenant-General William Hector Monro, who died at Bath suddenly, October 2nd, 1852. This window was presented to the Church in token of her lasting remembrance and regard, by his elder brother's widow, Henrietta Lewina Monro.'

The Church has now 1,250 sittings, of which 400 are free.

The Parsonage House, a large and substantial building, standing on high ground commanding most extensive views, was erected by the Rev. A. M. Bennett in 1846, from designs by Mr Pearce, architect, of Canford, who also furnished the design for the schools shortly afterwards opened.

As we have mentioned, shortly after the death of the Rev. A. M. Bennett in 1880, the project to commemorate his memory resulted in the erection of St Stephen's, known as the Bennett Memorial Church, and situated in the St Stephen's Road, which runs parallel to Bourne Avenue. The principal Bournemouth Churches had their beginnings in temporary buildings, and in this case that method was adopted. Bishop Harold Browne consecrated the temporary Church on the 14th August, 1881, the memorial stone of the permanent Church being laid on the same day, it being the anniversary of Mr Bennett's birth. Described as 'a noble piece of architecture, and a fitting monument to one whose memory is so deservedly cherished by residents in Bournemouth,' St Stephen's, now that it is completed, with the exception of the spire, adds very considerably to the architecture of the district. From the point of view of quietude the Church is ideally situated, and the interior and exterior are both handsome and pleasing. In style it is a transition of Early English to Geometrical Decorated. We regret a further description is impossible, much as this beautiful Church merits it. The Rev. A. S. Bennett, son of the first Vicar of Bournemouth, is the Incumbent, having been its Vicar since the 14th August, 1881, when the temporary Church was consecrated.

Just prior to the decade of Bournemouth's greatest prosperity the Churches of all the Denominations were feeling the need for expansion,

and this was especially the case with the Church of England. In 1867 a second Church being very much required, a distinct ecclesiastical district was formed and a temporary Church built, dedicated to the Holy Trinity, which was opened for divine worship on the 1st December, 1867, the foundation stone having been laid about three months previously by Mrs John Tregonwell. The completion of the Church on the 4th September, 1878, showed that it was 'a bold and somewhat original design, especially pleasing to the educated eye, if not to the casual observer.' In style it is Lombardo Gothic, though by a writer of the period it was said to be lamentable 'that the public taste is insufficiently advanced to be able to appreciate properly an architectural masterpiece, owing to its being in a somewhat unfamiliar style.' We are unable, owing to exigencies of space, to further describe the Church, which had as first Vicar the Rev. P. F. Eliot (now Dean of Windsor), then his brother, the late Canon W. Eliot, the present Vicar being the Rev. A. S. V. Blunt. Many memorials are placed in the Church, one being to Mr Robert Kerley, 'the liberal donor of the site of this Church, in testimony of his public and private works.'

The chief stone of St Michael's and All Angels' Church, Poole Road, was laid on the 8th August, 1866, the consecration ceremony taking place on the 9th December following. The foundation stone of the present handsome Church was laid on the 4th August, 1874, and consecrated on the 20th January, 1876. The addition of the tower adding very considerably to its beauty, was erected in 1901. The first Vicar was the Rev. Edward Wanklyn, whose decease was followed by the appointment of the present Vicar, Canon F. E. Tovne, on the 21st October, 1881.

Owing to the reasons before mentioned we are most regretfully obliged to give only the merest details of the other Churches of the Establishment. The dates given in parentheses relate to the completion of each Church St John's, Moordown (temporary, 31st May, 1851; permanent, 14th April, 1874); St James', Pokesdown (30th December, 1858); St Clement's (15th April, 1873); St Paul's (1887); St Swithun's, Chapel of Ease to St Peter's (1891); St Augustin's (1892); St Andrew's, Chapel of Ease to Holy Trinity (1892); St John's, Boscombe (1895); St John's, Surrey Road (1898); St Luke's, Winton (1898); St Ambrose (1900). St Katherine's, Southbourne (1900); All Saints', South- bourne Road (1902); St Alban's, Charminster Road (1909); also the proprietary Chapel of Christ Church, Seamoor Road, Westbourne.

Until the winter of 1861–2 the nearest Catholic Church was that of St Mary's, Poole. In that season a Mrs Washington Hibbert, a visitor from London, resided at the Belle Vue Hotel, where she formed a private oratory to which any Catholics residing in Bournemouth were welcome. It is recorded that a Father Mochler, S.J., died here in 1862,

and as he was probably an invalid guest of Mrs Hibbert's, services would be conducted by him. The Lady Catherine Petre was able to give similar opportunity during the winters of 1863-4 and 1864-5, in the Oratory she established in the Belle Vue Assembly Rooms. It is interesting to record that in 1863, Mr Thomas Long, now a retired and much respected resident of this town, was the only Catholic permanently living in Bournemouth. In Mrs Hibbert's year Mr Maurice O'Connell was the only known Catholic resident, but leaving the district temporarily, Mr Long, then a youth, had that distinction. In 1865-6 Mr Thomas Weld Blundell had his domestic Chaplain with him at Walton House, Richmond Hill; and in 1866-7 the late Lord Edward Fitzalan Howard (of Glossop) also had his Chaplain with him at 'Brunstath" on the East Cliff. At times of the year when these special facilities were not afforded to the Catholics of the district, they had to go to Poole, where it may be noted a mission was started in 1839. In 1868, through the generosity of an Irish gentleman visitor and his wife, Mr and Mrs Harnett, of County Kerry, a bus was provided, and the announcement given out in the Poole Church was to the effect 'that each Sunday till further notice a bus will start from the Square, Bournemouth, for this Church, at 9.30 a.m.' In 1869 permanent provision was made for the religious needs of the Bournemouth Catholics, when Fathers Brownbill and Eccles established themselves at Astney Lodge, St Stephen's Road, which became the first public Chapel and Presbytery. On the site of the present Church stood a house in the occupation of Dr Falls, which was burnt down in 1868. Here was erected in 1870 a small wooden Chapel to accommodate ninety worshippers, to which the remaining Windsor Cottage served as a Presbytery until 1896, in which year it was taken down for the purpose of extending the Church. Father Maurice Mann, S.J., who was responsible for the building of the Chapel, was the first regularly established Rector. He died at Stonyhurst in 1877.

The old Oratory of the Sacred Heart was begun by Father A. Dignam, S.J., in the summer of 1873, and, after certain variations in the structure, was opened by Dr Dannell, Bishop of Southwark, on the 5th February, 1875. From that time to 1888 the number of Catholics in the town had very considerably increased, the need for extension being always a most pressing one, and in that year Father H. S. Kerr, S.J., instituted a fund toward the erection of a new Church, the plans for which were prepared by Mr A. J. Pilkington, of Lincolns Inn Fields. The foundations of the new Church were laid in April, 1896, the late Father B. Cooney, S.J., being then the Superior of the Mission. The new portion was opened on the 10th March, 1900, and the alterations to the old portion, to unite it with the new, were next proceeded with, the ultimate result being a solemn opening

at Midnight Mass on 31st December, 1900, a fitting commencement of the new century. Alterations and extensions on the Presbytery side were afterwards completed, the whole edifice making a handsome addition to the architecture of the district. There were only about thirty Catholics in Bournemouth in 1871; at the present time the number is so large as to necessitate the provision of four churches. A branch mission was established at Boscombe on the 1st January, 1888, with Father C. de Lapasture, S.J., in charge; and in 1897, six months after the erection of the beautiful Corpus Christi Church, the gift of the Baroness Pauline de Hügel, the missions were separated, the number of Catholics being too large to be spiritually directed from Bournemouth. As well as the establishment of a Mission at Westbourne in 1893, a magnificent Church has been built for the Catholics of the Winton and Richmond Park districts at the sole cost of Mrs Coxon, from plans prepared by Mr Gilbert Scott. Mention should be made that the Convent of the Cross, Parkwood Road, now housed in the magnificent pile of buildings – probably the largest and most stately structure in Bournemouth – was first established in Branksome Wood Road in 1871. In August, 1887, the Dames de la Croix removed, to Boscombe, where they are now conducting a very successful Boarding School for Young Ladies, as well as being in charge of the Elementary School under the local Education Authority. Father A. Kopp, S.J., is the present Superior of the Bournemouth Mission, and Father P. J. Hayden, S.J., that of Boscombe.

The Wesleyan Methodists established themselves in a temporary building in Orchard Place in November, 1859, and when that became too small services were held at the Belle Vue Assembly Rooms. A new Church being needed to meet the growth of the Connexion, a project was set on foot which eventuated in the erection of a handsome Gothic building at the eastern part of Southbourne Terrace, the foundation stone being laid by Sir Francis Lycett on the 21st May, 1866, and the Church opened for service on the 27th September, 1867. Peculiarly situated, this Church was somewhat hidden by Southbourne Terrace on one side, and the Tregonwell Arms on the other. It should here be mentioned that the greater part of the frontages of the Church and Inn occupied the site now the Post Office Road at the Old Christchurch Road end. By 1883 the congregation becoming too large for the Church, a project was established to provide for a new building. A meeting was held in August of that year to consider a difficulty that had arisen which, fortunately, was overcome. The site of the old Church as well as that of the Tregonwell Arms, the license having lapsed, was sold for upwards of £20,000. The share of the Wesleyan considerably damaged, and it was not until the 8th March, 1859, that the building was opened for service.

Early Gothic in style, the Chapel was designed by Mr C. C. Creeke, and was a plain but substantially built structure of Purbeck stone, accommodating about 300, being 70ft. long and 43ft. wide; at a later period a gallery was added at the southwest end, wherein the organ was placed. With the large increase in membership it was found necessary to add to the size of the building, and in 1872 a transept was added, being 68ft. long by 25ft. wide, and crossed the nave at the northeast end; by this addition the accommodation was doubled. Including the tower, spire, classrooms and vestries, the total cost was £3,000. Mr H. T. Helyer, of Bournemouth, was the architect for the new portion, on whom, as well as Mr Creeke, great credit was reflected. In 1874 the Manse was erected from designs by Mr T. Reynolds; and in 1875 the handsomely carved pulpit, the work of the late Mr W. J. Worth, was executed. The new Church was opened on the 24 November, 1891, on the site of the old Church, the main objects being the accommodation of a much larger congregation and the provision of increased schoolrooms. The main building takes the form of a cruciform plan, and designed in the spirit of a somewhat late period of Gothic. The architects were Messrs. Lawson and Donkin. The accommodation provides for 1,100, and the cost of the whole structure was about £12,000. The Rev. Ossian Davies was Pastor of the Church during the years 1888 to 1898, when he was succeeded by the present Pastor, the Rev. J. D. Jones, M.A., B.D., who was Chairman of the Congregational Union for 1909-10.

St. Andrew's Scotch Church was, excepting, of course, St Peter's, the only Church in the district for some years. Being built of galvanized iron, its exterior was by no means prepossessing, yet the interior arrangements were satisfactory. Erected in 1857 at the foot of Richmond Hill, the accommodation was for 320 persons and cost £700, most of which was raised by the indefatigable Pastor, the Rev. H. McMillan, who, it should be mentioned, was presented with a gold watch and appendage by his parishioners in April, 1861; he resigned through ill-health in March, 1884. The iron church did duty for fifteen years, when it was taken down, and a handsome stone building erected, the foundation stone being laid by the Earl of Kintore on the 25th March, 1872, and opened on the 19th November in the same year by the Rev. Donald Fraser, D.D., of London. The Church was small, though exceedingly well situated, and measured only 60 feet by 37 feet. Here the Rev. James McGill was the Minister after the resignation of Mr McMillan. The cost of the building including the site, was £4,000, a schoolroom and vestry being under the Church.

In 1856 land was acquired in, Exeter Road, where the third and present handsome Church was erected. The land on which the two earlier Churches

stood became so valuable that although only a very small piece of ground the price of £7,000 was obtained, or at the rate of £100,000 per acre. The new Church and site cost about £12,000, vrhich also includes the provision of Sessions House, class and schoolroom. The accommodation provides for about 700 worshippers. The Church is a handsome Gothic structure of Purbeck stone and consists of nave, aisles, and tower, with spire 140 feet in height. The local Presbyterians have been fortunate in having a Pastor who has remained continuously with them for 25 years – the Rev. J. W. Rodger being inducted to the Pastorate on the 9th July, 1885. His brother, the Rev. Hugh Rodger, joined him a few years ago, and shares the burden of the work.

The Church of St Mark, Bath Road, was opened in 1902. The Pastor is the Rev. A. Morris Stewart, D.D.

The Baptist Church, designed by Mr Creeke, is situated in Lansdowne Road, and vims opened on the 18th July, 1876, the foundation stone having been laid in November of the previous year by Sir Morton Peto. The first Minister was the Rev. H. C. Leonard; the present Pastor being the Rev. A. Corbet.

The Friends' Meeting House is a small but convenient edifice, built in 1872, of red brick, the necessary funds being raised by voluntary subscriptions among the members of the Friends' Society in the country. The building accommodates about 100 persons, and the plans were prepared by Mr Creeke.

Other Churches in the Borough not previously referred to are as follows, the dates being those of opening:

Congregational: East Cliff Congregational Church, Holdenhurst Road (1879); Westbourne, Congregational Church, Poole Road (1878); Charminster Road, in connection with Richmond Hill (1906); Christchurch Road, Bos- combe (1887); Southbourne Road (1858); Malvern Road, Moordown (1906); Wimborne Road, Winton (1884).

Wesleyan: Holdenhurst Road, Malmesbury Park (1907); Darracott Road, Pokesdown (1907); Poole Road, Westbourne (1898); Ashley Road, Boscombe (1893); Victoria Place, Springbourne (1867); Wimborne Road, Winton.

Primitive Methodists: Commercial Road; Boscombe Grove Road; Wimborne Road, Winton; Ilannington Road, Pokesdown (1897); Nortoft Road, Malmesbury Park.

Baptists: Palmerston Road, Boscombe (1875); West Cliff Tabernacle, Poole Road; Harcourt Road, Pokesdown; Cardigan Road, Winton.

The Unitarian Church in West Hill Road was erected in 1890, and has accommodation for 200 worshippers. The Rev. C. C. Coe, F.R.G.S., is the Minister.

In addition to the foregoing there are numerous Parish Halls, Mission Halls, and Mission Rooms in connection with the various denominations, or as separate organisations.

25

Parliamentary Representation

Christchurch is the 'mother town' of Bournemouth. The Parliamentary borough bears also the name of Christchurch, though more than four-fifths of the electors are registered in the Bournemouth area. In 1885, at the time when the last Redistribution Bill was under consideration, the Board of Improvement Commissioners passed a resolution expressing their opinion that 'the Parliamentary Borough of Christchurch should in future be called the Parliamentary Borough of Bournemouth,' and Mr Horace (afterwards Lord) Davey was communicated with on the matter. His reply was that an alteration would not come within the scope of the authority of the Boundary Commissioners, and the matter could only be dealt with by amendment moved to the Bill in 'the House.' He added: 'I doubt whether it would be consistent with the duty I owe to all my constituents alike to moot it, and I don't think such an amendment would be accepted by the Government.' Nothing resulted from the suggestion, and the constituency continues to bear the title it has had for many centuries.

Christchurch was summoned to send representatives to the Parliament which met at Carlisle in 1307, in the reign of Edward I., but the earliest record of actual representation dates from the thirteenth year of the reign of Queen Elizabeth. Many of its members have been men of very marked ability, who have occupied some of the highest and most honourable positions in the country's service. In earlier chapters reference has been made to Sir Peter Mews, who built the mansion at Hinton Admiral, and to the accomplished Mr Banckes, son of the Sir Jacob Banckes who erected the memorial to John Milton in Westminster Abbey, and who had himself the distinction of having prompted the writing of Hutchins' famous 'History of Dorset.' Then there was Mr Sturges Bourne, chiefly known for his Act regulating Vestries; Mr Edward Hooper, Chairman of Customs, of Heron Court, and his two distinguished relatives, James Harris, 'the amiable philosopher of Salisbury' (known in current annals as 'Hermes' Harris), and his son, the great diplomatist, who became the first Earl of Malmesbury. Of these two men Heron Court has many interesting memorials: literary memorials of the former (the contemporary and friend of Dr Johnson),

and quite a large collection of valuable presents commemorating the services which the latter rendered to the British Empire at the French, Russian, Spanish, and Dutch Courts. These two – father and son – at one period shared the representation between them, for Christchurch at that time had the privilege of electing two members. Mention must be made also of the 'Roses': the Sir George Rose who in 1793 secured the passing of a Bill – the Friendly Societies Charter of Liberty –'for the protection and encouragement of friendly societies in the Kingdom, for securing, by voluntary subscriptions of the members, separate funds for the mutual relief and maintenance of the members in sickness, old age, and infirmity'; the William Stewart Rose, the friend and host of Sir Walter Scott; and the Right Hon. George Henry Rose, who fought the first contested election after Christchurch ceased to be a 'close' borough. Without pretending to observe anything like strict chronological order, we may mention also the eccentric Anthony Ettricke, Recorder of Poole – the magistrate who sent the unfortunate Monmouth to London after capture on Horton Heath. And we must not forget Captain (afterwards Admiral) Harris, grandfather of the present Earl of Malmesbury, who was twice elected – in 1844 and 1847 – but resigned on being appointed Her Majesty's Minister at Berne and the Hague.

Up to the time of the passing of the Reform Bill in the reign of William IV., notwithstanding that it was claimed by the resident householders paying scot and lot, the right of election was exercised exclusively by the Mayor and free burgesses, resident and non-resident – that 'Corporation' whose standing toast was, 'Prosperation to this Corporation,' Mr Hooper having the controlling power for the long period of fifty years, and this being subsequently shared between Lord Malmesbury and Mr Rose. By the Act referred to the privilege was extended to the £10 householders of an enlarged district, which, by the Act 2nd and 3rd William IV., Cap. 64, was for elective purposes incorporated with the former borough. Then it was that the area which we now know as Bournemouth first received representation as part of the Parliamentary Borough of Christchurch, and the first member elected under the new system was, as already recorded, Mr George William Tapps-Gervis, who originated the 'New Marine Village of Bourne.'

We have before us two interesting souvenirs of the elections in 'the forties.' The first is a record of the persons who polled, and how they voted, in the election of March 28th, 1844, when Captain Harris and Mr W. Tice were the candidates, the former receiving 180 and the latter 96 votes. The total number of electors on the Register was 333, and of these the following ten were apparently all who were resident in any part of what is now the County Borough of Bournemouth: James Antle, Bourne;

John Sydenham, Bournemouth; Wm. Castleman, Bournemouth; George Rose, Moredown; John Sloman, Wick; John Galton, Pokesdown; Robert Brinson, Tuckton; Richard Dale, Tuckton; James Allen, Boscombe; and Robert Best, jun., Pokesdown. The second souvenir is the Register for 1848, from which we note that the freemen had diminished from four to two (Mr Wm. Hiscock and the Right Hon. Sir George Henry Rose), and the number of other electors to 311, including among whom we notice the names of the Revs. A. M. Bennett, Mr James Lampard (of the Bath Hotel), Mr James Lodge and Mr David Tuck (of Boscombe), the Rev. E. G. Bayly, Messrs. J. Bell, M. Boyd, J. Domone, J. S, E. Drax, R. Elgie, G. Fox, J. Hibidage, G. Ledgard, J. Sweatman, J. Sydenham, and David and Peter Tuck.

Captain Harris was succeeded by Captain (afterwards Admiral) J. E. Walcott, a cousin of the famous Lord Lyons, and himself a distinguished naval officer. Elected in 1852, he held the seat till 1868, and is said to have been greatly Tespected throughout the borough 'for his genial and happy disposition, and for his earnest endeavour to benefit his native town and its neighbourhood.' He was a liberal subscriber to the building fund of Pokesdown Church, where a window to his memory was erected in 1870.

In 1865, Admiral Walcott had as his Liberal opponent, Mr Edmund Haviland Burke, a family connection of the well-known statesman, and father of the Mr Haviland Burke who now sits in 'the House' as the representative of an Irish constituency. This was the first election in which there was a polling station in Bournemouth. The Admiral had an easy victory, for he polled 211 votes as against his opponent's 143. But Mr Burke found his opportunity in November, 1868, when he obtained the support of 609 electors, as against the 560 votes recorded for Sir Henry Drummond Wolff.

In his 'Rambling Recollections,' Sir Henry has told how he began his exertions to repair his electioneering mishaps. 'From Lord Malmesbury I had purchased a small building property near the sea, in the neighbourhood of Bournemouth, and had there built a house, which I began to inhabit in 1868.' The borough of Christchurch, he adds, 'was a peculiar one. It covered an area of between thirty and forty square miles, and comprised a large variety of interests. There was the building interest at Bournemouth. There were also fishermen and agriculturists; and, to meet the requirements of this large population, the laundry interest had great developments.' 'When a Reform Bill passed, prohibiting the use, by candidates or their agents, of conveyances to take voters to the poll, the agents of Christchurch and Poole hit upon a notable expedient. The agent at Poole conveyed the electors to Christchurch, and the Christchurch agent conveyed the electors to Poole. This plan, however, only lasted one election, I fear.'

Sir Henry wooed the electors with such effect that when the next election came, in 1874, he secured return with the handsome majority of 371. Thus commenced a most distinguished career, leading on from stage to stage to the highest diplomatic appointments and also to great political distinction. In 1875 Sir Henry brought in a Bill which was called the 'House Occupiers' Disqualification Removal Bill,' which was suggested to him by the condition of the electorate at Bournemouth, and which Sir William Harcourt dubbed 'The Bournemouth Reform Bill.' 'By the law, as it then stood, all householders were debarred from letting their houses furnished without disqualifying themselves as voters. This was a great grievance to persons of moderate means. The Bill enabled owners of houses to let their tenements furnished for four months in every year without having their names taken off the register, and thus made it possible for them to enjoy their annual holiday.' 'I believe,' adds Sir Henry, in his work already quoted –'the Bill has worked successfully.' We cannot here attempt a long review of Sir Henry's Parliamentary career: it will, perhaps, be sufficient to say that he became recognised as one of the ablest debaters in the House (as early as 1876 he 'had the honour of being answered by Mr Gladstone himself'), he is credited with having been the creator of the Primrose League, and he was one of the members of the historic 'Fourth Party.'

In 1880 Sir Henry Avas elected as M.P. for Portsmouth, his place at Christchurch being filled by Mr Horace Davey, who in a subsequent Parliament became Solicitor General, and at a later stage was promoted to a Judgeship and raised to the peerage as Lord Davey. Mr Davey's candidature was supposed to have frightened Sir Henry away from Christchurch in 1880; but, however that may be, there is this personal incident to record: In 1885 Sir Henry supported Mr Davey in an amendment which he moved to the Registration Bill, providing that medical or surgical attendance, or the giving of medicine, should not be deemed to constitute parochial relief within the meaning of the Representation of the People Act. The proposal, however, was lost, the Government not being able to accept it as an amendment to a Registration Bill.

Mr Davey, whose association with the Borough is commemorated on the Pier Clock, which he presented to the town in 1880, was succeeded in 1885 by Mr C. E. Baring Young, who was re-elected in 1886. Mr Abel Henry Smith, another champion of the Conservative party, was elected in 1892 and again in 1895, after which he withdrew in response to an invitation to represent a Hertfordshire constituency with which his family had been long and honourably associated. In 1900, Major Kenneth Balfour and the Hon. T. A. Brassey, who had been school-boys together in Bournemouth, and both of whom had been recently doing military service in South Africa, were the two candidates, and the former won by the narrow majority of

three votes. In 1906 there was such a swing of the pendulum that Mr A. A. Allen – a gentleman who both before and since has rendered valuable service on the London County Council – was returned with a majority of 567; but he lost the seat in 1910, when there was another violent swing of the pendulum, Mr Henry Page Croft, one of the active organisers of the Tariff Reform party, securing election with a majority of 731.

The electorate of the Parliamentary Borough of Christchurch totals 10,991, of whom no less than 9,347 are registered to poll in the Municipal borough of Bournemouth.

To this review of Parliamentary representation it may be appropriate to add a reference to Bournemouth's association with some of the great political leaders. In the Preface of his Grace the Duke of Argyll mention is made of the fact that 'much of the history of England during the time of Lord Derby's Administration was guided by the Earl of Malmesbury,' one of Bournemouth's ground landlords and a near neighbour, and we have ourselves quoted from his lordship's reminiscences of Bournemouth far back into the last century, when he came hither as to 'the most secluded spot in England' with his friend and relative the 'good' Earl Shaftesbury. Lord Shaftesbury, we may add, was in various ways associated with Bournemouth; he took a great interest in its development, and laid the foundation stone of Holy Trinity Church in June, 1868. Ashley Road, Boscombe, was so named by some of his admirers, just as a neighbouring road was named Palmerston Road in commemoration of the great Statesman who formerly represented South Hants, in which county constituency Bournemouth was included. Lord Shaftesbury's noble work for the poor and for the general uplifting of humanity is commemorated also in the title – Shaftesbury Hall – given to the great public meeting-place now owned by the Young Men's Christian Association; while an adjoining building – the Cairns Memorial Hall – bears the honoured name of that great lawyer and statesman, the first Earl Cairns, for many years Lord Chancellor of England, who, even during the time of his Chancellorship, found opportunity to conduct a Bible Class in Bournemouth, and apparently esteemed such comparatively lowly service as neither undignified nor inconsistent with the highest duty towards an earthly monarch. Lord Cairns lived at Bournemouth during the whole time of his Chancellorship; he died here, and was laid to rest in the Cemetery, his funeral being attended, among others, by his last political chief, the Marquis of Salisbury. It was during Lord Cairns' first Chancellorship, we may add, that Mr Disraeli (afterwards Lord Beaconsfield) paid the visit to Bournemouth to which reference has already been made. The Right Hon. W. H. Smith, another great Conservative statesman, was also at one time very prominently associated with Bournemouth, as was also his father,

the founder of the well-known publishing firm, to whose memory there is a beautiful tracery window in the Sanatorium Chapel. We must recall the fact, too, that it was at Bournemouth that Mr Gladstone made his last public utterance – those few brief words which were a benediction alike upon the town and 'the land we love.' He had come here intending, if his life were spared, to remain for some time; but his sufferings increased, and, having at last consented to the calling in of a specialist, the discovery was made that the disease was mortal, and that the end would not be long delayed. 'The illustrious invalid,' says Sir Wemyss Reid, 'received the announcement not so much with calmness as with a serene joy... The announcement that his end was inevitable and near was hailed by him as a prisoner hails the order of release. But his desire was to die at home, amid the familiar surroundings of the house where he had spent his best years, in the peaceful seclusion of his family life. So, quickly following upon the announcement of the surgeons, he made his last journey from Bournemouth to Hawarden. One most pathetic incident attended that journey. The news that he was leaving Bournemouth spread abroad in the town, and some inkling of the truth as to his condition had leaked out. When he reached the railway station there was a crowd awaiting his arrival, and as he walked with almost vigorous step across the platform, someone called out, 'God bless you, Sir.' Instantly he turned, and facing the uncovered crowd, lifted his hat, and in the deep tones which men knew so well, said 'God bless you all, and this place, and the land we love.' This benediction was Mr Gladstone's last utterance in public.'

26

Some Literary Associations

Sir Percy Florence Shelley, who for a long period of years resided at Boscombe Manor, was a son of the poet Percy Bysshe Shelley, who was accidentally drowned while yachting in the Gulf of Spezzia in 1822. The widow, Mary Wolistonecraft Shelley, survived her husband for many years, and on her death on the 1st February, 1851, her son caused the body to be buried in a vault in St Peter's Churchyard. To this tomb he at the same time transferred from St Pancras Churchyard the bodies of her father and mother, William Godwin and Mary Wolistonecraft Godwin.

William Godwin was the author of a work entitled 'Political Justice,' which, in its time, attracted much attention and criticism. His wife's 'Vindication of the Bights of Women,' 'temperate as it appears today, roused a very whirlwind of abuse. Horace Walpole was only voicing the general opinion when he called the author by the cruel name of a 'hyena in petticoats.' Our quotation is from a recent work on 'Famous Blue Stockings,' by Ethel Rolt Wheeler. Professor Henry Morley, whose criticism is discriminating, says that 'the book, with a few touches characteristic of its time, was wholesome and, indeed, essentially religious, in its tone, the greater part of it having been justified by the experience of after years. Its plea was almost wholly for the rights of women to such education as would enable them to win strength for right living, and would not confine the means of intellectual and moral growth so commonly to the training of men as to 'give a sex to virtue.'

Mrs Godwin died in giving birth to a daughter, who survived and grew to womanhood, and married the poet Shelley. Inheriting the literary instincts of her parents, at the age of nineteen she wrote a remarkable and exciting story entitled 'Frankenstein,' which Sir Walter Scott is said to have 'preferred to any of his own romances.' Included in the 'Treasure House of Tales by Great Authors' are a number of other works by the same talented lady, respecting whom Dr Garnett comments as follows: 'The artistic merit of her tales will be diversely estimated, but no writer will refuse the authoress facility of invention, or command of language, or elevation of soul.' Of 'Frankenstein' he says: 'It is famous. It is full of faults venial in an

author of nineteen; but apart from the wild grandeur of the conception, it has that which even the maturity of some talent never attains – the insight of genius which looks below the appearance of things, perhaps even reverses its first conception by the discovery of some underlying truth.'

Sir Percy Shelley was desirous of rearing some further memorial to his father and mother, and the beautiful marble cenotaph which now stands in the tower of Christchurch Priory was first offered to St Peter's Church, but declined, on the ground, so it is said, that it would make the church into a show-place. Shelley, it will be remembered, was drowned by the upsetting of a boat in the Gulf of Spezzia in July, 1822. On his body being recovered, it was cremated and the ashes reverently buried in the English Cemetery at Rome. But the heart was snatched from the flames by one of his friends, and for many years it was among the collection of relics of the great poet which Sir Percy and Lady Shelley so lovingly cherished as Boscombe Manor. As mentioned above, Mary Wollstonecraft Shelley was buried in St Peter's Churchyard on her death in 1851. The occasion thus inspired a Fordingbridge correspondent of the 'Poole Herald':-

Oh, Mary, thou steepest, far, far from thy lover.
The poet, thy husband, the dear one to thee;
With kisses the zephyrs his smooth bed e'er cover,
Whilst thou hear'st the wail of the sombre pine tree.
The dove cooeth for him a mournful regret,
Italia's green myrtles, too, over him wave;
And so starry the blossoms around him are set.
His spirit seems changed to the flow'rs o'er his grave.
Sleep thou to the song of the hoarse-voiced water,
 To the buzz of the' wild bee, that wing'd minstrel elf;
The bard's honour'd wife, of talent a daughter,
Companion of genius, a genius thyself.
Ay, sleep, with thy white palms press'd close to thy sides,
While the heath purples o'er thy death frozen breast;
Smooth palms, that a Shelley once clasp'd as his bride's,
Soft hreast that the lip of his infant once press'd.
And know that the angels can watch o'er thy bed,
Though seagulls flit round it, and wild tempests rave;
While with lordly defiance each wave rears its head,
To part thee for aye from that lov'd southern grave.

But 'Mary' and 'her lover' sleep at last in the same grave; on the death of Sir Percy, the heart of the father was placed in the coffin of the son! William and Mary Godwin, Percy Bysshe and Mary Wollstonecraft Shelley, and the

late Sir Percy and Lady Shelley are all interred in the one vault in St Peter's Churchyard.

At Boscombe Manor, Lord Abinger still has the original cast of the cenotaph by Weeks, together with a collection of letters by the Godwins and the Shelleys, by Samuel Rogers (the banker poet), by Trelawney, by Keats, and others, including the last letters which Keats wrote to Shelley on going to Rome. Lord Abinger has also the manuscript of 'Frankenstein' – shown some years ago in the Keats-Shelley Exhibition, replicas of the portraits of Godwin and Mary Wollstonecraft now in the National Portrait Gallery, a portrait of Godwin by Sir Thomas Lawrence, and many other souvenirs of writers whose true greatness has only been appreciated since their death. Shelley's last home on the Gulf of Spezzia, we may add, formed the subject of the drop scene in the Boscombe Manor Theatre, where, as already recorded, so many delightful entertainments were formerly given.

Bournemouth was for three years the home of Robert Louis Stevenson, one of the most captivating and one of the greatest novel writers of the nineteenth century. These three years – 1884 to 1887 – although in the matter of health the worst and most trying of his life, were, in the matter of work, some of the most active and successful. According to Mr Colvin, Stevenson 'found in the heaths and pinewoods here some distant semblance of the landscape of his native Scotland, and in the sandy curves of the Channel Coast a passable substitute for the bays and promontories of his beloved Mediterranean.' For the first two or three months the Stevensons occupied a lodging house on the West Cliff, called 'Wensleydale'; for the next three or four, from December, 1884, to March, 1885, they were tenants of a house called 'Bonallie Towers,' pleasantly situated amid the pinewoods at Branksome Park, and lastly, about Easter, 1885, they entered into occupation of a house of their own, given by the elder Stevenson to his son, and re-named by the latter 'Skerryvore,' in reminiscence of one of the great lighthouse works carried out by the family firm off the Scottish coast. Here he lived, according to his own description, 'like a weevil in a biscuit,' and here it was that, notwithstanding the almost perpetual handicap of serious ill-health, he achieved some of his finest work. 'Kidnapped' belongs to this period; so, too, does 'Underwoods' – which he dedicated to Dr T. B. Scott and others of the medical profession – and the phenomenally successful story of 'Dr Jekyll and Mr Hyde' was also produced at Bournemouth. 'A subject much in his thought at this time,' says Mr Graham Balfour, 'was the duality of man's nature and the alternation of good and evil; and he was for a long while casting about for a story to embody this central idea. Out of this frame of mind had come the sombre imagination of 'Markheim,' but that was not what he required. The true story still delayed, till suddenly one night he had a dream. He awoke, and

found himself in possession of two or rather three of the scenes in the 'Strange Story of Dr Jekyll and Mr Hyde." 'Skerryvore' was an ivy-covered house pleasantly situated at the head of Alum Chine, with a garden, which was 'an endless pleasure to Mrs Stevenson.' The house, which stands at the foot of Middle Road, Westbourne, still bears the same name. Some day, perhaps, an enlightened authority will mark the spot with an appropriate tablet.

Among Stevenson's greatest friends at Bournemouth were Sir Percy and Lady Shelley, the latter of whom took 'the greatest fancy' to him, and 'discovering in him a close likeness to her renowned father-in-law, she forthwith claimed him as her son.' Away in far Samoa, Stevenson remembered his old friends at Bournemouth, as is shown by the dedication of 'The Master of Ballantrae' to his 'fellow sea-farers and sea-lovers,' Sir Percy and Lady Shelley. Other Bournemouth friends included Sir Henry Taylor and his wife and daughters, and it is recorded that on Stevenson leaving England his friends had to scour London one Sunday afternoon to secure a copy of 'The Woodlanders,' by Thomas Hardy – the only book he was anxious to take with him on the voyage.

Sir Henry Taylor was a resident in Bournemouth for a period of a quarter of a century, and wrote of it as being 'beautiful beyond any seaside place he had ever seen,' except the Riviera. Of the 'live beauties and the humanities' he was not so enamoured, and we find him describing the residents of 1861–62 as comprising 'two clergymen, two doctors, three widows, and six old maids. Of these, the doctors and two of the widows have families. The clergymen and the old maids have none.' The 'old maids' he describes as 'very various'; of the widows he had at the time of writing, only seen one: 'she is all purity and refinement, but has no more taste than the white of an egg.'

Sir Henry Taylor was the author, among other works, of 'Philip Van Artevelde,' one of the famous dramatic poems of the last century, the subject of which is said to have been suggested to him by his friend Robert Southey, Poet Laureate. Sir Henry was for many years in the Colonial service, and his work received the reward of a knighthood. Still higher distinction was at one time contemplated, for it is recorded in his autobiography that Lord Russell designed for him one of the peerages which it was proposed to create under the 'Life Peerage Bill' of 1869. The Bill referred to passed second reading in the House of Lords, but was defeated on third reading through the energy and persuasive power of the Earl of Malmesbury, who offered the most vigorous opposition, 'converting to my views both my leaders and many others who had supported the Bill.

James Payn was another penman who was a great admirer of Bournemouth. His last visit was in the winter of 1893–4, when, as he

subsequently told the readers of the 'Illustrated London News,' in one of his charming letters, he had an experience which came very near to cutting short the thread of life. He was staying at the time at Boscombe, and was being professionally attended by Dr Nunn. While riding in Bournemouth he had a sudden and severe attack of hemorrhage. He just managed to give the cabman the address of his medical adviser, and inaugurated his arrival by a fainting fit on the doorstep. For a time, we are told, he hung between life and death; but, later in the evening, was sent home in an ambulance. 'Our way,' wrote Mr Payn, 'lay under fir trees, with the crescent moon above them, and as I looked up I said to myself (very unreasonably, but I was not in a position to be logical), 'I am being buried, and a very handsome collection of plumes has been provided by the undertaker.' There was, indeed, a mile and a half of them.' 'But,' he added, 'the whole expedition was most successful.'

John Keble, the author of 'The Christian Year,' spent the last days of his sainted life at Bournemouth, and has no less than three memorials: the 'Minstrel Window' in St Peter's Church, erected shortly after his death; the Keble Chapel in the same building, dedicated only a short time ago; and a memorial tablet on the house where he spent his last days – a house known as 'Brookside,' overlooking the Lower Pleasure Gardens and the Pier Approach. Canon Twells, who wrote the popular hymn 'At even, ere the sun was set,' built and founded the Church of St Augustin, Wimborne Road, is appropriately commemorated on a memorial cross fronting the building, and has been succeeded in the vicariate by another hymnologist, the Rev. S. C. Lowry.

Comment has been made elsewhere on the references to Bournemouth – the 'Pleasure City of Detached Mansions' – in Thomas Hardy's 'Tess of the D'Urbervilles,' and in Besant and Rice's 'Seamy Side' and other works. 'Local colour' will also be found in works by R. D. Blackmore ('Craddock Nowell'), Conan Doyle, Orme Angus, John Oxenham, James Baker, and some others. The Rev. Mackenzie Walcott, several times quoted in these pages as a writer of local handbooks, was a son of Admiral Walcott, formerly M.P. for Christchurch; and the Rev. Richard Warner lived for many years at Christchurch. Dr George Macdonald was for many years a resident at Bournemouth; 'Rob Roy' Macgregor not only lived here, but took an active interest in many local institutions; his Majesty King Oscar of Sweden and Norway, who led a literary life unexampled among European Royalty, twice visited the 'Evergreen Valley,' and laid the foundation stone of the Hotel Mont Dore; Adeline Sergeant, Guy Boothby (the creator of the famous 'Dr Nikola'), and Dr Cunningham Geikie each spent their closing days here; M. Vladimir Tchertkoff, Tolstoy's literary representative in this country, has had the superintendence of the Russian colony at Tuckton;

and 'Rita' and 'Clive Holland' are well-known present-day residents. Mention has been made of the Christmas letter Mr Benjamin Disraeli wrote to Thomas Carlyle from the Bath Hotel, and of Huxley's letters written from a house overlooking Durley Chine. In another chapter also reference has been made to William Stewart Rose, friend and host of Sir Walter Scott, and formerly M.P. for Christchurch, and to 'Hermes' Harris, of Heron Court, the great philosophical writer described by Boswell as 'a very learned man' and declared by Goldsmith 'to be what is much better,' – 'a worthy, humane man.' Dr Johnson was not so sure as Boswell of Mr Harris's learning; 'his friends give him out as such, but I know not who of his friends are able to judge of it.' A lady member of the family, we,may add, avenged Johnson's slighting observation by leaving record of her impression of Dr Johnson as a man who seemed to be possessed of no benevolence, to be beyond all description awkward, untidy in dress and person, and a nasty and ferocious feeder!

Bournemouth in 1910

We come at last to a consideration of Bournemouth as we find it in the year of grace 1910, on the eve of the grand Centenary Fetes planned in celebration of the visit and settlement of the first 'proprietor resident' in 1810 – that Mr Lewis Tregonwell to whom we have so frequently referred as having been the first to 'bring Bournemouth into notice as a watering place.' Marvellous are the changes which have been effected in the century. Still more striking are the contrasts presented if we limit our survey to the last half-century, or to the period which has elapsed since the passing of the Bournemouth Improvement and Pier Act of 1856, and the first establishment of any system of local government: the starting, if we may so describe it, of the first piece of machinery for the administration of town affairs in the general interest of the whole community. Let us look for a moment at some of these developments and what they connote.

The area of the Commissioners' district – the Bournemouth as it then existed – in 1856, was, as we have shown, 1,140 acres, and the sea-frontage extended for two miles along the Bay. Today, the area of the County Borough of Bournemouth is 5,850 acres, and the sea-frontage is nearly six miles. In 1856, the population of Bournemouth was a few hundred only; in 1910 it is estimated at nearly 80,000. The rateable value of the district in 1856 was about £5,000, and a shilling rate was estimated to produce a sum of £282 13s. The last rate made by the Borough Overseers (including provision for the levies of the Board of Guardians as well as of the Town Council) was for a sum of upwards of £161,000! The total Revenue expenditure by the County Borough Council during the year ended the 31st March, 1909, is reported by the Local Government Board's District Auditor (Mr Harold Locke) – 'inclusive of a sum of £34,530 3s. Id. expended on Higher and Elementary Education' – to have 'amounted to £315,989 10s. 4d' – approximately £1,000 a day for every working day of the year, And this for a town which, in 1856, had a population of but a few hundred persons!

In a previous chapter we have quoted the number of employees in the Tramways Department as over 450; the staffs for whom the Education

Committee have responsibility total nearly as many – or slightly more if we include the teaching staff of Bournemouth School and teachers, in various departments, only rendering part-time service. The gross total of employees – salaried and wage-earning – in all departments is upwards of 1,600 – or about double as many as the total population of the town about fifty years ago.

Bournemouth, as we have shown, has risen through various stages to the status of a County Borough. It is also included in the list of places recognised as 'Great Towns' by the Registrar-General. It has a Municipal electorate of about 11,500, of whom about 2,850 are ladies – an unusually large proportion, even for a health and pleasure resort! The huge development which has been brought about is the result not merely of initial natural advantage, of judicious, persistent, and timely effort both of private and public enterprise, but of the unstinting expenditure of money. The rateable value of the County Borough is now upwards of £650,000 – as compared with about £5,000 in 1856. We shall not, we believe, be over-estimating if we assume that, including churches, chapels, and schools not rated, this represents a capital investment of, say, ten millions sterling. To this we have to add the expenditure by the London and South Western Railway Company on the provision of railway accommodation in and for Bournemouth, the invested capital of the Gas and Water Company, and the expenditure by the Electricity Supply Company and the National Telephone Company, adding, say, another two and a half millions. The direct expenditure by the Corporation itself has been enormous. The accounts for the year ended the 31st March, 1910, show that at that date the Municipal debt on reproductive undertakings totalled £487,673, and that on non-productive undertakings £410,413, making up a gross total of £898,086 as the balance at present remaining undischarged of a very much larger investment. In their early years the Commissioners were faced with considerable difficulty through the poverty of their financial resources, and upon one occasion had to apply to the National Provincial Bank for a temporary loan of £200 to carry out works most urgently necessary. At the present time – pending a new issue of Corporation Stock – the same Bank allows the Corporation an overdraft up to £250,000, – which, coming from such a quarter, is very conclusive testimony of Bournemouth's status in the Money Market.

Other comparisons are no less striking. Bournemouth in 1810 was a wild heathland – its central feature an undrained swamp – practically without population, and rarely visited except by a few sportsmen, an occasional picnic party from Poole, Wimborne, or Christchurch, or by bands of smugglers engaged in the illicit traffic which was then so common along all our coasts. Nearly half a century after the coming of

Mr Tregonwell, and more than half a century after the planting of the first pine trees, Bournemouth was still a mere village, remote from any railway station, lacking all the conveniences of modern life (except a few bathing machines – luxuries which, apparently, were first introduced by the Tregonwells), and, beautiful though the sea-front may have been, the Valley lacked all its present charm, and, in its undrained, boggy condition could hardly have been salubrious. Today Bournemouth has one of the best railway services in the Kingdom, bringing it into such direct association with all the great centres of population that one may travel, not only to and from the Metropolis, but to and from the most distant towns in the North, and from Scotland itself, without change of carriage, and with all the luxury and convenience which corridor cars and luncheon and dining saloons afford. Well organised steamboat services give communication with places along the coast, east and west, and occasionally across the Channel to France or the Channel Islands. Upwards of 600 acres of Parks, Pleasure Grounds, and other open spaces provide for the recreation of the people. The Valley, for something like two miles inland from the sea, is one continuous panorama of ever-changing beauty; while Piers and Skating Rinks, Municipal Golf Links, Cricket and Football Grounds, tennis and croquet lawns, hockey grounds and bowling greens, provide abundance of other means of amusement and recreation. There are Theatres and other places of entertainment, and the Symphony and Orchestral Concerts, which are the prominent features of the Winter Gardens entertainments, are unrivalled by any provincial town in the Kingdom. Nor is there any lack of provision for the moral and intellectual life of the people. Bournemouth's expenditure on Churches has been of the most liberal – we might almost say lavish – character; it has established, and is still developing, its Public Libraries; and its expenditure on institutions for the education of the people – at first, almost exclusively from funds voluntarily subscribed, and latterly from the public revenues – has been marked with the same appreciation of the wisdom of thoroughness and of such provision as will meet, and adequately and properly meet, all the reasonable requirements of the growing population.

Here we would like to emphasise a fact which is not, we fear, always recognised. As the years have rolled by, Bournemouth has grown, not less, but increasingly beautiful. The planting of the pine trees laid the foundation of much of the prosperity which Bournemouth has attained. But the suggestion one sometimes hears that Bournemouth is being ruined by the destruction of its pine trees is entirely misleading. We may all regret the loss of the pine woods; but the pine trees are with us still, and, taking the whole area of what we now call Bournemouth, probably the trees are more in number than they were, say, sixty or seventy years ago. All the

large estate owners and the Corporation have what we may call a tree-planting policy. Trees have to be cut down to make room for the building of houses; but the detached system of building is still the general rule, and every garden has its trees. They are not all pine trees, and it is fortunate that they are not, for the pine, with all its good qualities, unrelieved by other foliage, presents a sombrous appearance. Acacia and 'May,' laburnum and mountain ash, copper beech and silver birch, give welcome relief to the monotony of the pines, and the rhododendron completes the charm. And the tree-planting still goes on. In the Chines, for instance – where rusticity has not been entirely lost, but much beauty added, as well as convenience and accessibility. What wonder that a place with this charm is so popular a rendezvous for the conferences of important bodies such as the British Medical Association, the Institute of Journalists, the Association of Municipal Treasurers and Accountants, the Congregational Union of England and Wales, the Grocers' Federation, the High Court of the Ancient Order of Foresters, various Brigades of Volunteers, for occasional meetings of the Royal Counties' Agricultural Society, or as a Rendezvous for his Majesty's Fleets – as in 1907, when the Home Fleet anchored in the Bay for some days, receiving a hearty civic welcome from the Municipal Authority!

And with it all Bournemouth remains true to its description as 'a new world within an old,' for every visitor is struck with its appearance of modernity – with all the advantage which that implies – and everyone who makes the least inquiry finds himself equally impressed with its 'old-world' surroundings. In one instance there is a strange perversion of this order, for Bournemouth possesses a local institution which is older than itself. We refer to the Masonic Lodge of Hengist, No. 195, which was established at Christchurch as far back as 1770 – or forty years before the memorable visit of the 'Founder of Bournemouth.' It was transferred to Bournemouth in 1851, and has now three companion Lodges associated with the craft: Lodge Boscombe, No. 2158 (established 1886); Lodge Horsa, No. 2208 (established 1887); and Lodge Rowena, No. 3180 (established 1907), together with other branches of Masonic Art, as duly chronicled by Mr C. J. Whitting in his 'History of the Lodge of Hengist.'

From the small beginnings of 1810, when Mr Tregonwell found it necessary to build a house for his occupation before he could attempt to settle here, Bournemouth has grown, as these pages have revealed, till today it is a Great Town, including nearly fifteen thousand houses. Its resident population is large, and there is a continual stream of visitors all the year round. Included among its guests have been many royal and distinguished personages – some of whom have come again and again, testifying to their great appreciation of the town's climatic and other

attractions. It is impossible to give an exhaustive list. Mention has already been made of the visits paid by his late Majesty King Edward VII. in 1856 and in 1900; by our present King, George V., in 1890; and by H.R.II. the Princess Louise, Duchess of Argyll, in 1863 and 1903. Others associated with the Royal House of this country have included H.R.H. the Duke of Connaught, H.R.H. the Princess Beatrice in 1902, T.R.H. the Duke and Duchess of Coburg (formerly the Duke and Duchess of Edinburgh), H.R.H. the Duchess of Albany, H.R.H. Prince Henry of Battenberg, H.R.H. Princess Christian, their Royal Highnesses the Duke and Duchess of Teclc, and H.R.H. Princess Alexandra of Teck. Other royal visitors have included H.I M. the Emperor of Germany, the Empress of Austria, the late King of the Belgians, two Ex-Queens of France (Queen Amelie and the Empress Eugenie) – and we must not forget the very noteworthy visits of the late King and Queen of Sweden and Norway and the 'royal wedding' which took place in St Stephen's Church in 1888, when Prince Oscar married Miss Ebba Munck, one of the ladies of her Majesty's Court. King Oscar's speech on the occasion of the laying of the foundation stone of the Hotel Mont Dore, with its fine testimony to the Bournemouth climate, and to that 'charming evergreen which to northern eyes has so great a value,' is still remembered, and the hope of Bournemouth is that all its visitors, like his Majesty and his Royal Consort, may, when they come, have a 'happy time,' and leave it, as they did, with the declaration that 'never will we forget this place, but ever will we with the greatest interest hear of its prosperity and welfare.'

Mrs M. Ware, of Boscombe, has the distinction of being the oldest native still resident in the Borough. She was born in 1827, and has lived here ever since. On the country's roll of fame appears the names of two other natives: the late Sir Charles Parker Butt and Sir Hubert Parry, the former eminent in Law, the latter one of the most popular musical composers of the present day.

The long series of interesting events which it has been our pleasure to chronicle are to culminate shortly in a grand Centenary Celebration, under the arrangement of an influential and representative Committee, with the Right Worshipful the Mayor (Councillor G. E. Bridge, J.P.) as President. We cannot anticipate the result of that effort, but writing on the eve of the Celebration we should be lacking in our duty did we not put on record the fact that a guarantee fund of nearly £30,000 attests the determination of the townspeople to make the celebration worthy of the occasion. The Committee presided over by Councillor Bell is an unofficial body; but it is representative, nevertheless, and the personal enthusiasm of the Mayor may, we hope, be taken as an index of the feeling of the whole Corporation – 'Mayor, Aldermen, and burgesses' of every degree.

What yet remains to be accomplished? We have seen how Bournemouth has passed through various metamorphoses; how it has grown from village to town, how it became a municipal borough, and how, at length, it attained to its present position as a County and Quarter Sessions Borough, with the highest privileges given to any of the local governing authorities in this country. But there is one step yet to be taken. We hope to see Bournemouth become a City. It was denominated a 'City of Pines' years ago; that designation we hope will some day – and at no very distant day either – secure official recognition and Bournemouth be in fact as well as in popular designation a City. Bournemouth, we are confident, has not yet reached the zenith of its fame: not yet attained to the full measure of its potential development. It has nearly three miles of sea frontage not yet built upon, and north and east of the borough there are still large tracts of heathland and pinewood which sooner or later will become incorporated in the City of Pines!